PARIS

Between the Wars 1919–1939

ART, LIFE & CULTURE

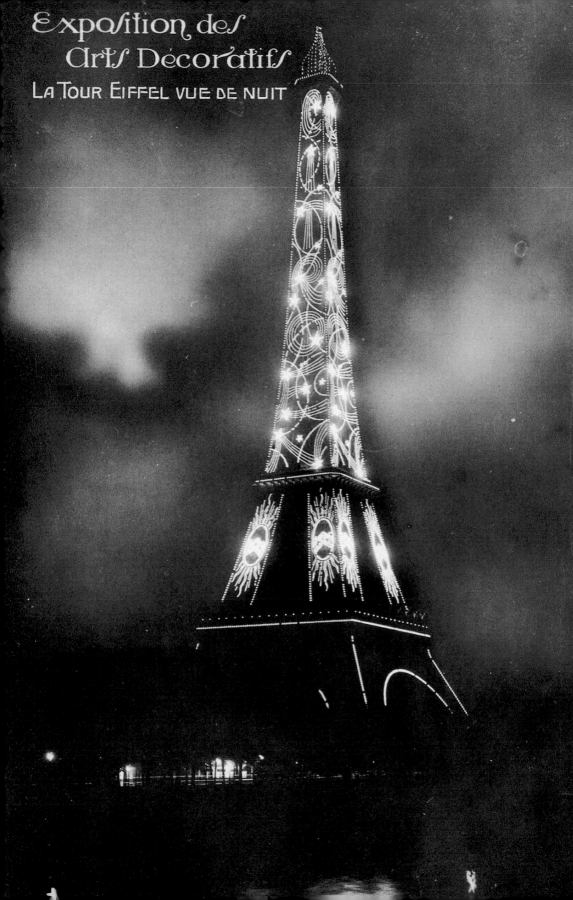

Exposition des Arts Décoratifs
La Tour Eiffel vue de Nuit

PARIS

Between the Wars 1919–1939
ART, LIFE & CULTURE

Vincent Bouvet & Gérard Durozoi

The Vendome Press
New York

My deepest thanks to my wife Violaine and my children Vianney and Flamine, for having patiently dealt with my obsessions and absences due to the research and editing of this book. I am also grateful for the enthusiasm of Nicole Hoentschel and the solicitude of Dominique Lesterlin. Thanks also to all those who have shown an sincere interest in this project and offered me their support while it was being written, especially Claude Billot and Roxane Jubert.

Vincent Bouvet

I would like to thank not only the living, who know who they are, but also the artists and writers of this period, without whom this book could not have been written.

Gérard Durozoi

First published in the United States of America in 2010 by
The Vendome Press
1334 York Avenue
New York, NY 10021
www.vendomepress.com

This edition copyright © 2010 The Vendome Press
Original French edition *Paris 1919–1939, art, vie et culture*
 copyright © 2009 Éditions Hazan, Paris

Translated from the French by Ruth Sharman

Printed by Toppan Printing Co., Ltd., in China
First Printing

Library of Congress Cataloging-in-Publication Data

Bouvet, Vincent.
 [Paris, 1919-1939. English]
 Paris between the wars, 1919-1939 : art, life & culture /
by Vincent Bouvet and Gérard Durozoi.
 p. cm.
 "First published in French in 2009 as Paris, 1919-1939"--T.p. verso.
 Includes bibliographical references and index.
 ISBN 978-0-86565-252-1
 1. Paris (France)--Social life and customs--20th century. 2. Paris (France)--Intellectual life--20th century. 3. Arts--France--Paris--History--20th century. 4. City and town life--France--Paris--History--20th century. I. Durozoi, Gérard. II. Title.
 DC715.B6813 2010
 944'.3610815--dc22

 2010015421

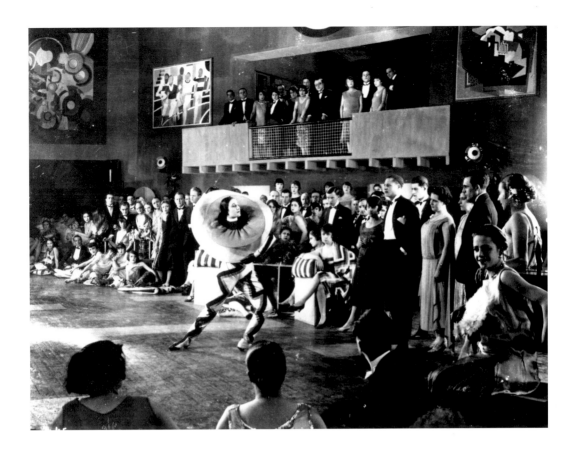

CONTENTS

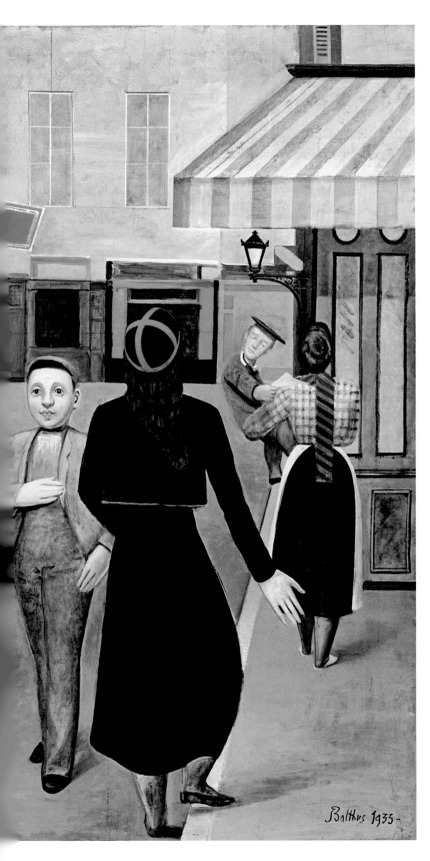

Endpapers:
Outside a café, *c.* 1925.

Page 2:
The Eiffel Tower seen at night during the Exposition des Arts Décoratifs, 1925. Postcard, photographer unknown. Musée Carnavalet, Paris.

Left:
Balthus, *The Street*, 1933. Oil on canvas, 195 × 240 cm (76 ¾ × 95 ½ in.). The Museum of Modern Art, New York, James Thrall Soby Collection

Overleaf, left:
La Coupole, on the boulevard du Montparnasse, opened on 20 December 1927.

Overleaf, right:
Cabaret Montmartre, 1935.

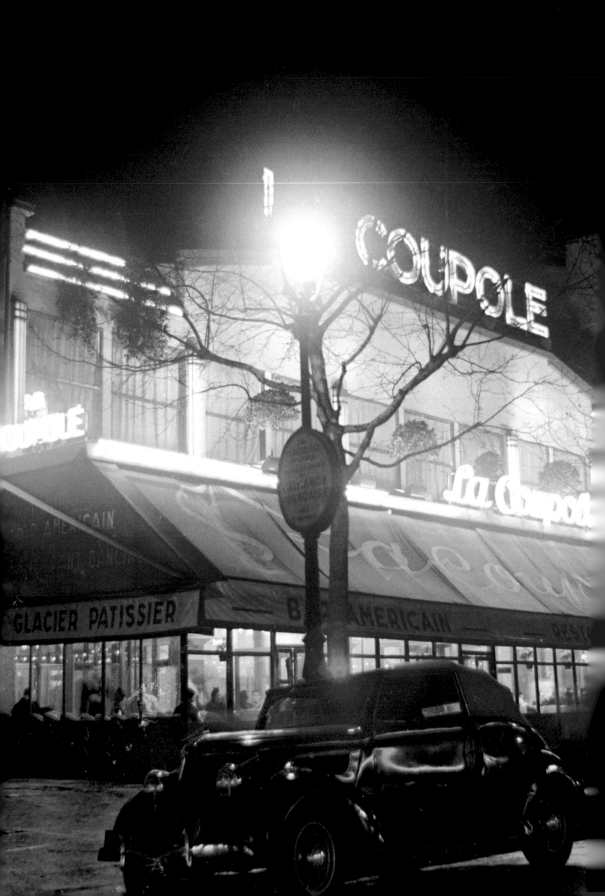

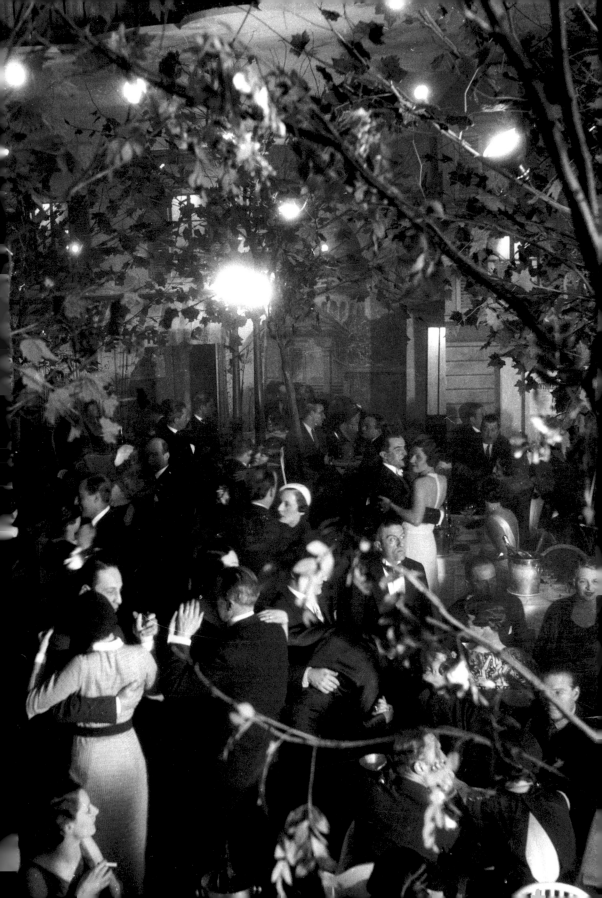

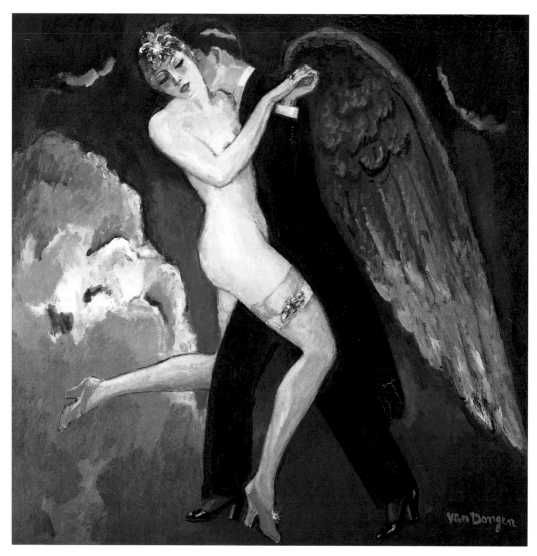

Kees Van Dongen, *Tango* or *The Tango of the Archangel*, 1922–35.
Oil on canvas, 196 × 197 cm (77 ⅛ × 77 ⅝ in.).
Nouveau Musée National, Monaco.

Opposite:
Paul Colin, *Black Magic*, 1928.
Illustration published in *Fantasio*, 15 December 1928.

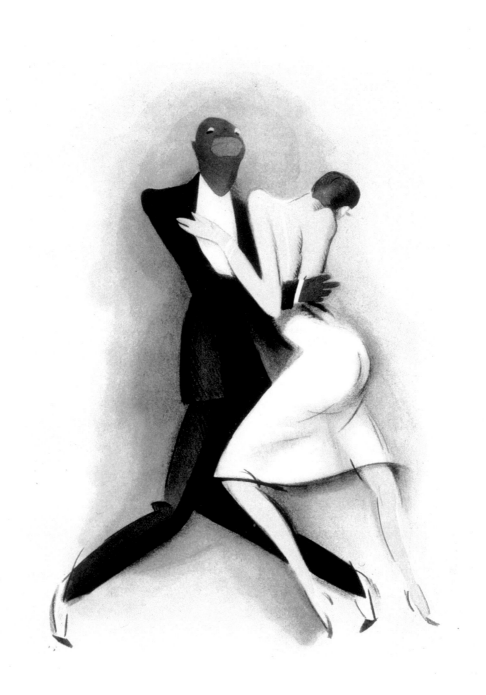

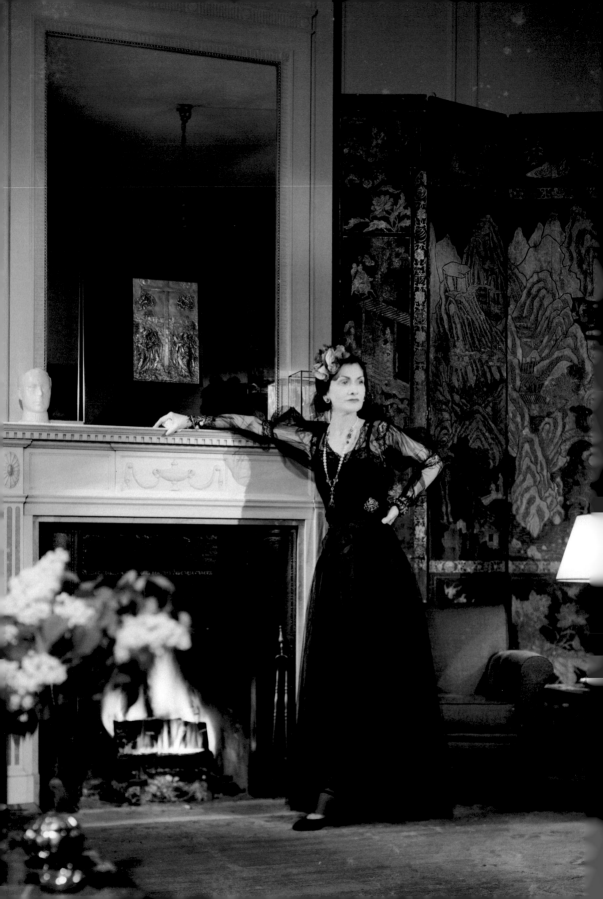

Opposite:
Coco Chanel
in her apartment
at the Ritz, 1937.
Photograph by François
Kollar for *Harper's Bazaar*.
Médiathèque de
l'Architecture et du
Patrimoine, Paris.

Right:
Jacques Émile Ruhlmann,
The Red Library-Boudoir.
Illustration from Jean
Badovici's book *Harmonies:
intérieurs de Ruhlmann*,
Paris, 1924.

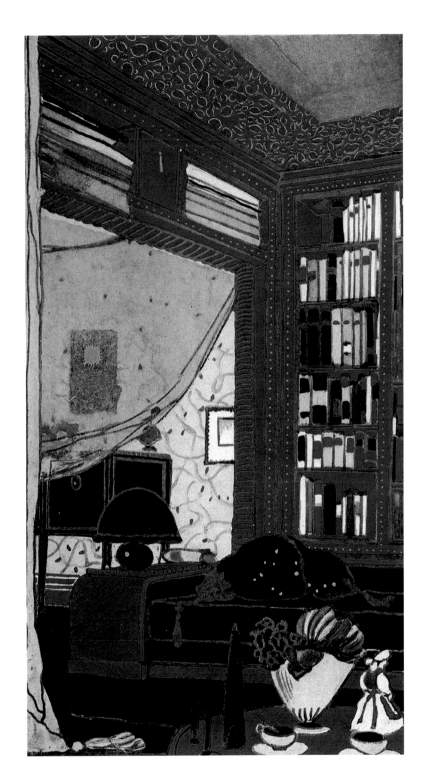

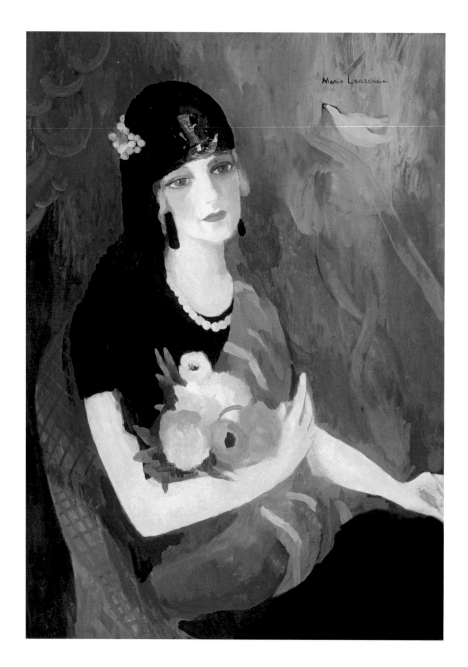

Above:
Marie Laurencin, *Portrait of Baroness
Gourgand with Black Mantilla*, 1924.
Oil on canvas, 92.5×65.5 cm (36 ⅜ × 25 ¾ in.).
Musée National d'Art Moderne Centre
Georges Pompidou, Paris.

Opposite
Jacques Émile Blanche,
*Portrait of Paul Ernest Boniface,
Comte de Castellane*, 1924.
Oil on canvas.
Private collection.

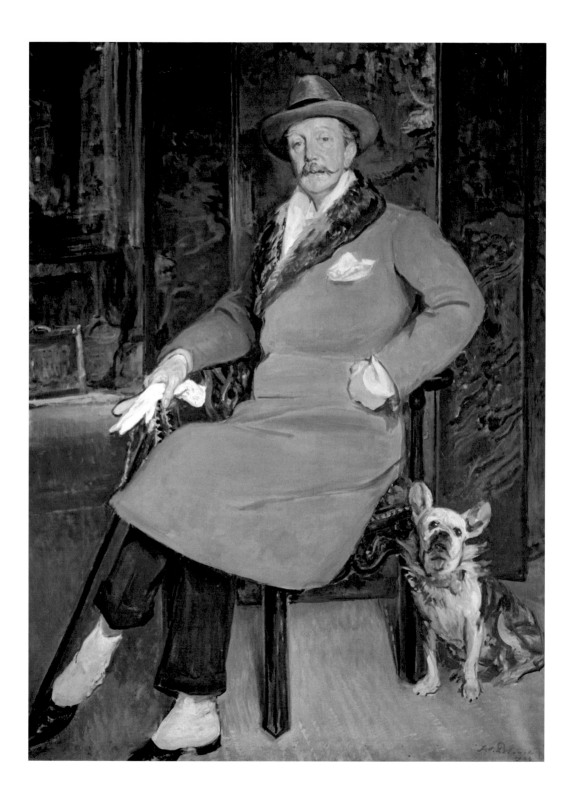

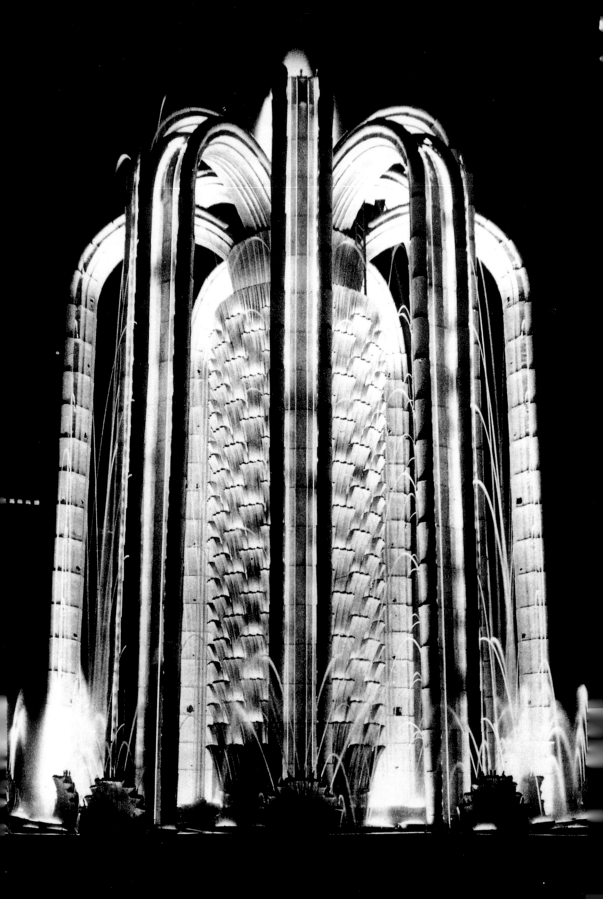

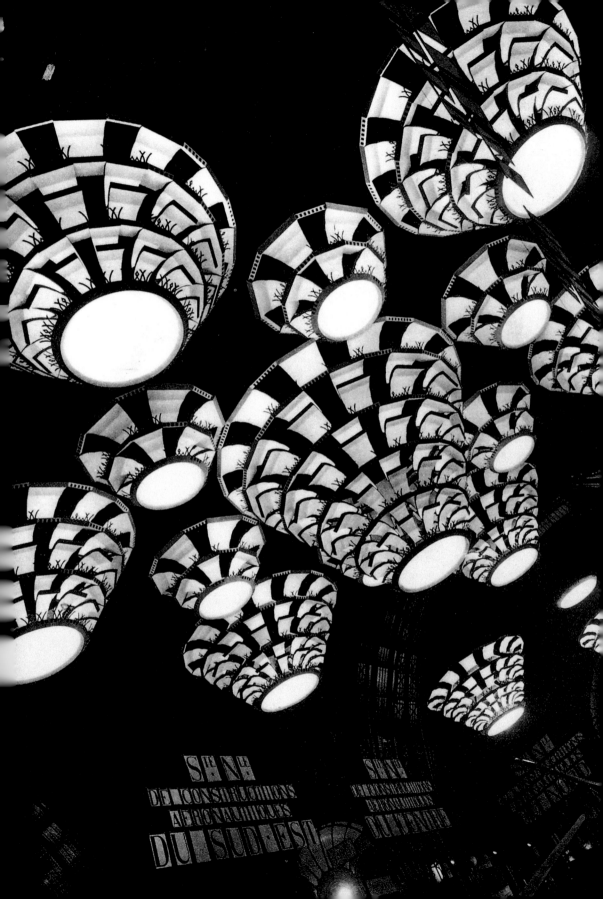

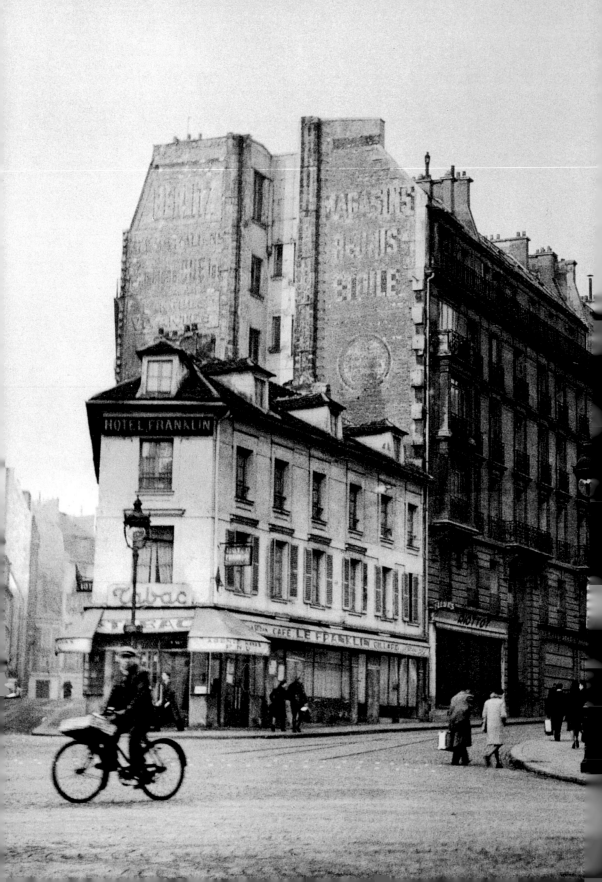

EVERYDAY LIFE
Vincent Bouvet

THE MANY FACES OF PARIS

Between the wars, there were just under three million people living within the city boundaries of Paris. Its twenty *arrondissements*, or districts, dated back to the Second Empire, and the dense population of the centre grew thinner as one moved towards the outlying areas. Social inequalities were marked, reflecting in simplistic terms a divide between the elegant districts in the west and the working-class areas in the east. The low-income communities were, in many cases, immigrants who had arrived from the provinces, at varying points in the recent past. The train stations that were the point of disembarkation for each region became natural hubs for the provincial communities who arrived in search of work: the Alsatians clustered around the Gare de l'Est, the Bretons around Montparnasse, and the Auvergnats near Austerlitz (these most famously included the *bougnats*, café owners who also sold wood and charcoal). Immigration could also be a seasonal phenomenon, with chimney sweeps arriving from Savoie, for example.

Paris teemed with people from all walks of life, and from every rung of the social ladder, as portrayed in the 19th-century novels of Honoré de Balzac, Eugène Sue and Émile Zola. The concierge, also known as a *pipelette* (after Pipelet, the caretaker in Sue's *Les Mystères de Paris*) or *bignole*, was a central figure of Paris life, while policemen sporting capes and white sticks or cycling in pairs – known as *hirondelles* ('swallows') – were also a familiar and picturesque sight.

Immigration increased after the war, when France began to employ foreign workers to fill the posts that had now become vacant in the mines, factories and workshops, and on the farms. Between 1921 and 1931, as much as 74 per cent of the total increase in population in France was due to immigration. In Paris, immigrants included not just those coming from the provinces but also refugees from Poland, Italy, Germany and Austria, Hungary and Spain. The capital also served as a refuge for Trotskyites and anarchists from all over the world. Jews from central Europe, Greeks and Armenians, all fleeing the pogroms, primarily settled in the four central arrondissements of the city.

For working-class Parisians, the reality was anything but picturesque. The workers slaved away in the workshops of the city centre, in the outlying factories and warehouses, on construction sites and on the banks of the Seine, and their standard of living was extremely low. More than half of a standard family budget would be spent on food, and ten per cent on rent, for mediocre housing often located in unsanitary blocks that lacked basic comforts, sometimes even heating. The Loucheur Act, which was passed in July 1928, led to the construction of

Above:
A concierge outside her rooms, rue des Grands-Augustins (6th arr.), *c.* 1938.

Opposite:
Brassaï, *Two Policemen on Bicycles*, 1930–32. Musée National d'Art Moderne, Centre Georges Pompidou, Paris.

Page 16:
Henri Roger Expert,
Cactus illuminated fountain,
Exposition Coloniale, 1931.

Page 17:
André Granet, lamps designed for the Salon de l'Automobile et de l'Aviation, Grand Palais, 1938.

Pages 18–19:
Brassaï, *Passy District*; the corner of the rue Franklin and the boulevard Delessert (16th arr.), 1940.
Private collection.

Right:
Breton festival in Paris, *c.* 1925.

Opposite:
André Kertész, *Dubo Dubon Dubonnet*, 1934.
Musée National d'Art Moderne,
Centre Georges Pompidou, Paris.

Overleaf:
Henri Zo, *La Rue Mouffetard*, 1921.
Oil on board, 45.5 × 60 cm (18 × 23 ⅝ in.).
Musée Carnavalet, Paris.

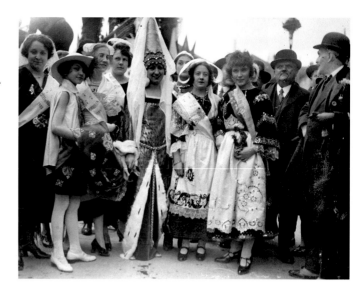

two hundred thousand cheap rental properties, but it was not enough to solve the crisis. On the eve of the Second World War, the average accommodation for those on low incomes was scarcely any more spacious than it had been in 1914 and still did not include a bathroom, although gas and running water were provided. By 1927, half of all Paris apartments had electricity, and in 1939 this figure had risen to ninety-four per cent. Parisians used the public baths once a week. In 1940, at least a third of all apartment blocks had no access to mains sewage and men were employed to travel through the working-class districts with their horse-drawn septic tanks, later replaced by trucks, to empty the cess pools.

To buy food, people relied on local grocers' shops and street vendors with their wheeled carts, known as *crainquebilles*, loaded with fruits and vegetables. Local branches of the big Félix Potin grocery stores, precursors of the supermarket chains, had their heyday in the 1930s and provided a wide choice of foods, many of them at competitive prices. The Galeries Dufayel, the first big department store to open outside central Paris (in 1856), remained the supreme example of its type, offering credit and a whole range of clothes and manufactured goods. But the major breakthrough that occurred in the 1930s – in response to the global economic crisis – was the emergence of single-price shops, similar to the five-and-dime stores of the US. In 1928–29, the Nouvelles Galeries were the first to open a Uniprix store, on the rue du Commerce in the 15th arrondissement; then Au Bon Marché opened its Priminime store, followed in 1931 by Printemps opening Prisunic; in 1932, the Galeries Lafayette created Noma (an acronym of 'Nouvelle Maison'), with shops in the place Blanche and the rue du Faubourg Saint-Antoine, and branches outside of the capital operating under the name Monoprix.

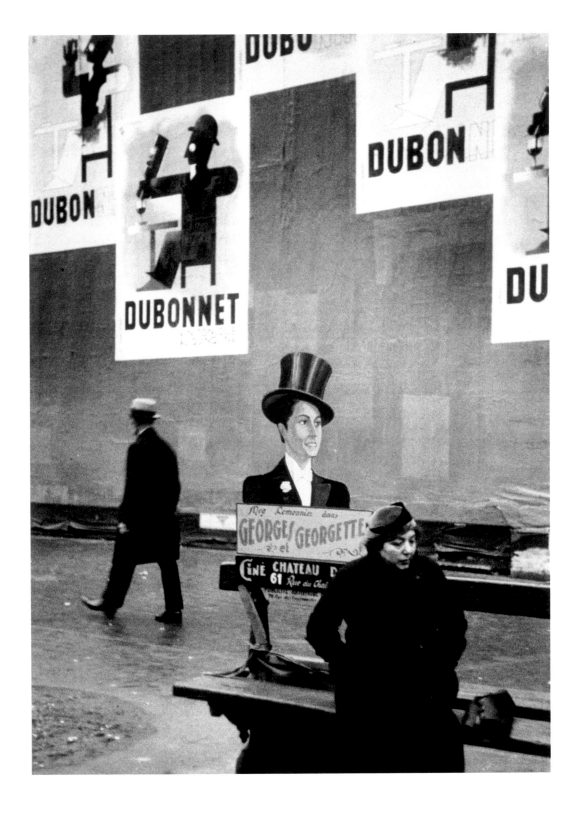

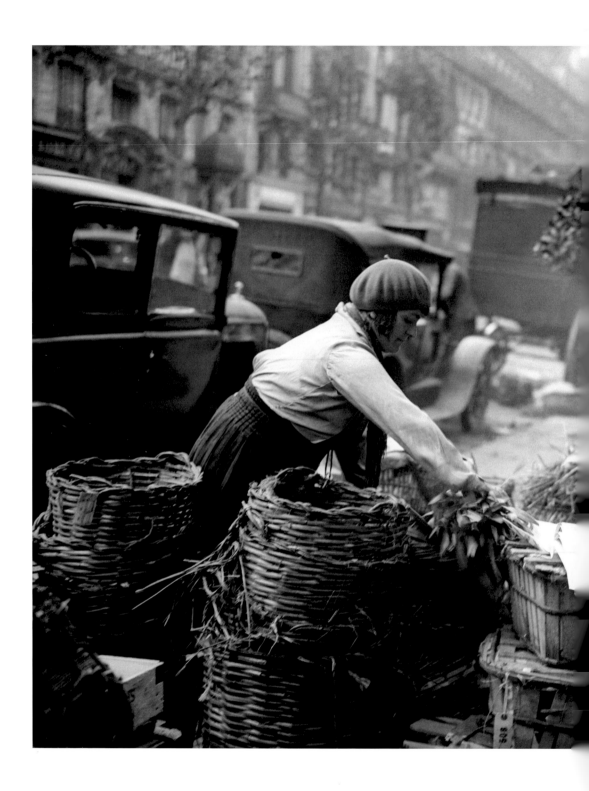

Above:
Eugène Atget, *Corner of the rue de Seine*, 1924.
From the series *Art in Old Paris.*
Bibliothèque Nationale de France, Paris.

Left:
A greengrocer, *c.* 1925.

Below:
Noma, the first single-price store to
be opened in Paris, *c.* 1925.

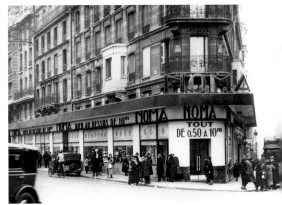

Below:
A street vendor on one of the
Grand Boulevards, c. 1930.

Opposite, above:
A picture-seller, c. 1930.

Opposite, below:
Bunches of lily-of-the-valley for sale,
a French tradition on 1 May, c. 1930.

The French National Lottery was founded in 1933 and buying tickets rapidly became a monthly, then a weekly, ritual for people on low incomes who dreamed of getting lucky, just like the hairdresser from Tarascon who was the first to win the jackpot of five million francs.

Simple Pleasures

Despite the advent of the motor car, Paris was still a city of pedestrians, a city crossed on foot by the working classes and the office employees, as well as being a place where a Walter Benjamin or a Léon-Paul Fargue – who described it in his *Piéton de Paris* (1939) – could wander at leisure, delighting in new discoveries. The pavements of the Grands Boulevards were always full of people plying various trades: sandwich sellers, one-man bands, sword swallowers, fire breathers, chain breakers, jugglers, conjurers, street singers, and people selling shoelaces or ties, often displaying their wares inside up-ended umbrellas. The Left Bank of the Seine, between the Pont Saint-Michel and the Passerelle des Arts, was the territory of the *bouquinistes*, who sold a colourful array of books and newspapers, prints and postcards. Mattress stuffers and tinkers pounded the pavements, and beyond the Pont des Tournelles to the north and the Pont Mirabeau to the south were the docks with their stevedores and coal yards.

The city's streets were often the scene of lively processions involving military conscripts, high-school pupils, rag parades from the *grandes écoles*, freshmen from the Collège des Beaux-Arts and students from the Latin Quarter letting off steam. On 1 May, the market workers known as the *forts des Halles*, dressed in their loose smocks and wide-brimmed hats, would present baskets of lily-of-the-valley to the French President, while the Communist Party earned a significant portion of its income by selling bunches of these flowers, picked in the woods at Chaville and Meudon and sold to the public as symbols of good luck.

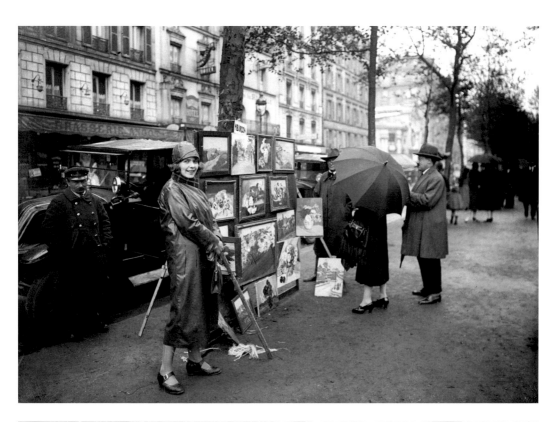

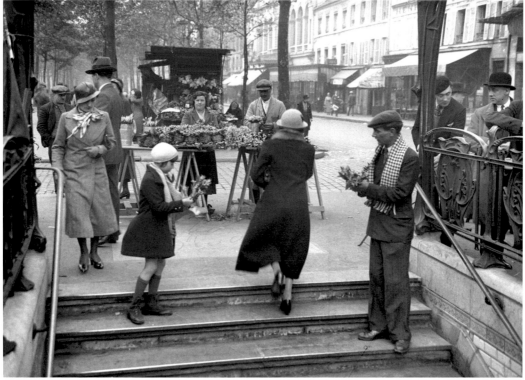

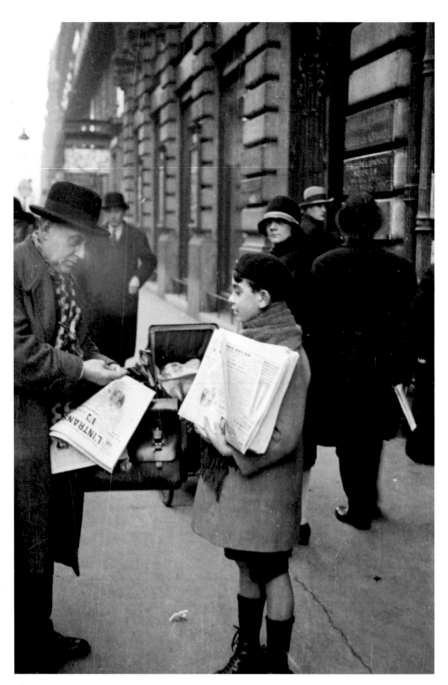

Above:
A young newspaper seller with copies of *L'Intransigeant, c.* 1930.

Opposite:
A balloon seller, place Saint-Michel, 1938.

Overleaf:
The Foire aux Pains d'Épices, cours de Vincennes (12th arr.), 1921.

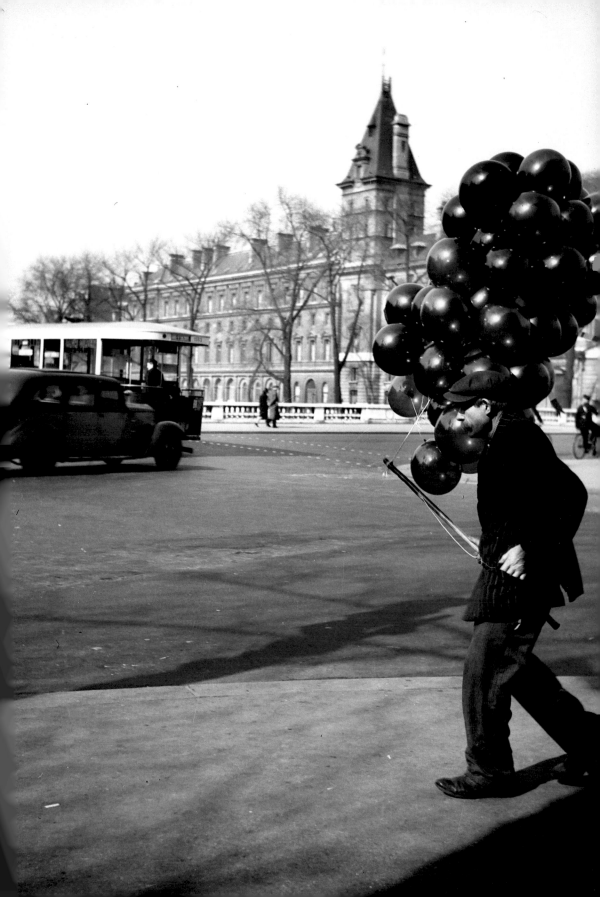

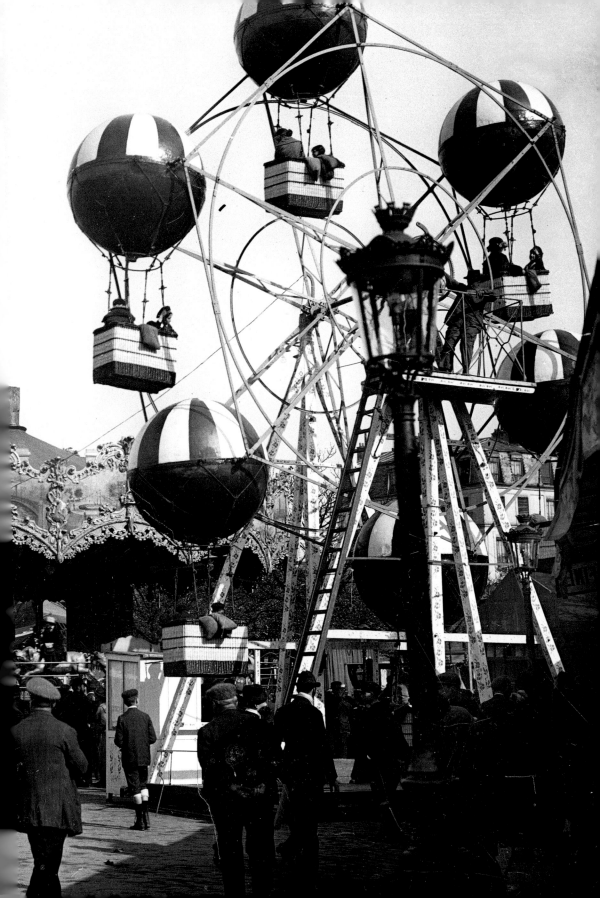

Above:
Students from the École des Travaux
Publics dressed up for the traditional
'Père Cent' parade that takes place a
hundred days before their final exams,
14 May 1935.

Below right:
Eugène Atget, *Fête de Vaugirard*, 1926.
From *Picturesque Paris*, series 3.
The Museum of Modern Art, New York.

Opposite:
The Water Chute at Luna Park, *c.* 1930.

Then there was the *Boeuf Gras* procession, in which the butchers from
the La Villette slaughterhouses led a fatted ox through the streets. The
feast of St Catherine, on 25 November, was a celebration for the *Cather-
inettes*, young unmarried women employed in the dressmaking and
millinery trades, who took to the streets in magnificent hand-made
hats. Paris also played host to a number of annual fairs, including the
Foire à la Ferraille and Foire au Jambon, held on the boulevard Richard-
Lenoir by the Bastille, and the Foire Saint-Germain.

In 1920, Old Montmartre was jokingly declared to be a 'free city',
providing an excuse for parades and festivities which became regular cal-
endar events, contributing to Montmartre's international reputation. In
1924, Francisque Poulbot, an illustrator famous for his images of jolly-
faced street urchins, began meeting with fellow artists and writers in a
Montmartre bar. The group came up the idea of taking over a piece of
wasteland that was threatened by property developers and planting
vines on it. Helpers arrived from all over France and the first grapes
were harvested in 1934, in the presence of the French President, with the
popular entertainers Mistinguett and Fernandel acting as 'godmother'
and 'godfather' of the vineyard.

Set up in the city squares, funfairs and carousels were popular
attractions. For the Exposition des Arts Décoratifs in 1925, Paul Poiret
commissioned a 'Carousel of Paris Life', which featured large painted
figures, representing caricatures of common city types. Deckchair
attendants in the parks, donkey carts and model sailing boats on the
ornamental lakes in the Tuileries and Luxembourg gardens, and rowing
boats on the lakes in the Bois de Boulogne and the Bois de Vincennes
were also part of the Paris landscape and provided inspiration for artists
and photographers. And then there were the immensely popular
Guignol puppet shows on Thursdays and Sundays, when the schools

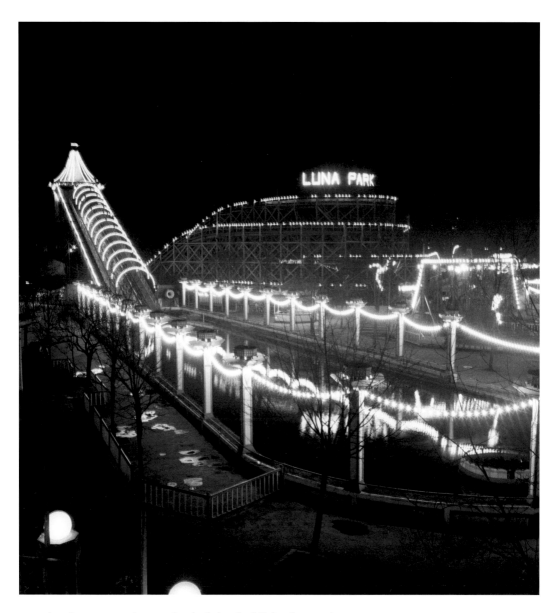

were closed – an entertainment that had already delighted generations of Parisian children. During the 1930s, there were two hundred and eighty-three puppet shows across the city of Paris and almost as many again in the outer suburbs.

The opening of Paris's Luna Park in 1909, between the avenue de la Grande-Armée and the old city walls, marked the return of permanent funfair attractions to Paris. Entry to the park included one free ride, except on Fridays, the day when fashionable Parisians visited and the cost of a ticket was higher. From one o'clock until midnight, the rides and rollercoasters were open to thrillseekers old and young. In 1912, a similar theme park, Magic City, was built in the space between the quai

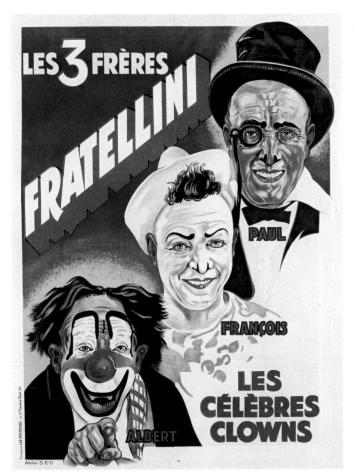

d'Orsay, the rue Malar, the rue de l'Université and the avenue Bosquet; like its predecessor, it was lavishly decorated and brilliantly lit.

Paris was also home to several circuses, including the Cirque Médrano and the Cirque d'Hiver on the Right Bank and the Cirque de Paris on the Left Bank. Artists such as Picasso (who designed sets and costumes for the circus-themed ballet *Parade*), Léger, Van Dongen, Rouault and Pascin were fascinated by the world of the circus, as were a number of writers including Apollinaire, Max Jacob and Colette — all of whom regularly attended Médrano shows. The famous Fratellini brothers, clowns with the Cirque d'Hiver and the Cirque Bouglione, were also hugely popular for their witty and charming performances. Léger designed costumes for them and Darius Milhaud composed the *Tango des Fratellini* in their honour.

When the Exposition Coloniale took place in the Bois de Vincennes in 1931, it included a temporary zoo intended to showcase living specimens of wildlife from France's colonies in Africa and Asia. The layout was designed to recreate the animals' natural environment as

closely as possible, an innovation inspired by the Hagenbeck Zoo in Hamburg. When the permanent Vincennes Zoo opened in 1934, it was the first major leisure park of its kind, and was centred around a massive concrete monolith, 68 metres (220 ft) high, designed by the architect Charles Letrosne. The park was a huge success and one of the favourite attractions for families was the evening show where they could watch the trainers taking the larger animals through their paces.

The Bastille Day celebrations on 14 July were *the* event on the Paris calendar, with every district of the city enjoying the public holiday and people of all ages eating and drinking and dancing – the waltz, the tango, the java – to the accompaniment of an accordion player or the strains of a local band. On their days off, the working classes would flock to the open-air cafés on the banks of the Marne and the Oise, to drink wine beneath trees, eat fish that they had caught themselves, swim, go for a row or dance. 'When you're walking by the water', sang Jean Gabin in Julien Duvivier's *La Belle Équipe* (1936), 'how lovely everything is, how new it feels…'

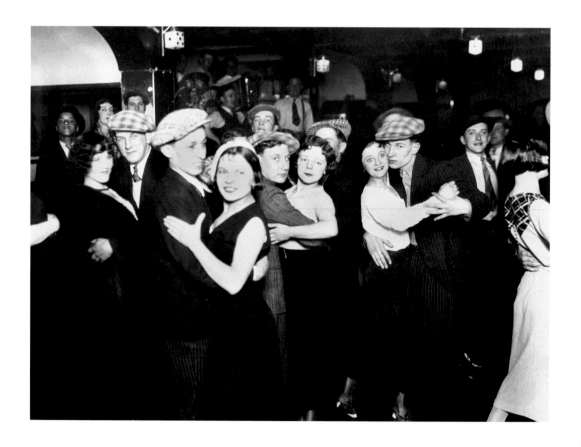

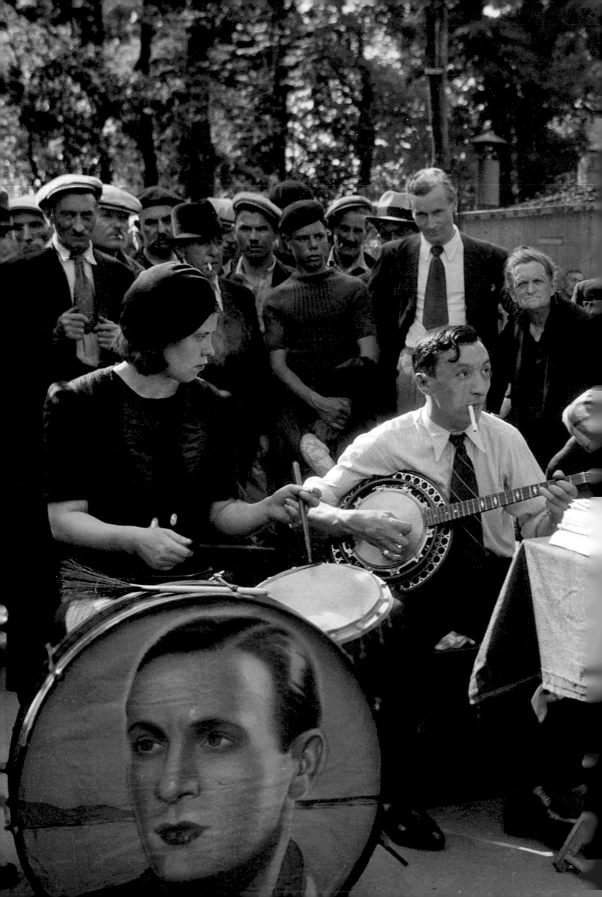

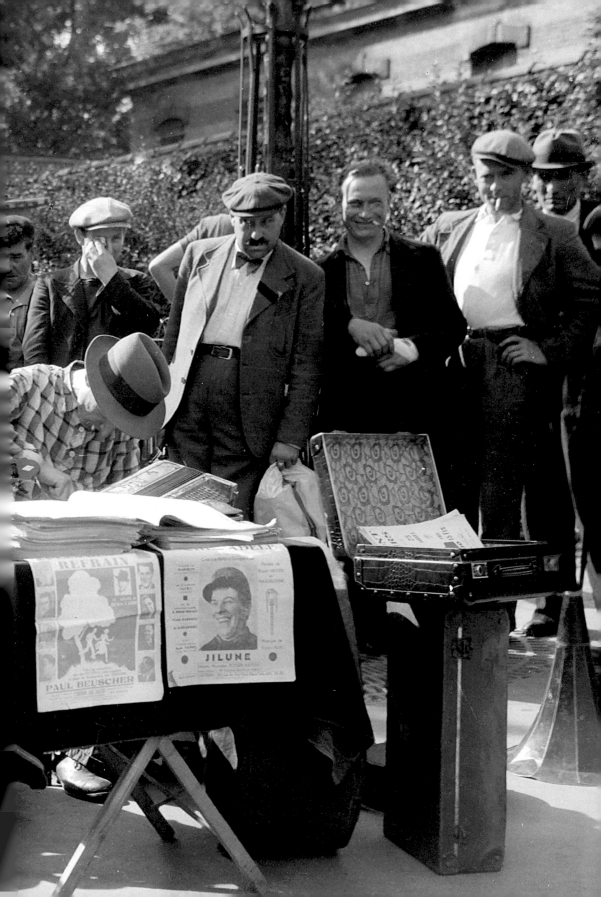

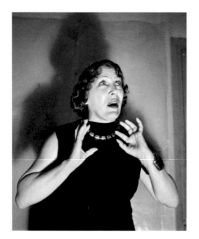

Above:
The singer Damia at the Théâtre de
l'ABC, September 1936.

Below:
Édith Piaf and Raymond Asso
at the Théâtre de l'ABC, 1937.
Photograph by Gaston Paris.

Opposite:
The singer and actress Fréhel, 1937–38.
Photograph by Gaston Paris.

Songs, Operettas and Revues

Between the wars, both the working-class faubourgs and the fashionable
quarters of Paris rang with music; radio popularized songs and per-
formers and sheet music could be bought on the street. The *chanson
réaliste* – 'realist song' – with its tragic tales of moral corruption and
social misfortune, was hugely popular. It was a genre dominated by
women, including the likes of Yvonne George, who dressed all in black
(making a stark contrast with her pale face), sang in a broken voice and
specialized in sailors' songs (*Nous irons à Valparaiso*), and Fréhel, whose
repertoire combined melodrama and nostalgia (*Où sont tous mes amants?*)
along with comic and sometimes bawdy songs. Other names associated
with the *chanson réaliste* included Damia, whose famous *Sombre dimanche*
was banned from Sunday radio broadcasts in 1936 on the grounds that it
might encourage suicide; Berthe Sylva, with her bitterly nostalgic *Les
Roses blanches*; Lucienne Boyer (*Parlez-moi d'amour*, 1930); Marie Dubas,
who sang Raymond Asso's song *Mon légionnaire*; Marianne Oswald, Suzy
Solidor, Lys Gauty, Lucienne Delyle and Rina Ketty. Just before the
Second World War, Louis Leplée, the owner of a nightclub on the
Champs-Élysées, discovered another young singer, a street performer
named Edith Piaf. Piaf's musical career began in 1937 with a contract at
the Théâtre de l'ABC.

There were also a number of notable male singers with large follow-
ings, including Henri Garat, Reda Caire and Jean Tranchant. Tino Rossi
debuted in 1936, singing Corsican songs set to music by Vincent Scotto

and combining a mellifluous voice with dashing Latin looks: he also appeared in films such as *Marinella*, which was a huge box-office hit. Jean Sablon sang in a more intimate style and scandalized audiences by using a microphone on stage, while Maurice Chevalier, wearing a dinner jacket and straw boater, established his own style as the 'kid from Ménilmontant', a working-class area of Paris.

French *chanson* experienced a breath of fresh air with the arrival of American swing: the duo Pills et Tabet debuted at the Boeuf sur le Toit brasserie, where they were accompanied by a jazz band. Their first hit song, *Couchés dans le foin*, was written by Jean Nohain and the pianist Mireille. Energy and wit were also the mark of Ray Ventura's jazz band, which notched up a series of successes including *Tout va très bien, madame la marquise* (1935), *Ça vaut mieux que d'attraper la scarlatine* (1936) and *Qu'est-ce qu'on attend pour être heureux* (1937). Charles Trenet, whose song *Y a d'la joie* was recorded by Maurice Chevalier in 1936, began performing solo the

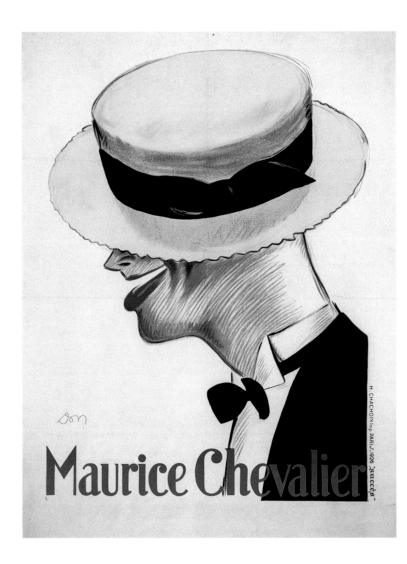

Opposite:
Marie Dubas, 1935.

Left:
Jean Don, *Maurice Chevalier*, 1926. Private collection.

Below left:
Charles Trenet, performing at the Théâtre de l'ABC on his first singing tour, 1936. Photograph by Gaston Paris.

Below right:
The singer Lys Gauty (centre), posing with Paul Broccardo and Marcel Guimbretière, winners of the Six Jours de Paris cycle race, 1935.

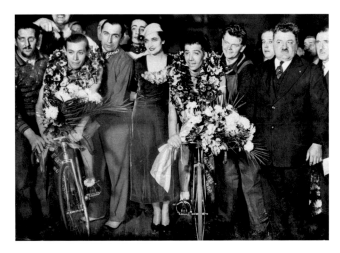

following year (*Je chante, Fleur bleue*). After the Front Populaire came to power, optimism became the order of the day.

After the Great War, the *café-concert* was supplanted by the music hall, with its variety shows that combined musical and novelty acts. Operettas and musical comedies were hugely popular, as were revues, famed for their extravagant staging and scantily clad showgirls. Between the 1918 armistice and the closure of the theatres in May 1940, more than 400 operettas and musical comedies were performed on the Paris stage. *Phi-Phi* (November 1918), with a score by Henri Christiné and a libretto by Albert Willemetz, was a parody set in ancient Greece, recounting the misadventures of the sculptor Phidias, while also alluding to contemporary events; the music, performed by a small ensemble, incorporated several jazz numbers. *Dédé* (1921) was another collaboration by Christiné and Willemetz, in which the action takes place in a Paris shoe shop, in which Maurice Chevalier sang, danced and acted with equal skill. Other successful operettas, featuring a mixture of American-style music and Gallic humour, were written by Yves Mirande, Albert Willemetz and Maurice Yvain: these included *Ta bouche* (1922), *La Dame en décolleté* (1923) and *Bouche-à-bouche* (1925), which saw the stage debut of actress Pauline Carton. Sacha Guitry wrote a number of comic librettos for his wife Yvonne Printemps, including *Mozart* (1925) with a score by Reynaldo Hahn. This friend of Proust received more

Above:
Pauline Carton and René Koval in
Toi c'est moi, an operetta by Moisés
Simons, Théâtre des Bouffes-Parisiens,
October 1934.

Right:
Yvonne Printemps in *Mozart*,
an operetta by Reynaldo Hahn, 1933.

Opposite:
Phi-Phi, an operetta by Henri
Christiné, 1924–25.

Below:
Josephine Baker in *La Créole* by Offenbach,
Théâtre Marigny, January 1935.

Opposite:
Mistinguett in the show *Féerie de Paris*,
Casino de Paris, December 1937

acclaim for his operettas (*Ciboulette*, 1923; *Brummel*, 1931; *Malvina*, 1935) than for his serious operas.

Mistinguett, who had already made her name at the Moulin-Rouge and the Folies-Bergère (alongside Maurice Chevalier) before the war, starred in several revues between 1919 and 1923, including *Paris qui jazz* at the Casino de Paris, which totalled more than two hundred shows in six months. Léon Volterra, owner of the Casino, had a Hollywood-style approach to publicity and the phenomenal budget for the show was common knowledge. This love of spectacle extended to Mistinguett and her 'boys', who enjoyed further success at the Casino de Paris with the revue *Ça c'est Paris*. The other queen of the revue between the wars was the American Josephine Baker, who began her Paris career in the *Revue Nègre* (1925), whose success was partly due to Baker's erotic dancing and the fact that she often wore nothing but a belt of artificial bananas. It was in the revue *Paris qui remue* (1930) at the Casino de Paris that Baker first sang her signature song *J'ai deux amours*, composed by Vincent Scotto – 'Two loves have I, my country and Paris.' Baker starred in the revue for thirteen months, and also encouraged some of America's great jazz musicians to perform in Paris. Maurice Chevalier returned to the

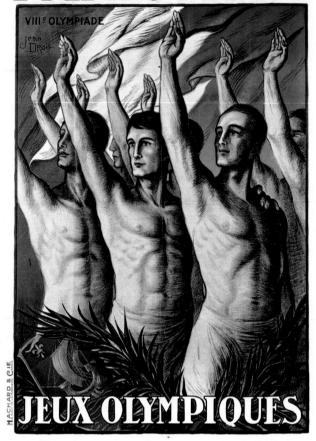

Casino de Paris in 1937 in *Paris sans joie*, then again in 1938 in *Amours de Paris*, but revue shows were gradually replaced by solo performers, who brought in full houses at a much cheaper cost.

Sporting Successes

Sport provided a means of relieving the tedium of a quiet Sunday. A primarily male audience was transfixed by football in the winter, with the Championnat de France and the Coupe de France, and cycling in the summer, with the Six Jours de Paris and the Tour de France. Working-class sports like football, cycling and boxing provided a means of climbing the social ladder, while athletics, rugby and tennis remained the preserve of the upper classes.

The dismantling of the city walls freed up areas of open ground all around the capital. A law was passed in 1919 granting this unused land to the City of Paris, on condition that it was used to build new housing,

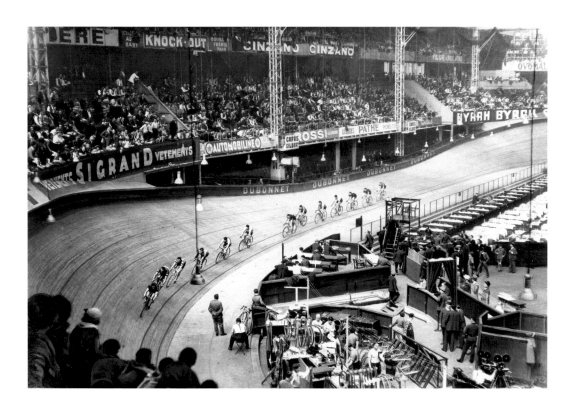

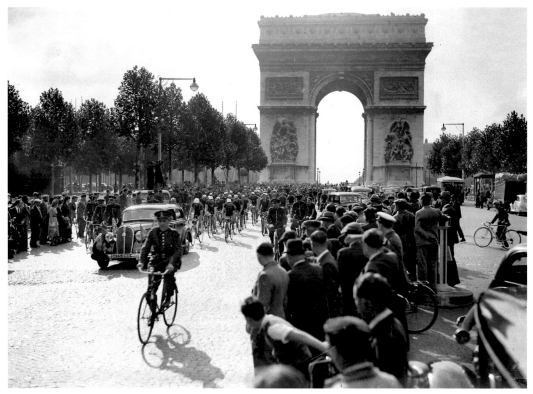

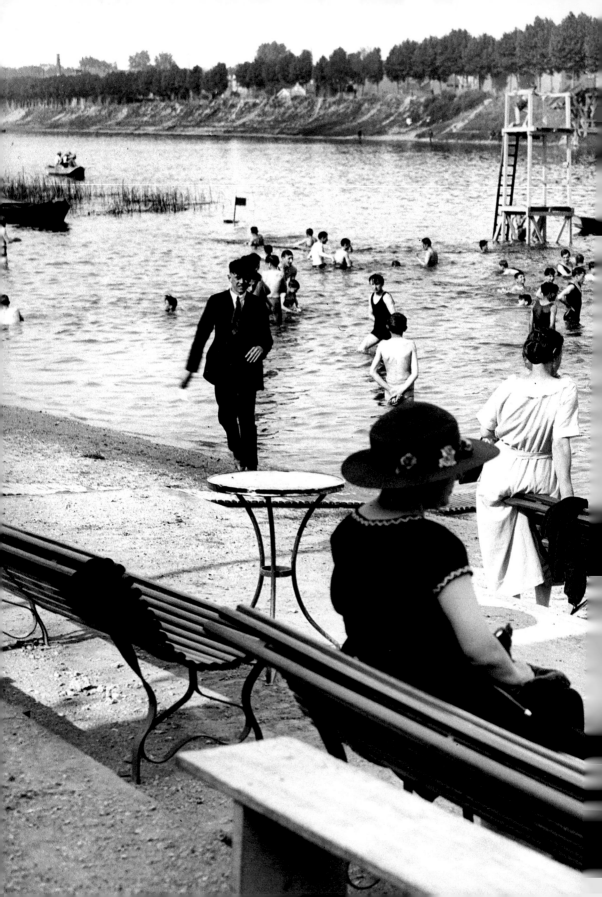

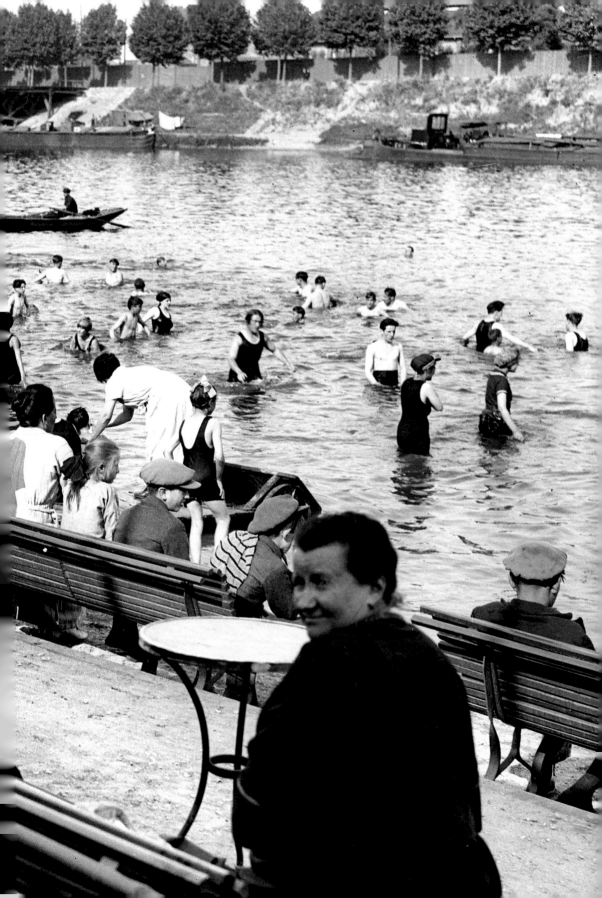

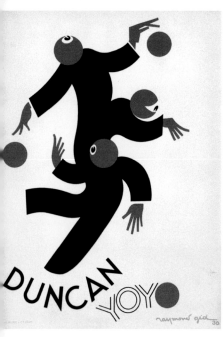

Above:
Raymond Gid, *Duncan Yoyo*, 1930.
Advertising poster. Private collection.

Opposite:
Swimming pool on the rue de Pontoise
(5th arr.), *c.* 1930.

sports centres and parks, for the benefit of the widest possible public. Public stadiums and swimming pools were opened. Private initiatives were also encouraged: the Paris Université Club built a stadium with a capacity of six thousand and facilities for fifteen different sports on a piece of land adjacent to the Porte Dorée, and the Club Athlétique de la Société Générale extended the Stade Jean-Bouin near the Bois de Boulogne.

The 1924 Olympic Games were held at the Stade de Colombes, on the southwestern outskirts of Paris, there being no site large enough to host the games within the city walls. The architect Louis Faure-Dujarric extended the existing stadium (dating from 1907) to a capacity of 60,000. The wide media coverage of these Olympics led to the games becoming a pop-culture phenomenon of the 20th century.

For the working and lower middle classes, the bicycle – or *petite reine* ('little queen'), as it was fondly known – remained a vital means of transport. The cost of a bicycle dropped considerably by 1936, to a mere sixth of what it had been in 1914. Celebrated in song, most famously by Charles Trenet's *La Route enchantée*, the bicycle was also a symbol of freedom, associated with the advent of paid holidays. As a sport, it had a huge following and there were two particular highlights in the cycling calendar: the Tour de France, and the Six Jours de Paris, held at the Vélodrome d'Hiver (commonly known as the Vel' d'Hiv). Champions like Antonin Magne, André Leducq and Henri Pélissier became folk heroes. The Six Jours was a six-day event first held in 1913, which enjoyed its glory period between the wars. Each year, a popular female celebrity would be chosen to signal the start of the race. Paul Morand, in *Ouvert la nuit*, described the extraordinary atmosphere which the event generated: spectators ate and slept beside the track; netting was erected to protect the cyclists from flying objects; famous brands of aperitif and sportswear roused the crowds by giving away free gifts; variety stars provided entertainment during the interludes, and for the fashionable world the event was a perfect excuse for a party. For the remainder of the year, the Vel' d'Hiv was used for boxing matches and fashion shows. Boxing was another working-class sport and was practised in gyms belonging to the city's many boxing clubs. Champions of the sport included Georges Carpentier, Marcel Thill and Marcel Cerdan.

Swimming in the Seine was commonplace, both up- and downriver of the city, but it was the construction of public swimming pools that elevated swimming to the status of a sport. While there were only seven swimming pools in 1922 (combined with public bathhouses), by the 1930s the number had grown to more than thirty. Sport now occupied such an important role in society that the Front Populaire set up a ministry department dedicated to sport, leisure and physical education.

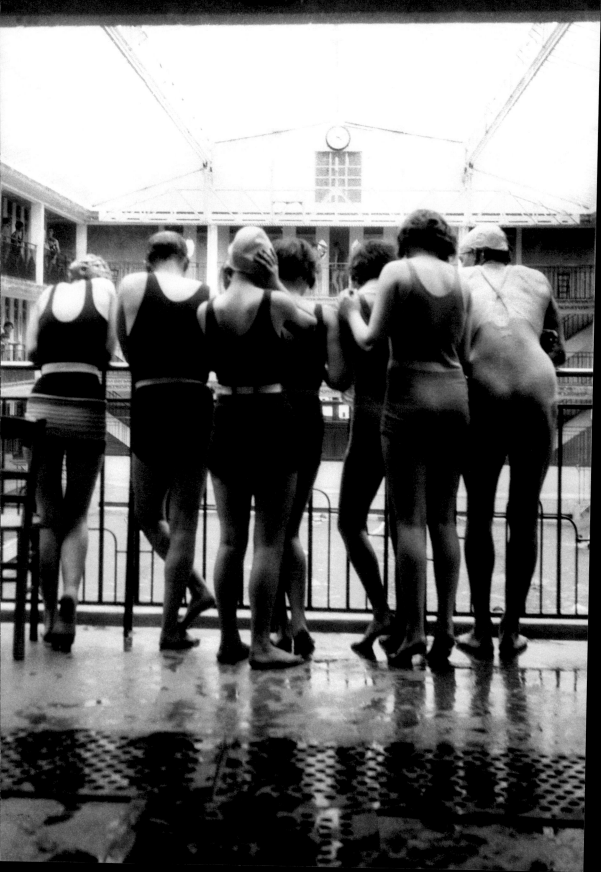

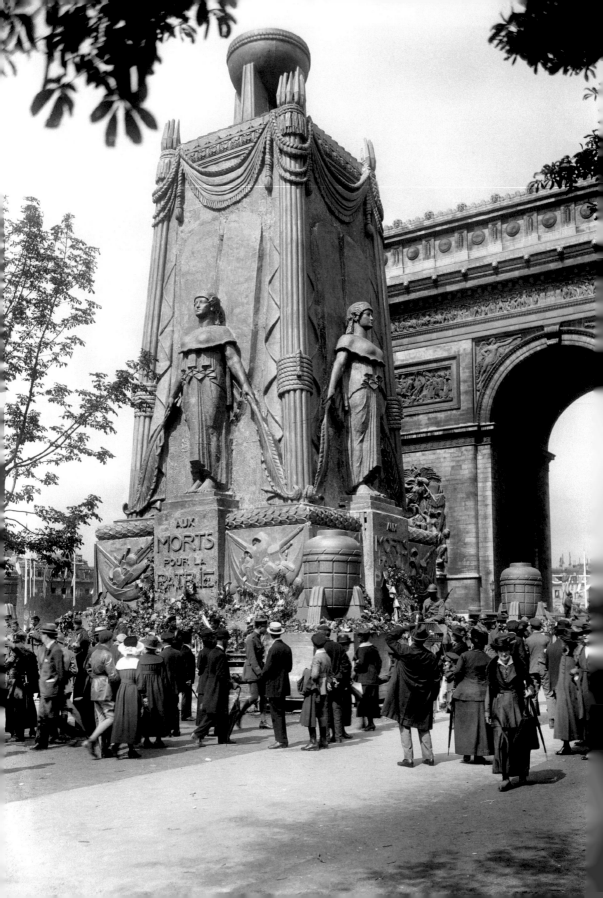

CULTIVATING PEACE

On 14 July 1919, the traditional Bastille Day festival was turned in a large-scale victory celebration, attended by vast crowds. For the 13 July vigil, an immense wood and plaster cenotaph, decorated with four winged figures of Victory, was erected in front of the Arc de Triomphe. The following day, delegations from the Allied Forces and the twenty-one French army corps, preceded by disabled or injured war veterans, walked in procession down the Champs-Élysées. On the Rond-point, pyramids of enemy cannons were erected, with the symbol of the Gallic cockerel perched on the top. The jubilation, however, could not obliterate the memory of France's losses, which included 1.4 million dead, 3.5 million wounded, 600,000 widows and 750,000 orphans. The fall in the birth rate during the conflict coupled with the 1919 Spanish flu epidemic accelerated the phenomenon of France's ageing population. In 1920, the desire to encourage patriotism and keep the memory of the Great War alive led to the construction of a monument to the Unknown Soldier and the kindling of an Eternal Flame beneath the Arc de Triomphe, and every district of Paris erected its own monument to the dead. The general feeling was that such a conflict should never be repeated: peace must be cultivated at all costs.

Paris regularly decked itself out in all its finery in order to receive foreign sovereigns and heads of state. The 1931 Exposition Coloniale and 1937 Exposition Internationale welcomed their fair share of royal

Opposite:
Victory celebrations on 14 July 1919.

Below:
The Galeries Lafayette decorated with British flags in honour of a visit by King George VI and Queen Elizabeth, July 1938.

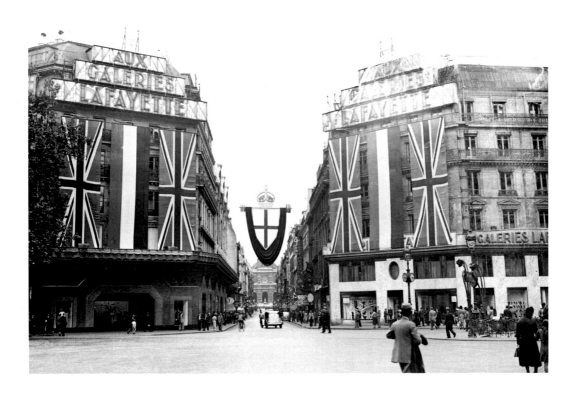

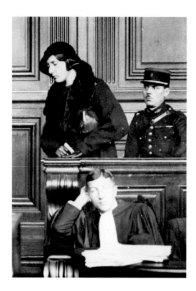

Above:
Violette Nozières during her trial, 1933.

Below:
The public execution of Eugène Weidmann outside Versailles prison, 17 June 1939.

Opposite:
Yves Brayer, *The Place Vendôme decorated for the visit of the British King and Queen*, 1938.
Gouache and Indian ink,
80.7 × 64.7 cm (31 ¾ × 25 ½ in.).
Musée Carnavalet, Paris.

guests, elected presidents, dictators and other foreign leaders; but it was the visit of the British sovereigns King George VI and Queen Elizabeth in 1938 which led to the most lavish of displays – coats of arms, flags and banners – as well as a splendid firework show on the Seine.

BLOOD ON THE FRONT PAGE

Some newspapers grabbed the attention of their readers by specializing in murders and other sensational crimes. The trial of Henri Désiré Landru, accused of killing ten women and one young boy, began in November 1921. In 1923, the younger son of Léon Daudet, co-founder and editor of the nationalist journal *L'Action française*, was mysteriously murdered and his body was discovered in an abandoned taxi with a bullet through the head. In 1932, President Paul Doumer was shot and fatally wounded by a Russian émigré at the opening of a literary salon. In 1933, nineteen-year-old Violette Nozières went on trial for poisoning her parents, and was loudly supported by the Surrealists in a landmark manifesto. A young German by the name of Eugène Weidmann succeeded in getting himself hired as an interpreter at the 1937 Exposition Internationale, and a number of unsuspecting tourists fell into his clutches; with the help of three accomplices, Weidmann brutally murdered six people, burying their remains at his small suburban home. The magazine *Détective* devoted several issues to the Weidmann case, the whole country followed his trial avidly and the writer Jean Genet began his novel *Notre-Dame-des-Fleurs* with Weidmann's name ('Weidmann appeared before you in a five o'clock edition, his head swathed in white bandages'). The serial killer was guillotined on 17 June 1939 in front of Versailles prison. The crowd was so unruly that, a few days later, Édouard Daladier banned public executions.

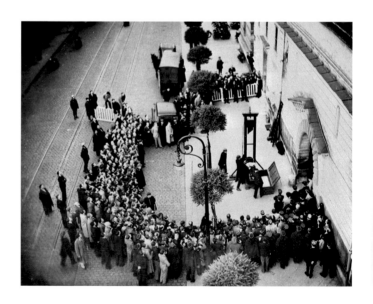

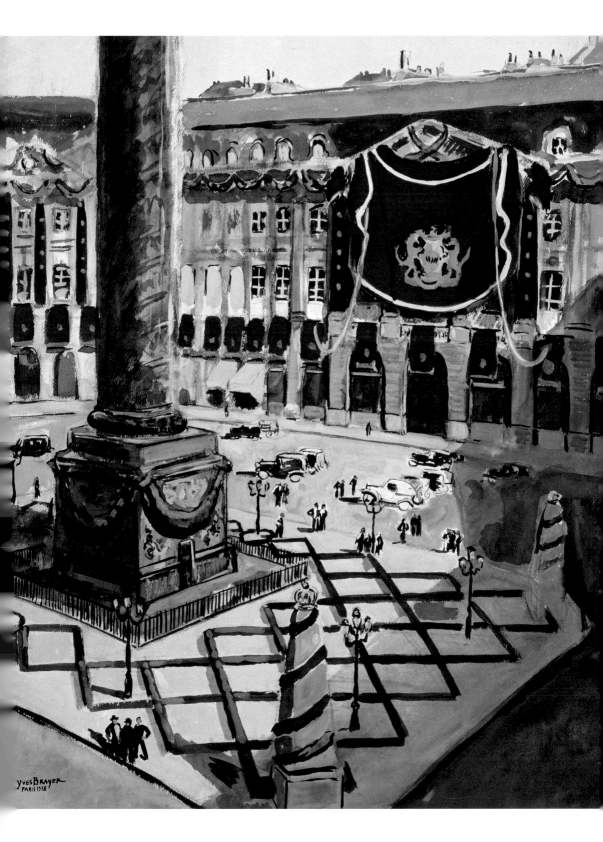

Right:
Demonstration in support of the
anarchists Sacco and Vanzetti, 1927.

Opposite:
Demonstration on 6 February 1934,
place de la Concorde.

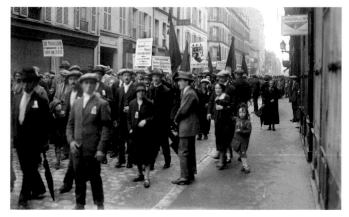

VIOLENCE AND UNREST

In August 1927, demonstrations organized by left-wing groups in support of the anarchists Ferdinando Nicola Sacco and Bartolomeo Vanzetti, executed in the United States, left several hundred wounded. Economic crises, including the crash of 1929, and government instability prompted crowds of demonstrators to take to the streets, resulting in damage to buildings and property, injuries and deaths, not to speak of the many scuffles that broke out between minor groups of activists.

The moderate parties, the Parti Radical-Socialiste on the left and the Alliance Démocratique and Fédération Républicaine on the right, grew increasingly extreme. The Communist Party and the Gauche Révolutionnaire demonstrated against far-right groups like the Camelots du Roi, the militant youth wing of Action Française, the Jeunesses Patriotes founded by Pierre Taittinger, the Croix-de-Feu led by François de La Rocque, and the Parti Populaire Français founded by Jacques Doriot, a Communist Party dissident. The most active of the far-right leagues was the Comité Secret d'Action Révolutionnaire, known as 'La Cagoule' ('The Cowl'), which received funding from a few powerful industrialists.

Both wings carved out their own territory across Paris and held on to it doggedly. The Communists held most of their meetings and rallies in the working-class districts and near the Communards' Wall in Père Lachaise Cemetery, while the Socialists congregated at the Panthéon, where the Socialist leader Jean Jaurès was buried. Right-wing gatherings to celebrate the feast day of Joan of Arc (on 8 May), Bastille Day and Armistice Day were held between the place de l'Étoile and the place des Pyramides. The ban on street marches did not extend to events that predominantly involved ex-servicemen and traditional parades were tolerated, even when they were openly linked to the far-right leagues.

In December 1932, 6,000 policemen and guards were brought in to control a 30,000-strong crowd of Camelot du Roi demonstrators that had engulfed the Latin Quarter and the neighbourhood of the Palais-Bourbon, seat of the Chambre des Députés. Events took a serious turn in 1934 when the Stavisky Affair provoked a major political crisis. The

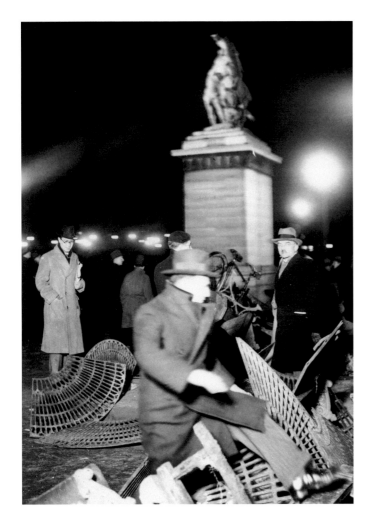

embezzler Alexandre Stavisky had made a fortune from selling worthless bonds and bribed a number of influential officials, lawyers and politicians. Stavisky's mysterious death was the subject of speculation and political conspiracy theories, and in a climate of anti-government feeling, the accusations of widespread corruption within the authorities were readily believed. On 3 February 1934, the French Prime Minister, Édouard Daladier, dismissed Jean Chiappe, head of the Paris Police, accusing him of taking too soft a line on the far-right leagues. Chiappe refused to leave his post, and three ministers and the head of the Seine prefecture resigned in support. The Paris city council set itself up as a semi-insurrectional opposition movement, with most of its members being opposed to the National Assembly and the more left-leaning government. The night of 6 February 1934 brought some of the most infamous riots in Paris's history, resulting in a total of 16 dead and 655 injured among the demonstrators, 1 dead and 1,660 injured among the forces of law and order. On 7 February, new scuffles broke out on the

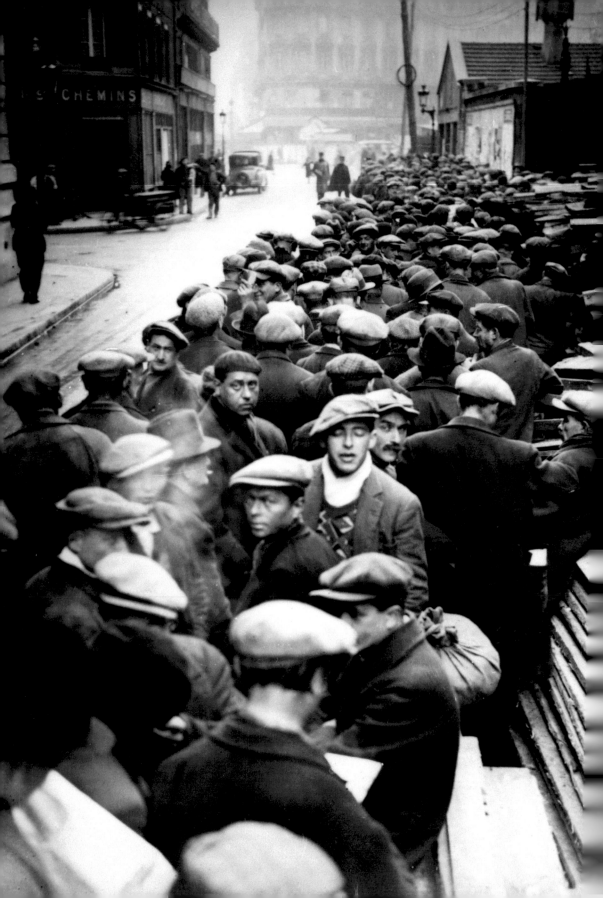

streets between the boulevard de la Madeleine and the avenue de l'Opéra. On 9 February, the Communist Party organized a counter-demonstration in the place de la République; this was banned by the government and gave rise to violent clashes around the Gare du Nord and the Gare de l'Est between the police and the Communist militants from Saint-Denis and Saint-Ouen. Four militants died and there were several hundred injured on both sides. When a general strike was called on 12 February, anti-fascist organizations were given permission to march between the porte de la Vincennes and the place de la Nation; there was no violence and the crowd, carrying red flags, marched past the platform where the leaders of the three left-wing parties – the SFIO (Socialists), the Communists and the Radical Socialists – were gathered.

More conflicts erupted in 1936 when the Front Populaire, a left-wing alliance, rose to power. In February, the Socialist leader Léon Blum was attacked by the Camelots du Roi, the youth wing of Action Française; a crowd of a hundred thousand marched from the Panthéon to the place de la Nation to show their support. The success of the left-wing parties in the legislative elections on 26 April and 3 May led to vast crowds of supporters demonstrating together, arms outstretched, fists clenched and bearing banners and red flags, the Socialist three arrows flying alongside the Communist hammer and sickle. The Bastille Day parade, between the place de la République, the place de la Bastille and the place de la Nation, attracted massive crowds. The period that followed was one of hope: after a general strike and workers' protests, the Matignon Agreements introduced the most far-reaching social reforms that France had ever seen, including a wage increase for all workers, a forty-hour working week and paid holidays, collective bargaining and works councils, broader social security measures, nationalizations and a raising of the school leaving age. Planned measures included pay scales, women's voting rights and proportional representation, but the Front Populaire had no time to introduce these; they lost power in 1938.

Violence was part and parcel of daily life during this period. The government seized arms caches belonging to La Cagoule, and disbanded the far-right leagues, who retaliated with marches and bombing campaigns. Clashes between police and trade unionists occurred during the general strike of May 1936 and continued until the Front Populaire government collapsed in November 1938. Other conflicts involved clashes between the members of various foreign communities and leagues – Italian fascists and anti-fascists, Russian émigrés and agents of the Soviet secret police, Croatian *Ustaše* and Serbian nationals. And then there were the abductions, murders and assassinations. The murder of Ernst vom Rath, an attaché at the German Embassy in Paris, by a seventeen-year-old Polish Jew on 7 November 1938 served the Nazi Party as a pretext for staging the vicious pogrom known as *Kristallnacht* (the Night of Broken Glass) against the Jewish community in Germany.

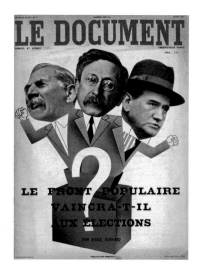

Above:
Cover of the monthly magazine
Le Document, January 1936.

Below:
A train taking workers on their first
paid holidays, summer 1936.

Opposite:
The unemployed waiting in line
for a soup kitchen, 1935.
Musée Carnavalet, Paris.

Overleaf:
Place de la Bastille, 14 July 1936:
the crowd celebrates the victory
of the Front Populaire.

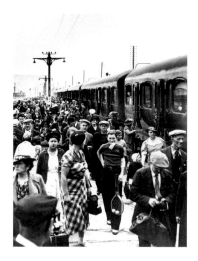

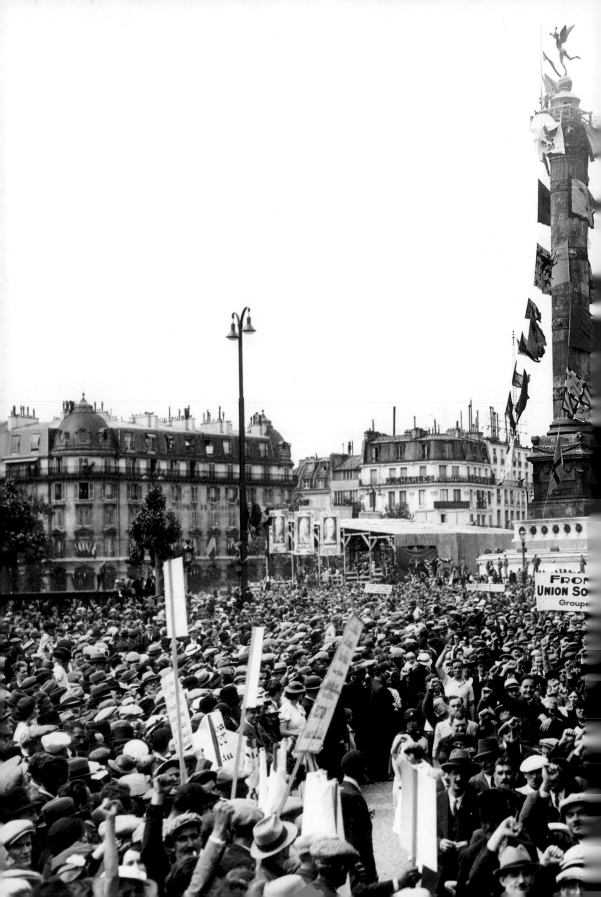

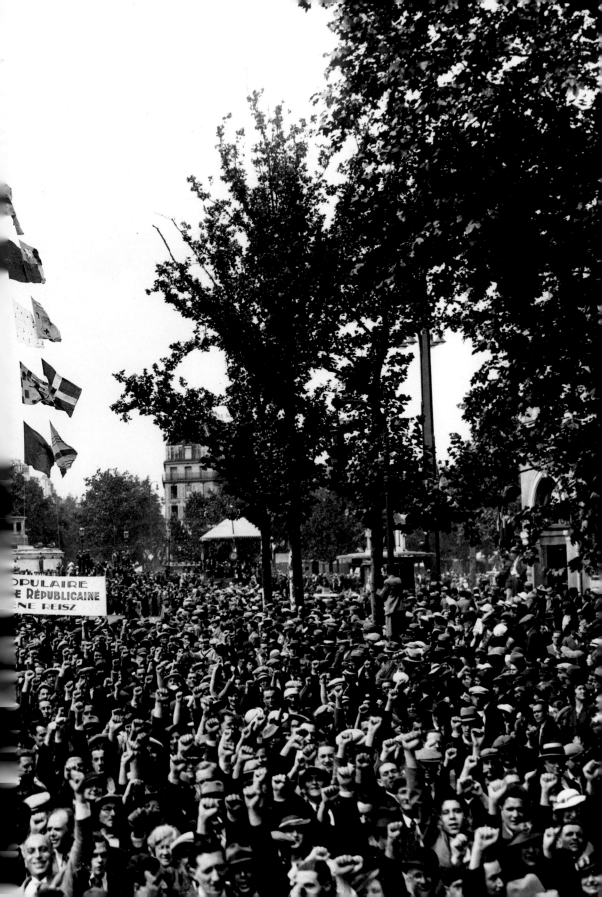

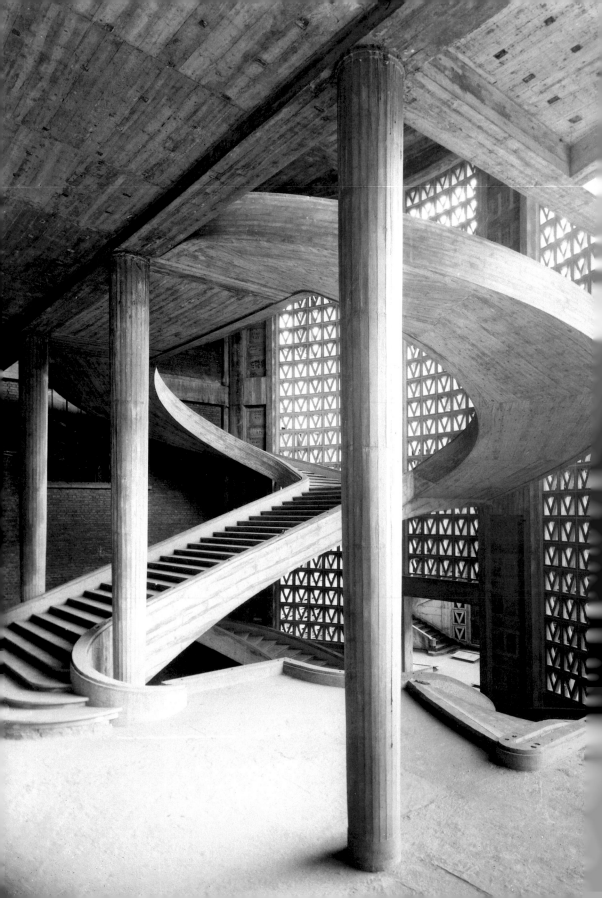

THE CITY OF LIGHT

Vincent Bouvet

CITY PLANNING AND MISSED OPPORTUNITIES

After the First World War, major legislative measures were put in place
to encourage the expansion and redevelopment of Paris; these were
accompanied by the founding of a number of specialist organizations.
In July 1919, submissions were invited for a competition to redesign the
area previously occupied by the defensive city walls and the adjacent
strips of land where building had formerly been prohibited, a place
known as 'the Zone' where slums had begun to spring up. Applicants
were asked to suggest ways of incorporating these areas in the capital as
a whole. The plans that were put forward basically attempted to remedy
some of the practical problems that had always beset Paris – pollution,
lack of light and lack of green spaces – and recommended a policy of
land acquisition with a view to creating a green belt and housing devel-
opments, with heavy industry being moved outside of this periphery. In
fact, the creation of this belt, though intersected by numerous roads
and dotted with monumental squares at the Porte Maillot, Porte de
Vincennes and Porte d'Orléans, actually doubled the gap between Paris
and its suburbs. Public amenities interspersed with cheap housing and
rental apartments were gradually built on the site of the old city walls;
and the Zone was improved by the creation of parks and gardens,
school complexes and sports centres.

REBUILDING PARIS

A number of architects had visions of transforming inner Paris into a
Futurist city. Henri Sauvage came up with the idea of stepped buildings
rising up in tiers (like the seats in an amphitheatre), and his plans for the
Seine waterfront – the Giant Hotel (designed 1927) on the Left Bank

Opposite:
Gustave Perret, staircase in the
Musée des Travaux Publics,
place d'Iéna (16th arr.), 1937.

Left:
Henri Sauvage, design for the
Métropolis building, quai de Seine,
1928. Gouache on paper, 56 × 76 cm
(22 × 29 ⅞ in.). Institut Français
d'Architecture, Paris.

Below:
Le Corbusier, aerial view of
the 'Plan Voisin' project, 1925.
Fondation Le Corbusier, Paris.

Opposite:
Robert Mallet-Stevens,
design for the Porte Maillot, 1931.
Musée des Arts Décoratifs, Paris.

and the Métropolis building (1928) on the Right Bank – had a scale and shape inspired by the pyramids of ancient Egypt. Le Corbusier, who settled in Paris in 1917, spent the rest of his life dreaming up ideas for rebuilding the city. The most famous of these was his radical 'Plan Voisin' (1925), which would have involved razing most of the historic Right Bank to create an area of 240 hectares (590 acres), within which eighteen cruciform skyscrapers would separate the residential and the business districts, with roads and green spaces occupying the remainder of the space. The idea of buildings that occupied vertical rather than horizontal space was one that also interested the Perret brothers, who designed a series of *villes-tours* ('tower-towns') for the west of the city as a means of resolving Paris's housing shortage.

Between 1928 and 1932, a great deal of thought went into the idea of designing and creating a Parisian region – 'Greater Paris', as André Morizet, Socialist mayor of Boulogne-Billancourt, envisaged it. However, the unique status of the capital as both a city and a *département* complicated its relationship with the French state, and disagreements between the two could result in somewhat aberrant decisions, particularly in matters of town planning. The plans for the creation of the Paris region were completed in 1934, not approved until 1939, and never in fact implemented. One idea that was adopted, however, was that the city's administrative border should be set at a distance of 35 km (22 miles) from the square in front of Notre-Dame. Major competitions were organized in an attempt to generate ideas regarding urban expansion to the west. In 1930, Léonard Rosenthal, who owned an arcade of shops on the Champs-Élysées, launched a competition to redesign the Porte Maillot. It was a tough challenge, which involved reconciling two very different things: the visual symbolism of a monumental square with a view of the Arc de Triomphe and the practical demands of traffic

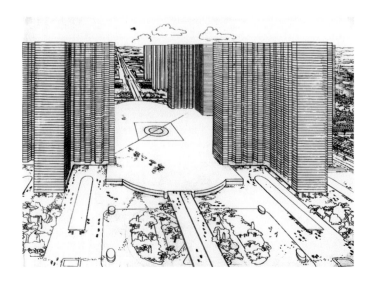

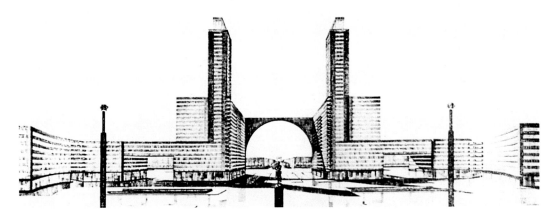

management at a major road intersection. The submitted designs by Le Corbusier, Sauvage and the Perret brothers all made use of twin towers to represent the city gates, and Mallet-Stevens also added an arch to his project, but none of the plans was ever used.

GREEN SPACES

Between the wars, more than sixty parks and garden squares were created in Paris, covering an area of 40 hectares (98 acres), the majority of them on the site of the old city walls. They incorporated modern materials such as reinforced concrete, glass blocks and coated gravel. To keep the maintenance costs down, the overall designs tended to be simple and greenery was massed in large compact areas. The most modest of these parks provided green spaces close to the new housing developments; the largest and most prestigious continued the tradition of classical-style French gardens. The Parc de la Butte-du-Chapeau-Rouge (19th arr.), for example, was landscaped and transformed with fountains and flights of steps – the undulating ground having prohibited the construction of housing blocks because of the major excavations that would have been necessary. Creating parks and gardens on the site of a former gasworks required major preparatory work because of contaminated soil and underground substructures: the square Saint-Lambert, in the Vaugirard district (15th arr.), was created between 1930 and 1933 over an area of 2 hectares (5 acres), and incorporated a large circular lake, occupying the site of an old tank. The most unusual of these newly created parks was probably the square des Gobelins (now called the square René-le-Gall; 13th arr.), completed in 1938 by Jean-Charles Moreux. On the site of the workers' gardens at the Manufacture des Gobelins and opposite the new Palais du Mobilier National, Moreux designed a large park divided into three sections, including a garden inspired by the geometric beds and architectural elements of the Château de Villandry, a play area for children and a

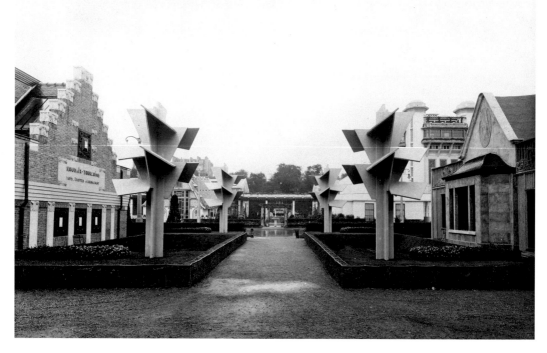

Above:
Cubist garden by Robert Mallet-Stevens,
Esplanade des Invalides, with concrete
trees by Jan and Joël Martel.
Exposition des Arts Décoratifs, 1925.

Below:
Gabriel Guévrékian, the 'Garden
of Water and Light'. Exposition
des Arts Décoratifs, 1925.

Opposite:
Bus with rear platform, 1927.

shrubbery. The major exhibitions also prompted a number of designs
for parks and gardens, including Mallet-Stevens's Cubist garden (1925)
on the Esplanade des Invalides, which created something of a sensation
with its concrete trees sculpted by Jan and Joël Martel. Another modern
composition was Gabriel Guévrékian's 'Garden of Water and Light',
based on decorative triangular elements with tiered flowerbeds and a
central fountain, topped by a stained-glass sphere designed by Louis
Barillet. Visitors to the Exposition Coloniale, in 1931, could lounge
dreamily in the Moroccan gardens recreated by Albert Laprade, while

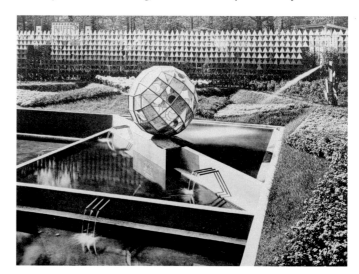

the gardens of the Palais de Chaillot, redesigned in 1937, sloped gently down to the Seine and had a large ornamental lake with fountains at their centre.

PUBLIC TRANSPORT

Plans to create a Greater Paris region were heavily reliant on an efficient public transport system, since traffic congestion and pollution were a major problem in the inner city. Under pressure from the automobile lobby, Paris's trams finally stopped running in 1936, while the bus network reached its maximum extent for the inter-war years in 1937, covering 1,890 km (1,170 miles). In 1929, work began on improving the Métro system, which was extended to stretch 33 km (20 miles) in fifteen different directions. In 1939, there were 159 km (99 miles) of track in use, with 13 lines serving the Paris suburbs, a total of 332 stations and 10 km (6 miles) of elevated track.

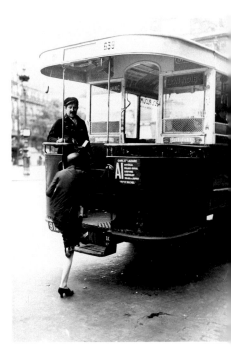

The most important factor affecting the city's transport, however, was the booming automobile industry. Factories on the outskirts of the city were responsible for producing most of France's motor cars: the Renault factory was located on the Île Séguin, in Boulogne-Billancourt, and Citroën were based at the quai de Javel, not far from the Eiffel Tower. Changes began to transform the urban landscape: pavements made of sandstone or wood were replaced with asphalt or concrete; pedestrian crossings were built; signposts and traffic lights sprang up, and bus lanes appeared. The boulevards des Maréchaux formed a ring road encircling the city, with eight underground tunnels running beneath them. For the 1937 exhibition, the sites of some of the old city gates were renovated and redeveloped: the Porte de Saint-Cloud, for instance, was given illuminated fountains, decorated with bas-reliefs by Paul Landowski.

The city's bridges had to be strengthened to support the flow of traffic. In 1928, the Pont de la Tournelle was rebuilt in concrete with stone facing and decorated with the figure of St Geneviève, sculpted by Landowski. At the end of 1931, a widened Pont de la Concorde reopened to traffic, while the Pont d'Iéna, between the Eiffel Tower and the Colline de Chaillot, was widened for the 1937 exhibition. In 1939, the cast-iron arches of the Pont du Carrousel, opposite the Louvre, were replaced with a reinforced concrete structure.

France's first motorway was built at the end of the 1930s with the section of the Autoroute de l'Ouest running as far as the Carrefour de Rocquencourt, on the edge of Versailles. Underground expansion seemed to offer a solution to the increasing number of cars on the road, and initial plans were drawn up in 1929 for a network of roads covering 25 km (15 miles), including underground car parks. In 1930, plans were put forward for a road junction beneath Les Halles, along with the construction of multistorey car parks with a capacity for five thousand cars.

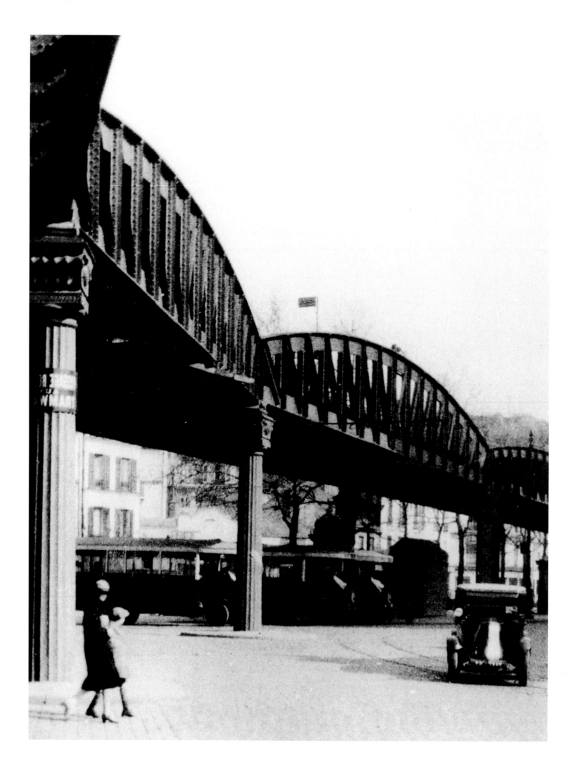

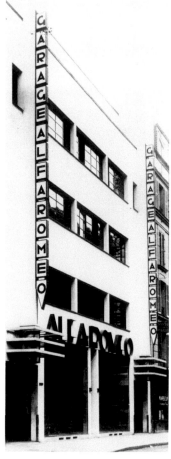

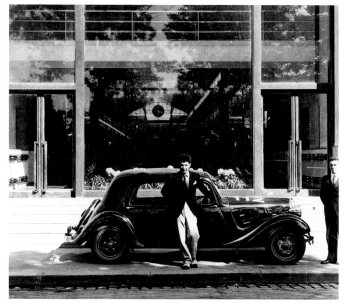

Above left:
Albert Laprade and Léon Bazin,
Citroën dealership,
32–34 rue Marbeuf (8th arr.), 1928–29.

Above right:
Robert Mallet-Stevens,
Alfa-Romeo dealership,
36 rue Marbeuf, 1925.

Below left:
Citroën dealership, 42 avenue
des Champs-Élysées, 1933–34.

Opposite:
Elevated section of the Métro,
near to Jaurès station.
Photograph by Germaine Krull, 1927.

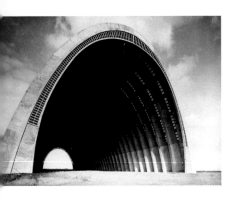

Above:
Eugène Freyssinet, airship
hangar at Orly, 1916–24.

Below:
Charles Lindbergh's *Spirit of Saint Louis*
at Le Bourget airport, 21 May 1937.

Opposite:
Albert Solon, *Lignes Farman*, 1932.
Musée Air France, Paris.

The aviation industry was also growing at a phenomenal rate, leading to the construction of concrete aircraft hangars such as those at Orly, and giving rise to some outlandish schemes, such as André Lurçat's design for an airport right in the heart of Paris, on an island in the Seine, close to the Eiffel Tower. In 1919, Le Bourget became Paris's first commercial airport, equipped with an extensive infrastructure that made it the largest in the world at the time. For the 1937 exhibition, Le Bourget became France's showcase for official architecture and the decorative arts, in addition to promoting the latest advances in aeronautics.

ARCHITECTURE: BETWEEN MODERNITY AND CLASSICISM

Paris was a magnet for the disciples of modernist architecture, even though, paradoxically, few of their designs ever saw the light of day. It was a place of lively architectural debate and magazines and books on architecture proliferated, promoting an image of French or Parisian immigrant architects as leaders of the avant-garde. Modern architects swiftly divided into two factions: the radical modernists grouped around Le Corbusier, nicknamed 'nudists' by academic critics, and the modern traditionalists, eager to defend classicism.

The charismatic Le Corbusier attracted an informal circle of colleagues such as André Lurçat, Pierre Chareau and Georges Pingusson in the 1920s, but these adherents of the 'International Style' remained an elite minority. Many of them belonged to groups whose aim was to promote a strictly 20th-century style of art, including the UAM (Union des Artistes Modernes) and the French section of the CIAM (Congrès Internationaux d'Architecture Moderne). They were interested in progressive European movements like De Stijl, Bauhaus and Constructivism and believed that buildings should be 'machines for living in', using standardized industrial products in order to build new

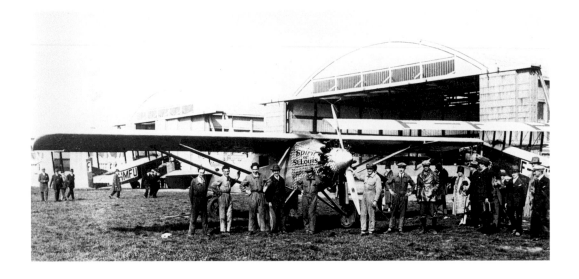

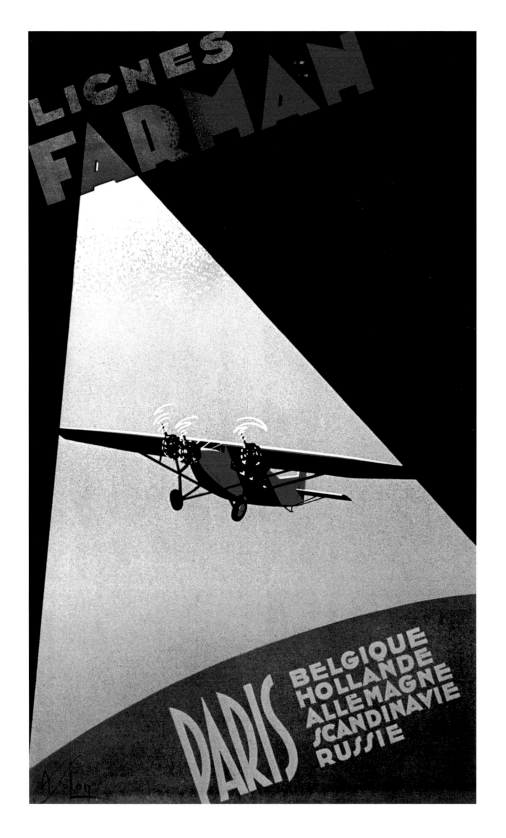

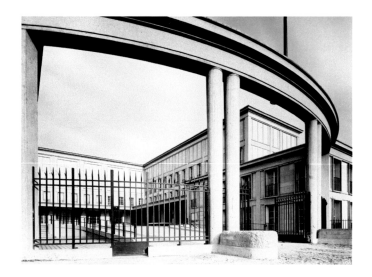

frameworks that depended on simple geometric forms and minimalist interiors with an emphasis on light. Their celebration of the machine extended to a fascination for the architecture of transatlantic liners, elements of which — brilliant whiteness, streamlining, portholes, rails and decks — they reproduced in their own work.

The modern traditionalists like Michel Roux-Spitz and Charles Siclis were not linked to either the Art Deco of the 1920s or the neoclassicism of the 1930s. Their acknowledged masters were Gustave Perret, François Le Coeur and Henri Sauvage. They advocated simple forms and rejected historicism, seeking to develop a modern decorative style by renewing structural traditions and giving importance to the texture and colour of the materials used. The French state commissioned a number of public buildings from Gustave Perret, an avant-garde figure from the beginning of the 20th century who later became the supreme representative of France's national architecture. His Garde-Meuble National (1934–38) was built entirely in concrete, in a monumental style that was carried through with exacting attention to detail.

The tradition of the École des Beaux-Arts was very much alive among wealthy private clients and those responsible for commissioning public buildings, but academicism was also able to evolve, fusing classicism and modernism to create an elegant monumentalism, the most successful examples of which were the buildings designed for the various international exhibitions, with their colonnades, rotundas, squares, fountains and rich sculptural details: the Musée des Colonies (Albert Laprade; p. 79) for the Exposition Coloniale in 1931; the Palais de Chaillot (Jacques Carlu, Louis-Hippolyte Boileau and Léon Azéma; pp. 84–85) and the Palais de Tokyo (André Aubert, Jean-Claude Dondel, Paul Viard and Marcel Dastugue; p. 84) for the 1937 exhibition.

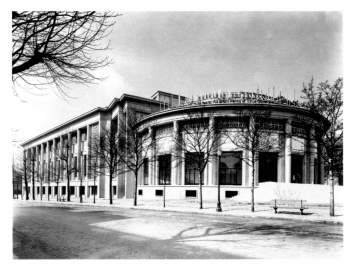

Opposite:
Gustave Perret, the Garde-Meuble National, rue Berbier-du-Mets (13th arr.), 1934–38.

Left and below:
Gustave Perret, the Musée des Travaux Publics, place d'Iéna (16th arr.), 1937–38. Built for the 1937 Exposition Internationale, the Musée des Travaux Publics marked the appearance of a new architectural order, with a type of baseless column with slightly curved capitals, which evoked ancient Egypt.

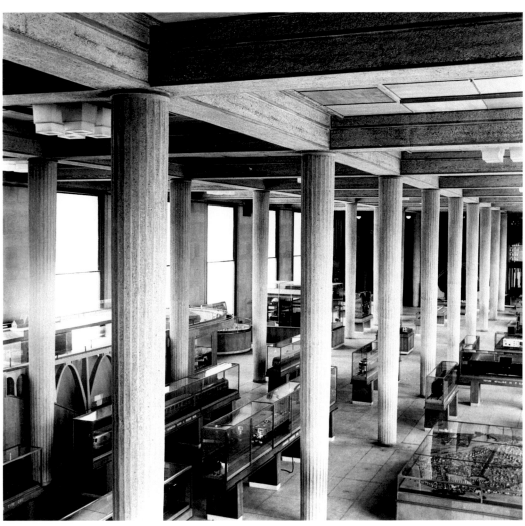

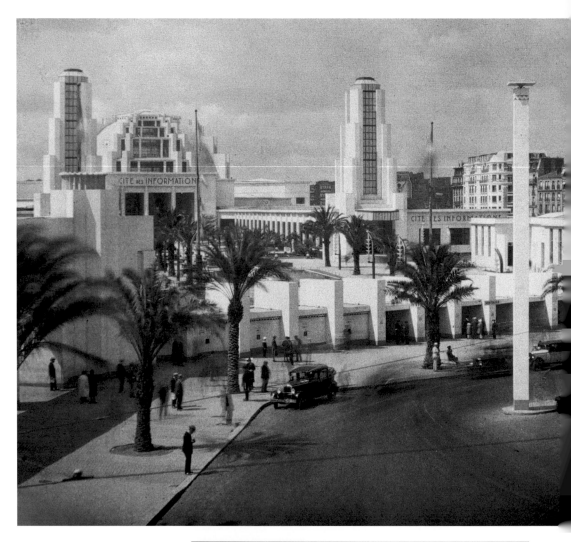

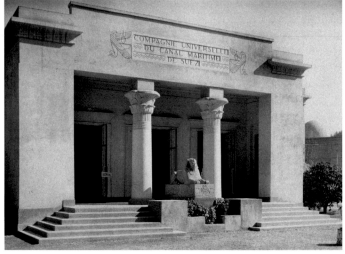

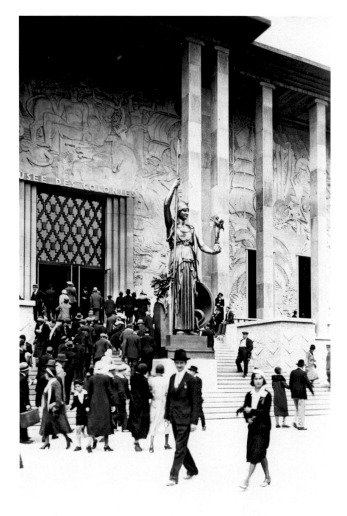

Above left:
The entrance of the Exposition
Coloniale, 1931.

Above right:
Albert Laprade and Léon Jaussely,
the Musée des Colonies, Porte Dorée,
built for the 1931 Exposition Coloniale.
Bas-relief sculptures on the façade by
Alfred Janniot; on the steps, *France Bringing
Peace and Prosperity to the Colonies*, gilded
bronze statue by Léon Drivier.

Opposite, below:
Pavilion of the Universal Suez Ship Canal
Company, 1931 Exposition Coloniale.

Right and opposite:
Henri Roger Expert,
illuminated fountains,
Exposition Coloniale, 1931.

Below:
Georges Pingusson,
Frantz-Philippe Jourdain
and André Louis,
the Pavilion of the UAM
(Union des Artistes
Modernes), 1937 Exposition
Internationale.

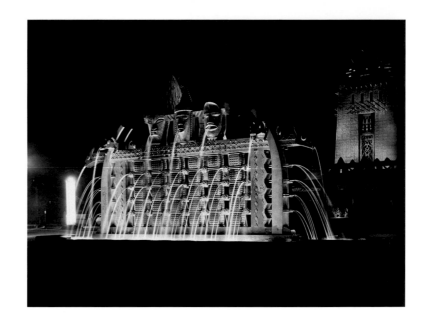

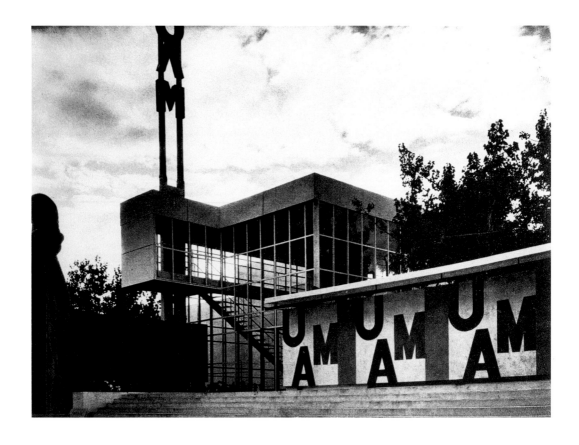

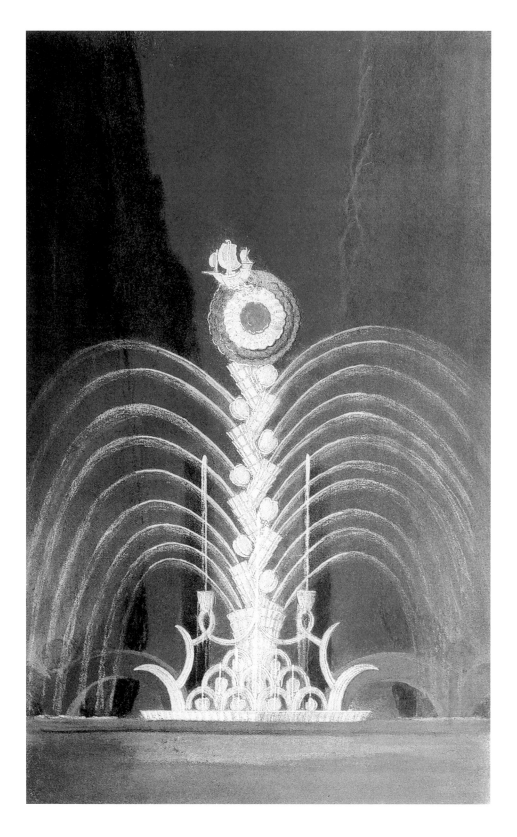

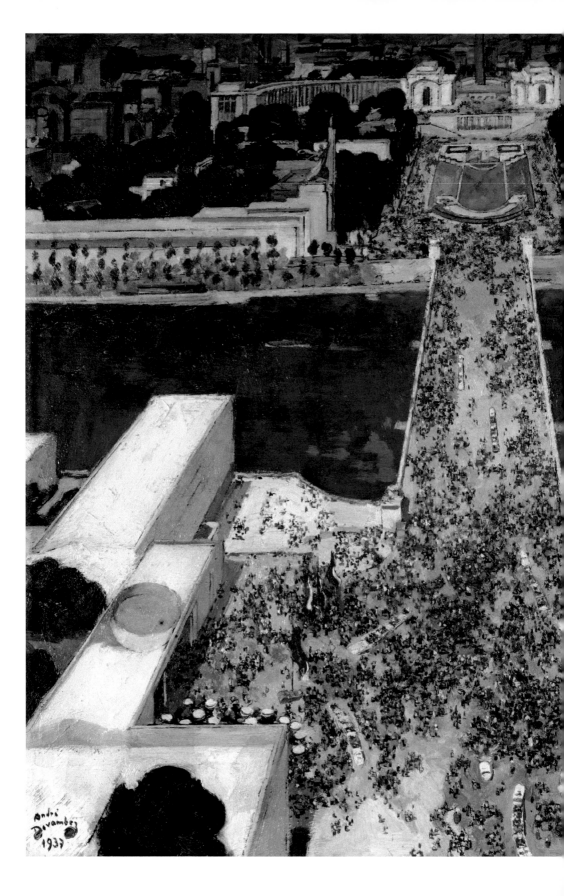

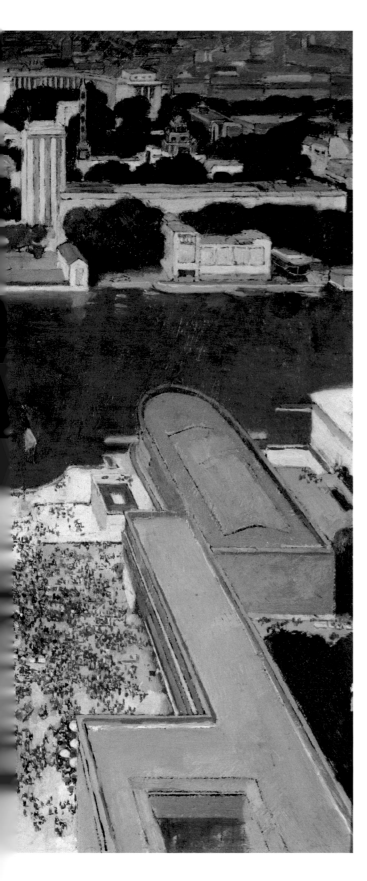

André Devambez,
The 1937 Exhibition
Seen From the Eiffel Tower, 1937.
Oil on card, 40 × 46 cm (15 ¾ × 18 ⅛ in.).
Musée Carnavalet, Paris.

Right and opposite:
Jacques Carlu, Louis-Hippolyte Boileau
and Léon Azéma, the Palais de Chaillot, built
for the 1937 Exposition Internationale.

Below:
André Aubert, Jean-Claude Dondel,
Paul Viard and Marcel Dastugue,
the Palais de Tokyo, built for the
1937 Exposition Internationale.

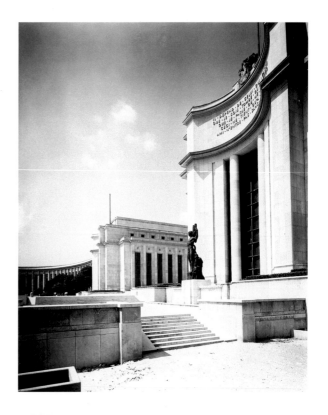

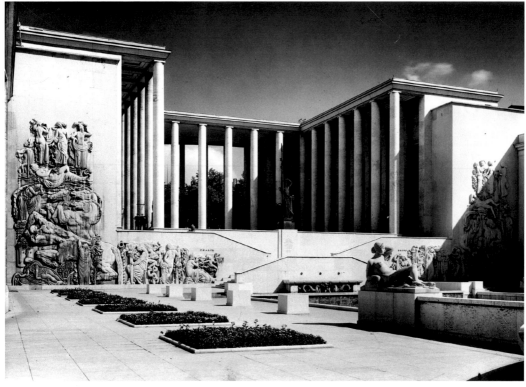

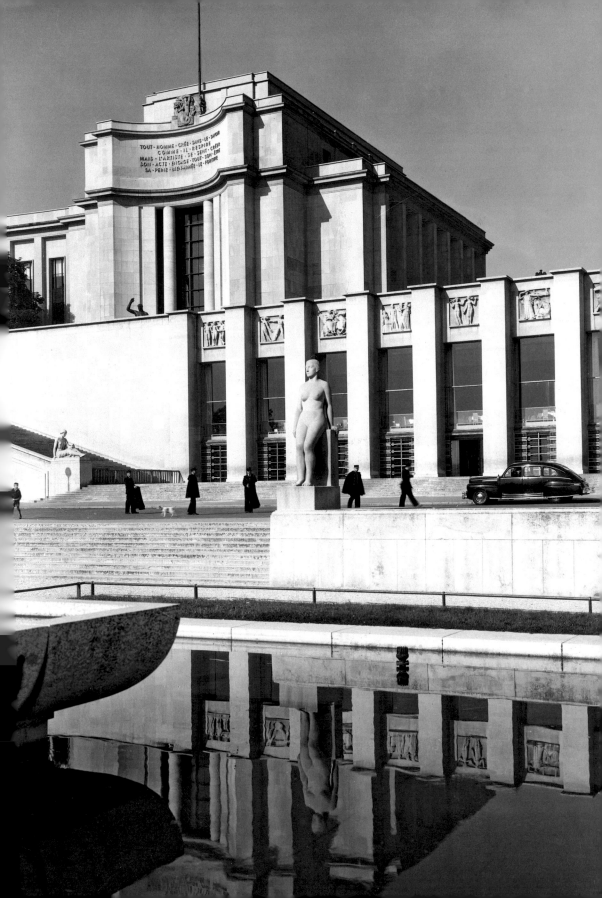

Right and below:
Tony Garnier, Boulogne-Billancourt town
hall, exterior and interior views, 1934.

Opposite:
Eugène Beaudoin, Marcel Lods,
Jean Prouvé, Vladimir Bodiansky,
the Maison du Peuple, Clichy, 1936–39.
Institut Français d'Architecture, Paris.

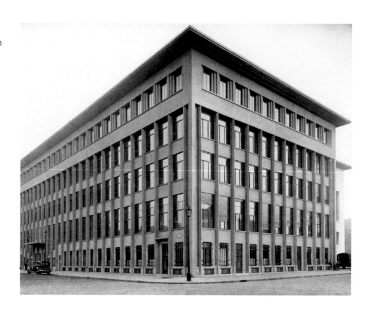

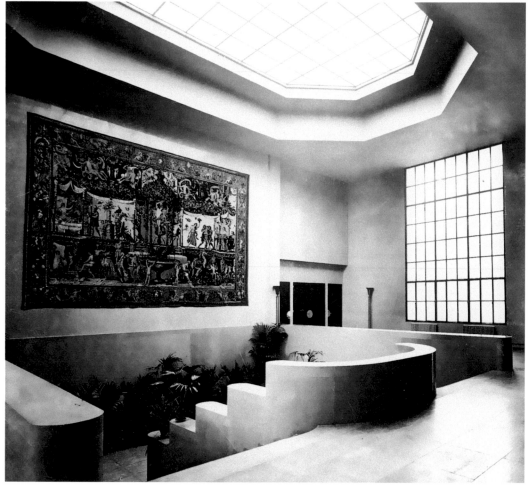

The rapid growth of the Paris suburbs stimulated the need for an active building policy. Local councils, most of them left-wing, took on innovative building projects, turning the city outskirts into an area for experimentation with new approaches to the modern urban environment. Local town halls – the symbolic heart of each district – became in many cases the symbolic focus for the new architecture.

The mayor of Boulogne-Billancourt, André Morizet awarded the task of designing a new town hall for his district to Tony Garnier. Garnier designed two main buildings (1931–34), each in a different architectural style, the southern one housing the public reception areas and the northern one the offices, arranged around a vast foyer lit both from above and from the sides, with four galleries serving the offices on the upper floors. Jean-Baptiste Mathon's designs for the Mairie de Cachan, built in red brick, were inspired by the town hall that Willem Marinus Dudok had designed for Hilversum in the Netherlands. For the new town hall in Puteaux (1931–33), the brothers Jean and Édouard Niermans drew on the tradition of the École des Beaux-Arts but added their own modernist slant. The reception rooms boasted monumental interiors painted and sculpted by the best-known official artists of the time, and the complex included a post office, fire station and municipal garage. The Maison du Peuple in Clichy (1936–39), which also housed a covered market, was the joint work of architects Eugène Beaudoin and Marcel Lods, designer Jean Prouvé and engineer Vladimir Bodiansky. This strikingly modern building combined steel girders – the metal being soldered rather than riveted – and panels of sheet steel. The complex encompassed a market, a cinema and a series of meeting rooms. The market on the ground floor could be extended out beneath the exterior canopy and into the first-floor galleries, and a retractable

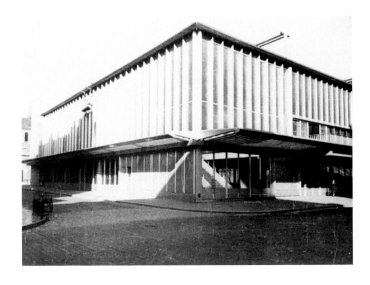

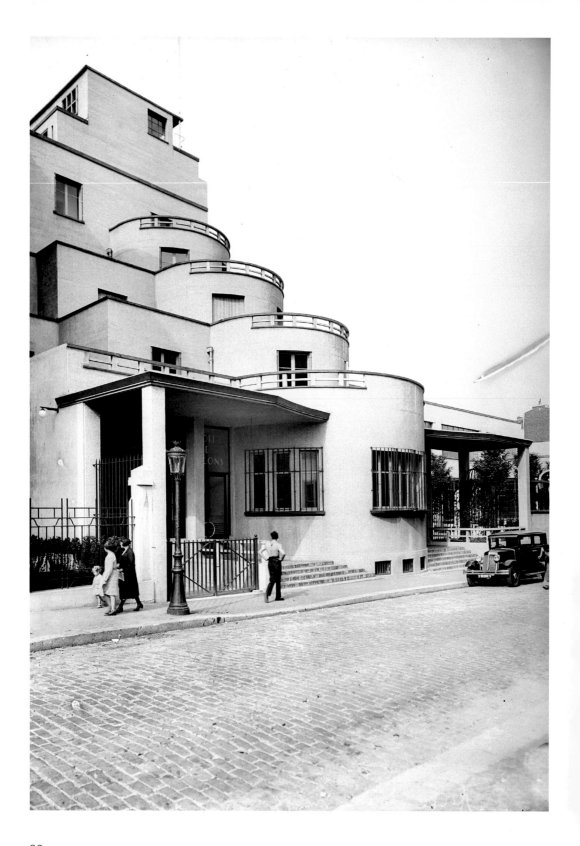

floor could be used to fill the central space and form an additional large-capacity hall, while a sliding wall provided the option of creating a projection room.

Between 1930 and 1940, the city of Paris built around twenty school complexes, most of which used frameworks of reinforced concrete and brick facing for ease of maintenance and durability. The use of heavy girders made it possible to create large internal spaces, broadly illuminated by long strip windows. Buildings of this sort were designed by the architects Jacques Brandon and Pierre Sardou, while the school in the rue Kuss (13th arr.) designed by Henri Roger Expert involved a succession of terraces reminiscent of the decks of an ocean liner. On the Paris outskirts, two left-wing councils founded schools that also served as advertisements for their forward-thinking policies. André Lurçat designed the Karl-Marx School in Villejuif, under the auspices of its Communist mayor Paul Vaillant-Couturier, arranging the buildings as a series of right angles, with the emphasis on horizontality, and creating an impression of lightness and transparency by elevating the reinforced concrete structure on supporting pillars and introducing strip windows with light metal frames. The inclusion of a solarium on the roof terrace reflected contemporary concerns about tuberculosis and other health issues. The Socialist mayor of Suresnes, Henri Sellier, commissioned plans for an open-air school, on the slopes of Mont Valérien, from Eugène Beaudoin and Marcel Lods. The design, which was inspired by Scandinavian models, involved a series of pavilions on a level with the gardens, a roof terrace and a building housing the common areas; folding glass panels on three sides of the classrooms could be opened or closed as required.

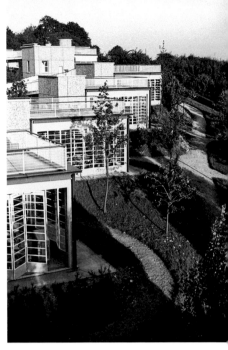

Above:
Eugène Beaudoin and Marcel Lods,
open-air school, Suresnes, 1935–36.

Opposite:
Henri Roger Expert, school on the rue
Kuss (13th arr.), 1934.

Below:
André Lurçat, Karl-Marx School
buildings, Villejuif, 1930–33.

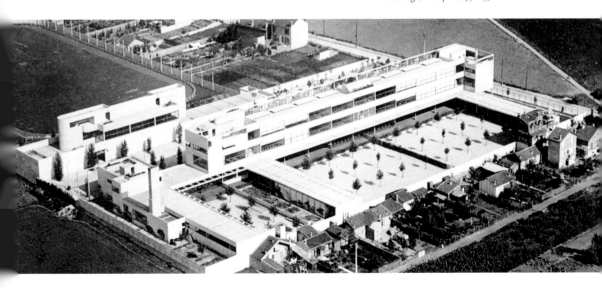

Right:
Auguste and Gustave Perret,
the church of Notre-Dame de la
Consolation, Raincy, 1922–23.

Opposite:
Robert Fournez, Maurice Mantout
and Charles Heubès, the Paris Mosque
(5th arr.), 1924–26.

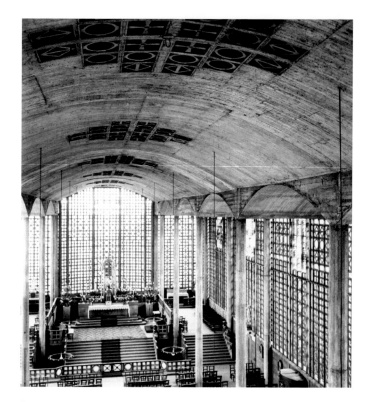

RELIGIOUS ARCHITECTURE

Religious art received a new lease of life in the period between the wars. In 1931, Jean Verdier, Cardinal-Archbishop of Paris, founded the Chantiers du Cardinal or 'Cardinal's Building Yards', with the aim of building and decorating new churches in Paris and in the working-class suburbs. Verdier attracted the collaboration of architects Paul Tournon and Dom Bellot, painters Maurice Denis and Marthe Flandrin, stained-glass artists Marguerite Huré and Louis Barillet, sculptors Jan and Joël Martel, and designer and silversmith Jean Puiforcat. In 1923, Notre-Dame de la Consolation in Raincy, nicknamed the 'Holy Chapel of Concrete', was the first church to be built in a totally modernist style, an example of strictly utilitarian architecture stripped of stylistic references. The building, designed by Auguste and Gustave Perret, was a rectangular structure in reinforced concrete, with its nave divided into three by two rows of slim fluted columns. The outer 'envelope' of the building was independent of the supporting structure, allowing light to flood through openwork screens decorated with stained glass. The Perret brothers were not alone in seeing the noble potential of a humble material such as reinforced concrete and it came to be used in churches by a number of other architects: Jacques Droz at Saint-Louis de Vincennes, Éric Bagge at Saint-Jacques-le-Majeur de Montrouge, and Marc Brillaud de Laujardière and Raymond Puthomme at Sainte-Agnès de Maisons-Alfort. In some cases, a church façade would be designed around a major decorative project,

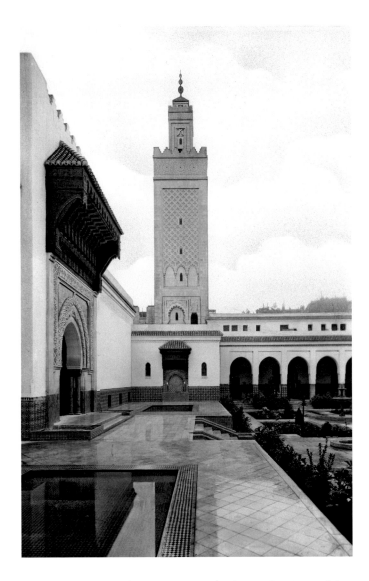

such as the monumental stone tympanums by Georges Saupique at Saint-Ignace de la Cité Universitaire in Gentilly, and by Henry Bouchard at Saint-Pierre de Chaillot and Anne-Marie Roux-Colas at Sainte-Odile. In 1926, Carlo Sarrabezolles devised a method of carving directly into setting concrete, which enabled him to create rows of monumental statues that were closely integrated with the architecture of a building. He used this technique at the Église du Saint-Esprit in Paris, where he worked on the bell tower in collaboration with architect Paul Tournon.

Work on the construction of the Paris Mosque began in 1926. The building was intended as a symbol of friendship between France and the Islamic world and as a homage to the Muslims who died fighting for France in the Great War. The city provided the land and the architects drew their inspiration from the mosques in the city of Fez, designing a

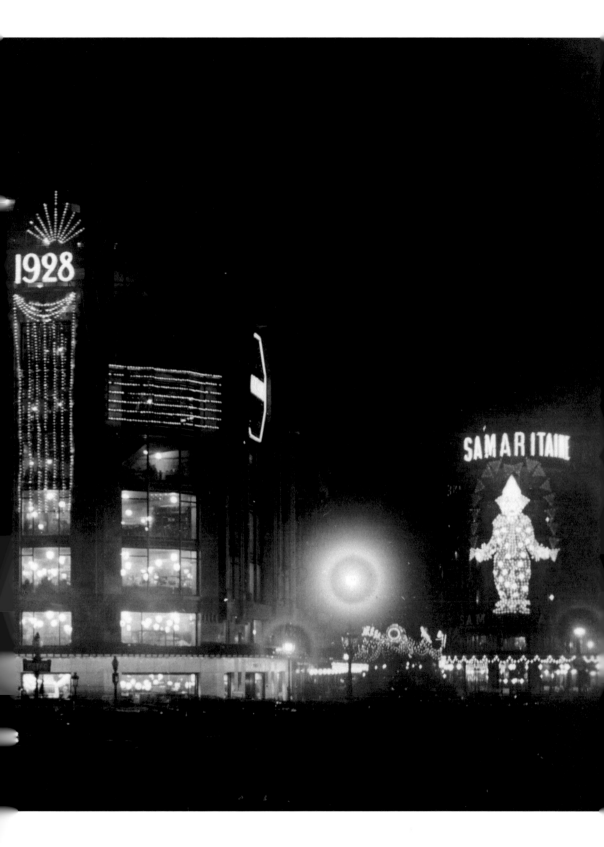

structure in reinforced concrete decorated with traditional materials
from the Maghreb.

DEPARTMENT STORES

The famous department stores of Paris had first opened in the second
half of the 19th century. Between the wars – before the impact of the
global economic crisis was felt on the high street – these 'cathedrals of
commerce' were the focus of major expansion, with architects and deco-
rators alike using their skills to lure in customers and ensure that they
would keep coming back.

When the new Printemps store was rebuilt in 1921 (after the existing
building was destroyed by fire), a majestic cupola made up of 3,185 glass
panels was installed to let in the daylight. In 1929, the tea room was
totally refurbished in a modernist style, complete with tubular furniture
and geometric-patterned carpet, and in the early 1930s the rooms in the
rotundas were lavish decorated in the spirit of the 1925 Exposition des
Arts Décoratifs, with frescoes and crystal chandeliers.

From 1926 to 1928, La Samaritaine's Seine building was enlarged by
Henri Sauvage, who installed night lighting designed to accentuate the
store's monumental size. At the request of the city council, the building
was faced with cream-coloured stone so that it would blend in harmo-
niously with its neighbours. Between 1930 and 1933 there was further

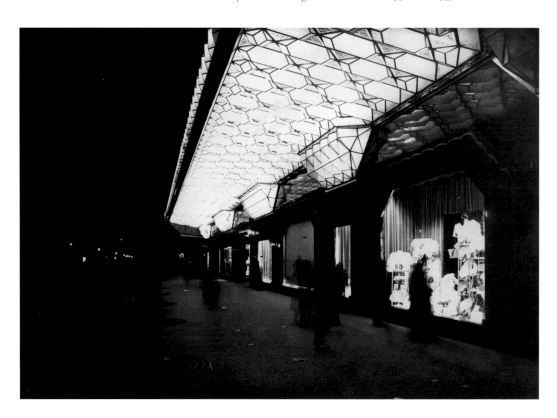

modernization of the store's rue de Rivoli building, designed by Francis Jourdain, who incorporated a gigantic wrought-iron rose into the façade.

The modernization of the Galeries Lafayette was the most innovative. In 1928, Ferdinand Chanut designed the windows that looked on to the boulevard Haussmann in line with the principle of taking the store outdoors, 'turning the windows into a theatre, with the pavement as the auditorium, and the passers-by as the audience'. The windows were richly framed in coloured marble; the panes reached almost to the ground and a wide glass canopy provided a brightly lit roof over the pavement. A few years later, Pierre Patout adopted the opposite principle, designing a 'closed' store with windowless façades, punctuated by vertical structures on the upper levels and by horizontal bands at ground level, with ventilation shafts and artificial lighting. The internal layout was to include state-of-the-art fittings, including escalators, elevators and pneumatic tubes, but the project was abandoned in 1936 and only the side façades with their fluted bow windows were completed.

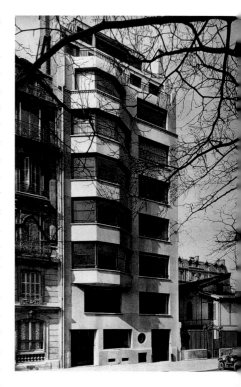

The traditional Parisian covered walkways began to turn into shopping arcades with the opening in 1926 of the Arcades des Champs-Élysées, described as 'a permanent bazaar of luxury goods'. The diamond dealer and property developer Léonard Rosenthal had an arcade built in a style that combined Art Deco with Corinthian columns and fountains by René Lalique. In the basement was the fashionable Lido complex, with beauty treatment rooms and a swimming pool that became the setting for many outrageous parties.

Private Apartments

Up until 1931, a great many beautiful apartment blocks were built in Paris. Under the convenient term 'School of Paris' – coined by its leading architect, Michel Roux-Spitz – these building programmes shared a bias towards modern classicism and typically made use of a concrete structure, with stone façades, bow windows for maximum light, a roof terrace, and metal frames and railings, which gave the look of an ocean liner. Interior layouts were kept simple for the sake of increased comfort, although there was still a division between reception, private and service areas. Roux-Spitz designed a series of five white apartment blocks that remain archetypes of their kind, including his own apartment in the rue Guynemer, buildings on the quai d'Orsay and the boulevard du Montparnasse, and his office in the avenue Henri-Martin. The same elegant attention to detail and harmony of volumes was to be found in the work of Pierre Patout, whose apartment building known as Le Paquebot ('the Liner'), on the boulevard Victor (15th arr.) was built on an extremely narrow strip of land by the city's peripheral railway line. The façade of Bruno Elkouken's apartment block on the boulevard Raspail (14th arr.) was enlivened by an arrangement of Cubist blocks, with bow windows on two levels and graduated terraces on the upper floors.

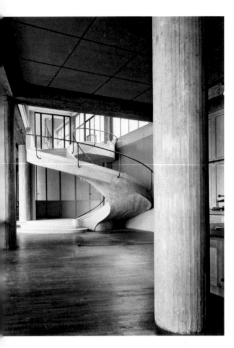

The avant-garde architects received very few commissions for apartment blocks. Le Corbusier designed one in the rue Nungesser-et-Coli (16th arr.), piercing the black metal framework of the façade with blocks of Nevada glass, produced by the firm of Saint-Gobain. The interior layout, in concrete, was completely open plan so that the inhabitants could divide the space in whatever manner they chose. Le Corbusier himself occupied the top floor, which he turned into an apartment-cum-studio. Jean Ginsberg, a student of Mallet-Stevens and Le Corbusier, created a new role for himself as both architect and developer, designing five apartment blocks between 1931 and 1935 in association with Berthold Lubetkin and later François Heep — projects in which he was free to combine functionalist innovation with rational aesthetics.

Left:
Auguste Perret, staircase in the Agence
Perret, rue Raynouard (16th arr.), 1930–33.

Below:
Jacques Debat-Ponsan, façade of a
block on the rue de Vaugirard, c. 1930.

Opposite:
Auguste Perret, building
on the rue Raynouard
(16th arr.), 1930–33.

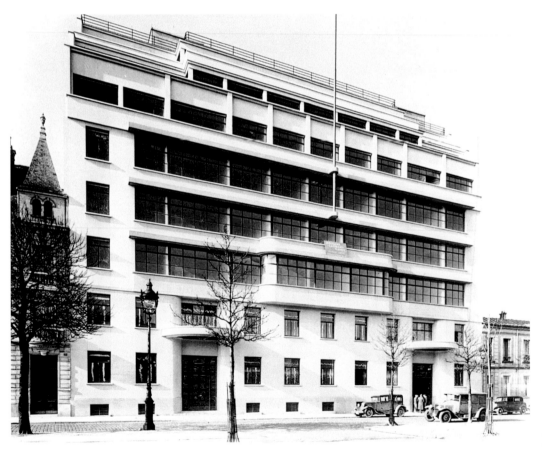

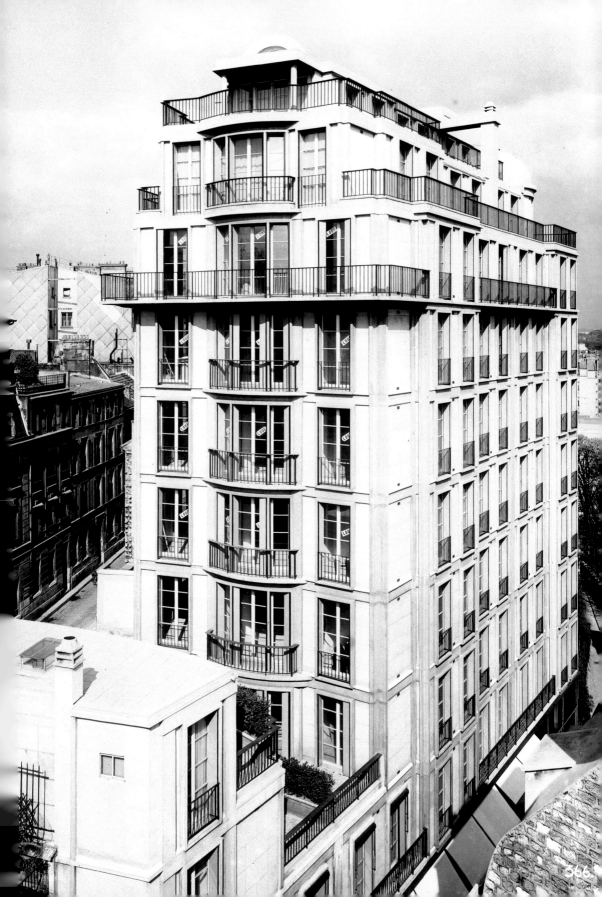

366

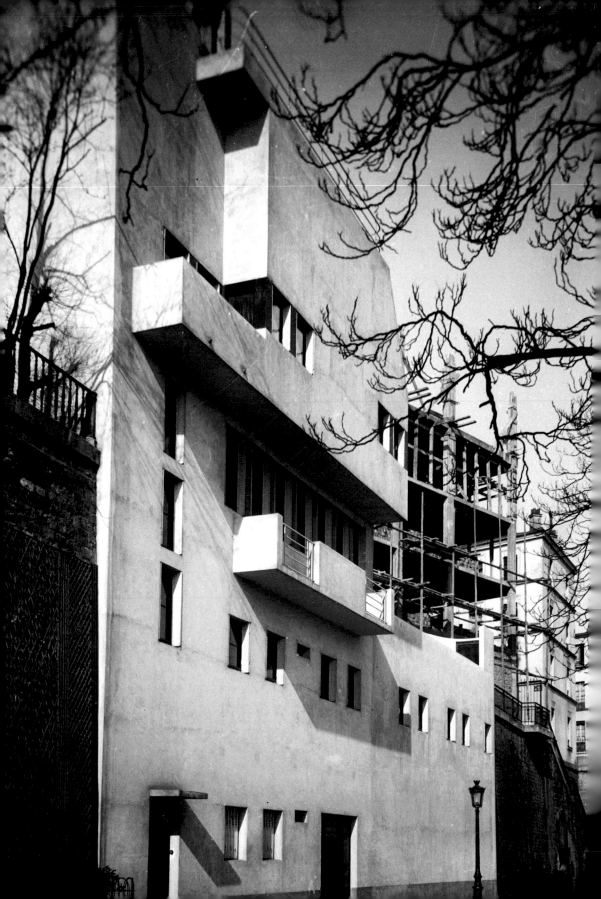

Private Homes and Gardens

The 1920s saw the new phenomenon in Paris: the development of private streets, made up of apartment blocks known as 'villas', each of which differed from its neighbours while meeting the same specifications. The modernist movement – whose principal clientele were artists and supporters of the avant-garde – embraced this type of urban development with enthusiasm. The private square du Docteur-Blanche (16th arr.) boasts two houses built by Le Corbusier: the Villa Jeanneret-Raaf, with its bow window on the first floor, duplicated by a series of bays running the length of the façade, and the Villa La Roche, designed for the Swiss banker and art collector Raoul La Roche, whose main living area was housed in an elevated wing supported by piles. Further along the street, the impasse Mallet-Stevens offers an example of something quite unique in Paris: a row of six houses designed by Robert Mallet-Stevens (beginning in 1926) – on what was, for Paris, a fairly substantial plot of land – for various artist friends including the sculptors Jan and Joël Martel (p. 101), with one of the houses serving the architect himself as a home and workplace. The relationship between the houses, the interplay of volumes and space and the quality of the decorative details, including stained glass by Louis Barillet and ironwork by Jean Prouvé, along with furniture designed by Mallet-Stevens himself – all these things combined to create an exceptional piece of urban architecture whose impact can still be felt today, despite subsequent alterations. The Villa Seurat, in a cul-de-sac in the 14th arrondissement, is a collection of eight artists' houses designed by André Lurçat. The Perret brothers also designed a studio for the sculptor Chana Orloff, whose cement and brick-faced façade provided a striking contrast with the smooth, painted surfaces of the neighbouring buildings. Another isolated example of avant-garde architecture in the same district (Montsouris) is the Maison-Atelier Ozenfant, the creation of Le Corbusier and Pierre

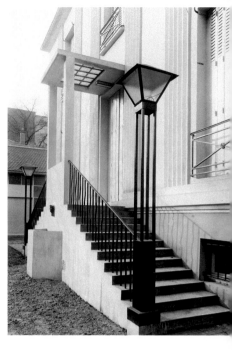

Above:
Robert Mallet-Stevens, the front entrance of the home of Mme Rossignol, rue Michel-Ange (16th arr.), 1925.

Below left:
Robert Mallet-Stevens,
Office in the home of Mme Rossignol, 1936.

Opposite:
Jean-Julien Lemordant,
home and workshop, 50 avenue
René-Coty (14th arr.), 1929.

Right:
Robert Mallet-Stevens
in his automobile.

Below:
The opening of the rue
Mallet-Stevens in 1927
Robert Mallet-Stevens
is in the centre, face on.

Opposite:
Robert Mallet-Stevens,
the Hôtel Martel, on
the rue Mallet-Stevens
(16th arr.), 1927.

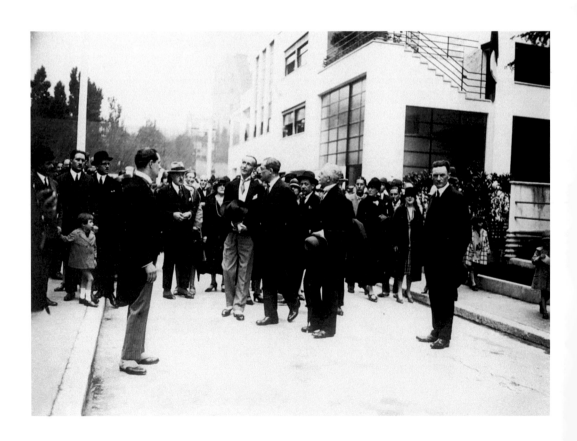

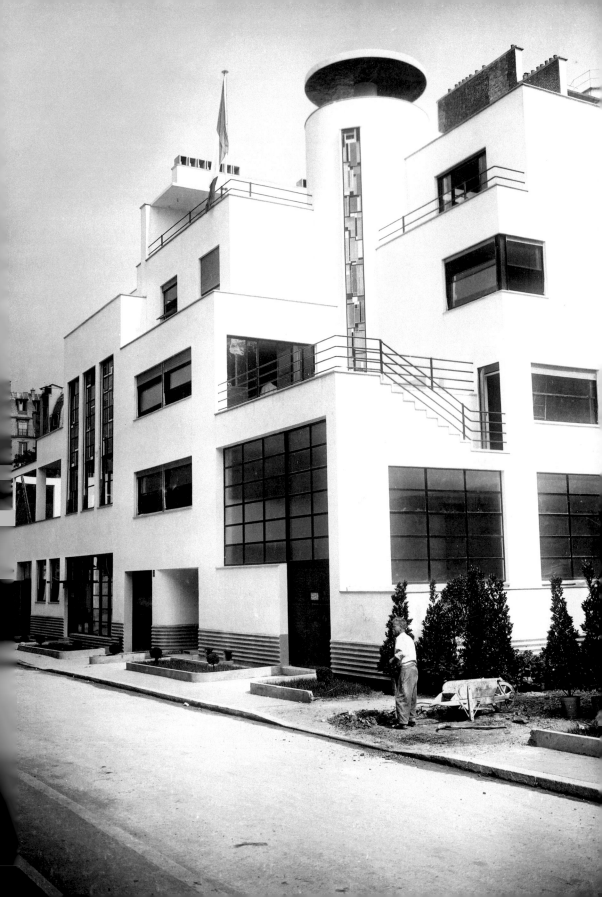

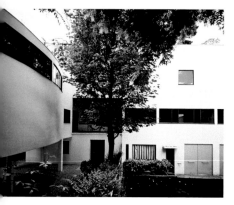

Above:
Le Corbusier, the Villa La Roche
(left) and the Villa Jeanneret-Raaf,
square du Docteur-Blanche (16th arr.).

Below:
André Lurçat, the Villa Guggenbuhl,
14 rue Nansouty, by the Parc Montsouris
(14th arr.), 1926–27.

Jeanneret, whose sawtooth roof was a reference to industrial architecture. The Villa Guggenbuhl, designed by André Lurçat, has a strikingly austere look reminiscent of a Cubist sculpture, while the Maison-Atelier Lemordant, designed by the painter Jean-Julien Lemordant (blinded during the war), recalls an ocean liner with its solid base, prow-like projecting upper floors, balconies and recesses (see p. 98).

On the western side of Paris, in the rapidly expanding suburb of Boulogne-Billancourt, the district around the new Parc des Princes stadium boasted a number of small private residences designed by some of the leading architects of the day: exploring this area is like taking a stroll through an open-air gallery demonstrating the richness and diversity of 1920s French architecture. The rue Denfert-Rochereau features three adjoining houses in the International Style – the Hôtel Collinet by Mallet-Stevens, the Villa Cook by Le Corbusier and Pierre Jeanneret, and a villa by Raymond Fisher – which create an impression of unity despite the diversity of their façades. In the allée des Pins, Le Corbusier built two studio homes for the sculptors Jacques Lipchitz and Oscar Miestchaninoff, using prows and gangways that recalled naval architec-

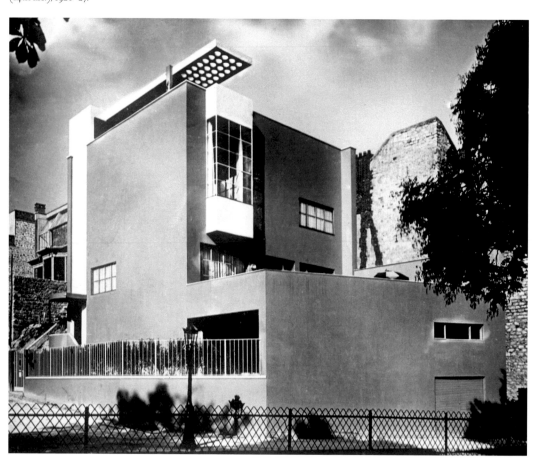

ture. In 1927, Le Corbusier defined the 'Purist house' according to his 'five points for a new architecture': concrete stilts, a freely-designed façade, an open-plan interior, ribbon windows, and a roof garden. The Villa Stein and Villa de Monzie in Vaucresson and the Villa Savoye in Poissy illustrate the practical application of his theories.

A modernist approach to the town garden, from 1920–25 onwards, focused on purity of line, geometric shapes and strong colours. The socioeconomic constraints of the post-war period also led to space restrictions and simplified compositions to allow for minimum maintenance. In 1924, Paul Véra designed the garden for the Vicomte de Noailles's private residence in the place des États-Unis, with the help of Jean-Charles Moreux: beds of brightly coloured foliage were alternated with gravelled areas in various shades to form geometric patterns; surrounding this was a honeycomb of large square paving stones, with strong lines leading the eye in different directions, while mirrors incorporated at the outer limits of the garden gave the illusion of space. Moreux's 1928 designs for the gardens of the Hôtel Rothschild, on the avenue de Marigny, included a covered swimming pool and a sports hall, both of

Above:
The Perret brothers, workshop for Chana Orloff, Villa Seurat (14th arr.), 1926.

Below:
The rue Denfert-Rochereau, in Boulogne-Billancourt.
From left to right: the Hôtel Collinet by Robert Mallet-Stevens, the Villa Cook by Le Corbusier and Pierre Jeanneret, and a villa by Raymond Fisher, 1926–27.

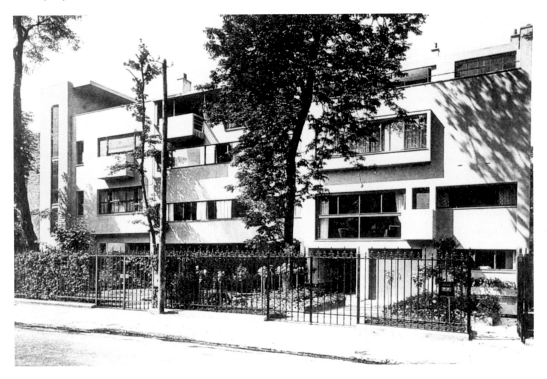

Below:
Pierre Patout, low-cost housing block
(HBM), Porte d'Orléans, c. 1935.

Opposite, above:
Eugène Beaudoin and Marcel Lods,
the Cité de La Muette, Drancy, 1933.

Opposite, below:
Henri Sauvage, HBM on the rue des
Amiraux (18th arr.), 1925–30.

them concealed behind mirrored panels, and a portico in a simplified
classical style, framing a fresco by Giorgio De Chirico.

SOCIAL HOUSING

In addition to the political and economic crises of the inter-war years,
plans to expand Paris also failed due to the impossibility of annexing the
outlying districts. This would have been possible back in 1860, when the
villages around Paris were part of a market gardening region that was also
a holiday destination for city dwellers. But since then, they had been
turned into industrial suburbs where private housing estates had sprung
up, cheaply built, without proper planning or easy access to road and rail
networks. The chronic housing crisis led first of all to plans for cheap
public housing projects – *habitations à bon marché*, known as HBMs – and
then to the Loucheur Act of 1928, which provided state funding for new
homes, and finally to public financing of supported housing projects.

The first HBMs on the outskirts of Paris were built at Montmartre,
where a total of 2,734 units were created. Their designs included some
imaginative decorative detail, with a combination of brick facing in
various colours, alternated with plastered surfaces, chamfered corners,
oriel windows and projecting balconies, and concrete pergolas on
rooftops – an attractive feature, but not well suited to the Paris climate.
Housing estates built in the new peripheral belt and new developments
within the city itself broke with the tradition of building around narrow,
dimly lit courtyards. From now on, blocks of flats were built around a
square or garden, bring in light and fresh air. An alternative was the *boule-
vard à redans*, incorporating open courtyards that merged with the street.

In the inner city, Henri Sauvage had been working since 1910 on proj-
ects involving large-scale stepped apartment buildings that had the

double advantage of increased light and optimum use of space. The HBM on the rue des Amiraux (1913–30) underwent a lengthy and difficult development but remains the only one of these projects to be successfully completed. The central space created by the stepped apartments was filled by a public swimming pool.

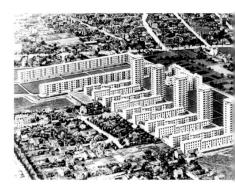

The garden city or *cité-jardin* (a concept first advocated in the late 19th century) became a central tenet of town planning between the wars. Some fifteen garden cities were created under the direction of Henri Sellier, Socialist mayor of Suresnes, with advice from Louis Bonnier and the collaboration of a number of prize-winning architects who had submitted projects to a major 1913 competition to design HBMs for Paris. One of the most successful was Suresnes, where the architects Alexandre Maistrasse, Julien Quoniam, Félix Dumail and Louis Bazin created a mixture of public and private housing. In Plessis-Robinson, on the southern outskirts of Paris, Maurice Payret-Dortail, Jean Demay and Jean Festoc drew up plans that made provision for a mixture of individual houses and blocks of flats, and Joseph Bassompierre-Sewrin, Paul de Rutte, Paul Sirvin and André Arfvidson scattered a number of small apartment blocks, in simple but varied styles, over the wide green spaces of the Cité de la Butte-Rouge, in Châtenay-Malabry. Unlike the British garden-city prototype, collective housing replaced individual homes completely, and none of the plans for satellite towns ever saw the light of day. Prefiguring the tower blocks that characterized the post-war years in France, two new building programmes marked a break with the contemporary approach to social housing: Eugène Beaudoin and Marcel Lods's plans for the Cité du Champ-des-Oiseaux, in Bagneux, and the Cité de La Muette, in Drancy, introduced the phenomena of standardization and industrial prefabrication, with some buildings fifteen storeys tall.

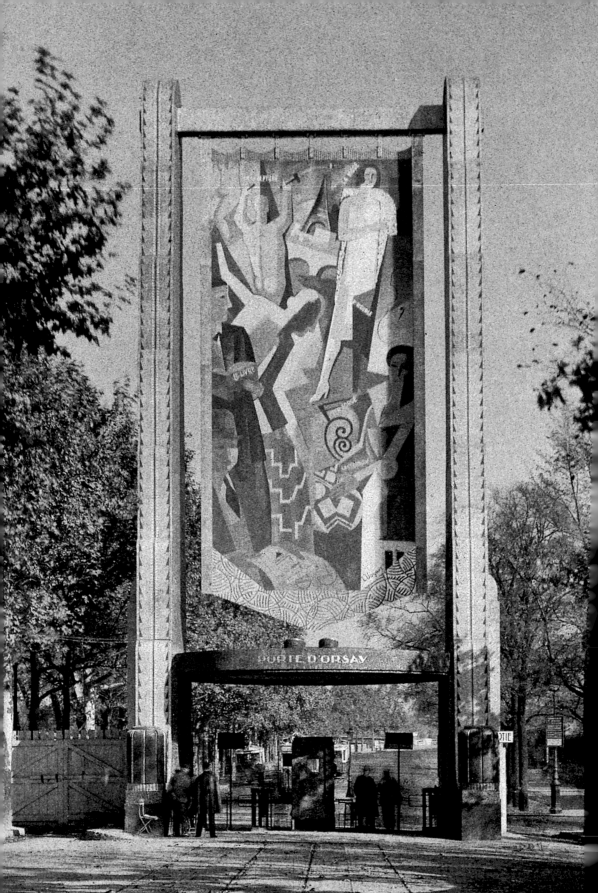

THE DECORATIVE ARTS

Vincent Bouvet

COMPETING TRENDS

After the upheavals of the Great War, comfort, hygiene and functionality became the important elements of interior design, outweighing formal considerations. Rooms were smaller, decoration simplified to the point of austerity, lighting modified and furnishings reduced to their most basic forms. However, this minimalist approach ran contrary to many people's desire to return to the lavish styles of the past, treating the conflict as if it had been no more than a temporary interlude.

This tension was illustrated at the 1925 Exposition des Arts Décoratifs Modernes, in which interiors were a key feature. The *coloristes*, most notably Louis Süe and André Mare, Henri Rapin, André Groult and Jacques Émile Ruhlmann, favoured a luxurious style in the great French tradition of craftsmanship, while the *ingénieurs constructeurs*, who included Robert Mallet-Stevens, Francis Jourdain and Djo-Bourgeois, were creating a stripped-down style of furniture that was designed to be an integral part of a particular room.

There were three large pavilions at the 1925 exhibition which encapsulated this opposition between the *contemporains* and the *modernes*. The Collector's Pavilion was built by the architect Pierre Patout for the interior designer and cabinetmaker Jacques Émile Ruhlmann, with the

Opposite:
Louis-Hippolyte Boileau and Louis Voguet, the Porte d'Orsay, Exposition des Arts Décoratifs, 1925. Autochrome. Musée Départemental Albert-Kahn, Boulogne-Billancourt.

Below:
The 1925 Exposition des Arts Décoratifs. On the right, the pavilion of the department store À la Place de Clichy; in the background, the Bon Marché pavilion. Autochrome. Musée Départemental Albert-Kahn, Boulogne-Billancourt.

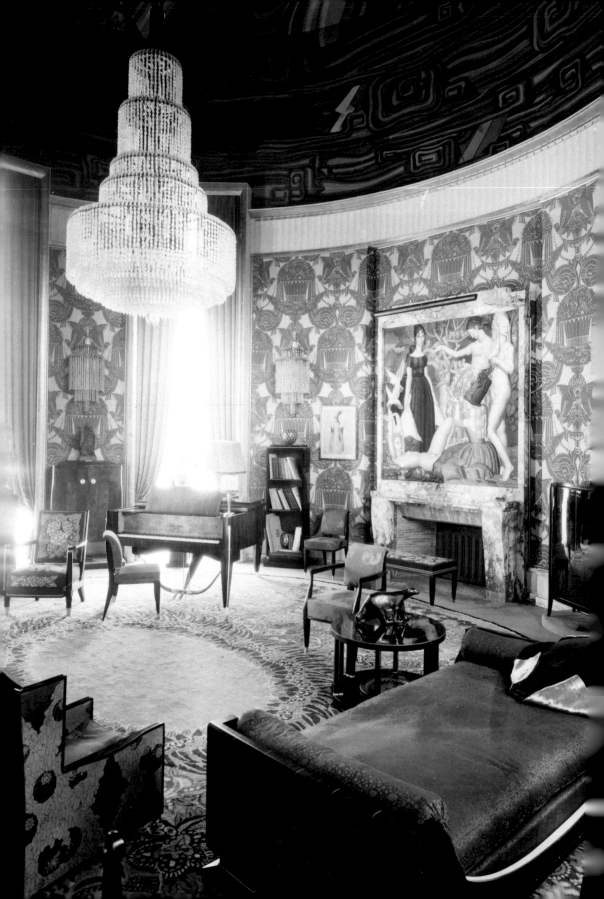

Above:
Jean Dupas, *The Parakeets.*
Oil on canvas, 200 × 200 cm (78 ¾ × 78 ¾ in.).
Painting exhibited in the salon of the Collector's Pavilion,
designed by Pierre Patout and Jacques Émile Ruhlmann.
1925 Exposition des Arts Décoratifs.

Opposite:
Jacques Émile Ruhlmann,
salon of the Collector's Pavilion,
1925 Exposition des Arts Décoratifs.

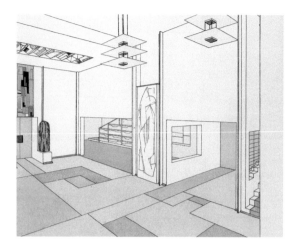

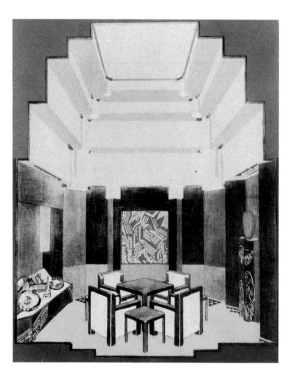

Above left:
Robert Mallet-Stevens,
the hallway of the
Ambassade Française
pavilion, 1925 Exposition
des Arts Décoratifs.
Watercolour.

Below left:
Jean Dunand,
the smoking room of the
Ambassade Française
pavilion, 1925 Exposition
des Arts Décoratifs.
Watercolour.

Right:
Pierre Chareau,
the study and library of
the Ambassade Française
pavilion, 1925 Exposition
des Arts Décoratifs.
Watercolour.

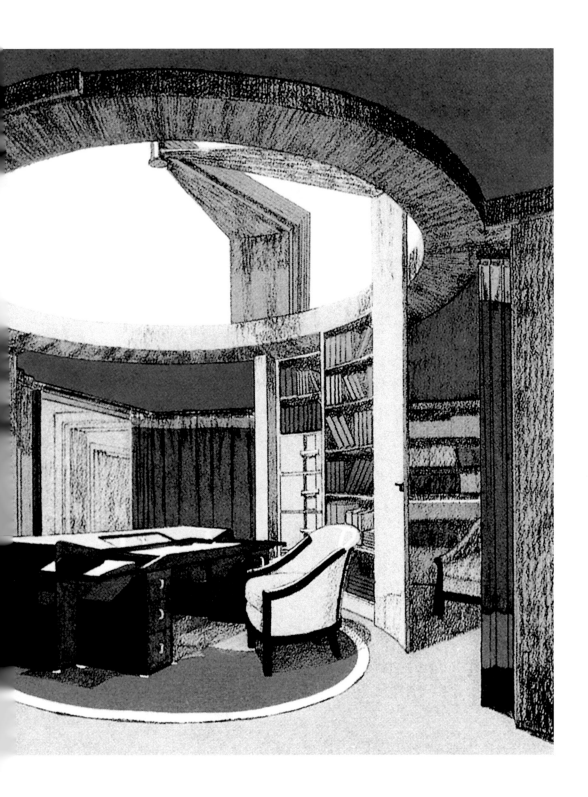

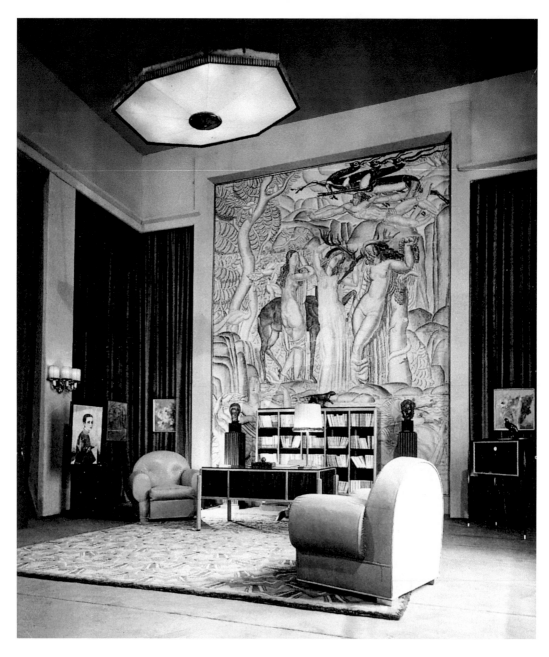

assistance of the sculptors Joseph Bernard and Alfred Auguste Janniot, the metalworker Edgar William Brandt and the painter Henri Marret. This was the pavilion that attracted the most visitors: it was the quintessential expression of the luxury arts and exquisite craftsmanship. The second was the prestigious Ambassade Française à l'Étranger, which was sponsored by the French government and brought together leading Paris designers and artists under the auspices of the Société des Artistes Décorateurs (SAD). Designed by the architects Henri Rapin and Pierre

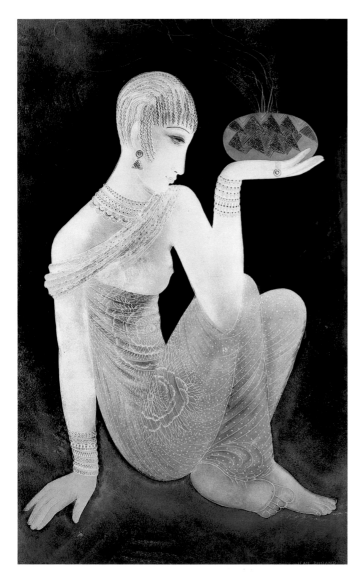

Above:
Jean Dunand, *Portrait of Madame Agnès*.
Polychrome lacquer in red, ivory,
black, gold, silver, and eggshell,
82 × 51 cm (32 ¼ × 20 ⅛ in.).
Exhibited in the 'Reception Room of a
Collector' by Jacques Émile Ruhlmann,
Salon des Artistes Décorateurs, 1926.

Left:
Jean Dunand, *The Offering*.
Polychrome lacquer.
Screen designed for the home of Jean-
Charles Worth in Neuilly-sur-Seine.
Private collection.

Opposite:
Jacques Émile Ruhlmann,
in collaboration with Alfred Porteneuve,
'Reception Room of a Collector';
decorative screen by Alfred Janniot,
sculptures by Joseph Bernard and
François Pompon. Salon des Artistes
Décorateurs, 1926.

Selmersheim, who divided the building into two wings, with twenty-
four rooms in total, the Ambassade represented any and every artistic
trend, the sole criterion being one of artistic excellence. Robert Mallet-
Stevens designed the hallway, Francis Jourdain the smoking room and
gymnasium and Pierre Chareau the study-cum-library – in celebration
of the *moderne* style – while the *contemporains* made their mark through
Michel Roux-Spitz, who designed the art gallery, Paul Follot, who
designed the anteroom (in collaboration with the Au Bon Marché
department store's Pomone studio, of which Follot was artistic direc-
tor), and Georges Chevalier, Léon Jallot, Ruhlmann, Jules Leleu and
Maurice Dufrêne, who were responsible for the private apartments.
Three moored barges, *Délices*, *Amours* and *Orgues*, provided the setting for

the creations of Paul Poirot's Atelier Martine, and housed an exhibition room, a restaurant and a cabaret.

In total contrast to this cavalcade of expensive materials and decorative motifs, Le Corbusier's Esprit Nouveau Pavilion – named after the journal that the architect co-founded with Pierre Jeanneret – was a declaration of allegiance to modernity in its most committed form, and its unsparing austerity was the cause of much heated debate. Le Corbusier's villa with its hanging garden was intended to 'demonstrate the radical transformations and the new freedoms that reinforced concrete and steel bring to the concept of the urban dwelling'. The design of the interior was governed by functional rather than decorative needs and contained 'equipment' rather than 'furniture', all made from standardized elements.

INTERIORS

When Jean-Michel Frank furnished the apartments belonging to art patrons Charles and Marie-Laure de Noailles in 1927, the results caused a sensation and launched the interior designer's career. The salon of the Hôtel de Noailles had walls tiled with vellum and white leather seating. In the boudoir, straw marquetry covered the walls, screen, table and small double-fronted cupboards; low tables were topped with shagreen, and crystal and ivory lamps cast their soft light over this minimalist and costly décor. Frank's trademark was 'austere luxury', his credo pure

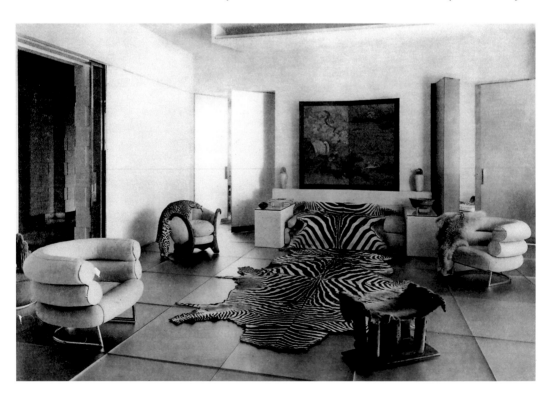

forms and noble materials. In 1930, he was appointed artistic director of Chanaux & Cie, Paris's premier cabinetmaker, and he continued to design interiors for a fashionable clientele both at home and abroad.

Pierre Chareau, another giant of modernist design, built and furnished the house known as the Maison de Verre (House of Glass) or the Maison Dalsace, after its owner (see overleaf). This project lasted from 1928 to 1930 and offered him the ideal opportunity for experimenting with new ideas. He designed every last detail, incorporating new industrial materials and stripping down the living space, turning light into a feature in its own right. Paul Dupré-Lafon, Gabriel Guévrékian and Pierre Petit also designed complete interiors for wealthy clients who were attracted by the modernist approach but demanded traditional materials and time-honoured craftsmanship.

MATERIALS

Because of its lightness, solidity, ease of maintenance and suitability for mass production, metal was an increasingly popular material with designers. Steel was the basis of the exhibits shown at the 1928 Salon des Artistes Décorateurs by three young avant-garde designers: Charlotte Perriand, René Herbst and Georges Djo-Bourgeois. In 1929, Mallet-Stevens, Chareau, Jourdain and Le Corbusier wanted to mount a group exhibition with them, but their refusal to meet the SAD's requirements provoked a schism. The dissidents formed a new collective, the Union des Artistes Modernes (UAM), with Mallet-Stevens as its president. Its credo was the creation of a 'social art', accessible to all and adapted to suit contemporary life. The UAM claimed affiliation with the Dutch movement De Stijl, which viewed all art forms as part of a single unified whole, and also with the German Bauhaus movement, with its multidisciplinary approach, cooperative working methods and functional creations. The UAM brought together leading designers of metal furniture like Louis Sognot and Jean Burkhalter. In around 1930, René Herbst created several designs for chairs with seats and backs made from tautly stretched elastic ropes (see p. 122). In 1928, Le Corbusier and Charlotte Perriand designed their famous adjustable chaise longue, in chrome-plated steel with black-painted metal legs (see overleaf), which was manufactured by Thonet, a famous firm of cabinetmakers. Jean Prouvé, meanwhile, developed a method for cold-rolling sheet steel or aluminium.

Wrought ironwork also came back into favour with both architects and interior designers. In 1919, Edgar William Brandt opened a workshop within his ironwork and armaments business and employed around thirty designers to produce decorative furnishings with stylized and geometric designs, which were made from bronze, steel or aluminium then hammered, gilded or plated as required. These were exquisitely produced pieces and Brandt went on to collaborate with the

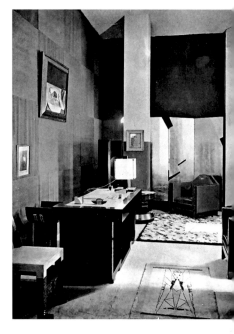

Above:
Pierre Legrain, office for the couturier Jacques Doucet, 1924.

Opposite:
Eileen Gray, salon in the apartment of the fashion designer Suzanne Talbot, 1929.

Overleaf:
Pierre Chareau and Bernard Bijvoet, the home of Dr Dalsace, known as the Maison de Verre, rue Saint-Guillaume (7th arr.), 1928–30.

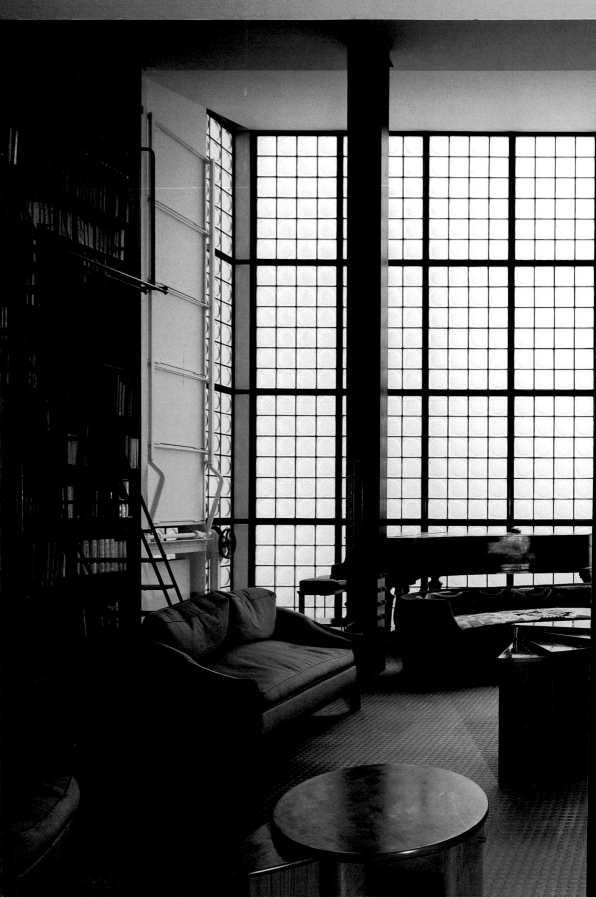

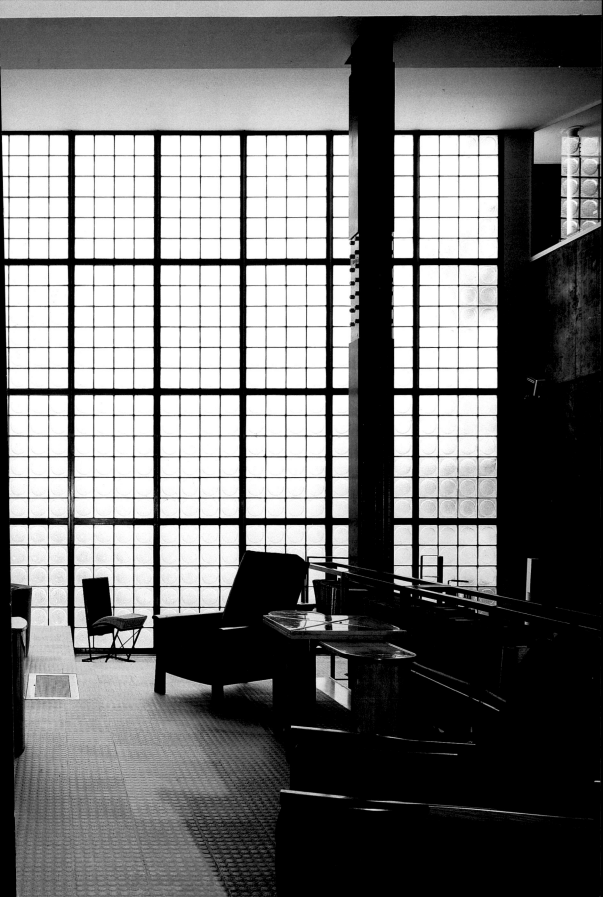

Right, above:
Charlotte Perriand,
dining room with extendable
table and swivel chairs covered
in coral-coloured leather.
Salon des Artistes Décorateurs,
1928.

Right, centre:
René Herbst, smoking room
with furniture in nickel-plated
steel. Salon des Artistes
Décorateurs, 1928.

Right, below:
Charlotte Perriand,
Le Corbusier and Pierre
Jeanneret, the 'LC 4' chaise
longue in chrome-plated steel
and leather, 1928.

Opposite:
Eugène Printz, dressing table
exhibited in the 'Lady's
Bedroom', Salon des Artistes
Décorateurs, 1930.

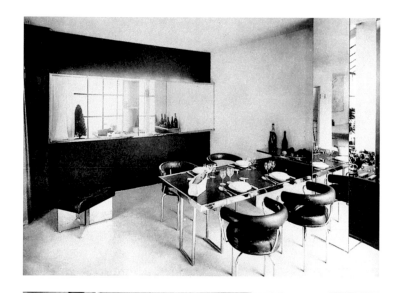

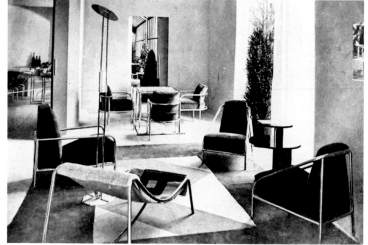

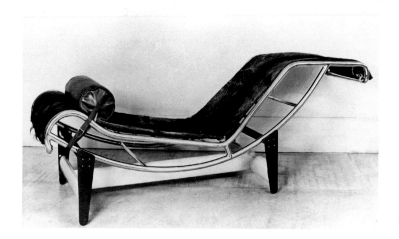

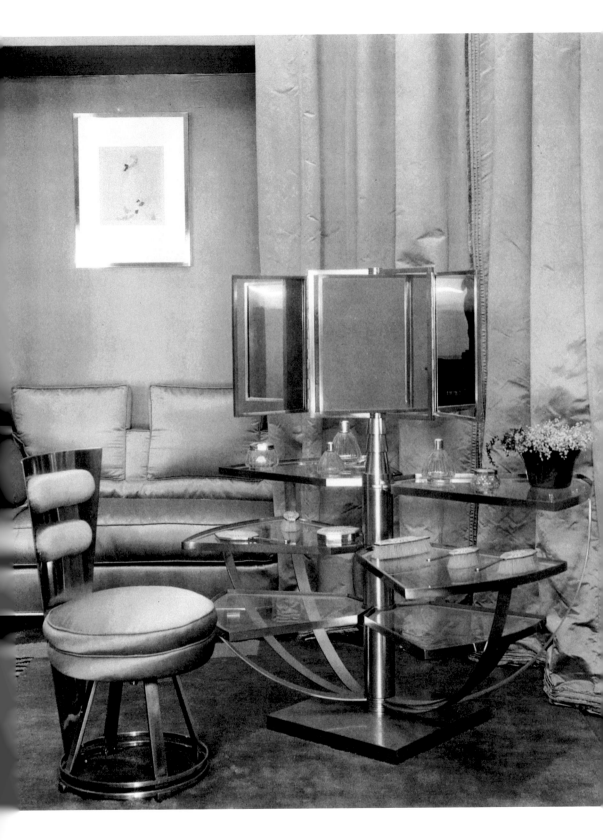

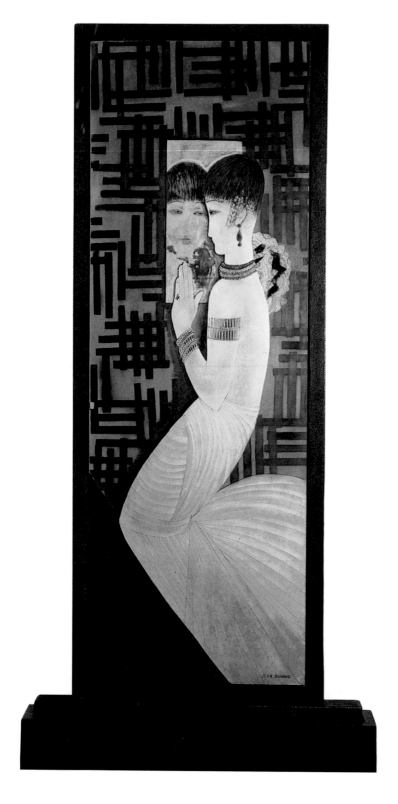

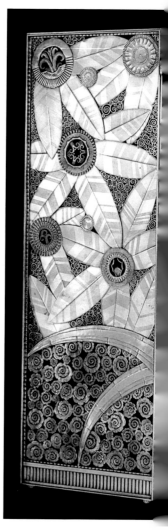

Left:
Jean Dunand, mirror with
lacquered door and frame.
Private collection.

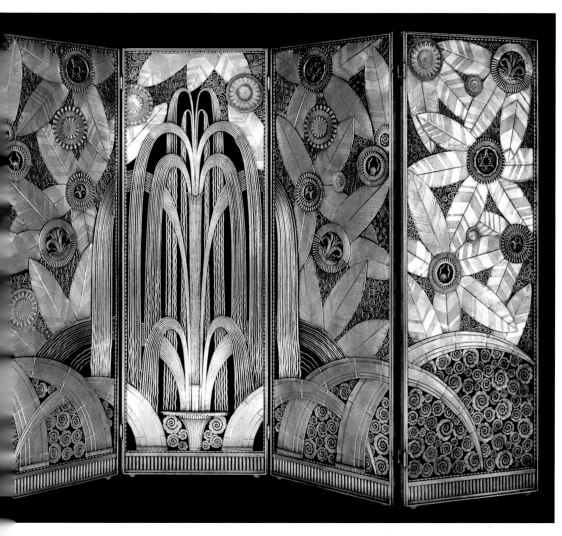

Above:
Edgar William Brandt and
Henri Favier, *Oasis* screen, 1924.
Wrought iron and brass,
180.5 × 266.5 cm (71 × 105 in.).
Private collection.

Cristallerie Daum and the Manufacture Nationale de Porcelaine de Sèvres, working with artists like Jean Dunand and Max Blondat. His works were widely represented at the 1925 exhibition, but his masterpiece there, displayed in the Collector's Pavilion, was his *Oasis* five-panel screen in wrought iron and brass, with a blue and gold patina, representing a fountain and flowers (see p. 121). Raymond Subes was another renowned metalworker, who produced a great many decorative pieces for hotels and restaurants, banks and offices, and also transatlantic liners (see p. 132). Another was Gilbert Poillerat, who opened a design workshop within a construction and metalwork company in 1927 and rapidly made a name for himself with the distinctive arabesques of his grilles, tables, consoles, lamps and fire-irons in matt or polished iron. Poillerat worked with interior designers like Jacques Adnet, André Arbus and Jean Pascaud, for whom he made bronze accessories and metal furniture. And in the early 1920s Armand Albert Rateau created a large and luxurious collection of furniture in patinated, gilded and chased bronze for the couturière Jeanne Lanvin, often featuring animal and bird motifs.

During the 1930s, the other material that played a central role in interior decoration and furniture manufacture was glass. The *contempo-*

rains particularly favoured engraved glass – gold and silver leaf applied to the polished base of mirror glass enhanced the effect of the etched motifs – and blocks of moulded and etched glass which reflected the light in such a way as to create an illusion of depth. Paule and Max Ingrand produced some beautiful works of this type, as did Jean Dupas. The modernists regarded glass as an economical material that lent itself to a variety of different treatments: in their hands, it could be transparent, matt, coloured, etched or moulded.

Jean Dunand trained as a coppersmith and learned the technique of lacquering from a Japanese master, adapting it to Western tastes using inlays of metal, mother of pearl, ivory and eggshell, enhanced with flat areas of colour. The general popularity of lacquer was such that when, in the early 1930s, Dunand was commissioned to make four large gold-lacquered panels for the first-class smoking room on the liner *Normandie*, his Paris workshops were already employing as many as a hundred craftsmen working on metal, wood and lacquer. Other lacquer artists included Pierre Bobot, who specialized in producing large panels and screens with panoramic views of Paris, and Louis Midavaine, who used cellulose lacquers to produce his predominantly zoological motifs.

Due to the financial difficulties imposed by the Depression, lifestyles became simpler and cheaper materials tended to be used to produce goods for the general public. These were natural materials like light woods, such as sycamore and ash, wicker, leather and string, as well

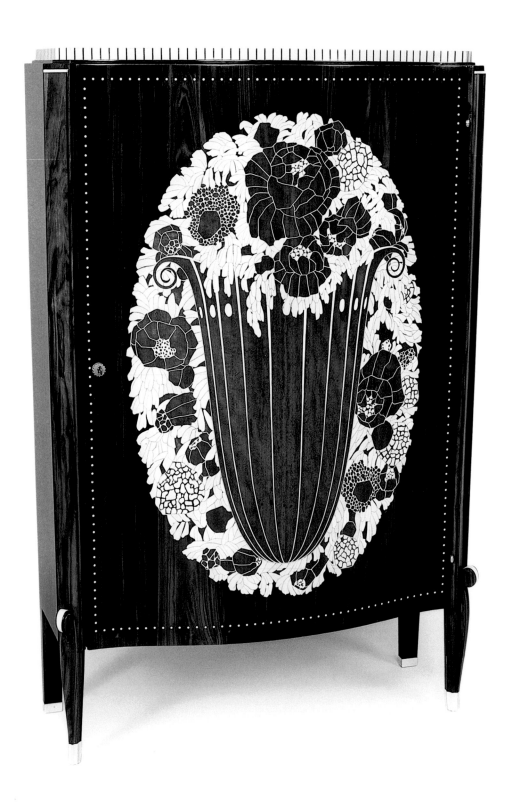

Opposite:
Jacques Émile Ruhlmann, corner cabinet, *c.* 1922.
Ebony and ivory, 120×82×32 cm (47 ¼×32 ¼×
12 ⅝ in.). Mobilier National Collections.

Right:
Jean Dunand, vase, 1937.
Hammered and lacquered copper, 50×40 cm
(19 ⅝×15 ¾ in.). Mobilier National Collections.

Below:
Émile Guillot, desk and chair, 1930
(with lamp by Édouard Wilfried Buquet).
Wood, glass, mahogany veneer and chrome.
Desk: 109×106×60 cm (42 ⅞×41 ¾×23 ⅝ in.);
chair: 80.5×50×55 cm (31 ¾×19 ⅝×21 ⅝ in.).
Produced by Thonet. Musée des Beaux-Arts, Reims.

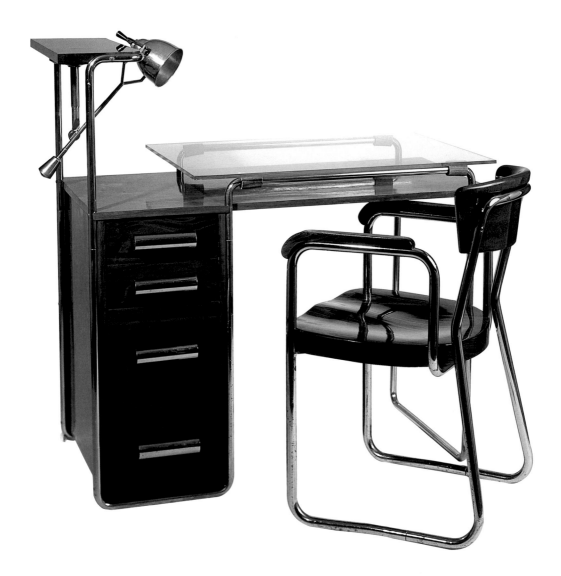

Right:
Maurice Dufrêne, living room, c. 1930.
From *Ensembles nouveaux*,
Éditions Charles Moreau.

Opposite, above:
Paul Follot, dining room, 1926.
Produced by Pomone (Bon Marché).

Opposite, below:
Charlotte Chauchet-Guilleré,
bedroom, 1922.
Rosewood and marquetry.
Produced by Primavera (Au Printemps).

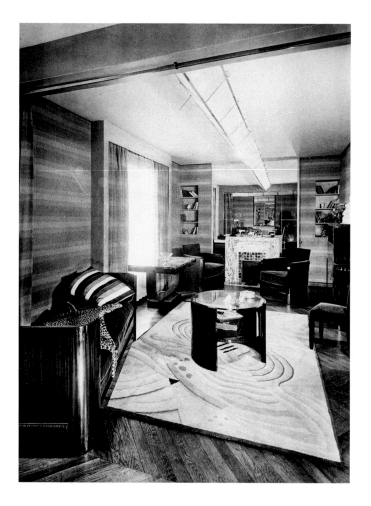

as percale and glazed chintz. Charlotte Perriand herself used pine for a collection of rustic-look tables and desks.

Shops and Department Stores

The shops and department stores of Paris offered a selection of beautiful modern goods designed with a demanding clientele in mind. Georges Rouard, who was later appointed president of the Chambre Syndicale de la Céramique et de la Verrerie, opened a prestigious store in 1913 that sold silverware by Jean Dunand and Jean Puiforcat, glassware by Henri Navarre and ceramics by Marcel Goupy. The Maison Georges Rouard displayed the creations of the Groupe des Artisans Français Contemporains, which included leading ceramicists and glass artists including François-Émile Décorchemont, René Buthaud and Jean Mayodon. On the Champs-Élysées, large stores such as Desnys and the Palais de Marbre offered a wide range of furniture and decorative objects in a modern style. A number of designers sold their own work and the work of friends directly through their own shops, including

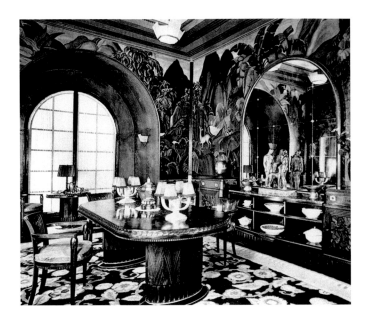

Eileen Gray (Galerie Jean Désert), Pierre Chareau (La Boutique), André Arbus (L'Époque) and Francis Jourdain (Chez Francis). The shops selling furniture and decorative goods in the Saint-Antoine district, including Gouffé, Mercier Frères, Rémon and Nelson, attracted a wealthy clientele equally drawn to the classical style and to a restrained

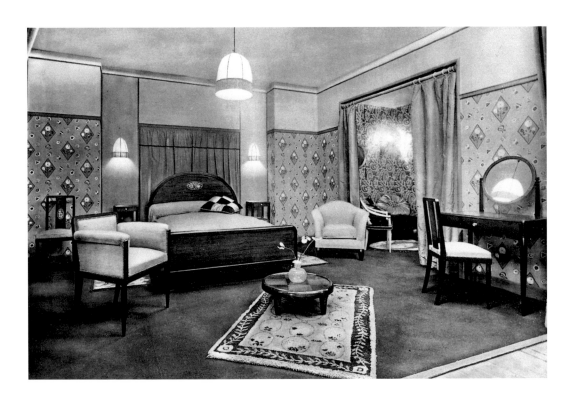

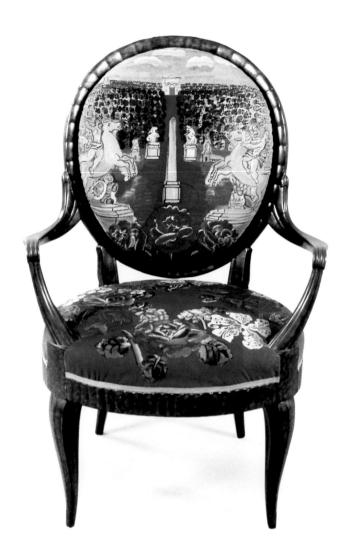

form of modernism. Maison Jansen, which opened in around 1880, employed up to seven hundred craftsmen in its workshops, and its artistic director, Eugène Boudin, created his own inimitable style from an improbable mix of 18th-century French elegance, Hollywood theatricality and the timeless charm of country houses.

The Paris department stores succeeded in creating a link between art, the media, commerce and industry, and so contributed to the spread of modernist trends in the decorative arts. They sold a whole variety of objects that were designed in their own workshops or specially commissioned from freelance designers, in an attempt to offer reasonably affordable versions of the works of the great designers. The choice was between the fairly classicist goods available from Pomone (Au Bon Marché) and the strictly modernist Studium (Grands Magasins du Louvre), with the styles adopted by La Maîtrise (Galeries Lafayette)

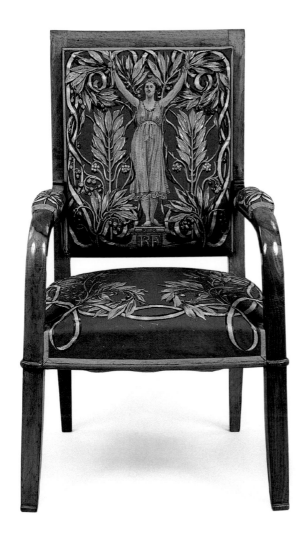

Opposite:
Raoul Dufy (design),
the Manufacture de Beauvais (tapestry)
and André Groult (woodwork),
The Champs-Élysées, 1924–33.
Large chair, part of a set of *Paris* furniture.
Lacquered beech and tapestry,
107 × 60 × 58 cm (42 ⅛ × 23 ⅝ × 22 ⅞ in.).
Mobilier National Collections.

Left:
Adrien Karbowsky (design),
the Manufacture de Beauvais (tapestry)
and René Prou (woodwork),
The Republic, 1929–36.
Part of a set of twelve chairs.
Walnut and tapestry,
110 × 64 × 60 cm (43 ¼ × 25 ¼ × 23 ⅝ in.).
Mobilier National Collections.

Overleaf:
The Paul Reynaud Room at the Musée
des Colonies (now the Cité Nationale
de l'Histoire de l'Immigration).
Fresco by Louis Bouquet and furnishings
by Jacques Émile Ruhlmann, 1931.

and Primavera (Au Printemps) offering a compromise between the two
opposing trends.

PUBLIC BUILDINGS
Public commissions have always played an important role in France's
artistic development and under the Radical Socialists the preference was
for traditional ceremonial buildings that recalled the monarchy and its
palaces, rather than modern experimentation. The Ambassade Française
pavilion designed for the 1925 exhibition brilliantly encapsulated this
aspiration, but due to the uncertainties of the time, few projects were
ever finished. The Musée des Colonies, built for the Exposition Colo-
niale in 1931, incorporated two oval salons: the Salon Paul Reynaud
(overleaf), decorated with murals depicting African scenes and furnished
by Ruhlmann in macassar ebony, chrome-plated metal and shagreen, and

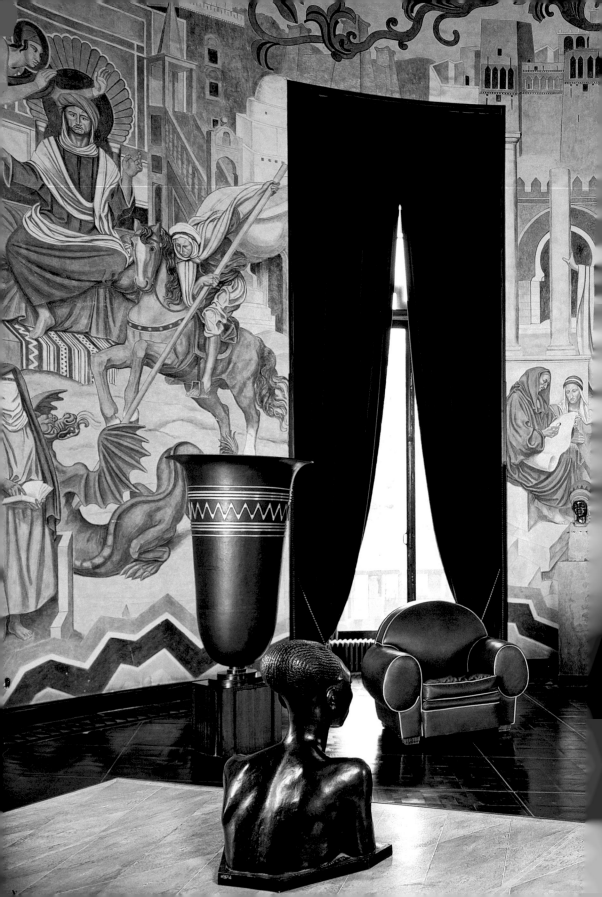

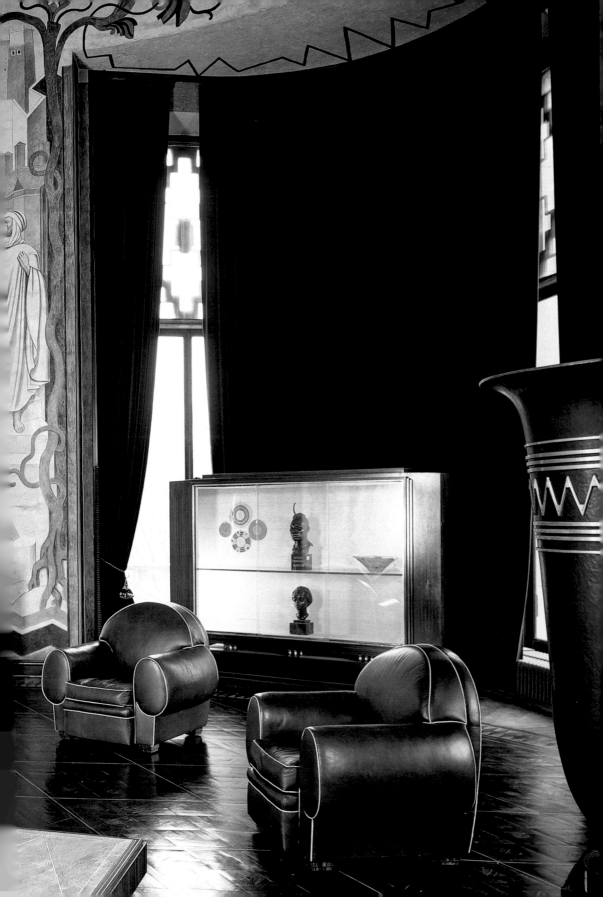

an Asian Salon, imaginatively furnished by Eugène Printz in palmwood veneer and gilded metal. At the end of the 1930s, Jules Leleu, Eugène Printz, René Prou and Léon Jallot collaborated on a design for the office of the Minister of Post and Telecommunications, using a modern style with a few 18th-century touches.

Under the auspices of Jean Ajalbert, director of the Manufacture Nationale de Beauvais, modern tapestries were produced to adorn government ministries and embassies. Artist-decorators such as Adrien Karbowsky, Émile Gaudissard, René Piot, Louis Valtat, Paul Véra and Raoul Dufy (see p. 137) created the tapestry cartoons, which were adorned with distinctly French motifs such as the monuments of Paris or flora and fauna from France's colonial empire.

During the 1930s, the French state compensated for the paucity of private commissions by subsidizing the construction and decoration of transatlantic liners belonging to the Compagnie Générale Transatlantique (CGT). The *Normandie*, which made its maiden voyage in 1935, henceforth became an ambassador carrying French style across the North Atlantic. Working with a team of engineers, the architects Henri Pacon and Henri Roger Expert, created a number of sumptuous interiors for the ship, which showcased the collaborative efforts of many of Paris's artists and design houses.

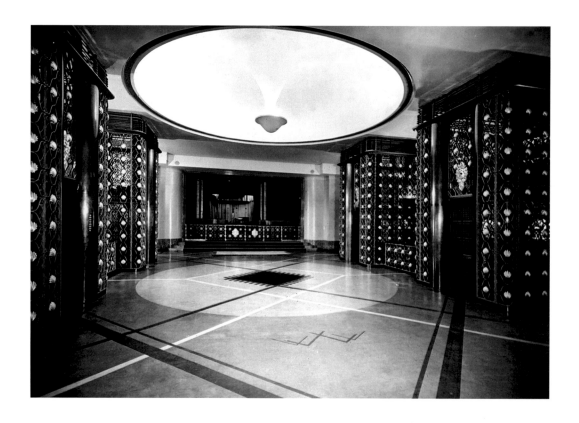

Textiles, Carpets and Wallpapers

In the 1920s, the silk manufacturers of Lyon dominated the global market. While most Lyon silk was destined for the clothing industry, and for haute couture in particular, it was also turned into wall hangings, seat covers and furnishing fabrics for the major Paris design houses. Collaborations with some of the leading artists of the day – Bianchini-Férier, for example, called upon the services of Raoul Dufy and Sonia Delaunay – resulted in designs whose innovation was unrivalled. The Maison Rodier, which had formerly produced woollen clothing fabric, now extended its production to furnishing fabrics whose motifs and colours, supplied by artists such as Picasso, harmonized with modernist interiors. Élise Djo-Bourgeois (Élise George) teamed up with her husband Georges, designing fabrics with geometric motifs for his pared-down interiors. The weaver Hélène Henry, a founder member of the Union des Artistes Modernes (UAM), worked closely with design houses and architects, including traditionalists like Ruhlmann and Dupré-Lafon, and modernists such as Francis Jourdain, Pierre Chareau and Robert Mallet-Stevens.

In a more modest field, Paule Marrot brought fresh impetus to the realm of printed textiles, creating harmonious patterns of birds and flower garlands, with motifs and colour schemes to suit every type of

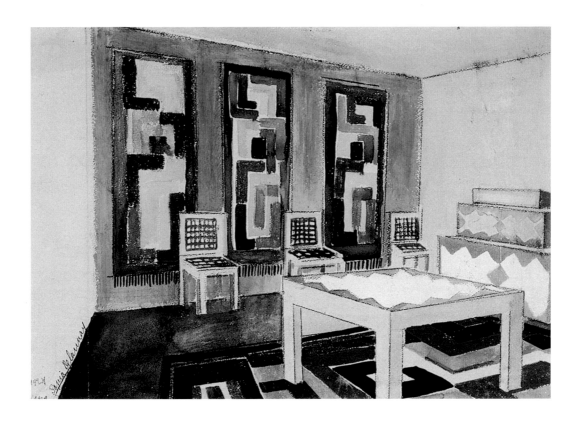

contemporary interior. In 1928, Adolphe Allard founded the Société Nobilis and opened a shop not far from the École des Beaux-Arts. He commissioned designs from a number of contemporary artists – the best known being Suzanne Fontan – for his wallpaper and furnishing fabric collections.

Carpet design also began to reflect the modern style. In 1919, the Brazilian-born artist Ivan da Silva Bruhns began designing carpets inspired by Berber rugs from Morocco, using natural dyes and geometric motifs that gave them a restrained elegance. His *tapis-tableaux*, or 'picture-carpets', were very popular and he started working with top interior designers like Ruhlmann and Jules Leleu and opened his own shop near the Odéon. Jane Lévy also designed carpets with geometric motifs, in bold colours; Voldemar Boberman and Otto Eckmann collaborated with Maison D.I.M. and Gustave Miklos designed irregularly-shaped fringed rugs with abstract motifs for the couturier and collector Jacques Doucet. The big Paris stores popularized the fashion for modern carpets: À la Place de Clichy, for example, produced rugs from stylized flower designs by Édouard Bénédictus and Émile Gaudissard and Cubist-inspired geometric designs by Francis Jourdain.

Marie Cuttoli tapped a new vein of inspiration by promoting the concept of the 'art rug'. These rugs were enlarged reproductions of

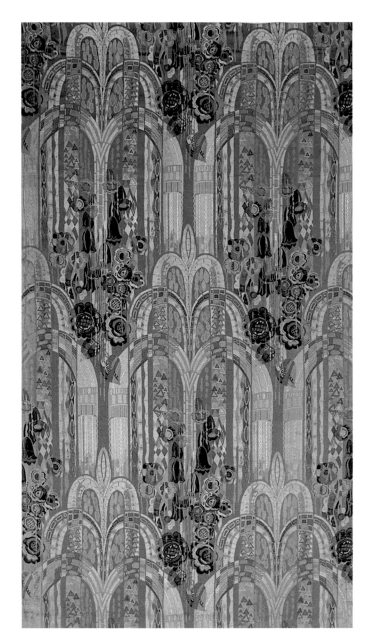

existing paintings or, in some cases, of works specially commissioned by Cuttoli from artists such as Picasso, Fernand Léger, Jean Arp, Joan Miró, Giorgio De Chirico, Louis Marcoussis and Natalia Goncharova. The rugs were woven in Algeria and displayed in Cuttoli's shop, the Galerie Myrbor, which André Lurçat designed for her. Cuttoli also commissioned her friends Raoul Dufy, Georges Rouault and André Derain to design tapestries, which were woven at the Aubusson or Gobelins workshops. In the mid-1930s, she teamed up with the Galerie Jeanne Bucher, which was a showcase for great names in modern art.

Below:
Louis Billotey, *The Riders' Departure.*
Preparatory design for a tapestry
commissioned in 1933 by the Manufacture
des Gobelins and exhibited at the
1937 Exposition Internationale.
Oil on canvas, 233×376 cm (91¾×148 in.).
Mobilier National Collections.

Opposite:
Raoul Dufy, *Paris*, 1934.
Commissioned by Marie Cuttoli.
Aubusson tapestry; wool,
191×161 cm (75¼×63⅜ in.).
Musée National d'Art Moderne,
Centre Georges Pompidou, Paris.

The 'return to order' of the 1930s was accompanied by a certain neoclassical sobriety. The carpets designed by the likes of Louis Süe, André Arbus and Paule Leleu were flatweaves or pile rugs with a pattern drawn on a plain ground and a modest colour palette. Ernest Boiceau, who owned a shop where he sold his own creations, was a specialist in designing rugs in what was known as Cornély stitch.

Artists who designed tapestry cartoons and textile prints also received commissions from upmarket wallpaper manufacturers. The motifs designed by Adrien Garcelon, Henri Stéphany and Édouard Bénédictus were particularly popular. Between 1920 and 1928, René Gabriel blockprinted his own wallpapers at his Au Sansonnet printing works, while the Maison Leroy's factories just outside Paris were among the most modern in Europe and catered for a wider public using roller-printing and later photogravure. Its catalogue featured most of the colours and decorative styles that were popular at the time, with particular emphasis on floral motifs and geometric designs.

Between 1911 and 1929, the innovative design house founded by couturier Paul Poiret, the Atelier Martine, produced a whole series of textiles, rugs and wallpapers that were distinguished by their naturalistic, even naive, motifs and use of strong colours. The motifs were created by young female designers from working-class backgrounds with no formal artistic training. It was from their imaginations that the Atelier Martine's distinctive style was born, a cross between folk art and children's drawings. The Compagnie des Arts Français, the Maison

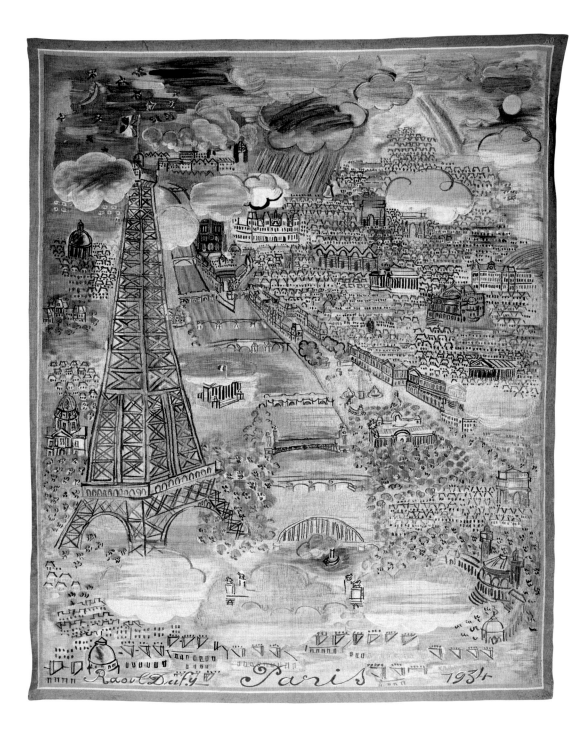

Ruhlmann and the big Paris stores all had in-house studios that could design every detail of an interior, while freelance interior designers like André Groult also relied on the collaboration of other artists — in his case, Marie Laurencin and Jean Émile Laboureur.

Jewelry and Silverware

Most of Paris's major jewelry houses opened in the 19th century and were located in the place de l'Opéra, the rue de la Paix or the place Vendôme. In 1930, 75 per cent of France's goldsmiths, 83 per cent of its silversmiths and 96 per cent of its jewelers were located in Paris. But the financial crisis of 1929 was devastating for the luxury goods industry, which exported most of its products; jewelry was particularly badly affected, being forced to reduce its workforce by ninety per cent in the period between 1932 and 1934.

Silverware between the wars followed the dominant artistic trends, gradually moving away from the geometric forms inspired by Cubism (with or without ornamental additions) towards curving lines and completely smooth surfaces. Three major exhibitions reflected this stylistic evolution, in which restrained decoration emphasized the form and function of the object. Despite this apparent simplicity, most finished designs were the result of careful mathematical calculations. At the 1925 Exposition des Arts Décoratifs, the major Paris silver firms (Boin-Taburet, Cardeilhac, Fouquet-Lapar, Lappara, Ravinet d'Enfer and Tétard) showed their latest creations under the same roof. In a separate pavilion, shared with Baccarat Crystal, Christofle — the firm that developed the electroplating technique in the mid-19th century — showed a collection of very varied pieces, ranging from ornate creations by André

Groult, Louis Süe and André Mare to Christian Fjerdingstad's pure geometric forms. In 1930, Henri Clouzot, curator of the Musée Galliera, who was keenly involved in the latest decorative art trends, organized the 'Décor de la Table' exhibition, showing tableware by André Aucoc and Jean Tétard among others, all characterized by broad shapes and smooth, polished surfaces that sparkled under artificial light. At the 1937 exhibition, thirty firms showcased the best French silverware of the day and demonstrated that softer lines and rounded shapes had definitively ousted the strict geometric designs of the 1920s.

Just a handful of great artists dominated the world of jewelry and metalwork between the wars. First and foremost among these was Jean Puiforcat, who sought to highlight the intrinsic beauty of his materials through forms that included spheres, cones and cylinders. In his early career, Puiforcat combined precious and non-precious materials, marrying silver with ivory, lapis lazuli, jade, rosewood and macassar ebony; then, in the 1930s, he began combining silver and vermeil, using sycamore wood, and choosing cut crystal or alabaster for handles and

ornaments. Three of Puiforcat's contemporaries, Jean Després, Jean Dunand and Raymond Templier, adopted a more avant-garde approach. Després's dynamic forms were inspired by the mechanical world, while Dunand exploited the contrasts of his two favourite materials – the translucency of lacquer and the opacity of enamel – and Templier created small objects that used surprising combinations of silver, eggshell and lacquer.

In the 1920s, jewelry began to incorporate colour, in combination with simpler forms. Designers experimented by applying different treatments to the surface of the metal, inserting cut hardstones such as jade, malachite and onyx, and using semi-precious gems such as topaz, aquamarine, amethyst, citrine and tourmaline, along with enamel, mother-of-pearl and coral. Pearls were another favourite in the 1920s, worn either as long *sautoirs* or in multiple strings, and sometimes combined with other precious materials. The Jewelry Pavilion at the 1925 exhibition was hugely successful, and the French contingent – with thirty exhibitors, including Aucoc, Boucheron, Chaumet, Fouquet, Lacloche, Mauboussin, Templier and Van Cleef et Arpels – was the largest of all. These sumptuous pieces of jewelry – tiaras, earrings, necklaces, brooches, bracelets and rings – were all designed to make an immediate impact, in keeping with the fast-paced spirit of the times, in which life was a headlong rush and speed had become the watchword of modernity. From this point on, the major fashion houses and jewelry firms worked together on specific designs for each season's collection. A major exhibition held at the Musée Galliera in 1929 heralded the dominant theme of the jewelry of the 1930s: the *note blanche* or 'white note', characterized by a wealth of diamonds and rock crystals mounted on silver-grey platinum, together with the darker shades of jade, lacquer and enamel. Major jewelry houses now called more frequently upon the services of freelance designers, whose drawings were then technically

Above:
Boucheron, gold ring with rubies, amethysts and diamonds.

Below right and opposite:
Gouache jewelry designs for
Van Cleef et Arpels, 1930–36.

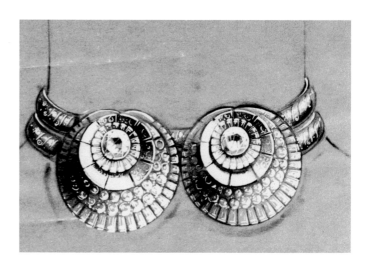

Above:
Gérard Sandoz, *Semaphore* brooch
in polished and matt platinum,
diamonds, coral and jet, 1925.
Private collection.

Below:
Jewelry from the first Chanel collection,
1930–32.

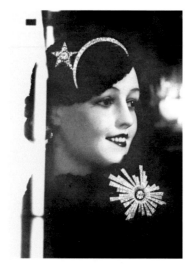

adapted by the workshop head. Some of these artists even came to define the style of a particular jewelry house, such as Louis Fertey for George Fouquet, Madeleine Chazel for Dusausoy, Suzanne Belperron for Boivin, and Charles Jacqueau and Jeanne Toussaint for Cartier.

The avant-garde also produced jewelry designs and often broke all the rules, for example by combining stainless steel and diamonds. For Jean Fouquet, Gérard Sandoz, Raymond Templier and Jean Després, who all came from families of jewelers and clockmakers, it was form rather than ornament that was crucial, and their work is characterized by rigorous construction coupled with a restrained use of colours and materials. As members of the UAM, these artists rejected traditional stylistic themes in favour of the pure beauty of mechanical forms, as exemplified by Charlotte Perriand's ball-bearing bracelet in chrome-plated steel, designed for Fouquet. Immediately before the Second World War, however, the return to a more decorative style can be seen in the work of Line Vautrin, who created a sensation with her jewelry and accessories in gilded bronze, to which she added all kinds of natural and man-made materials.

Decoration was inspired by China and Japan, India and Persia, or drawn from the modernist repertoire of stylized floral motifs or geometric and architectural shapes. In 1930, Van Cleef et Arpels invented the *Minaudière* case as a new style of evening bag, just large enough for all the paraphernalia that a fashionable woman needed to carry. The *Minaudière* was made of precious metal and had an ingenious jeweled clasp that could double up as a clip brooch. More traditional evening bags were made from woven and embroidered fabrics or in soft leather, with a whole range of jeweled clasps and decorations. A host of other objects such as desk accessories, photograph frames and small clocks were designed in gold, silver or vermeil, sometimes with gemstones for decoration; perhaps the most spectacular were the *pendules mystères* or 'mystery clocks' made by Cartier. Women's wristwatches became fashionable and could be simple or ornate, depending on whether they were intended for day or evening wear, but fob watches and brooch watches also continued to be popular.

Coco Chanel invented the concept of couture jewelry in the 1930s, designing transformable pieces in precious metals and gemstones; comets and stars were the theme of her first collection. Her collaboration with Fulco di Verdura was enormously fruitful and it was Verdura's designs for a whole range of items, including necklaces, bracelets, hat pins and brooches (using real gemstones for Chanel herself and imitation ones for the couture house), gold chains and pearl *sautoirs,* that set the Chanel style for jewelry.

Luxury was no longer the preserve of a social elite. The first cultured pearls had come on to the market in 1912, when Jo Goldman launched Maison Técla, and in 1929 Goldman's new enterprise, Maison

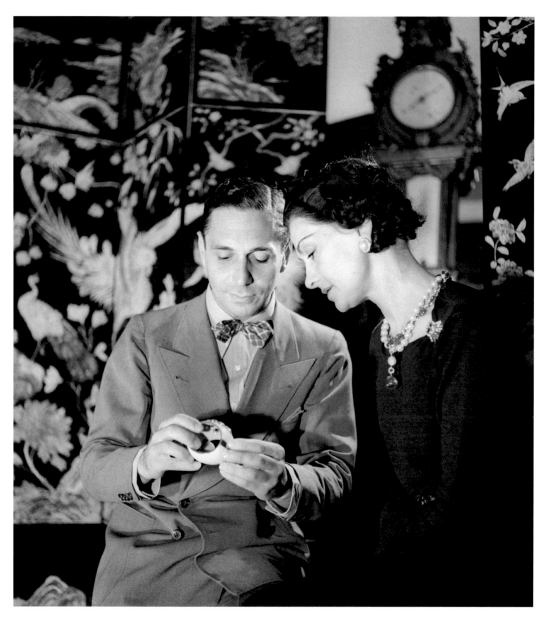

Above:
Coco Chanel with the Italian jeweler
Fulco di Verdura, 1937.

Right:
A selection of jewelry made by
the firm Paul Piel et Fils, 1931–34.
Photograph by François Kollar.
Bbibliothèque Forney, Paris.

Opposite:
André Lhote, *Seated Woman*, c. 1925.
Oil on canvas, 91.5×56 cm (36×22 in.).
Musée des Beaux-Arts, Nantes.

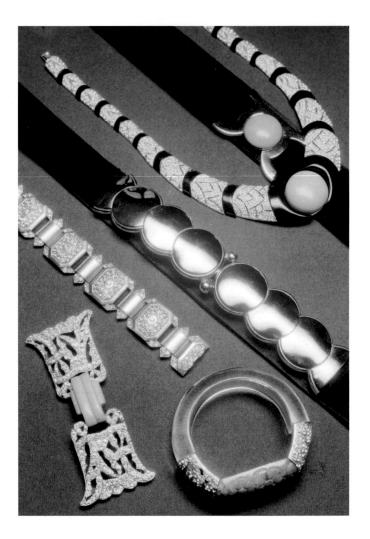

Burma, began selling imitation gemstone jewelry, made by skilled craftsmen in small quantities. Costume jewelry was initially limited to copying more valuable pieces – with varying success – but between the wars, original designs were created which were suitable for mass production. These used cheaper materials such as white metal, copper and beaten silver, diamanté, semi-precious stones and exotic woods. Synthetic materials such as Bakelite, Galalith and Rhodoid, along with imitation pearls, coloured glass and crystal, were turned into fashionable jewelry that was accessibly priced, a crucial factor during economic hard times. A great many workshops, particularly in the district of Le Marais, manufactured costume jewelry that was exported worldwide, and these pieces became known as *articles de Paris*.

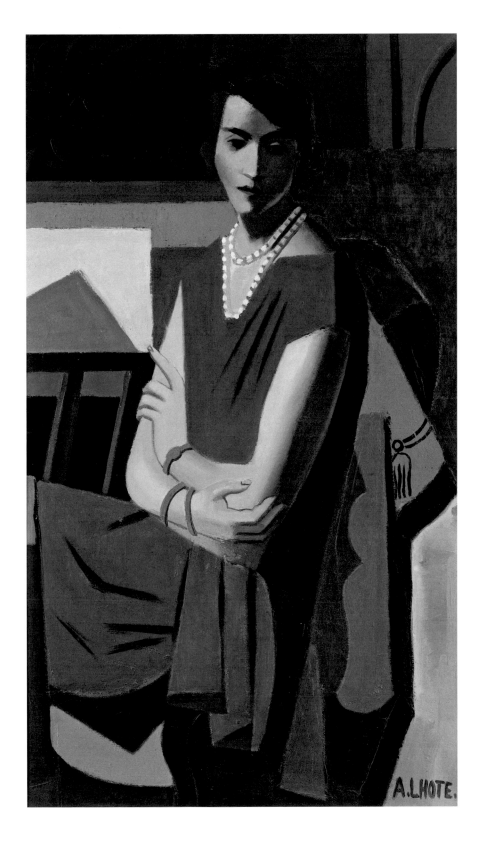

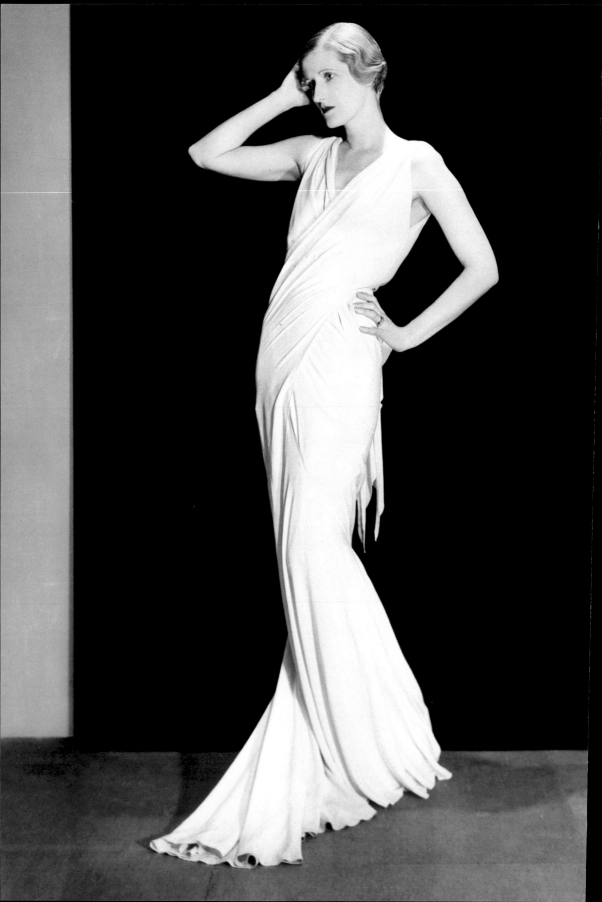

THE WORLD OF FASHION

Vincent Bouvet

A Golden Age for Haute Couture

After the Great War, several couture houses – such as those of Paul
Poiret and Jeanne Lanvin – quickly reopened, and new firms were
founded by designers such as Coco Chanel, Maggy Rouff, Jean Patou,
Edward Molyneux and Lucien Lelong. The fashion business played a
significant role in the French economy between the wars, with Parisian
haute couture representing as much as fifteen per cent of France's
export trade during the 1930s. Around eighty couture houses, governed
after 1910 by the Chambre Syndicale de la Couture Parisienne, employed
a substantial workforce and generated trade for many related profes-
sions, whose range and expertise were unique to France.

Paul Poiret set up his business not far from the Rond-point des
Champs-Élysées in 1914 and, following his example, all the top couturi-
ers began to converge on 'the most beautiful avenue in the world'. The
acknowledged heartland of Parisian luxury had been moving slowly
westwards since the first half of the 19th century, shifting from the
Palais-Royal up towards the Grand Boulevards, the rue de la Paix and
the place Vendôme.

Before 1914, couturiers were regarded simply as purveyors of goods,
but since that time they had carved out a place for themselves as an elite

Opposite:
Photograph by Man Ray.

Below:
The Maison Paul Poiret, at the Rond-
point des Champs-Élysées: furnishings
by the Atelier Martine, 1925.

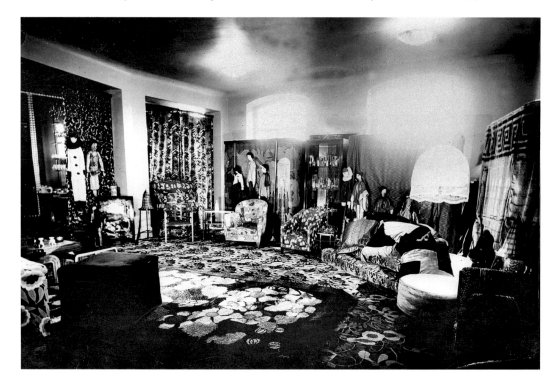

Opposite, above:
The *Catherinettes* who worked in the studio
of the couturier Lucien Lelong, 1920s.

Opposite, below:
'Simultaneous' dress and coat,
with a matching car, all designed
by Sonia Delaunay.

Below right:
Sonia Delaunay, scarf and hat, *c.* 1928
Palais Galliera, Musée de la Mode
de la Ville de Paris, Paris.

group within Paris society. They were members of the artistic scene –
working frequently with the worlds of theatre and cinema – and pos-
sessed sufficient wealth to be able to extend their patronage to writers
and musicians, and to commission work from architects, sculptors and
interior designers. Their couture houses became thriving businesses
with varied sources of revenue, often including their own perfumes.
And we need only think of names like Madeleine Vionnet, Jeanne
Lanvin, Coco Chanel and Elsa Schiaparelli to realize what an important
place women occupied in this world.

The female employees of these firms formed a sort of working-
class aristocracy. On the eve of the Second World War, the Madeleine
Vionnet house was serviced by some thirty or so workshops, employed
almost 1,200 seamstresses and sold around 200,000 garments a year. The
workers benefited from some forward-thinking social policies, includ-
ing a crèche and free medical treatment. In 1939, the Chanel workshops
occupied five buildings in the rue Cambon and employed 3,000 people.
Couture houses such as these, which also had stores in the French
provinces and in other cities across the globe, required top financial and
administrative expertise to help run them. They also had to protect
themselves against plagiarism and forgery, and in 1923 Madeleine
Vionnet co-founded the Association pour la Défense des Arts Plas-
tiques et Appliqués, the first copyright protection association.

New designs were worn for potential clients by models, with the
models who worked for a particular house being known as the *cabine*.
The Maison Lelong was famous for recruiting the most beautiful girls,
Chanel for employing young exiled Russian aristocrats, while Jean
Patou preferred to hire Americans for their natural looks.

The choice of suppliers was crucial, given that the couture houses
showed two collections a year, summer and winter, of around three
hundred designs each, and two mid-season collections of about a

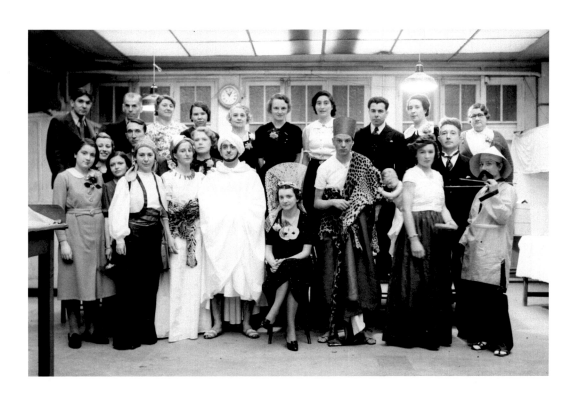

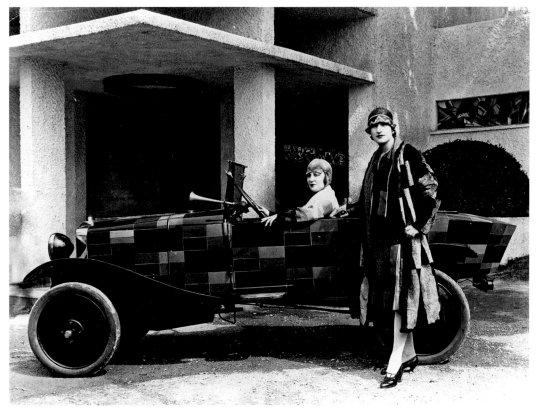

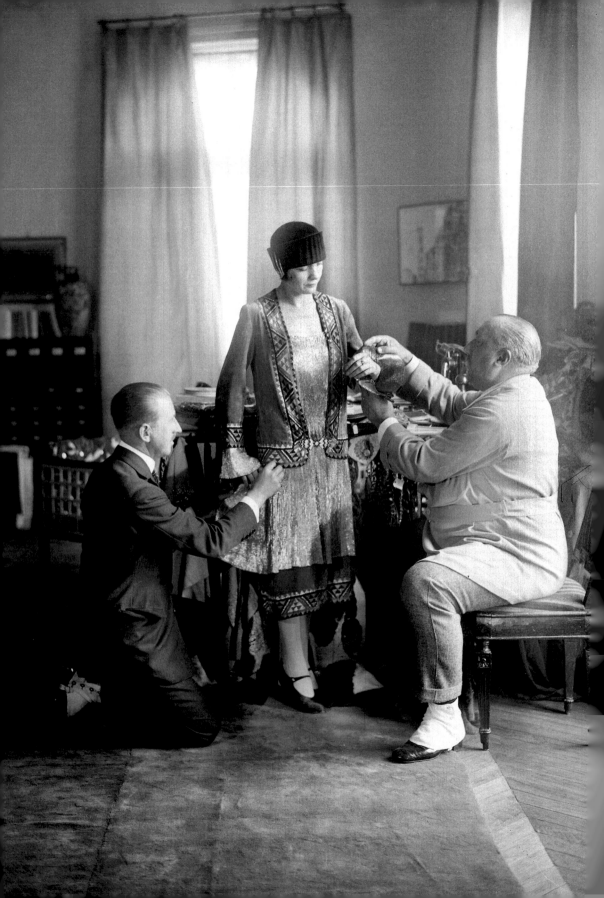

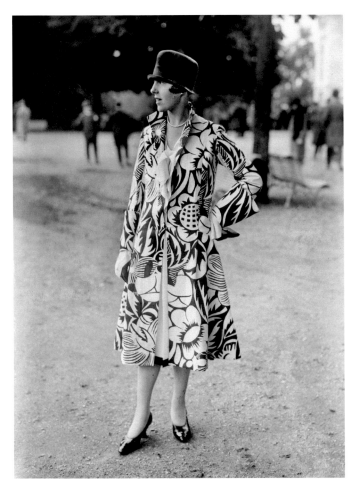

Opposite:
Paul Poiret (right) and his tailor
at a fitting session, October 1925.
Paul Poiret, known as 'le Magnifique',
was a pioneer of modern couture:
He transformed women's silhouettes
by eliminating corsets, took decorative
inspiration from Oriental art, chose bold
colours and regularly worked with artists
such as Raoul Dufy to create a unified
decorative view of the world.

Left:
Coat by Paul Poiret, in a fabric
designed by Raoul Dufy, 1925–30.

hundred garments. From the manufacturing point of view, an extensive selection of woven, knitted and printed fabrics was available. The big Lyon silk manufacturers led the field: Raoul Dufy was artistic director of Bianchini-Férier between 1912 and 1928, during which time he produced four thousand designs, giving free reign to his love of floral and animal motifs, in single colours and in a whole spectrum of brilliant hues. The silk manufacturer François Ducharne provided Michel Dubost with a workshop and a team of helpers in exchange for exclusive rights to his designs. Other famous partnerships included Coco Chanel and Jacques Rodier, who created the famous jersey fabric (originally intended to make men's underwear) that launched her career, and Jacques Heim and Sonia Delaunay, creator of the boldly colourful, abstract-patterned 'simultaneous dresses' (see p. 179).

In the 1930s, the situation was less rosy for the Paris couture houses. Before the Depression struck, American buyers would purchase several copies of each of their chosen designs, which would then be adapted to suit the tastes of the US market, but after 1929 the US's protectionist

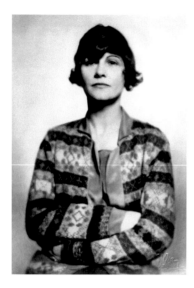

Left:
Coco Chanel, 1923.
Gabrielle 'Coco' Chanel was inspired by riding gear, military uniforms and work clothes, and gave a new elegance to fabrics formerly seen as commonplace, including gabardine, white cotton drill, tweed, chiné jersey and knits. She also had a preference for black, white and gold in an age in which bright colours were all the rage. In 1926, she created the famous 'little black dress', which swiftly became a staple piece of stylish eveningwear.

Opposite:
A Chanel suit, May 1935.

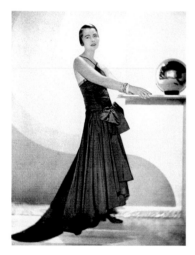

Above:
Jeanne Lanvin, evening dress in black faille, modelled by the Comtesse de Robilant. Photograph by Egidio Scaioni. *Fémina*, February 1929.

Right:
Jeanne Lanvin and a model, 1930. Gowns by Jeanne Lanvin were known for their restrained luxury, their drape, their attention to detail and their intricate embroidery. The designer took her inspiration from her many travels and her extensive library of books on art history.

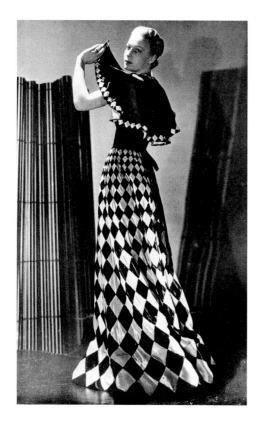

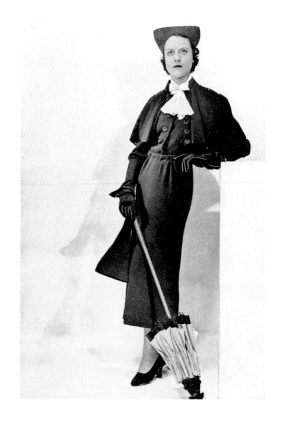

Opposite, top left:
Dress designed by
Madeleine Vionnet, 1922.
Palais Galliera, Musée de
la Mode de la Ville de
Paris, Paris.

Opposite, top right:
Madeleine Vionnet, long
gown in white satin crêpe.
Fémina, October 1928.

Opposite, bottom left:
Madeleine Vionnet,
evening dress in black
and white panne velvet
with diamond motifs.
L'Art et la Mode,
December 1938.

Opposite, bottom right:
Elsa Schiaparelli, black
wool dress with short
cape. *L'Art et la Mode*,
May 1935.

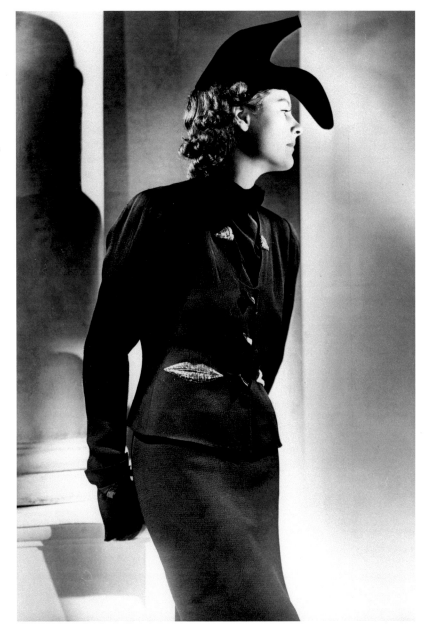

Above:
A Schiaparelli design, 1937.

Elsa Schiaparelli designed functional clothes, until a black sweater that featured the image
of a large white scarf tied around the neck launched her career. She opened her couture
house in the place Vendôme in 1935, luring in some of Coco Chanel's clients. A friend of
the Surrealists, she loved to take a playful approach to the meanings of objects, designing
a hat in the shape of an upside-down shoe, a bag that looked like a telephone, gloves
adorned with gilded fingernails, and a dress with genuine rips in the fabric.

Right:
Lucien Lelong, 1935.
Lucien Lelong began his career in
1918. The classical beauty of his
designs, especially his draped
gowns, was just one aspect of
his visionary talents in all areas
of the fashion world, both artistic
and commercial.

Below left:
Lucien Lelong, evening gowns
in artificial silk crêpe.
Fémina, April 1934.

Below right:
Tennis player Suzanne Lenglen
wearing a design by Jean Patou,
c. 1930. Photograph by Laure
Albin-Guillot.

Opposite:
House models at Patou, 1927.

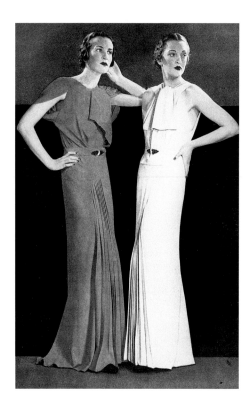

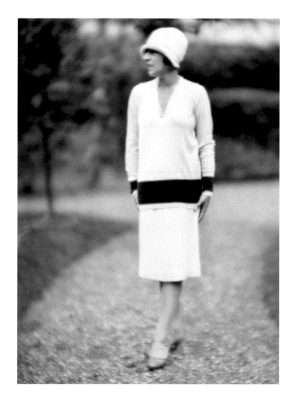

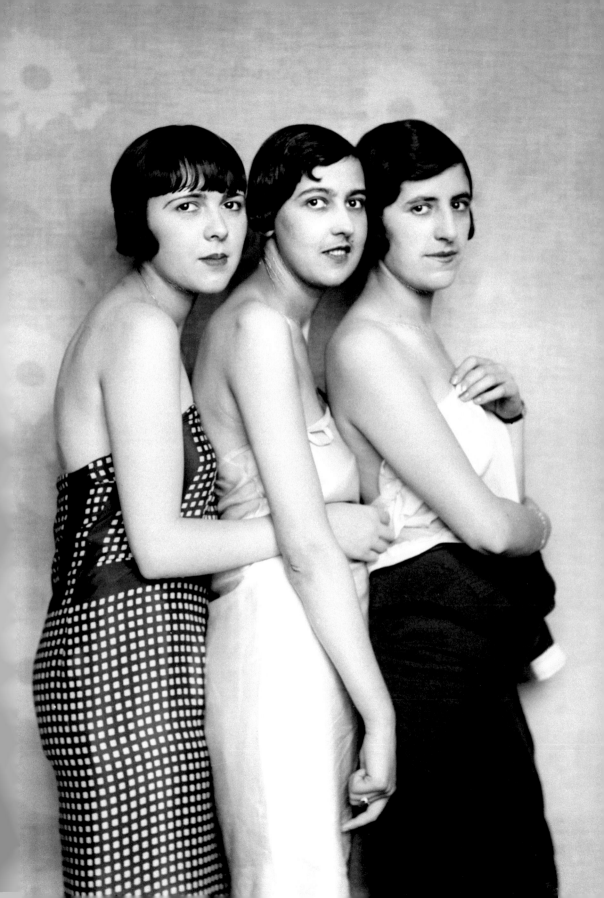

Left:
Cristobal Balenciaga, 1927.

Below:
A Balenciaga suit, 1938.
Photograph by Laure
Albin-Guillot.

Right:
An outfit by Robert Piguet,
modelled on the Pont
Alexandre-III, February 1936.

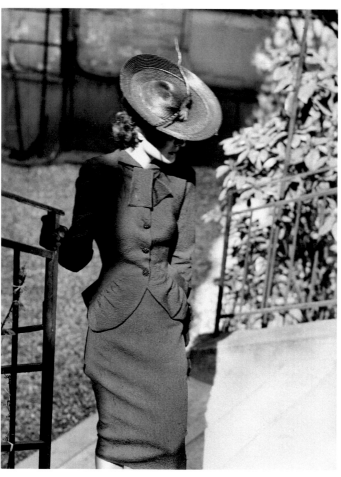

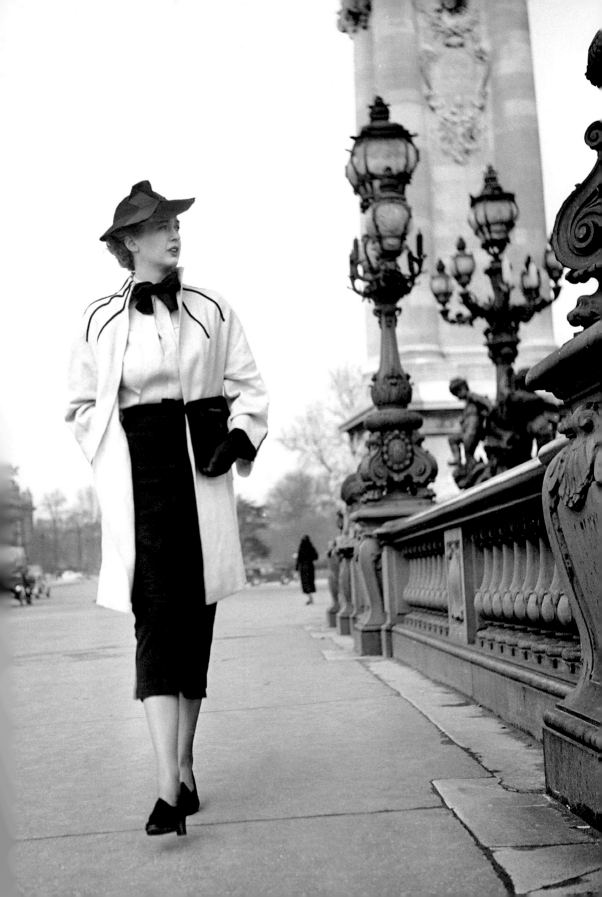

policy favoured the importing of *toiles*, muslin patterns for the finished garment, which could then be copied. The Paris houses were forced to sell their designs, albeit it at high prices, but without making any further profits from the sale – to the detriment of their workforce and the brand name. One solution to the crisis was to produce designs at more affordable prices, aimed at a younger clientele.

LIBERATED WOMEN

The moral standards and social constraints that characterized pre-war society had apparently failed, since they had not been able to prevent world conflict. So, now it was time to reject constraints of any kind and to encourage individual freedom. The new fashions reflected the changing female ideal: the arbiter of fashion was now young and liberated, modelled on *La Garçonne*, the tomboyish and scandalous heroine of the eponymous novel by Victor Margueritte (1922). The new tendency was to conceal a woman's natural attributes. With her cropped hair, bare legs and arms, skimmed hips and flat chest, slim almost to the point of skinniness, a woman was now an androgynous creature. In 1921, hemlines rose to the top of the calf and long knits accentuated the rangy look; in 1922, the necklines of evening dresses dropped lower, until they revealed the wearer's back right down to waist level; after 1925, hemlines rose to the knee and the waistline dropped practically to the groin, which was seen as immodestly low.

In 1928 another shift occurred: the waistline rose again to its natural location, skirts became pleated, bodices curved gently around the bust and hair was worn long and wavy. Daywear was influenced by the pleated skirts and V-necks of tennis dresses, while evening hemlines

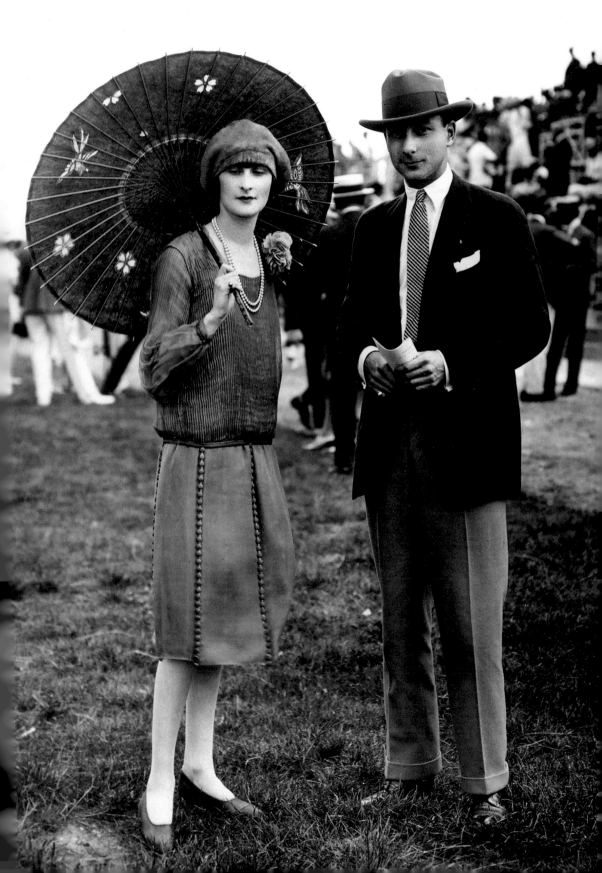

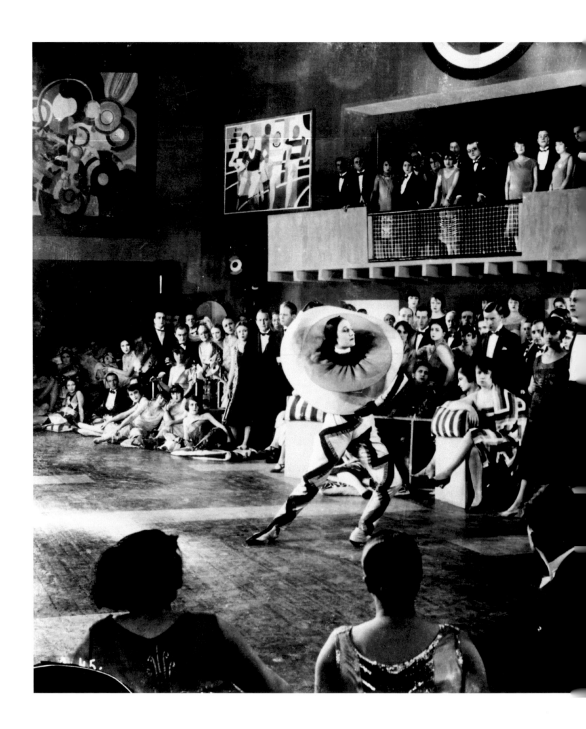

Above:
Sonia Delaunay, costume design for *Le P'tit Parigot*, 1926.
Watercolour on paper, 22.8 × 19.4 cm (8 ⅞ × 7 ⅝ in.).
Musée National d'Art Moderne, Centre Georges Pompidou, Paris.

Left:
Le P'tit Parigot, a film by René Le Somptier, 1926.
Costumes by Sonia Delaunay, set design by Robert Delaunay.

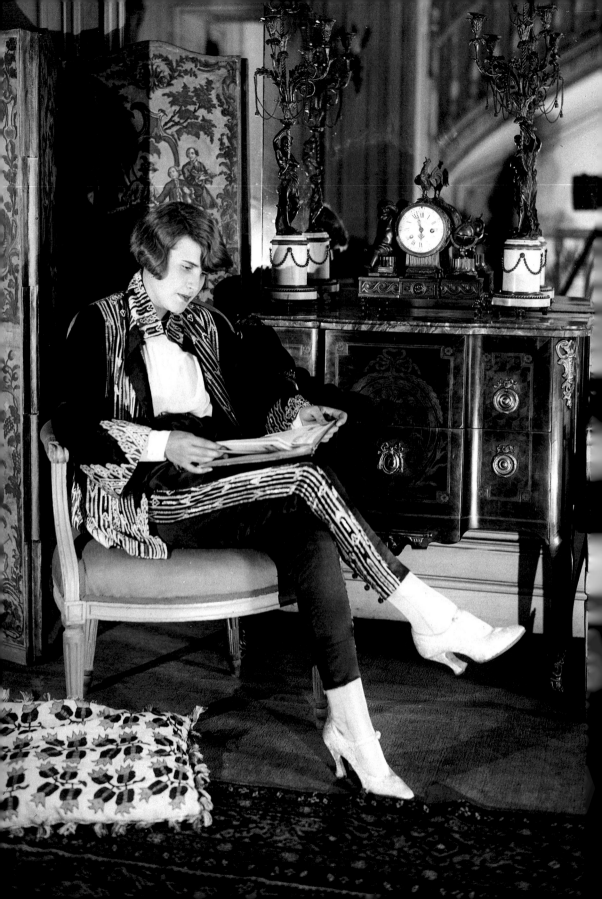

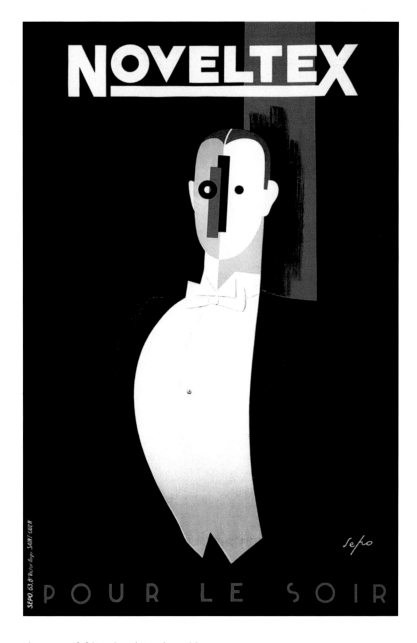

dropped to below the knee, with swags of fabric brushing the ankles. The 1930s marked a definitive break with the short, simple forms of the straight silhouette in favour of longer, more sophisticated shapes which emphasized traditional feminine curves once again.

PARTIES AND BALLS
Elegant outfits were made to be seen and there was no lack of opportunities to show them off, since a fashionable woman's day was a succession of visits, tea parties and receptions. Many parties and balls

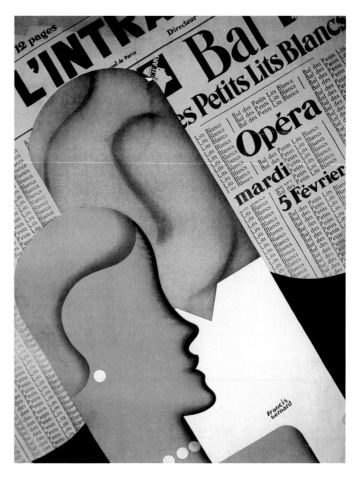

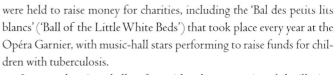

were held to raise money for charities, including the 'Bal des petits lits blancs' ('Ball of the Little White Beds') that took place every year at the Opéra Garnier, with music-hall stars performing to raise funds for children with tuberculosis.

Large-scale private balls, often with a theme, continued the illusion of ostentatious society life as it existed before the war. Elsa Maxwell, a famous American gossip columnist, put on parties for royalty and high society that were widely reported in the press and elsewhere. Photographs by Man Ray, Horst P. Horst, George Hoyningen-Huene and André Durst, and the memoirs of Jean Cocteau and many others preserve the details of these ephemeral but lavish events.

The annual ball held by Comte Étienne de Beaumont was the event of the season: it was a misfortune to miss it, and an even greater one not to have been invited in the first place. Raymond Radiguet's novel *Le Bal du comte d'Orgel* was inspired by the eccentric Comte, and he was also caricatured by Édouard Bourdet in the satirical play *La Fleur de pois*. The most memorable of his balls were the 'Famous Paintings Ball' in 1935, which featured *tableaux vivants* inspired by Vélasquez, Goya, Renoir,

Opposite, above:
Francis Bernard,
Le Bal des petits lits blancs, 1929.
Private collection.

Opposite, below left:
Comte Étienne de Beaumont in
the main salon of his home on
the rue Masseran (7th arr.).

Above left:
Guests at a ball held by
Comte Étienne de Beaumont;
in the centre are Picasso
and his wife Olga, 1924.
Photograph by Man Ray.

Below left:
Coco Chanel and the jeweler
Fulco di Verdura at the Bal des
Valses held by the Prince
de Faucigny-Lucinge and the
Baron de Guinzbourg, July 1934.

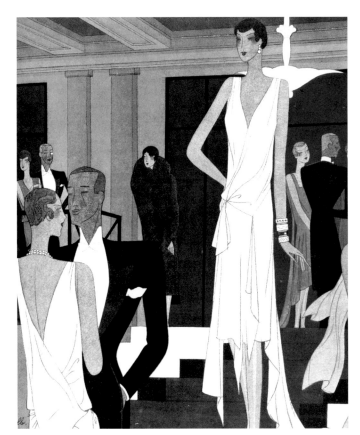

Left and opposite:
Gowns designed by Madeleine Vionnet,
Fémina, December 1928.

Watteau and Botticelli, and the 'Racine Anniversary Ball' in 1939, at which Serge Lifar danced, while dressed as 18th-century dancer Auguste Vestris in a costume by Coco Chanel.

Costumes for the 'Bal des Matières' ('Materials Ball'), organized by the Vicomte and Vicomtesse de Noailles, in 1929, had to be made using cardboard, paper and other cheap materials. The room was lit by magic lanterns decorated with designs by Jean Hugo. Georges Auric wrote the music and Francis Poulenc composed an *Aubade* for eighteen instruments, playing the piano himself. For the 'Bal Champêtre' held in the Bois de Boulogne, in 1931, by the Baron de Guinzbourg, with help from Elsa Maxwell, guests were expected to arrive by motor car or on bicycles, carrying vegetables and other provisions. The decoration for the house and garden was the work of Jean-Michel Frank, Boris Kochno and Christian Bérard and used blue, red and white satin, giant paper flowers, artificial fruit and paper animals.

THE FASHION PRESS

A number of women's magazines were launched between the wars, including *Les Élégances parisiennes*, the official journal of the French fashion industry. *L'Officiel de la couture et de la mode de Paris*, a monthly mag-

Right:
A woman and a little girl in
summer clothes, *Le Petit Écho
de la mode*, 5 August 1928.

Below:
Suits by Coco Chanel (left)
and Jeanne Lanvin (right) photographed
for *Le Jardin des modes*, 15 June 1933.

Opposite:
Georges Lepape, *The Judgment of Paris*, 1925.
Costumes designed by Jeanne
Lanvin for the Bal de la Parure,
Modes et manières d'aujourd'hui, 1925.

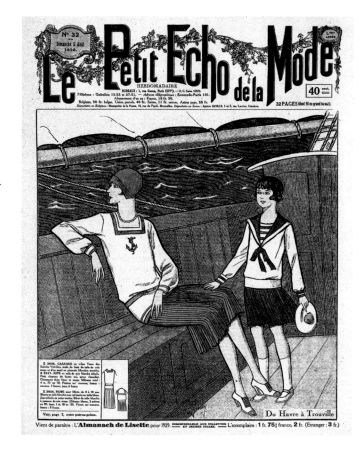

azine founded by Max Brunhes in 1921, used the best contemporary photographers, one of whom was Phillippe Portier, who was the first to photograph models in a street setting. The journal *Art, gout, beauté*, launched in the autumn of 1920, was a solid success until it closed in 1936. *L'Illustration des modes* embraced the avant-garde and offered its readers an unusual mix of patterns and recipes featured alongside the latest fashions, drawn by the top illustrators of the day. Newspapers also produced weekly fashion supplements, including *Excelsior Modes* (1929–39), which incorporated large black-and-white photographs of Paris fashions and scenes from society events, and *L'Art et la Mode*, founded in 1880, but which acquired a new lease of life in the 1920s through its coverage of cultural events. The year 1936 saw the launch of *Votre beauté*, published by L'Oréal and aimed at giving modern women the latest advice on health and beauty. Like the two major US publications that dominated the fashion press, *Vogue* and *Harper's Bazaar*, these magazines were designed with a small, privileged audience in mind. Two other magazines were aimed at a wider readership: *Modes et travaux*, which was launched in 1919 and provided practical advice and sewing patterns to cut out, and *Marie-Claire* (1937) – the first women's magazine with

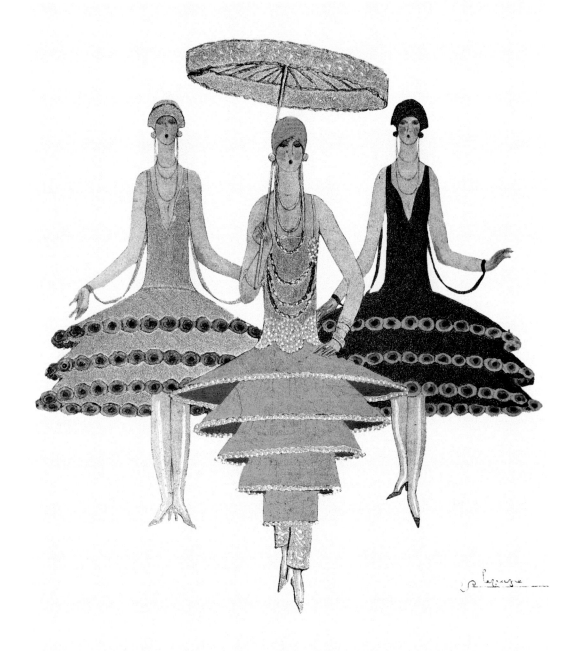

LE JUGEMENT DE PÂRIS

TRAVESTIS DE JEANNE LANVIN POUR LE BAL DE LA PARURE

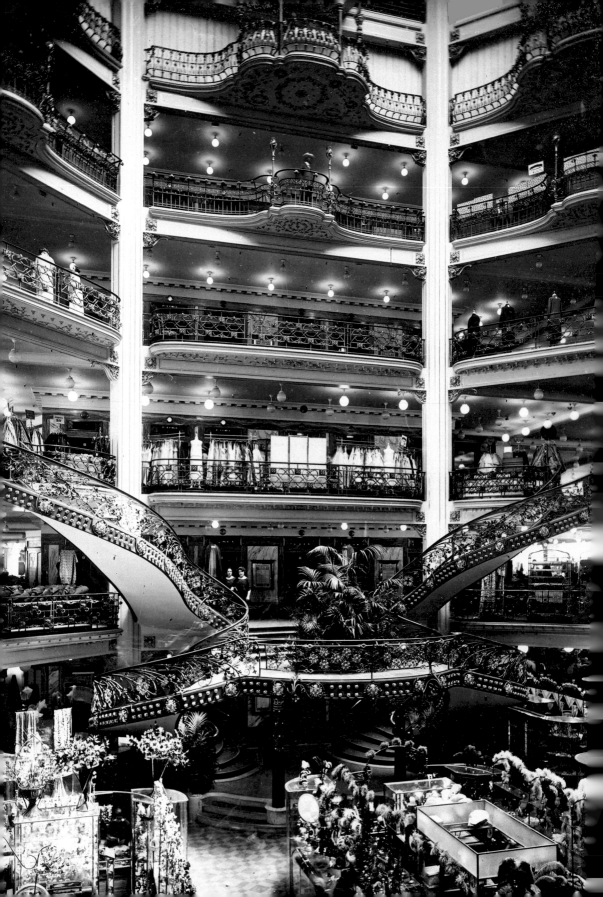

colour photographs – which had a circulation of 600,000 and caused a considerable social impact.

DEPARTMENT STORES AND READY-TO-WEAR

Paris's department stores were founded in the latter half of the 19th century and aimed to meet all a woman's needs from household goods to elegant clothes. Imaginative advertising campaigns were designed to bring customers into the shops: some were seasonal events, like the 'Saison du Blanc' in January or the lively Christmas window displays; others were one-offs, such as the Paul Poiret show at Printemps, with models strutting up and down a silver catwalk suspended above the heads of the crowd. There were also revolutionary changes in the art of window dressing: while shop dummies were traditionally made of wax, painted by specialist artists to appear as life-like as possible, in 1925 Siegel & Stockman began producing geometric-style mannequins from varnished papier mâché. Not only were these more in keeping with the modernist spirit, they also had the advantage of being lighter and less likely to melt under the heat of artificial lights.

The making of women's and children's clothing was a major industry in Paris after the Great War. The workshops employed a huge number of women and there were also many seamstresses doing piece-work from home. Gradually, the big stores began opening their own garment-production facilities: in the early 1920s, the 1,200 workers in the Galeries Lafayette workshops were making as many as 2,500 dresses a day, but as machine stitching increasingly took over from hand-sewing, a great many seamstresses found themselves out of a job. In response to the economic crisis, Toutmain launched a luxury ready-to-wear dress which could be bought for 150 francs (fitting included), and opened a store on the Champs-Élysées. The production of cheap artificial silk and other synthetic fibres encouraged mass production and made stockings accessible to all, while woollen fabrics and cotton yarn could now be machine-made too. Meanwhile, the idea of buying up remaining stocks of airplane cloth manufactured during the war was the brainwave of the entrepreneur Marcel Boussac, who made thousands of shirts, blouses and pairs of underpants from it.

After 1936, the increase in working people's salaries and the introduction of paid holidays brought a greater variety to clothing production, particularly for sport. Cheap clothes were sold in many general stores, while the sale of second-hand clothing was also a thriving business, especially in Le Marais and the Paris fleamarkets.

Opposite:
The Printemps department store, 1924.

Below:
The Bon Marché department store, c. 1925.

LINGERIE

In 1900, the lingerie firm founded by Herminie Cadolle in 1889 invented
a soft corset as a comfortable alternative to whalebone. Cadolle was the
first to use elastic in underwear and in the 1920s she designed (for
Chanel) a foundation garment that flattened the chest to create the
fashionable *garçonne* look. The suspender belt, fastened at the waist, was
designed to hold up stockings, which were generally flesh-coloured so
as to give the impression of bare legs. The year 1933 saw a small-scale
revolution occurring in the world of underwear: Robert Perrier, a man-
ufacturer of surgical corsets, invented the 'Scandal' elastic roll-on, a fine,
soft garment that was also washable. A combination of elastic and tulle
flattened the stomach, slimmed the hips and held a woman's stockings
in place, creating a streamlined silhouette. For the first time, bras meant
that the breasts were separated and supported, and plunging necklines
became fashionable; backless bras were also available, to wear with the
most daring of low-backed evening gowns.

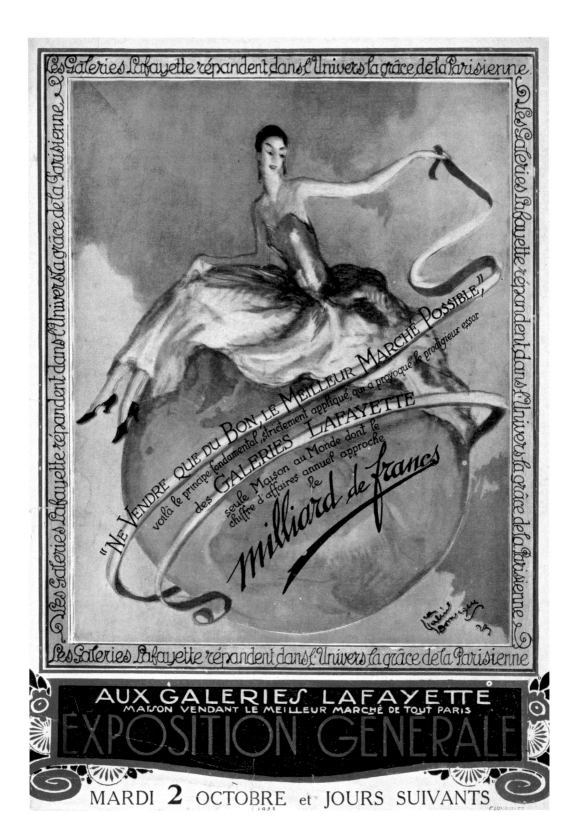

Above:
Gloves by Hermès, *c.* 1938.

Opposite:
Plate decorated with a design
by Georges Lepape, *c.* 1927.
Porcelain, diam. 32 cm (12 ⅝ in.).
Private collection.

Hats

Hats were an essential ingredient of any woman's outfit in the 1920s, and both the shape and the materials used offered huge scope for creativity. A small felt trilby, inspired by men's styles, could be worn with a tailored suit in the daytime, while a broad-brimmed straw hat was ideal when paired with a long dress of the kind worn at the races or at garden parties. Caroline Reboux, established in the rue de la Paix since 1865, made hats for royalty – the Duchess of Windsor wore a Reboux hat on her wedding day in 1937 – and counted stars like Greta Garbo and Marlene Dietrich among her regular clients. She also collaborated on stage costumes for plays. Lucienne Rebaté, who had previously worked for Chanel, took over as director of the Reboux company in the 1920s. Many milliners did their apprenticeship at Reboux, including Mme Agnès, who invented the 'modernist hat', commissioning decorative motifs from Mondrian, Fernand Léger and Robert Delaunay. The Maison Claude Saint-Cyr was opened by Simone Martin on Faubourg Saint-Honoré in 1937 and immediately became famed for its elegant creations. The proud millinery traditions of Paris were also carried on

by new names such as Maison Paulette, founded in 1929 by Pauline Adam. It was in 1937 that Léontine Prusac, who had previously worked at Hermès, opened her own milliner's boutique, working under the name Lola Prusac.

LEATHER AND FUR

Founded in 1837 as a high-class saddlemaker's, Hermès created its first range of leather garments in 1928, alongside leather accessories inspired by the horseriding world. In 1937, the firm produced the first of its world-famous silk scarves, knows as *carrés* ('squares'). Gloves – made of net, velvet, silk, leather and other materials – were another key Hermès product, though their popularity began to decline when fashionable ladies began to wear nail varnish.

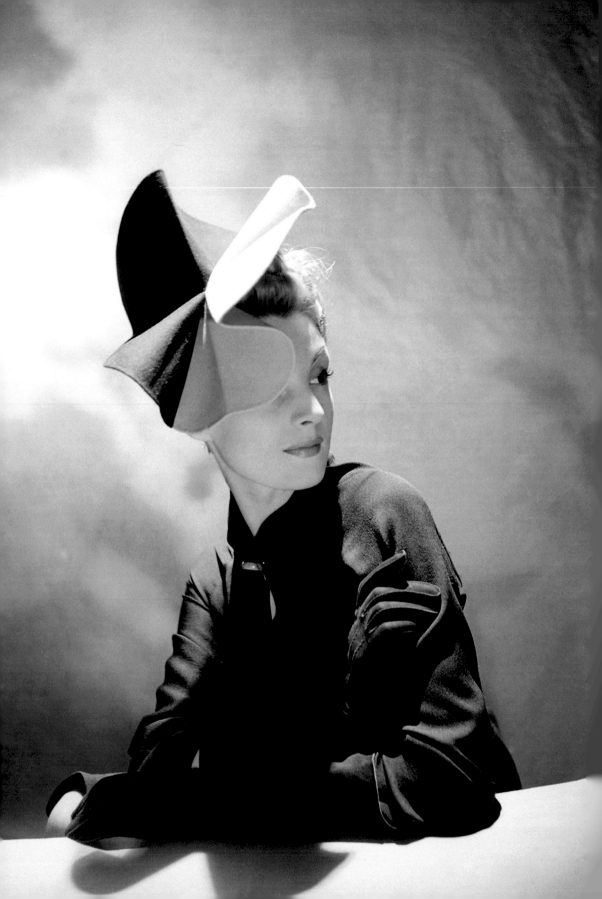

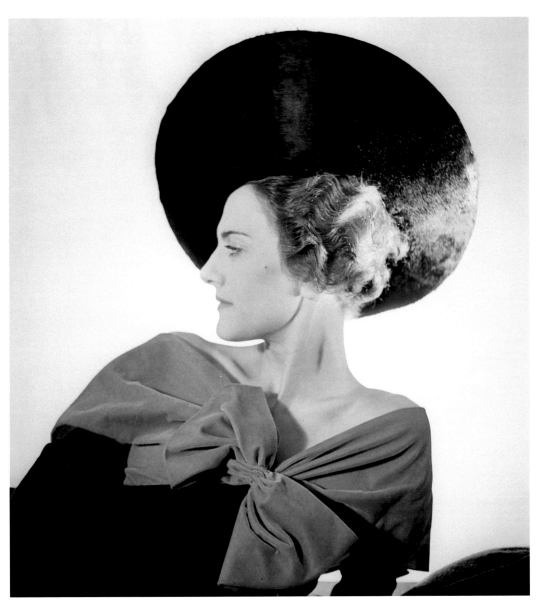

Above:
Broad tilted felt hat by Molyneux, November 1937.

Opposite:
Hat by Claude Saint-Cyr, January 1939.

Paris had been dealing in furs since the 17th century, thanks to its links with fur trading companies in Canada. Between the wars, the big Paris houses supplied fur for pelisses and stoles, collars, pockets and wrist bands. In the 1930s, as fur coats became part of every fashionable woman's wardrobe, they began producing coats in ermine, astrakhan, seal, beaver, otter, fox and mink. Arctic fox was considered the top of the range. At the end of the 1930s, fur began to be more widely available to less wealthy customers, with an extensive selection of ready-to-wear garments in muskrat, otter and foal skin.

Adding the finishing touch to a woman's outfit, feather boas, ostrich and marabou plumes and other exotic decorations were produced in small workshops, more than two hundred and seventy of which were still operating in Paris in the 1940s.

SHOES

Because the feet were now very much on view, a great deal of technical ingenuity and creative flair went into shoemaking. Hellstern, founded in around 1870, in the place Vendôme, was at peak production during the years 1920–25, employing more than a hundred craftsmen to produce top-quality shoes for royalty and the stars of stage and music hall. There were female shoemakers too, like Julienne, who combined imaginative flair with skilled craftsmanship and reflected the avant-garde and exotic fashions of the day. The career of André Pérugia, who

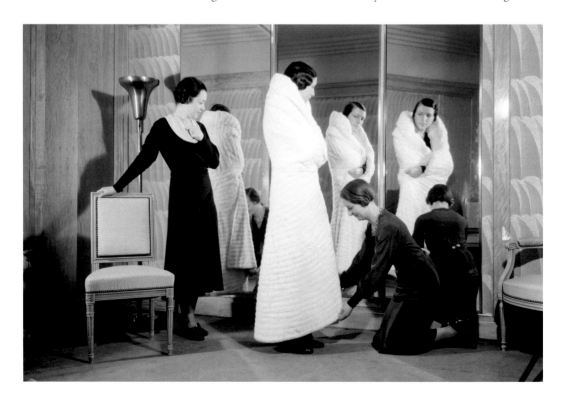

FOURRURES
BONNETERIE
CHAUSSURES

came from an Italian shoemaking family and originally worked in Nice, was launched by Paul Poiret, for whom he produced a number of designs. In 1920 Pérugia opened a shop on the rue du Faubourg Saint-Honoré, Paris's heartland of chic. Its interior was magnificent, with black-lacquered doors and furniture upholstered in green velvet and snakeskin, black and yellow marble columns, walls of concrete and polished granite, and curtains in a fabric designed by Rodier. The clientele was exclusively female and included royalty, big names from showbusiness (such as Arletty) and wealthy American heiresses.

A number of new designers began to make a career for themselves in the 1930s. Sarkis Der Balian arrived from Armenia in 1929 and quickly proved his talents in various Paris shoe workshops. Roger Vivier started his own business in 1937, creating designs for major French manufacturers such as Pinet, Swiss firms such as Bally and German companies such as Salamander.

An increasing number of shoes now began to be mass produced. In 1918, Alfred Heyraud, who trained as a luxury shoemaker, launched the Aurore label, which quickly became a leading brand. Originally from the shoe-trade centre of Limoges, Eugène Blanchard gave his brand of luxury shoes an English-sounding name, J. M. Weston, and opened his first Paris shop in 1927. The Swiss firm Bally also succeeded in combining mass production with skilled craftsmanship – its 'couture' range was designed by the couturier Robert Piguet – and opened around fifty shops in Paris and other major French cities. Good-quality shoes at low prices were produced by Bata, a Czech company that opened factories and a chain of stores in France in the 1930s. André was another popular brand of cheaper shoes, and advertised itself with the slogan 'the shoemaker that knows how to make shoes'.

SWIMWEAR

In summer, the fashionable set would leave the capital and head down to the French Riviera. At the beginning of the 20th century, both sexes wore modest full-length bathing costumes, but by the 1920s a whole wardrobe of specially designed seaside clothes and accessories had appeared. The fashion for watersports and sunbathing, popularized by Coco Chanel in Deauville in 1915, led to the creation of a simple and functional swimsuit with a cutaway back – a style soon emulated by top couturiers like Jean Patou and Elsa Schiaparelli. In around 1925, knitted wool swimsuits were gradually replaced by softer, more clingy materials, and with the new fabrics came new decorative motifs, often with a Cubist influence, and geometric shapes and brilliant colours began to invade the beaches. In particular, Sonia Delaunay produced some wonderfully experimental swimsuit designs.

PERFUMES

A number of Paris perfume houses – including Guerlain, Roger et Gallet and Coty – had continued trading through the Great War. The potential profit from this field was considerable, as was demonstrated by the lavish Perfumery Pavilion at the 1925 exhibition, with its perpetually flowing Lalique crystal fountain.

Almost eight hundred perfumes were created between 1919 and 1930. The scents of the period were marked by the combining of natural flower essences with synthetic substances. These years also saw the debut of the first perfumes created by couturiers. Paul Poiret founded the firm Parfums de Rosine, with its emphasis on rose scents; Jean Patou launched twenty fragrances in ten years, Guerlain more than fifty, including Mitsouko, Shalimar and Vol de Nuit; and Jeanne Lanvin opened the perfumery that was to create Arpège. All of them hired leading glass manufacturers such as Baccarat to design and manufacture crystal bottles for their precious elixirs.

Opposite:
Jean Patou, beach outfit in waterproof satin, 1929.

In 1921, Coco Chanel called upon the services of Ernest Beaux, perfumer to the Russian court, who experimented with various aldehydes and synthetics, from which he created two test series numbered 1 to 5 and 20 to 24. Famously, Chanel chose No. 5. This perfume, the first of modern fragrance made from synthetics that were better than nature, was also innovative in its striving for simplicity: it was sold in a plainly shaped glass bottle, with a simple black and white label. In 1925, Jean Patou created three fragrances, each designed to appeal to a different type of woman: Amour Amour for brunettes, Que Sais-Je for blondes and Adieu Sagesse for redheads. Then as an act of cheerful defiance, in the wake of the Wall Street Crash, Patou created Joy, 'the most expensive perfume in the world', reputedly made from 10,000 jasmine flowers and 28 dozen roses. His Normandie (1935) commemorated the maiden voyage of the ocean liner of the same name, and its glass and steel bottle echoed the shape of the ship. Elsa Schiaparelli's perfumes were also marketed with wit and humour: Shocking came in a bottle (designed by Léonor Fini) in the shape of a woman's hourglass figure, topped with a bouquet of flowers, while the bottle for the men's fragrance Snuff was pipe-shaped. Scents for men tended to be more traditional, with notes of Russian leather and lavender (Pour un Homme by Caron) or tobacco (Snuff by Schiaparelli), for example.

HAIR AND MAKE-UP

Shifts in fashion also affected the field of hairdressing. 'Monsieur Antoine' launched the androgynous shingle bob, which showed off the nape of the neck, and popularized artificial hair colours, such as a blue rinse to conceal grey hair – first worn by the American interior designer Elsie de Wolfe – and peroxide blonde. For evening, hair pomades such as Bakerfix – launched by Josephine Baker after her success in the *Revue Nègre* – were used to create kiss curls and to sculpt hair so that it lay flat against the head. Short hair was still in vogue in the 1930s, but could be

given volume by permanent waving, now possible thanks to machines that used heated rollers.

In 1907, the chemist Eugène Schueller created an artificial hair colour called Auréale. In 1909, he founded the Société Française de Teintures Inoffensives pour Cheveux, which was renamed L'Oréal in 1939, buying up the popular Monsavon brand and launching popular products such as Dop shampoo and Ambre Solaire suncream.

It seemed that the fewer clothes a woman wore, the more she made up her face. Make-up had previously been considered as only fit for actresses and prostitutes, but now everyone was wearing it – drawing dark lines around their eyes, highlighting their cheekbones with rouge, and painting brilliant rosebud lips. In the 1930s, eyebrows were redrawn using a pencil, eyelids shaded and lashes lengthened with mascara, and lips were first defined with lip liner, then painted using a brush.

In the 1920s, the two American cosmetics queens, Helena Rubinstein and Elizabeth Arden, competed against one another with their chains of beauty salons. In 1935, Germaine Monteil started a business

selling beauty products that was based on the philosophy that skincare, diet and exercise were all as important as make-up. In 1939, the prestigious Maison Guerlain opened a beauty parlour in its salons on the Champs-Élysées, whose austere elegance was enhanced by a hallway with witty *trompe l'oeil* decorations designed by Christian Bérard. Paul Poiret also opened a beauty salon, with walls and ceilings in silver and purple. Other more surprising figures also launched themselves into the beauty business. These included former opera singer Lina Cavalieri, who created a whole range of products and sold them from her own salon, and the writer Colette, who marketed 'Colette' face powder and a little cosmetics brush known as the *patte du chat* or 'cat's paw' with help from her friend Henriette Gabilla, the first female perfumer.

Men's Fashion

With the return of peacetime, men too felt the need to wear simpler and more comfortable clothing. Jackets lost their shoulder padding and became single-breasted, in checks or stripes; trouser legs became wider. The city suit began to appear in lighter colours and patterns such as Prince of Wales check. Flannel shirts (often striped) had soft collars, either detachable or fixed. The outfit was finished off by a trilby hat. The black smoking jacket with silk lapels was traditional for evening dinners and formal events.

In 1927, Printemps opened a menswear store (rue de Provence) named after the 18th-century English dandy Beau Brummell, and the same year the Société Armand Thierry launched the Thiérylux collection of fixed-price made-to-measure garments. For the leisured classes, Paris offered a number of excellent tailors such as Larsen, Voisin, Carette, Damien and Dupouy-Magnin. Lanvin was one of the first couturiers to open a men's department, while Charvet, in the rue de Castiglione, was *the* supplier to go to for tailor-made shirts. Since stylish menswear was associated with England, the tailors' shops tried to recreate the feel of a gentlemen's club. One example was the Paris branch of Knize & Co, on the Champs Élysées, designed in 1927 by Adolf Loos. Its oak-panelled rooms had brick fireplaces and full-length mirrors, leather armchairs and oriental rugs over wall-to-wall carpeting, providing a luxurious setting for trying on clothes.

It was only in the realms of sports and leisure wear that there were any real changes in men's clothing. Otherwise, styles that had been adopted from Britain tended to be worn by every social class. These included the Norfolk jacket, a narrow tweed belted affair, and the baggy breeches known as knickerbockers, which fastened with a band below the knee. It was also common for a man to wear a matching cap.

Young people from the middle classes were passionate about sport and flocked to use the facilities at the Sporting Club and the Racing Club de France, which owned a large area in the Bois de Boulogne where

Above:
Jean Carlu, *Monsavon*, 1925.
Private collection.

Opposite:
Colette at her beauty parlour on the rue Miromesnil (8th arr.).

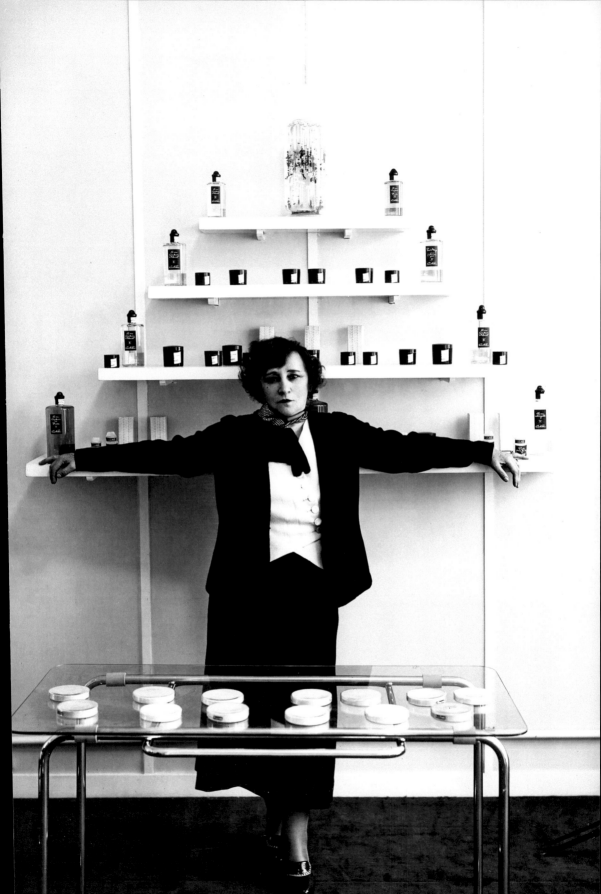

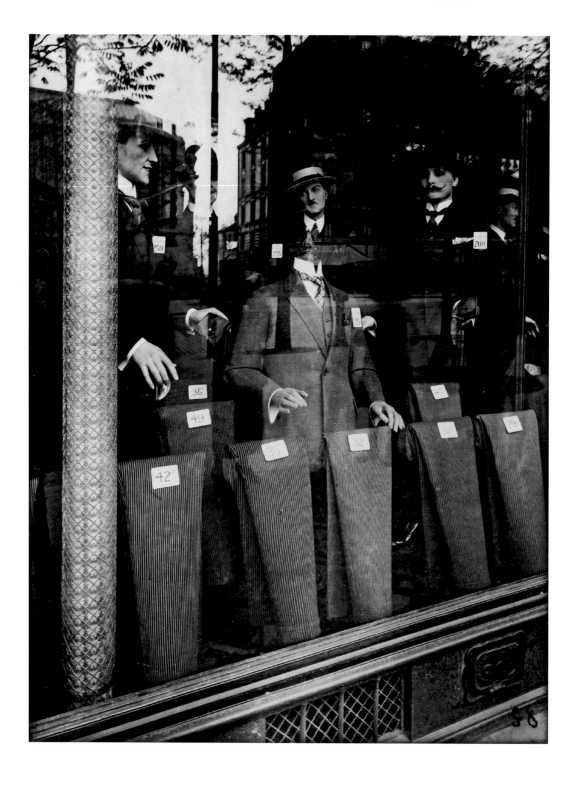

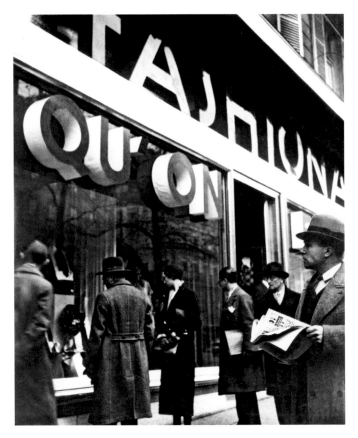

there were pools and tennis courts. Tennis became very popular in the 1920s and the new Roland-Garros stadium, built by the architect Louis Faure-Dujarric, opened in 1928. The tennis players known as the 'Four Musketeers' (Jean Borotra, Jacques Brugnon, Henri Cochet and René Lacoste) won the Davis Cup there five times in a row, from 1928 to 1932, and in 1933, René Lacoste launched a company to sell the short-sleeved shirt in cotton piqué that he had designed to wear on the tennis court, which bore a small green embroidered crocodile as a logo.

Above left:
Dora Maar, *Shop Window*, 1935. Gelatin silver print, 29×23 cm (11 ⅜×9 in.). Private collection.

Above right:
Early advertisement for Lacoste shirts, 1933.

Opposite:
Eugène Atget, *Shop on the Avenue des Gobelins*, 1925. From *Picturesque Paris*, 3rd series. Museum of Modern Art, New York.

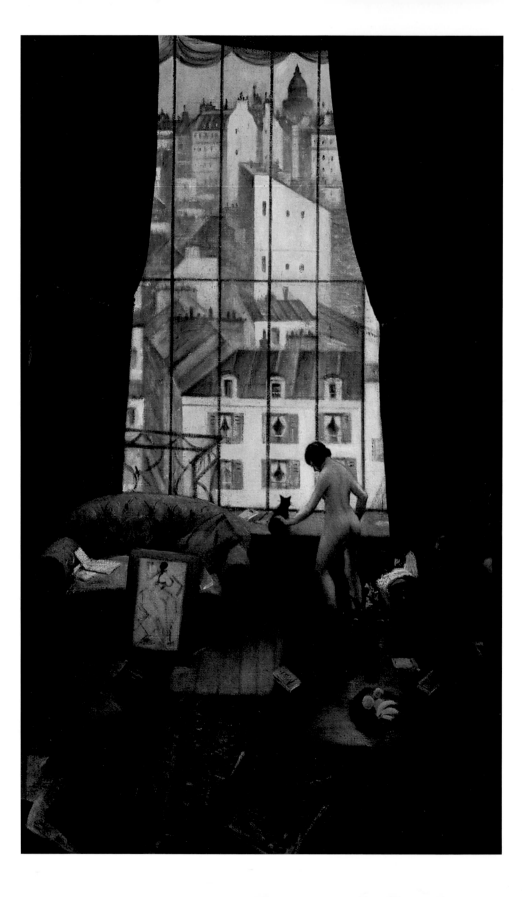

PAINTING AND SCULPTURE

Gérard Durozoi

In *The Life of Forms in Art* (1934), Henri Focillon writes: 'The history of art shows us survivals and anticipations juxtaposed in a single moment of time, slow-moving belated forms existing alongside bold and rapid forms.' These lines could have been written to describe the fine arts in Paris between 1919 and 1939. Some artists of the time, in their eagerness to forget the 'excesses' of Fauvism and Cubism, sought a 'return to order' or variants of 'realist' painting; others formed groups of varying longevity in an attempt to establish an 'abstract' art of the kind that spread across Europe but barely touched France. All of them were fighting against an institutional academicism which was unfailingly reactivated by the exhibitions that marked the period, and the commissions that sprung from them, while, out on a limb of their own and uninvolved in these debates, Dada and Surrealism appealed to the visual arts, as redefined by them, in an attempt to modify our culture and our way of thinking profoundly, exalting the power of the imagination and hoping to incite a revolution.

These diverse movements led to a boom in the number of galleries, to the point where, in January 1920, Léon Moussinac complained that the 'poor critics' found themselves 'inundated', both by specialist publications (often short-lived) and by salons where new artistic movements regularly attempted to prove their worth with group shows. But it would be inaccurate to suppose that co-existing art movements were necessarily hostile to one another: exhibitions that were officially described as 'abstract' could accommodate both Picasso and Brancusi; the unstable nature of daily life brought together artists with different leanings, and figures such as Balthus, Christian Bérard, Dalí and Buñuel were all welcomed by the same fashionable circles. Some galleries adopted a policy of alternating the art movements that they exhibited; artistic links might be forged through political crisis, and it was always possible, of course, to rub shoulders in the cafés of Montparnasse.

The situation was complicated still further by the fact that the arts were part of an economic and ideological context that was itself shifting, and that political stances which saw themselves as 'progressive' could justify works of art that were stylistically the complete opposite: in 1936, an abstract painter (Herbin), a figurative artist (Léger) and a Surrealist (Tanguy) all declared that society needed to change, but this shared belief was certainly not expressed by similar artistic means.

Above:
Fernand Léger in his studio at 86 rue Notre-Dame-des-Champs (6th arr.), 1931.

Opposite:
C. R. W. Nevinson,
A Studio in Montparnasse, c. 1925
Oil on canvas, 127 × 76 cm (50 × 29 ⅞ in.).
Tate Modern, London.

The 'Return to Order' or an End to Experimentation

When Braque showed his recent paintings at Léonce Rosenberg's gallery L'Effort Moderne in 1919, the time seemed to have come to relegate Cubism to history. Braque's works seemed to have moved beyond the Cubist style that had been denounced as 'Boche art' or 'Bolshevik art', and Roger Bissière, in his articles for *L'Opinion*, described them as embodying a 'return to order' – an expression adopted by André Lhote soon after, in *La Nouvelle Revue française*. The current concern was to contextualize the 'lessons' of Cubism into the French tradition going back to Jean Fouquet in the 15th century, viewing it as a discipline marked by controlled emotion, sustained attention to form, and a particular colour palette. This plan to integrate Cubism into art history was also a way of removing its novelty, by ceasing to question it. However, it did have the advantage of not brutally consigning it to non-existence or relegating it to the level of a passing fad of merely commercial interest.

The return to order was not just a Parisian phenomenon. After the Great War, its effects were felt in the major artistic centres of Europe: while France harked back to Fouquet, Italy recalled Giotto, and Germany did the same with Dürer. The end of the war was accompanied by outbursts of nationalist feeling, and there was widespread talk of paving the way for a new Renaissance – a concept that encouraged traditionalists in every country to redouble their efforts.

Another sign that it was time to turn the page on Cubism was a series of auctions (between 13 June 1921 and 8 May 1923) of stock sequestered by the French government from the Galerie Kahnweiler, which totalled more than 1,500 works, including 124 Braques, 56 Gris, 132 Picassos, 315 works by Vlaminck and 22 by Van Dongen. The artists involved feared that the abundance of supply would lead to a drop in prices, while critics tried in vain to prevent the works from being dispersed in a hasty and disorganized way. At the final sale, collages by Braque and Picasso and drawings by Léger were sold off in bundles, but the prices obtained, although lower than those pre-war, were still higher than the detractors of Cubism and the Académie des Beaux-Arts had hoped. The French institutions bought nothing, but the buyers included a number of artists (Crotti, Lipchitz, Le Corbusier and Ozenfant) and writers (Jean Paulhan, Tristan Tzara, Henri Pierre Roché, Paul Éluard and André Breton, who acquired at least three Picassos, seven Braques, one Léger and six works by Derain, and almost certainly some collages too). Kahnweiler himself opened a new gallery in the rue d'Astorg in the mid-1920s, but only succeeded in selling a handful of works – perhaps because the market was at saturation point.

On a more intellectual and aesthetic front, *L'Esprit nouveau*, the journal of Purism founded by Ozenfant and Jeanneret (better known as Le Corbusier), published in its fourth issue in early 1921 a manifesto entitled 'After Cubism', stating that Cubism 'remains, whatever may be

Above:
Juan Gris, *Portrait of Daniel Henry Kahnweiler*, 1921. Pencil on paper, 32.5 × 26 cm (12 ¾ × 10 ¼ in.). Musée National d'Art Moderne, Centre Georges Pompidou, Paris.

Opposite:
Amédée Ozenfant, *Composition*, 1929. Oil on canvas, 92 × 73 cm (36 ¼ × 28 ¾ in.). Musée Zervos, Vézelay.

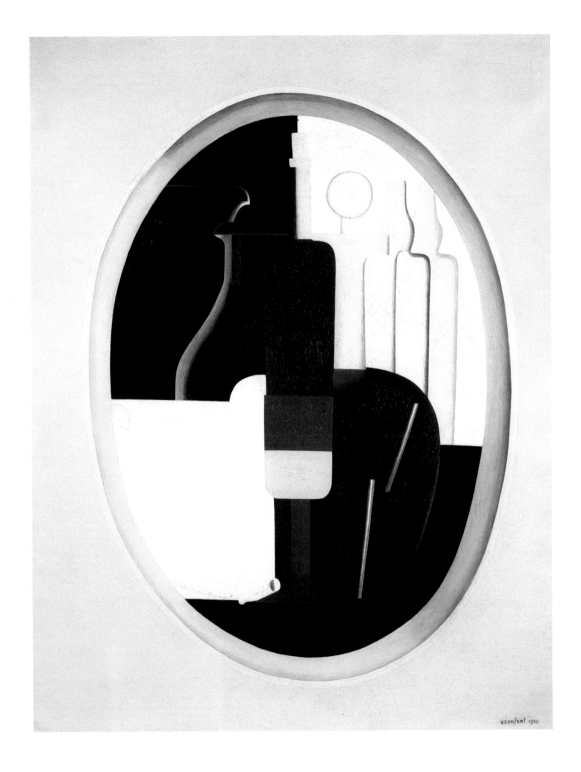

said about it, a decorative, ornamental and romantic art'. These adjectives have little in common with the works of 1907–12, but are better applied to what the Cubist movement became in the hands of Gleizes and Metzinger. Whatever the case, if Cubism was to be superseded, the proposed solution was a firmly rationalist approach. By embracing the world of machines and all that it implied, Purism rejected the effects of chance or the unconscious and strived to produce works that were composed according to strict geometric principles. It also embraced a 'return to order', but in a very specific way, not by demanding a revival of pictorial tradition, but by establishing a visual order that suited the 'modern' world.

Picasso – now settled in the rue La Boétie – and Matisse also seemed to indicate that the days of excess were over: Picasso in his shift to naturalistic 'Ingresque' figures, and Matisse in the sensual *Odalisques* that he produced in Nice, where he had been living since 1917. Picasso's periodic exhibitions at Paul Rosenberg's gallery demonstrated that he was practising a broad combination of different styles, either alternately or simultaneously, including a restrained and brilliantly coloured form of Cubism (*Three Musicians*, 1921) and neoclassical composition (*Three Women at the Spring*, 1921) as well as an apparently sedate figurative style on a partially unpainted ground (*Paulo as Harlequin*, 1924) and the 'Ingresque' approach that appealed even to those who disliked his daring innovations. The Galeries Georges Petit showed a retrospective of 236 works chosen by Picasso himself (with no Cubist works included) in June–July 1932. Critical reactions were naturally divided: Germain Bazin declared that Picasso 'belongs to the past', while Jacques Émile Blanche wrote that he 'succeeds in all that he does' and the *Cahiers d'art* devoted a special edition to him. And of course, there are whole areas of his work that have yet to be mentioned: his experiments with sculpture, the wire constructions that coincided with his rediscovery of volume (*Bather*) in 1928, as well as the welded metalwork he produced with Julio González and the plaster heads made in Boisgeloup. Until the early 1930s, it seemed as if critics wished to confine his protean output to a category of art that would be most acceptable in the long term: the monographs devoted to him by Maurice Raynal, Jean Cocteau, André Level and Wilhelm Uhde (*Picasso and the French Tradition*, 1928) only touch upon Cubism as belonging to a moment in the past that had now passed by, and little attention is paid to the fact that Picasso participated in both the first Surrealist painting exhibition in 1925 and the collage exhibition at the Galerie Goemans (1930), for which Louis Aragon wrote 'The Challenge of Painting'. Picasso attracted insults of every kind: he was described as inferior to Marie Laurencin and Matisse, 'inconsistent', a 'wily conjurer', the creator of 'blatant frauds', a 'perverse alchemist [distilling] a profound sense of ennui', a 'quick-witted clown', capable only of a 'hesitant and feeble kind of drawing', and it was said that 'the preposterousness of

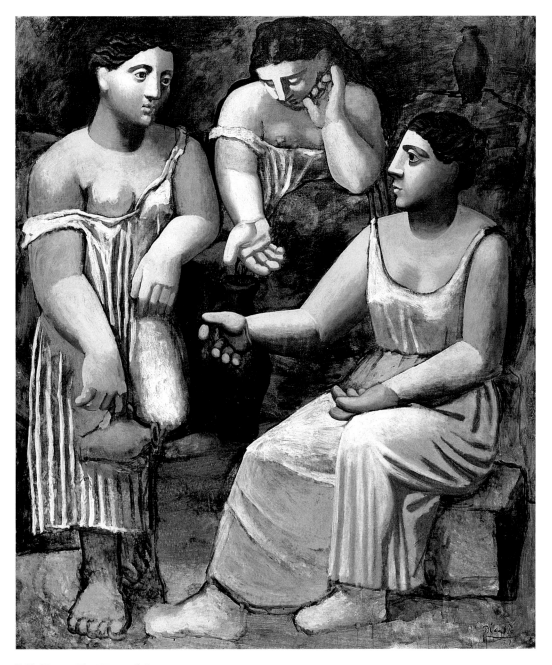

Pablo Picasso, *Three Women at the Spring*, 1921.
Oil on canvas, 204×174 cm (80 ¼×68 ½ in.).
The Museum of Modern Art, New York, gift of Mr and Mrs Allan D. Emil.

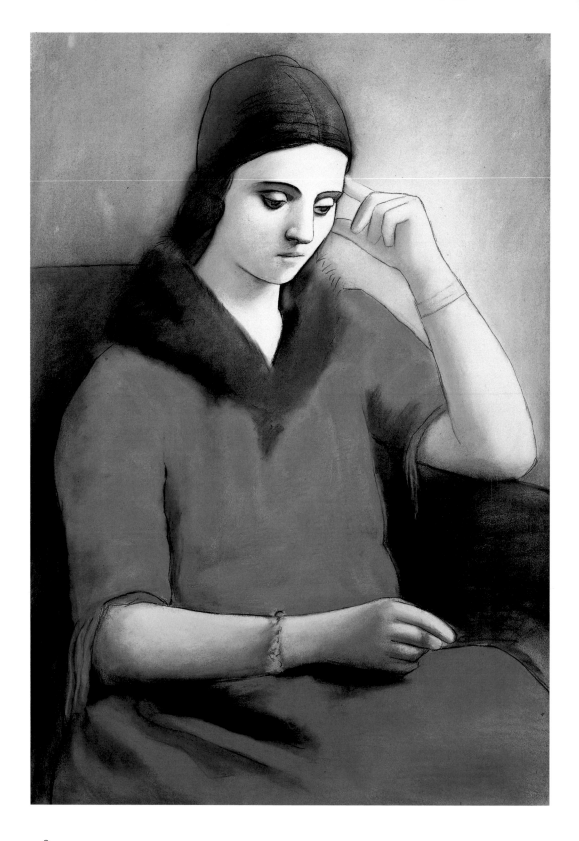

his manner derives from a feeling of revulsion towards painting linked to a keen business sense'.

The response to Matisse grew a great deal less aggressive when he began showing his 'Niçoise' paintings at the Galerie Bernheim-Jeune in 1919. Indeed, his windows, odalisques and tranquil still lifes delighted both the critics and potential buyers alike. The colours were vivid, but remained realistic, unlike those from his brief experimental forays into Fauvism; the subjects were immediately recognizable, the representational space appeared to make use of a relatively classical perspective, and the treatment of light was skilful. André Lhote may have deplored what he saw as a regression in comparison with the artist's pre-war experiments, but the paintings themselves were enchanting. Matisse too seemed to have subscribed to a 'return to order', so clearly had his work moved away from its earlier tensions and contradictions in order to give immediate pleasure to the eye. In this way, the artist was fulfilling an aspiration he had expressed as early as 1908, when he described himself as searching for a 'balanced art … which, for anyone engaged in mental work, is rather like a comfortable chair that offers rest from physical exertions.' What he was now trying to create was a hedonistic art, with clear decorative qualities. It was not until 1931, when he was working on *The Dance* for Albert C. Barnes, that he began once again asking fundamental questions about colour and its relationship with simple forms.

If there was a single painter who personified the notion of a 'return to order', it was André Derain. Starting before the war, and after his experiments with Fauvism, Derain produced still lifes that were influenced by Cézanne – a key figure in the French artistic tradition that Cubism was said to have betrayed. Derain had thus, as Élie Faure wrote in 1923, 'renewed the chain, which is harder to do than breaking it', and the rediscovery of pictorial space as defined during the Renaissance is much more clearly affirmed in Derain's work than in Matisse's. Because Derain succeeded in allying the art of composition and the mastery of colour with a respect for craftsmanship and an eye for commercial considerations, it is tempting to regard him not only as the central figure of the 1920s, as admired by André Breton as he was by the followers of classicism, but also as 'the greatest French painter' of the time (Lhote, January 1920). His painting drew on an entire tradition of artistic craftsmanship and used it to produce still lifes, landscapes, nudes, portraits and mythological subjects that rival Poussin's, and which demonstrate in various ways the quest for a higher, perhaps even spiritual order, that is capable of transcending the trivial and the mundane in everyday reality. The pages devoted to Derain in 1929 by Waldemar George in *La Grande Peinture contemporaine à la collection Paul Guillaume* confirmed this view: 'Derain represents the psychological duality of a realist age in search of a God and a mystery', wrote George, and the book's cover featured a reproduction of *Harlequin and Pierrot* (1924), commissioned by Guillaume. This

Pablo Picasso,
Portrait of Mme Olga Picasso, 1923.
Pastel and black pencil on paper,
104 × 71 cm (41 × 28 in.).
Musée Picasso, Paris.

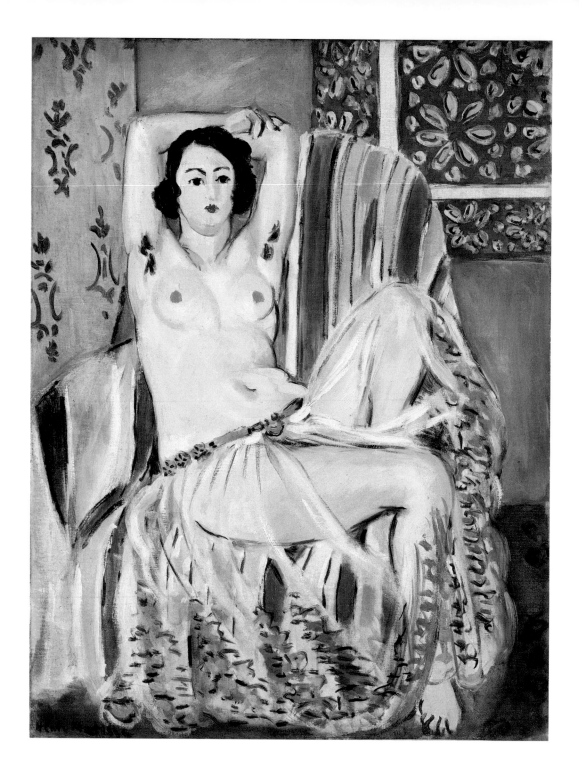

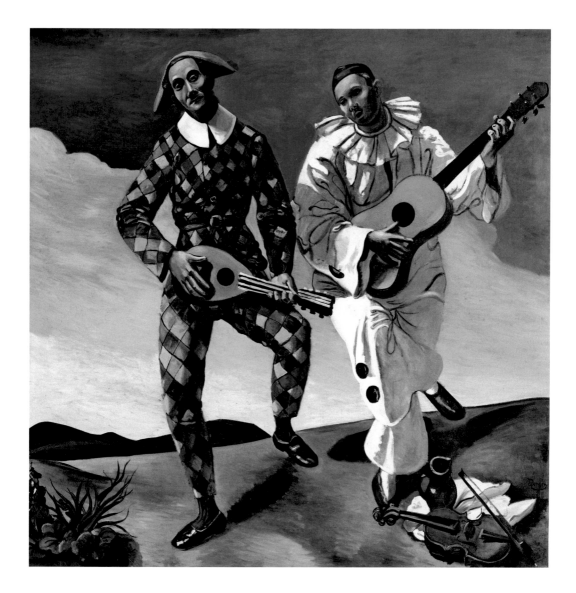

square painting situates the two figures with their impassive faces against a background that resembles a stage curtain, and this sense of artifice is echoed by the stringless musical instruments. On the ground in front of Pierrot stands a group of objects that form a quasi-autonomous still life, but the coherence of the composition is affirmed by the interplay of colours and by the massive presence of the two figures against their non-naturalistic backdrop. The Derain of the 1920s was a realist painter in one sense, but he was painting a reality altered by the demands of what he termed '*la' peinture*, a reality overwhelmed by the possibility of achieving a figurative approach that would come close to the 'grand style' – worthy of the museums. *Harlequin and Pierrot* was an affirmation of a compositional style in which the visible, the imaginary and the cultural

Above:
André Derain, *Harlequin and Pierrot*, 1924. Oil on canvas, 175×175 cm (68 ⅞×68 ⅞ in.). Musée de l'Orangerie, Paris.

Opposite:
Henri Matisse, *Odalisque Seated with Arms Raised, Green Striped Chair*, 1923. Oil on canvas, 65×50 cm (25 ⅝×19 ¾ in.). Chester Dale Collection, National Gallery of Art, Washington DC.

Above:
Maurice de Vlaminck, *Thatched Cottages*, 1933.
Oil on canvas, 73×93 cm (28 ¾ × 36 ⅝ in.).
Musée National d'Art Moderne,
Centre Georges Pompidou, Paris.

Opposite:
François Pompon, *Owl*, 1923.
Bronze, 19×8.5×8 cm
(7 ½ × 3 ¼ × 3 ⅛ in.).
Musée d'Orsay, Paris.

(the subject was taken from an Italian print) all converged. A painting capable of such a synthesis does not question its own existence – which was what Matisse and Picasso were doing, even when they did not appear to be. When Derain called Picasso 'A genius… – what a shame he's not a painter!', it is easy to see what he meant: to Derain, being a painter meant being part of a continuously unfolding history – the history to which the museums gave their official approval – and never doubting the power of the image.

André Derain and Maurice de Vlaminck collaborated closely during the early days of Fauvism. Next to Derain, however, Vlaminck cut something of a sorry figure – despite the assertion by Jacques Guenne, writing for *L'Art vivant* in 1927, that his work 'at the opposite pole from Matisse's … appears to dominate contemporary painting'. The absence of tension in Vlaminck's work rapidly led to the repetition of a limited number of concepts. Vlaminck not only concluded that Cubism was a fraud and conceived an eternal hatred for Picasso, but went further still: in turning his back on his Fauvist experimentation, he simply forgot the difference between strength and violence, and between expression and effect. His thickly applied paint and heavy brushstrokes preserved only the broadest

recognizable outlines of his motif and served his wish to avoid being trapped into anything that could have brought any element of nobility to his landscapes and still lifes. His palette was subdued, the imagery repetitive, and the paintings – which were intended to be 'simple' and accessible to all – lacked grace.

The 'return to order', with its admiration for the artist's craft and skill, and its respect for 'moderate' taste, also applied to sculpture. Academic practice had not died out with Rodin. It dominated the work of the animal sculptors (Paul Jouve, Paul Troubetzkoy, Marguerite de Bayser-Gratry and Jane Poupelet, several of whose works were purchased by public institutions), who were expected to provide a certain sense of realism and potential emotional effect. François Pompon was probably the only one among them who succeeded in achieving any real purity of form. But it was Aristide Maillol (described by Jacques Lassaigne, as late as 1937, as a valuable role model for young sculptors) and Antoine Bourdelle whose work served as a benchmark for most aspiring practitioners. Constantin Brancusi caused a scandal when he showed his phallic *Princess X* at the Salon des Indépendants in 1920, but the dominant trend was towards a 'modernism' based on a few superficially Cubist ideas about the treatment of volumes, used for purely decorative effect. Even Jacques Lipchitz, whose early works experimented with the geometric representation of volumes in a way that left the human form barely recognizable, started to reduce his massive shapes and worked with curving forms that brought him closer to neoclassicism. It would have been pointless to seek the rigour of Henri Laurens's sculptures (see p. 207) or Picasso's string and cardboard *Constructions* in the works of Joseph Csáky, Chana Orloff (who gave up a moderate style of Cubism after the war in order to specialize in busts of artists and society figures; see p. 206), Jean Lambert-Rucki, Jean Chauvin or Gustave Miklos, who took up sculpture in 1922 while also producing jewelry and interior designs for the couturier Jacques Doucet.

The 1925 Exposition des Arts Décoratifs saw Cubist influences being fused with a contemporary wish to embellish everyday life. In so far as it promoted the purely decorative aspects of painting and sculpture, the exhibition helped to establish a roughly post-Cubist approach alongside a more strictly academic style of art that was favoured by state commissions. On one hand, visitors could admire avant-garde works such as the Martel brothers' concrete Cubist trees (see p. 70), erected in the garden designed by Mallet-Stevens on the Esplanade des Invalides, the two large columns by Miklos, made of painted wood and silver and decorated with non-figurative motifs, and Marie Laurencin's canvases, which were hung in the bedroom of the Ambassade Française pavilion (see p. 208). On the other hand, the same visitors were confronted by a surfeit of frescoes and vast painted panels on both exterior and interior walls, as if striving to cover every available surface. These competed with

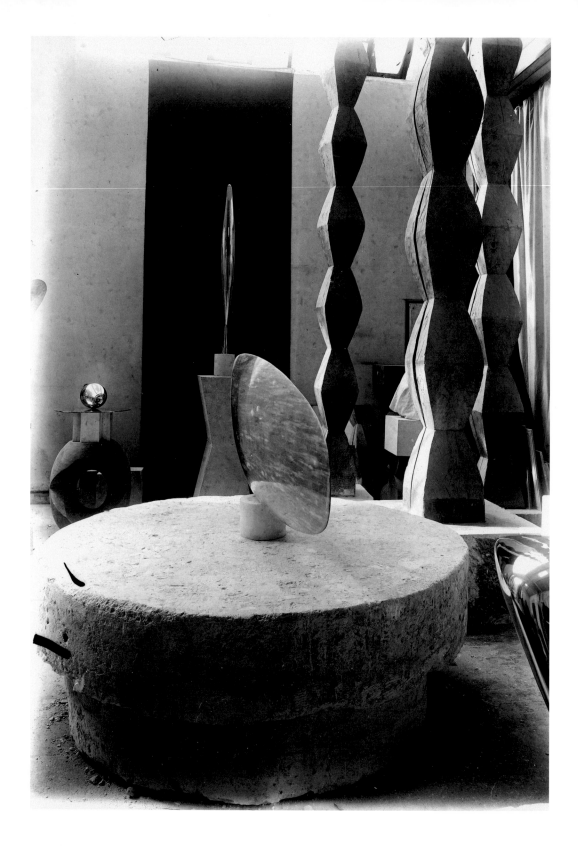

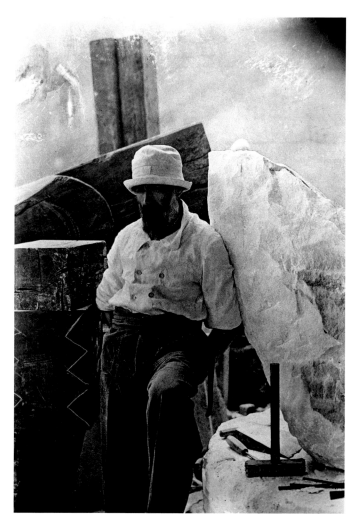

wrought-iron scrolls and foliage-covered drapery, sculptural groups,
fountains, and statues scattered across the gardens and squares, including
a plethora of nude putti romping about in the style of classical antiquity.
The Salle d'Honneur in the Grand Palais held a series of panels by
Gustave Louis Jaulmes dedicated to the months of the year, the garden
of the Collector's Pavilion contained frescoes by Henri Marret and a
group by Alfred Janniot entitled *Homage to Jean Goujon*, while a decorative
panel by Octave Guillonnet was displayed in the Cour des Métiers.
Other works included bas-reliefs by Joseph Bernard, Marcel Bouraine
and Pierre Le Faguays (*Harmony* in the Pavilion of the City of Paris), a
large *Wall of Christ* by Paul Landowski, Marcel Loyau's *Fountain of Swans*,
an impressive stone sculptural group by Lucienne Heuvelmans (*Illusions
and Regret*), François Pompon's *Polar Bear*, displayed in the hallway of the
Ambassade Française, and *Equilibrium*, a fountain by Max Blondat repre-
senting a chubby infant balancing on a sphere. These works – some of

Right:
Jacques Lipchitz, *c.* 1935.
Photograph by Rogi-André.
Musée National d'Art Moderne,
Centre Georges Pompidou, Paris.

Below:
Chana Orloff, *Woman with Fan*, 1920.
Wood, height: 93.2 cm (36 ⅜ in.).
Anna Ticho House Museum, Jerusalem.

Opposite:
Henri Laurens, *Caryatid*, 1930.
Chamotte clay, 87 × 49 × 42 cm
(34 ¼ × 19 ¼ × 16 ½ in.).
Musée Zervos, Vézelay.

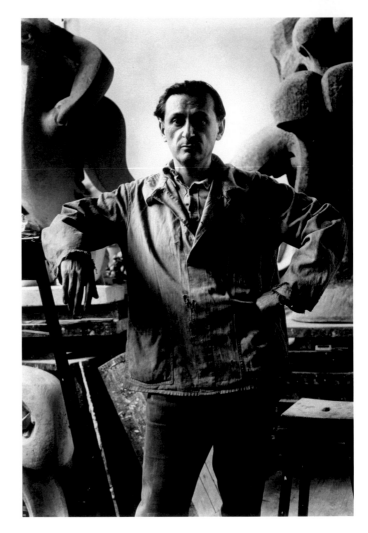

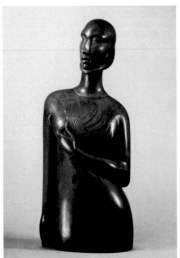

whose creators would also contribute to the 1931 Exposition Coloniale, and later to the 1937 exhibition – could have been exhibited in the same year (or ten years earlier, or ten years later) at the traditional Salon des Artistes Français, the mecca of the academicism that was ritually derided by all those who wanted to promote living, energetic art – but they would no doubt have reached a smaller audience there. Anyone interested in more contemporary artistic trends had to be content with the canvases by Juan Gris, Fernand Léger and Amédée Ozenfant displayed by Le Corbusier in his Esprit Nouveau Pavilion (see p. 210), and Robert Delaunay's *La Ville de Paris*, which hung alongside a non-figurative work by Léger in the anteroom of the Ambassade Française. The nudity of one of Delaunay's figures shocked some exhibition officials and he was obliged to add a dab of gouache – later removed – to conceal it.

One of the effects of the Exposition des Arts Décoratifs was to establish a lasting Art Deco style of painting that was readily compatible

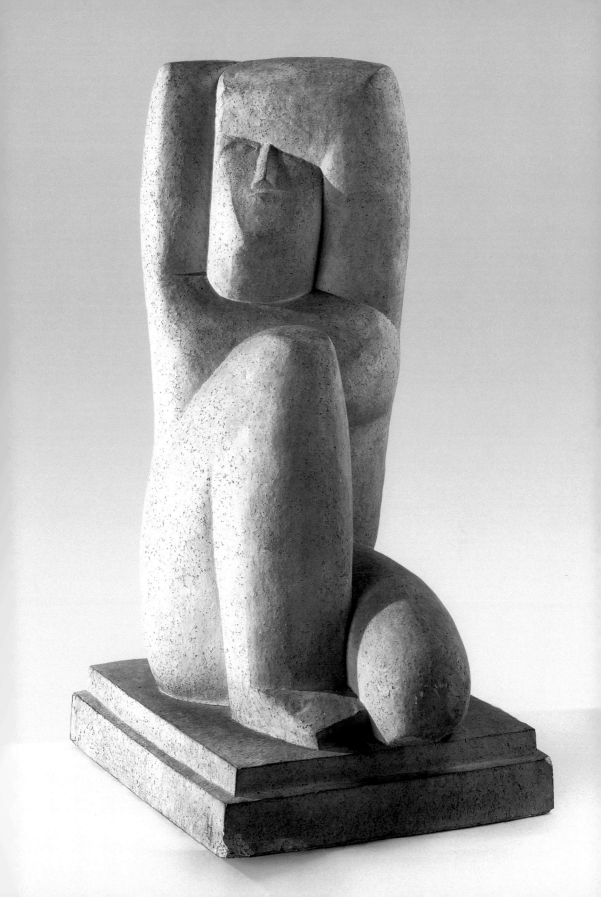

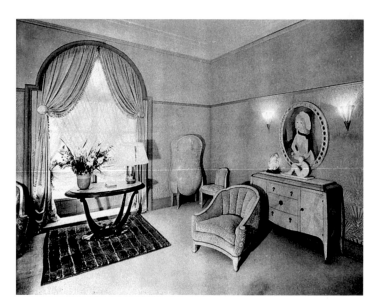

Left:
Bedroom in the Ambassade Française
pavilion, decoration and furniture
by André Groult, watercolour
painting by Marie Laurencin.
1925 Exposition des Arts Décoratifs.

Below:
The Collector's Pavilion, designed by
Pierre Patout for the Ruhlmann group.
1925 Exposition des Arts Décoratifs.

Opposite:
Pavilion of the City of Paris.
1925 Exposition des Arts Décoratifs.
Hachette Photo Library.

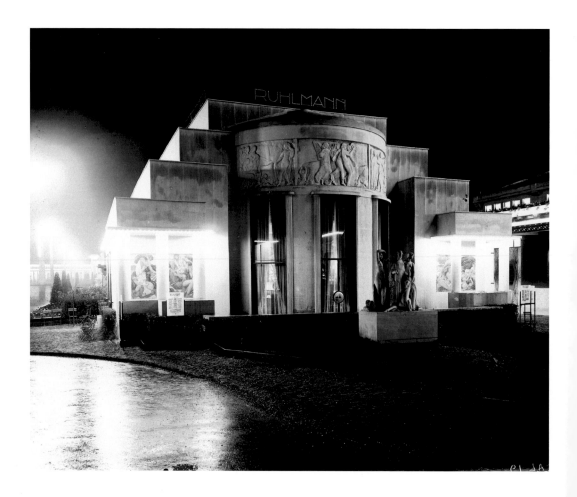

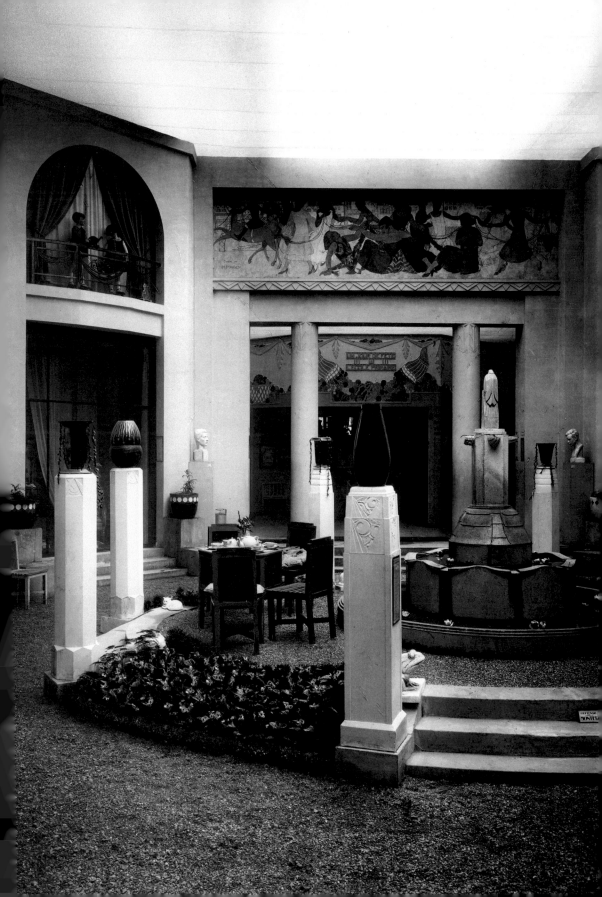

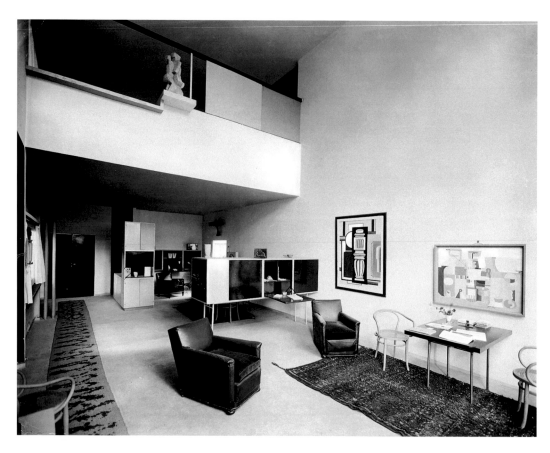

Above:
Interior view of the Esprit Nouveau
Pavilion by Le Corbusier.
1925 Exposition des Arts Décoratifs.

Opposite:
Fernand Léger, *The Baluster*, 1925.
Oil on canvas, 129.5×97.2 cm (51×38 ¼ in.).
The Museum of Modern Art, New York,
Mrs Simon Guggenheim Fund.

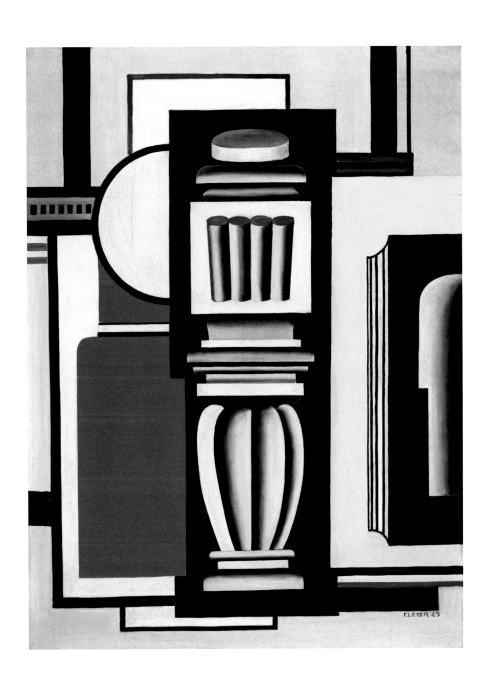

with the furniture, vases and *objets d'art* of which France – as the exhibition set out to prove – was the creator *par excellence*. This style continued to be successful up until the war, and the artists famously associated with it (Jean Dupas, Robert Eugène Pougheon, Jean Despujols, Louis Billotey and Émile Aubry) were born in the 1880s and trained at the École des Beaux-Arts, where they were influenced by the neoclassicism of Albert Besnard. They had all been awarded the Grand Prix de Rome before the First World War and regularly showed their work at the Salon de la Société des Artistes Français. Dupas painted a large panel, entitled *Parakeets* (see p. 109), for the Ruhlmann salon at the 1925 exhibition and went on to produce large-scale paintings on glass for two transatlantic liners, the *Île de France* (1930) and the *Normandie* (1935). Like his fellow artists, he favoured a rich palette, the volumetric treatment of bodies (which tended to be nude or semi-nude, in the neoclassical tradition), a wealth of decorative detail and figures whose proportions and postures suggested a spectacular but non-specific heroism. Almost all of the compositions by these painters are characterized by such coldness that

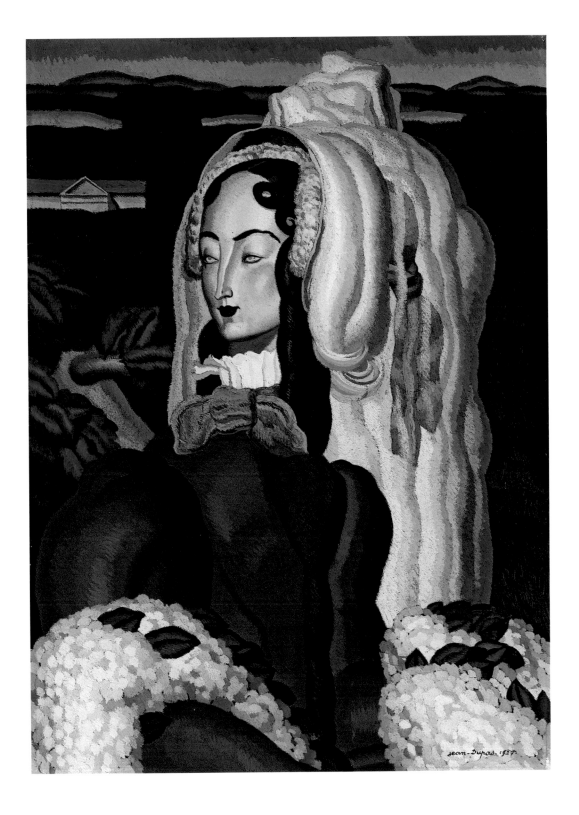

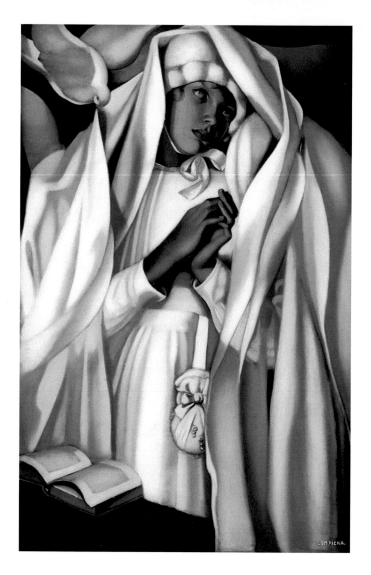

even the abundance of flesh on view arouses no hint of eroticism what-soever: the nudes in these works are as sanitized as their surroundings, which often have the flatness of a cardboard cut-out.

Although her works are characterized by the same cold figurative style, the painter Tamara de Lempicka was an artist of an altogether different calibre. In a completely different sense from a Van Dongen or a Kisling, she was very much a painter of the *années folles* — those crazy years that belonged to the privileged classes with their relaxed attitude to sexual mores. Lempicka's many neoclassical portraits are striking in their treatment of clothing and décor — which is indebted to a subdued style of Cubism — and their deliberately artificial poses inspired by the art of the plaster saints, with deeply 'sculpted' areas of light and shadow and glacial-looking flesh. Lit by a harsh and uncompromising light,

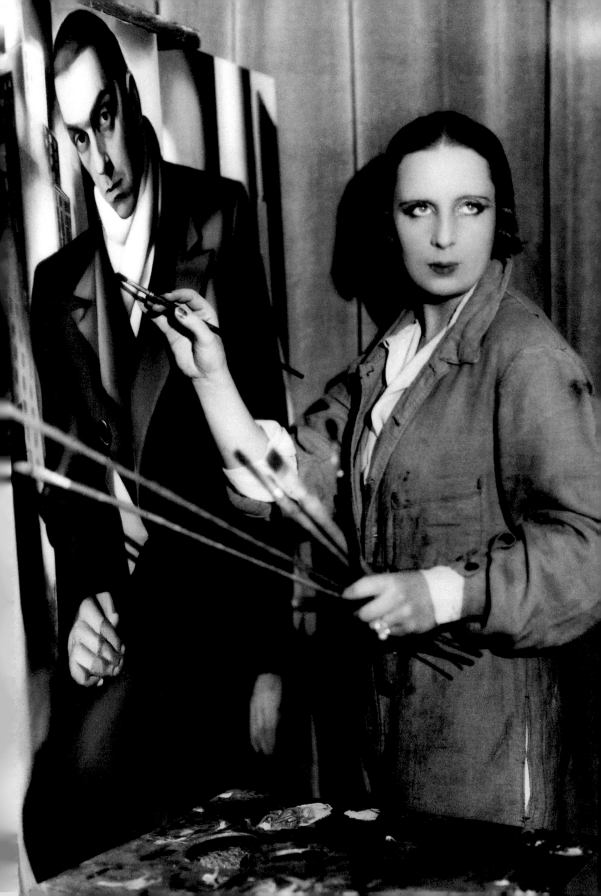

these figures offer up no intimate insights, simply acknowledging that the image is all there is.

THE SCHOOL OF PARIS

Writing in the *Revue française*, in February 1924, Roger Allard referred to the existence of a 'School of Paris'. The term was vague and Allard was using it to describe a group of exclusively foreign artists; it was not until a year later that André Warnod included French artists under the term. The 'School of Paris' implied an international dimension, however, and referred specifically to one district: Montparnasse. Since the war, Montparnasse had become a place of freedom, where it was possible to find cheap lodgings and studios, and where writers, artists and their models (including the famous Kiki, later a singer and a painter in her own right), critics, dealers and art lovers, all rubbed shoulders day and night. While Montmartre (whose Basilique du Sacré-Coeur was consecrated in 1919) was content to sit back and celebrate its golden age – from Toulouse-Lautrec to the Bateau-Lavoir – by becoming a tourist attraction, Montparnasse, with its hotels, bars and cafés, offered a cosmopolitan atmosphere, a microcosm of more or less like-minded souls, where reputations could easily bud and flourish, even if they went no further than a few streets away. The poverty in which most foreign artists lived distanced them somewhat from the dominant morality of the day and fostered a resigned attitude to the periodic outbursts of xenophobia that

Opposite:
Kiki de Montparnasse
at Le Dôme café, 1929.

Below:
Costume party in Montparnasse,
with Foujita on the right.

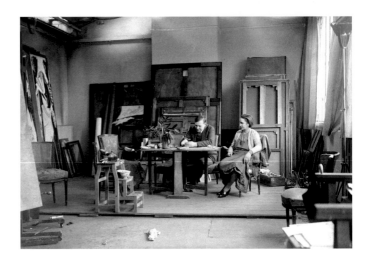

occurred during police raids on bars, many of which were also criminal haunts. Everyone knew everyone else in Montparnasse, and that was enough to nourish the idea that success might be just round the corner.

In reality, the School of Paris had existed (albeit without a name) ever since its main representatives arrived in the city: Kees Van Dongen (1897), Jules Pascin (1905), Amedeo Modigliani (1906), Jacques Lipchitz (1909), Moïse Kisling and Marc Chagall (1910), Chana Orloff (1911), Chaim Soutine and Tsuguharu Foujita (1913), Mikhail Larionov and Natalia Goncharova (1914). They all shared a love of French art, which they had either seen or heard about, and were drawn to this city where life seemed easy, even when you were poor and living a bohemian life. Some of these artists had come into contact with Apollinaire and Picasso, and the majority had given the academic École des Beaux-Arts a wide berth, preferring to attend 'free' academies – Marie Vassilieff's 'Russian' academy, the Académie Julian and the Grande Chaumière. They did not show their work at the official Salon – which Guillaume Janneau called a place for those who were 'stubbornly respectful of the methods that teach how to imitate' – but gravitated instead to the Salon d'Automne and the Salon des Indépendants. When the latter closed its doors, they switched to the Salon des Tuileries: in its second year, this salon exhibited 540 artists, 116 of them women, and 141 listed as foreign in the catalogue (among them, Foujita, Henri Hayden, Per Krohg, Larionov, Lipchitz, Louis Marcoussis, Chana Orloff and Josef Sima).

Some of the new arrivals, such as the Russians Antoine Pevsner (1922) and Jean Pougny (1923) and the Hungarians Étienne Beöthy and Henri Nouveau (1925), had already made clear-cut artistic choices, but a great many inexperienced young artists also came to swell the ranks: in 1924, the Académie de l'Art Moderne founded by Léger and Ozenfant attracted a mixture of Scandinavians, Poles, Americans, Romanians and Japanese. For the artists of the School of Paris, the objective was not to

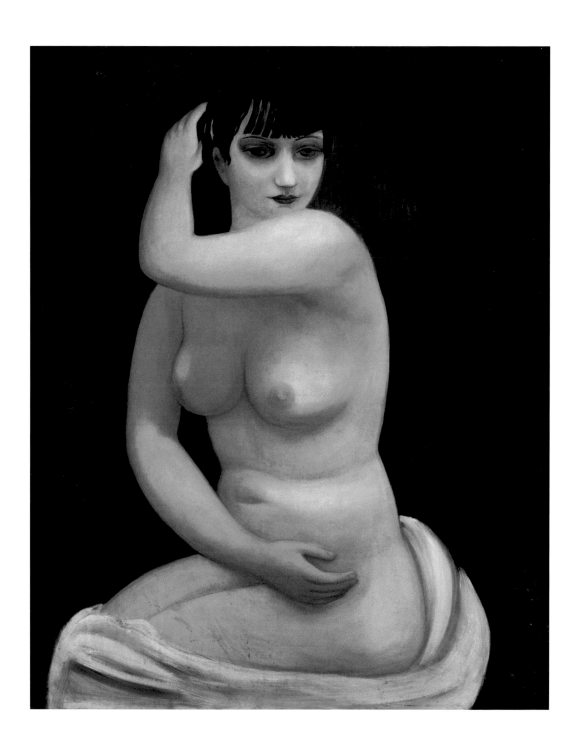

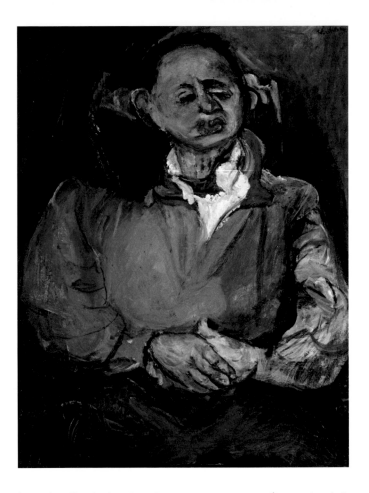

learn the official rules of art, but to acquire a means of expressing their creativity. The death of Modigliani, in 1920, was seen by Francis Carco as the passing of the 'a generation's last bohemian', but Modigliani's determination to continue painting in his own particular style was ultimately sanctioned by success, albeit posthumous. Chaim Soutine also suddenly became a wealthy man when Paul Guillaume took Albert C. Barnes (an American multimillionaire responsible for developing the antiseptic drug Argyrol) to visit his dealer Zborowski in 1923 and Barnes began collecting Soutine's canvases – amply demonstrating that, despite the terrible poverty with which he struggled and the stubborn incomprehension that greeted his work, Soutine was right to persevere in his endeavours to uncover the 'other', potentially terrifying, side of appearances. Since it seemed that even the most despised could ultimately be rewarded with success, sometimes during their own lifetime, it was possible to believe that failure gave added authenticity to an artist's work.

The need for individual 'expression' was such that the School of Paris did not exhibit a single unified style – and even less so if it is deemed to include Picasso and Juan Gris, who clearly had little in

common with the likes of Pascin and Chagall. This 'school' did not encompass an existing trend, as did those associated with Mondrian, or Brancusi, or the Surrealists, or painters whose reputations were founded on a clearly defined trajectory (Léger, Matisse, Bonnard, Dufy). It had no leader, no organization and no manifesto. Its 'members' were not avant-garde; they painted numerous portraits and nudes, subjects that were generally avoided by the Cubists; they were simply content not to be academic painters, and even Kisling's rather insipid classicism shared no real common ground with the subjects that were generally awarded the Prix de Rome: *Youth and Old Age* (1920), *The Burial of St Anthony* (1921), *Fortune and Abundance Emerging from the Ploughman's Furrow* (1922), *The Faun Musician, At Work, Jesus at the House of Martha and Mary* (selected in 1924, along with the sculpture *The Woodcutter Calling for Death, after La Fontaine*), and *The Legend of St Ronan* (1925, the year that Odette Pauvert became the first woman to win first prize).

The artists of the School of Paris practised a whole range of figurative styles, although they maintained enough of a connection with their subject matter to keep it recognizable: Soutine's tortured expressionism,

Opposite:
Chaim Soutine, *Portrait of the Sculptor Oscar Miestchaninoff*, 1923.
Oil on canvas, 83×65 cm (32 ⅝ × 25 ⅝ in.).
Musée National d'Art Moderne,
Centre Georges Pompidou, Paris.

Below:
Jules Pascin, *The Temple of Beauty*, 1923.
Oil on canvas, 124×150 cm (48 ⅞ × 59 in.).
Musée d'Art Moderne de la Ville de Paris.

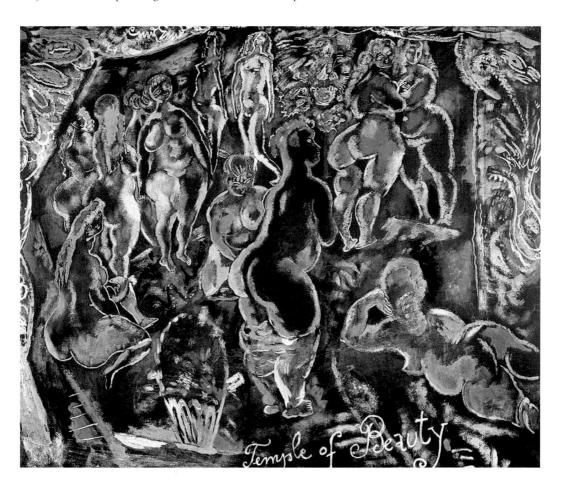

the elegant lines, precision and pearly colours characteristic of Foujita, Chagall's dreamy fantasies, or Van Dongen's society portraits, which sometimes carry a hint of aggressive coloration. If we compare their output with that of contemporary German artists – Expressionists and artists of the 'New Objectivity' movement – we note the absence of any political or critical dimension in the works of the School of Paris (with the exception of Georges Rouault). For them, the city was not a place of ideological conflicts or class confrontation, but simply a context where particular locations – interiors for portraits and still lifes, and public places (streets and walls for Maurice Utrillo, brothels for Jules Pascin) – could be found and used to create art. Was this because artists of foreign extraction were wary of taking sides publicly regarding the situation in their adoptive country? Or was it because in France – which was officially 'victorious' – there was a prevailing atmosphere of insouciance that pushed the complex politics of the 1920s into the background? It is true, however, that the Surrealists did have political concerns at the time, although these are barely detectable in their paintings.

From 1930–31, the effects of the Depression began to make themselves felt in the art world: galleries, now deserted by their American clientele, sold less and some went out of business, and many artists of foreign extraction returned to their homelands, while those who remained in the capital had to survive on relief funds for 'unemployed intellectuals' (six francs a day). Paris would soon see a new wave of immigrants arriving, this time for more political reasons, including artists who had already completed their training, and who often only stayed in the capital for a brief time, before going on to London or the US.

In 1931, Waldemar George, one-time supporter of the School of Paris, declared that it had gone on long enough: 'The time has come for

France to take a look at itself,' he wrote in the journal *Formes*, 'to go back inside itself and find within its own heritage the basic elements of its salvation.' His article, significantly entitled 'L'École de Paris et l'École française', was not outwardly aggressive towards foreigners, but it suggested a certain weariness and asked the question: had their presence in fact corrupted the spirit of the French nation? For two years, Camille Mauclair had been running a campaign in *Le Figaro* and *L'Ami du peuple* (a paper founded by the perfume manufacturer François Coty in 1928, which had a circulation of a million in 1930) in a much more virulent style, clearly affirming his xenophobia and his anti-Semitism. Mauclair detested virtually everything the century had produced in artistic terms and regarded the School of Paris merely as a pitiful example of the pictorial Esperanto that had been enthusiastically embraced 'by a powerful majority of foreigners, Scandinavians, Germans and Judeo-slaves'. He accused a consortium of dealers – 'Gluant, Lévy-Tripp and Rosenschwein' – of treating art lovers as fools by selling them goods that had nothing artistic or French about them.

Partisans of the 'French tradition' had long warned of the 'risks' of welcoming foreign artists, but the cosmopolitan nature of the School of Paris was inevitably perceived as increasing this risk. Writing in 1928 in *Partisans* (formerly an anti-nationalist journal), L. Eugène-Parturier judged that it was time to preserve the 'ethnic character' of art and put an end to foreign imports. Camille Mauclair was thus far from being an

Opposite:
Foujita in his Montparnasse studio, *c.* 1924.

Below:
Tsuguharu Foujita,
Reclining Nude with Toile de Jouy, 1922.
Oil, Indian ink and pencil on canvas,
130 × 195 cm (51 ⅛ × 76 ¾ in.).
Musée d'Art Moderne de la Ville de Paris.

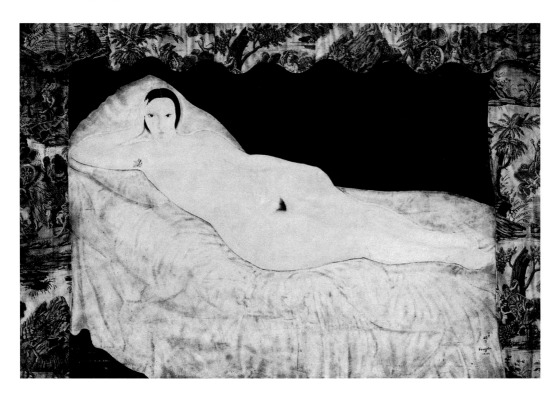

isolated case: the widespread atmosphere of xenophobia, provoked by competition for jobs, began to affect the art world too, challenging dealers (linked to 'Jewish bankers of Germano-American extraction') and those who were sometimes 'in their pay'. In a time when protecting 'all French businesses' and 'French industries' was a paramount concern, artistic production itself had to become national once more.

The final days of the School of Paris coincided with a scattering of exhibitions bringing together artists with shared origins. An exhibition of 'Italian Painters in Paris', held in Milan in 1930, moved to the Galerie Bernheim in 1932, and then to the Galerie Charpentier: among the exhibitors were Modigliani, Campigli, De Chirico, De Pisis, Savinio (who returned to Turin for good that year), Tozzi and Severini. Also in 1932, forty-six Paris-based American artists exhibited together at the Galerie de la Renaissance.

In December, the Musée des Écoles Étrangères Contemporaines (showing five hundred canvases and a hundred or so sculptures) was opened at the Jeu de Paume. For ten years, the Jeu de Paume had served

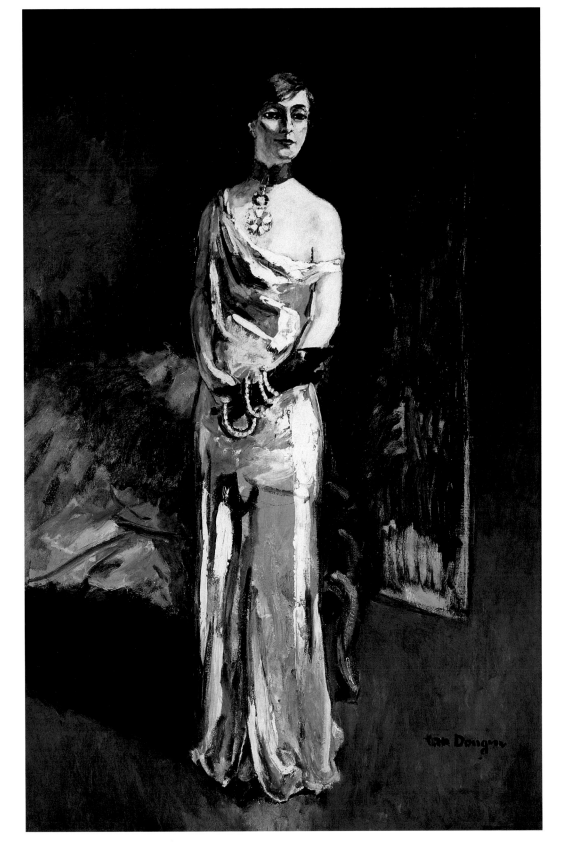

as an annexe of the Musée du Luxembourg, for works by foreign artists. Its curator André Dezarrois was more open to the 'modernists' than his colleagues. But the classification of works by nation completely ignored the international nature of art movements and raised the question of where works by foreigners based in Paris should be placed. In the end, they were hung in Room 14, dedicated to the School of Paris and frequently judged to be the most interesting. It contained works by Zadkine, Chana Orloff, Manolo, Gargallo, Modigliani, Van Dongen, Picasso, Juan Gris, Eugène Zak and Soutine among others, most of them on loan from dealers or collectors.

Until the end of the decade, the Jeu de Paume continued to hold exhibitions dedicated to art from abroad: 'Modern Italian Art' (1935), 'Contemporary Spanish Art' (more than four hundred works in 1936, with a room devoted to Picasso and Juan Gris, though the public appeared to prefer the realism of José Solana), 'Catalan Art' (1937), 'Three Centuries of Art from the USA' (1938, an exhibition organized in tandem with the Museum of Modern Art in New York, with sections on architecture and popular art, photography and cinema), and 'Art in Latvia' (1939). Shows such as these were a way of letting Parisians know what was happening elsewhere, but without shaking their belief in the dominant role played by French art: 'France is currently *the* country of painting', declared André Lhote in 1936.

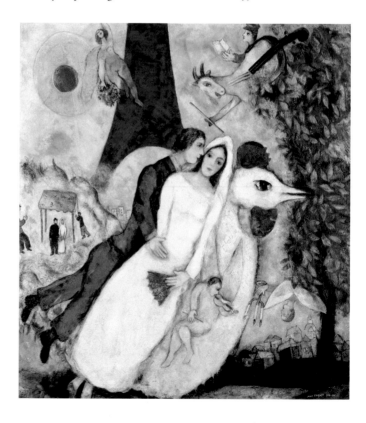

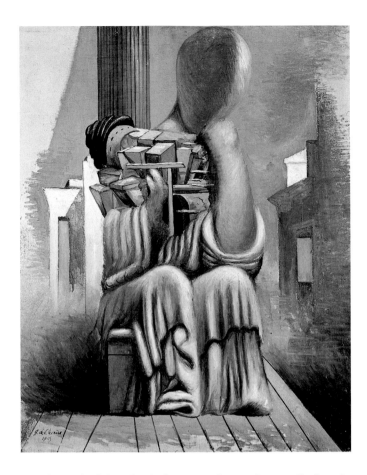

The myth of the School of Paris, confirming the capital's allure for artists from all over the world, did nothing to help artists from abroad who wished to show their work there: from the end of the Great War until the early 1930s, few galleries offered their wall space to Klee, Grosz, Kokoschka or Beckmann. Newspapers and journals covered exhibitions in the city, but news of contemporary foreign art was only to be found in a handful of small-circulation publications such as *Formes* and *Les Chroniques du jour*. The same was true for monographs: between 1919 and 1933, Gallimard published some seventy volumes in the series 'Les peintres français nouveaux', edited by Roger Allard, a supporter of a mild form of modernism, but with the exception of Klee (with text by René Crevel), the only foreigners to be included in the series were those who had been based in Paris (Picasso, De Chirico, Kisling, Man Ray, Severini, Marcoussis). Other publishers (Georges Crès, Les Écrivains Réunis) produced volumes on Kokoschka and Grosz and *Contemporary German Painting* (in which Émile Waldmann barely makes mention of Kandinsky), and in 1932 *Les Cahiers jaunes* devoted a special edition to Prampolini and the painters and sculptors of Italy, but generally speaking, very little was heard about developments in art beyond France's borders.

Below right:
Marie Vassilieff in her studio.
Photograph by Marc Vaux.
Bibliothèque Kandinsky, Centre
Georges Pompidou, Paris.

Opposite:
Alexandre Iacovleff,
Djerma Warriors in Parade Uniform, 1924.
Watercolour, 38 × 28 cm (15 × 11 in.).
Musée du Quai Branly, Paris.

THE ART OF THE EXOTIC

Primitive and tribal art, discovered by the Fauves and the Cubists, became a growing source of interest. In 1919, Paul Guillaume curated an exhibition of African sculpture at the Galerie Devambez, wrote in his journal *Les Arts à Paris* about the historical background of what he called this 'new aesthetic', and invited all of fashionable Paris to the 'Fête Nègre' at the Théâtre des Champs-Élysées. This show involved the collaboration of dancers, musicians (Poulenc, Honegger) and painters (Van Dongen designed tattoos and Dunoyer de Segonzac and Luc Albert Moreau worked on props), and Blaise Cendrars read some of the pieces that would later be published in his *Anthologie nègre*. Tribal art had been embraced by high society.

At the end of the following year, Félix Fénéon published a survey on tribal art in *Le Bulletin de la vie artistique* (Galerie Bernheim-Jeune), asking the question 'Should it be allowed into the Louvre?' and receiving very mixed responses. In 1923, an exhibition (with an ethnological bias) brought together examples of the 'indigenous art of the French colonies in Africa and Oceania and the Belgian Congo', and the same year Fernand Léger designed the 'African-inspired' costumes and sets (see p. 366) for Darius Milhaud's ballet *The Creation of the World*, commissioned by the Ballets Suédois. There were several well-respected private collections of African art (belonging to Léonce Rosenberg, André

Level and Paul Guillaume), and a proliferation of articles (in *L'Art vivant*, by Henri Clouzot and André Level, and in *Les Feuilles d'art* by Lucien Vogel) and books on the subject, including *African Sculpture* by Carl Einstein (1922), *Sculptures of Africa and Oceania* by Clouzot and Level, *African Negro Civilizations* by Maurice Delafosse (1925), *Primitive Negro Sculpture* by Paul Guillaume and Thomas Munro, and *The Art of Primitive Peoples* by Adolphe Basler. Working from her Montparnasse studio, in 1922–23, Marie Vassilieff also began producing primitive-style dolls, predominantly using materials recovered from neighbourhood dustbins: these terracotta figurines, covered in fabric, ribbons, buttons and pieces of metal, were conceived 'in response to the extreme banality of modern and classical sculpture'.

The 1925 exhibition encouraged the craze for all things African: one of the pavilions celebrated the Croisière Noire, an epic journey across

Above:
Jean Victor Desmeures, poster
for the 1931 Exposition Coloniale.
150×99.5 cm (59×39 ¼ in.).
Musée de l'Armée, Paris.

Below right:
A reconstruction of the temple of
Angkor Wat, 1931 Exposition Coloniale.

Opposite:
The Asian Pavilion at the 1931
Exposition Coloniale.

Africa by car, sponsored by Citroën (Alexandre Iacovleff was its official painter), and the cast of the *Revue Nègre* – a huge success at the Théâtre des Champs-Élysées, thanks to Josephine Baker dazzling the audience with her wild and athletic dance routines – were invited to put on a performance of the show. Designers at the exhibition also showed chairs and day beds inspired by 'African' forms: in lifestyles and social customs apparently far removed from their own, they found decorative qualities for which the likes of Vlaminck and Picasso showed little concern. This trend for *'l'art nègre'* was not limited to African art alone, but extended to the Americas and the Pacific islands, and its musical backdrop was a mixture of what was called 'jazz' (although it had little in common with the music of New Orleans or Chicago) and the Caribbean *biguine*.

The Exposition d'Art Africain et Océanien, organized by Tristan Tzara, Pierre Loeb and Charles Ratton at the Galerie du Théâtre Pigalle in 1930, provided a timely reminder that these internationally inspired creations could sometimes resist efforts at domestication: prior to the opening, seven works were withdrawn on the grounds of 'obscenity' (in the view of the gallery's owner, the Baron de Rothschild), but they were swiftly reinstated by the organizers.

The Exposition Coloniale in 1931 promoted assimilation with quite formidable efficiency. Colonial ideology meant that the original characteristics of the colonized countries could only be presented in modified terms, through the filter of the 'beneficence' that emanated from the metropolis. The result was that, in the field of art, it was the Western, or French, viewpoint that inevitably took precedence: the various pavilions either recreated indigenous buildings with relative accuracy, but underlined their otherness, or only retained only a few details of original styles to add spice to unremarkable forms of French architecture and decoration. The focus was not just on Africa, but on a colonial style that

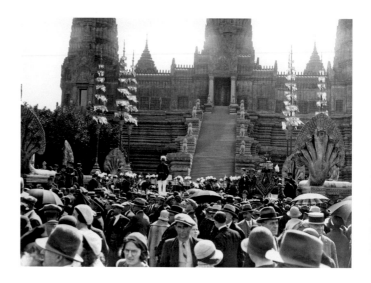

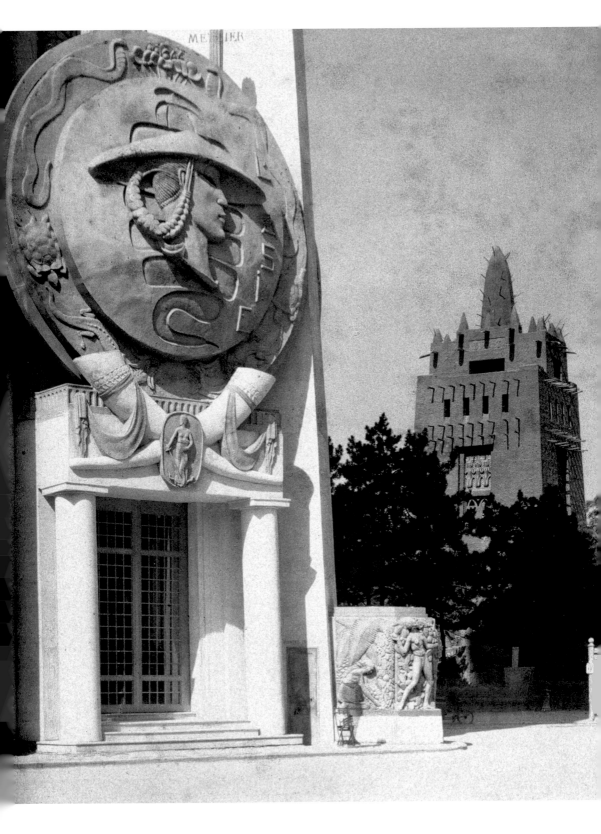

had global ambitions, capable of taking control of every region of the world and keen to demonstrate only the manifestly 'positive' aspects of colonization. Aside from a few masks and statuettes that were inconspicuously displayed, and a number of archaeological finds that demonstrated French achievements in the field of excavation, 'indigenous' works of art were rare: live dance performances were much more popular. Instead, the pavilions were decorated with frescoes and bas-reliefs symbolizing the continents, narrating the major events of colonial history and evoking the charms of local life. Jean Bouchaud designed four large panels for the cupola of the Information Building, and paintings by Pierre Ducos de la Haille, Louis Bouquet and Ivanna Lemaître were displayed in the Musée des Colonies (now known as the Cité Nationale de l'Histoire de l'Immigration). Alfred Auguste Janniot created a bas-relief façade with the assistance of no fewer than thirty fellow sculptors, and a statue in gilded bronze by Léon-Ernest Drivier was erected in front of the building. Entitled *France Bringing Peace and Prosperity to the Colonies* (see p. 79) it represented the goddess Minerva wearing a Phrygian cap, in an academic style that befitted its subject. The Algerian Pavilion was decorated with another frieze by Jean Bouchaud (whose work also featured in the Indochina Pavilion) and panels by Eugène Corneau and Armand Assus; Mme Tholnot created a large fresco for the Oceania Pavilion; Mme Chateaud-Chabas painted another for the mosque at the Somali Pavilion; and Marie-Antoinette Boullard-Devé painted a frieze 40 metres (130 ft) long, representing the peoples of Indochina and French India, for the central staircase of the

replica of the temple of Angkor Wat. The exhibition featured work by a number of female artists (including African dioramas by Jeanne Thil and frescoes by Louise Janin) and in many cases gave them their first professional commissions. Sculptures were scattered around the parks – including two monumental elephants at the entrance to the French India Pavilion, which were the work of Jean Magrou – and displayed in many pavilions, but perhaps the most notable sculptor was a woman. Anna Quinquaud's work could be found in the Palais des Beaux-Arts and the French West Africa Pavilion and successfully combined 'realism' and classical tradition: her first-hand experience of Africa (which she had first visited in 1925) gave her work documentary value, while her technique transformed its otherness into something that fit with conventional ideas of 'beauty'. Quinquaud's *Woman of Fouta-Djallon* was reproduced on the cover of *L'Illustration* on 27 June 1931.

QUIMPER À L' EXPOSITION COLONIALE

Jean R. ROTTÉ *Bernard Jules VERLINGUE*

In a sense, the Exposition Coloniale marked a shift from avant-garde primitivism to Art Deco exoticism. The Manufacture Nationale de Sèvres even exhibited a collection of 'colonially inspired' vases and sculptures, including designs by Anna Quinquaud. The millions of visitors who flocked to the exhibition had never read the Surrealist tract entitled 'Do Not Visit the Colonial Exhibition'; nor did they know about the 'Anti-Exposition Coloniale' organized by the Communist Party with the help of Aragon, Sadoul and Tanguy and held in the Soviet Pavilion from the 1925 exhibition, now rebuilt in the avenue Mathurin-Moreau; nor did they attend the sale of 'African, American and Oceanian sculptures' held by Breton and Éluard at the Hôtel Drouot on 2 and 3 July. What most

fascinated these visitors was not the unusual nature of this art from other cultures: it was the uplifting interpretation that they could bestow upon it, allowing these images of 'elsewhere' to give them a brief thrill of excitement but never letting them challenge the values of their French homeland. Colonial art was not a new phenomenon (a Société Coloniale des Artistes Français had existed since 1907 and, like the trading companies, was responsible for awarding prizes and travel grants), and in a sense it picked up where Orientalism left off. In the early years of the century, Chabaud, Van Dongen, Matisse and Klee all spent time in North Africa, but the works that they subsequently produced did not focus on local folklore (whether authentic or filtered through the imagination), but instead reflected their personal artistic journeys. In comparison, colonial art lost ground: although it set out to satisfy people's curiosity about unfamiliar landscapes, customs and lifestyles, in fact it only presented the most innocuous aspects, showing nothing that might recall the scenes of oppression recorded by André Gide in his *Travels in the Congo* (1927) and *Return from Chad* (1928). After the 1931 exhibition, colonial artists quietly slotted into the official Salon, where their works added a hint of the exotic to commonplace genres such as portraits, nudes, flower studies and regional scenes: often the only differences between a 'Moorish coffee house' and a 'Breton inn' were the furnishings and the costumes. Every painter and sculptor had a speciality: North Africa for Étienne Dinet, Rodolphe d'Erlanger and André Suréda, Cameroon for Marie-Marguerite Martin, and Sudan for Albert Dequenne.

DADA AND SURREALISM

In Zürich, members of the Dada movement found inspiration in African songs, dances and masks, but rather than seeking exoticism, they wanted to confront the audience at the Cabaret Voltaire with a 'primitivism' that reflected a radical urge to abandon so-called European 'values' – those same values that had made it possible for the Great War to occur. After Zürich, Dada had moved to Berlin (with Richard Huelsenbeck, Hannah Höch, George Grosz, the Herzfelde brothers and Johannes Baader) and to Cologne, where Max Ernst and Johannes Theodor Baargeld distributed their journal *Der Ventilator* in the streets and caused a scandal in November 1919 when they were invited to exhibit at the Kunstverein and submitted, alongside other work, drawings by children and mental patients.

Paris was not immune to all this brouhaha. Tristan Tzara's *Dada Manifesto*, published in 1918, brought Dada to the attention of Breton, Aragon and Soupault and, taking Rimbaud and Lautréamont as their role models, the group took it upon themselves to shake up the literary establishment. In October 1919, their journal, *Littérature*, began publishing extracts from *The Magnetic Fields*, experiments in automatic writing conducted jointly by Breton and Soupault.

PREMIER VENDREDI

DE **LITTÉRATURE**

Le 23 janvier 1920, à 16 h. 30
AU PALAIS DES FÊTES 199, rue Saint-Martin

M. André Salmon parlera
DE LA CRISE DU CHANGE

Poèmes de
MM. Max Jacob, André Salmon, Pierre Reverdy, Blaise Cendrars, Maurice Raynal, Francis Picabia, Louis Aragon, Tristan Tzara, André Breton, Jean Cocteau, Georges Ribemont-Dessaignes, Philippe Soupault, Pierre Drieu la Rochelle, Paul Eluard, Raymond Radiguet.
lus par
Mademoiselle Valentine Tessier; MM. Herrand, Bertin et Fraenkel; MM. Louis Aragon, André Breton, Jean Cocteau, Pierre Drieu la Rochelle, Raymond Radiguet.

On présentera des toiles de
MM. Juan Gris, Georges Ribemont-Dessaignes, Georges de Chirico, Fernand Léger, Francis Picabia.
et des sculptures de
M. Jacques Lipchitz.

On interprétera la musique de
MM. Georges Auric, Darius Milhaud, Francis Poulenc, Henri Cliquet.

Au piano Madame Marcelle Meyer.

ENTRÉE : 2 FRANCS

Above:
Advertisement for the journal *Littérature*'s first 'Friday session', January 1920.

Opposite:
Man Ray, *Tristan Tzara*, 1921.
Photomontage, gelatin silver print.
Musée National d'Art Moderne,
Centre Georges Pompidou, Paris.

Above:
Special issue of the journal *391*,
'Le Pilhaou-Thibaou', 15 July 1921.

Right:
Francis Picabia on his *dada* (hobby horse),
c. 1919; behind him stands his partner,
Germaine Everling.

Visitors to the Salon d'Automne were scandalized by Francis Picabia's mechanical art – technical diagrams of functional objects accompanied by a handful of words, intended to evoke emotional states and situations. These works made a mockery of figurative traditions and viewers were torn between amusement and indignation. Like the other Dadaists, Picabia rejected the idea of specialization and wrote as much as he painted, publishing his journal *391* wherever he happened to be at the time. Breton read Picabia's *Pensées sans langage* and invited him to contribute to *Littérature*. When Tristan Tzara arrived in Paris in January 1920, it was Picabia who offered him a roof over his head and it was at Picabia's home that Breton, Soupault and Aragon finally met the Romanian-born poet. They were somewhat disappointed by his physical presence, but recognized his genius for 'publicity', a talent that had been heavily practised in Zürich and which enabled Dada to establish itself rapidly in Paris. The first of the Surrealist journal's 'Friday sessions' involved readings of various texts, punctuated by ringing bells and other noises, and was deemed a partial failure. As the Dadaists' tactics gradually grew more extreme, they provoked heckles and shouts from audiences who may have thought themselves 'progressive' but

Francis Picabia, *The Cacodylic Eye*, 1921.
Oil on canvas with photographs and postcards,
148.6 × 117.4 cm (58 ½ × 46 ¼ in.).
Musée National d'Art Moderne,
Centre Georges Pompidou, Paris.

could not bear this debunking of traditional values which appeared to offer no positive alternatives. Readings of incongruous texts and manifestoes (every Dadaist wrote one), stagy or deliberately bad sketches, musical interpretations, readings (including Tzara's *The First Heavenly Adventure of Mr Antipyrine*) by narrators hiding inside huge paper bags or cardboard boxes, the Dadaist soirées and performances (at the Club du Faubourg, the Maison de l'Oeuvre and the Salle Gaveau) were widely reported – if only critically – and soon became *the* events to attend.

In Zürich and Germany, not only did the Dadaists overturn the rules of logic and of language, they also launched an attack on the visual arts through photomontages, collages and randomly produced works that made earlier similar attempts look like old hat. In Paris, on the other hand, Picabia was really the only artist who was leading an equally ambitious offensive against painting (and had been since before the war). He contributed two works to the first of the 'Friday sessions': *Riz au nez*, a chalk drawing on slate which Breton rubbed out with a sponge, and *The Double World*, which blurs the boundaries between painting and packaging. At the Théâtre de l'Oeuvre, on 27 March 1920, he showed *Still Lifes*, an image of a toy monkey captioned as a 'portrait' of Rembrandt, Cézanne and Renoir. The exhibition he held at Jacques Povolozky's Galerie La Cible, at the end of the year, combined Impressionist canvases, portraits of Spanish women and mechanical pictures, and the private view was attended by Dadaists and society people.

The early date of Picabia's first forays into anti-art led him to think of himself as the only authentic Dadaist. In May 1921, he announced that he was leaving the group, though he continued to mount his own personal offensives, publishing the journal *Le Pilhaou-Thibaou* and various tracts denouncing all dissenters, and exhibiting *The Cacodylic Eye* (see p. 237), a panel featuring signatures and slogans written by his friends (and

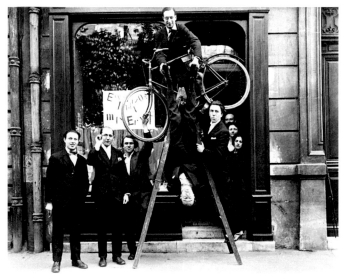

enemies), at the Salon d'Automne. The Salon des Indépendants showed Picabia's *Dance of St Guy*, an empty frame with strings stretched across it, hung with phrases written on cardboard, but turned down two of his other works in 1922, giving him an excuse to condemn all official art.

The Dadaists produced a number of short-lived journals (*Bulletin Dada*, *Dadaphone*, *Proverbe*, *Cannibale* and *La Pomme de pin*) in which they praised one another's work, settled old scores, started rumours and made untimely announcements, as part of an all-out campaign to demoralize the opposition. Two exhibitions (both of them fiascos) demonstrated that Picabia was not in fact the only Dadaist producing

Above:
Man Ray, *Gift*, 1921.
Flat iron and nails, 16.3 × 9.5 × 11 cm
(6 ⅜ × 3 ¾ × 4 ⅜ in.).
Work exhibited at and stolen from
the Galerie Six in December 1921.
Photograph by Man Ray.

Right:
The Dada Salon at the Galerie
Montaigne, Théâtre des Champs-Élysées,
6–30 June 1921.

Opposite:
Marcel Duchamp, *L.H.O.O.Q.*, 1919/1964.
Assisted readymade: pencil on a
reproduction of the *Mona Lisa*,
19.5 × 12.5 cm (7 ¾ × 5 in.).
The Vera and Arturo Schwarz Collection,
Israel Museum, Jerusalem.

visual art. The first of these was the Max Ernst exhibition organized by
Breton at the Galerie au Sans Pareil in May–June 1921. Ernst was not
present, being unable to travel to Paris without a passport, but Breton
was enthusiastic about Ernst's 'overpaintings' (engravings in which the
original image was distorted by layers of applied gouache), and his col-
lages (unlike Cubist collages, these were made from fragments of
existing engravings, rearranged to produce surprising new forms).
Breton saw these works as forging unexpected relationships between
'distant realities', and thus as inventing a visual world that was compara-
ble to the revelations of poetic imagery, particularly of the kind that is
freed from the censoring effects of consciousness, as advocated by *The
Magnetic Fields*.

Late in 1921, an exhibition of pictures and objects by the American
artist Man Ray caused another sensation. Man Ray had arrived in Paris
on 14 July and was welcomed by Marcel Duchamp, whom he had met in
New York. Throughout the 1920s he and Duchamp collaborated on a

La Joconde.

series of photographs in which Duchamp appeared dressed as a woman, under the pseudonym 'Rrose Sélavy'. In addition to working as a photographer, in 1917 Man Ray also began producing 'aerograph' paintings using an airbrush on photographic paper (an idea of Duchamp's). He collaborated on Picabia's journal, *391*, and he and Duchamp published a single issue of *New York Dada*. At the Galerie des Six, he showed thirty-five pictures, prefaced by a series of statements made by his new-found Paris friends, ranging from Aragon to Tzara. The pictures were concealed behind bunches of balloons and only revealed their simple forms and bold colours once the balloons had burst. Man Ray was still busy making his *Gift* – a flat-iron bristling with a row of nails – when the private view was underway. This work was stolen in the course of the evening, but was the only one to leave the premises: nothing else was sold. Man Ray settled in Montparnasse and was fortunate enough to make a living as a photographer, producing portraits and carrying out commissions for couture houses.

Marcel Duchamp rarely exhibited his work. He returned to New York in June 1921 and his subsequent trips to Paris were taken up with lengthy chess sessions, which he seemed to find more engrossing than art. When the Paris Dadaists invited him to contribute to their Salon at the Galerie Montaigne, from 6 to 30 June, he sent his response in a telegram to his brother-in-law Jean Crotti, which read simply 'Pode Bal' – 'balls to you'. He liked meeting friends at La Rotonde or Bar Certa, in the passage de l'Opéra (a favourite haunt of the Dadaists, who avoided both Montmartre and Montparnasse), but said very little about his 'ready-mades', objects which he merely 'chose' (because they left him indifferent) and then supplemented with a title or an inscription, or about the progress of his *Large Glass*, located in his New York studio. If he ever alluded to a particular project – relating, for example, to optical illusions – it generally bore little connection with the usual preoccupations of painters and sculptors. Duchamp's signature appears in Picabia's *The Cacodylic Eye* (see p. 237) and Picabia published an (incomplete) reproduction of *L.H.O.O.Q.* (see p. 241), Duchamp's 'version' of the Mona Lisa, with a moustache and a beard, in *391* in March 1920, and a pun by Duchamp in *Le Pilhaou-Thibaou*.

Among its Paris practitioners, Dada soon seemed to be restricted to scorn and mockery. The mock-trial of Maurice Barrès, instigated by *Littérature*, for 'crimes against the security of the mind', demonstrated

that Breton and his immediate circle acknowledged that some values were worth defending, whereas Tzara was in the habit of 'judging nothing'. In January 1922, Breton attempted to organized an 'International Congress for the Determination of Directives and the Defence of the Modern Spirit', but Tzara refused to participate, maintaining that there was nothing 'modern' about Dada. Three months later, Breton published his poem *Lâchez tout*, which contains the injunction 'Abandon Dada... Set off down the road'. It seemed that the time had come to reassess past experiences – some of them preceding the arrival of Tzara – and to find new ways of moving forward while continuing to foster a spirit of revolt. Painting offered too many interesting possibilities for Breton to reject it completely: following Derain and Modigliani ('unappreciated geniuses', as they came to be seen), Picasso showed that anything was possible on a canvas, and De Chirico's enigmatic compositions – with incongruous objects surrounded by silent architecture – questioned the act of thought itself.

When Surrealism was founded – with the publication of the *Manifesto of Surrealism* in October 1924, the launch of the journal *La Révolution surréaliste* in December 1924, and the opening of a 'Bureau of Surrealist Research', whose purpose was to gather data on the strange phenomena of everyday life – the visual arts seemed to be momentarily in retreat. *La Révolution surréaliste* was illustrated with drawings and pictures, works by

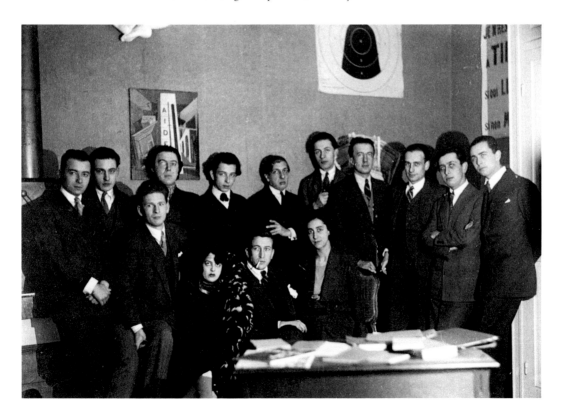

mental patients and photographs, but priority was given to poetry, recorded dreams and statements of belief, promoting anti-patriotic sentiments and the struggle against a restrictive concept of the life of the mind. Max Morise and Pierre Naville even argued that painting could never compete with automatic writing. The reply to this came from Breton himself, who began to publish 'Surrealism and Painting' in issue 4 of *La Révolution surréaliste*: the Surrealist enterprise could not just be limited to literature, ideology and social politics; it concerned all aspects of existence. Breton's text described not what 'Surrealist painting' might entail, but what the Surrealist point of view on painting was. Since 'the eye exists in an untamed state', the most important thing was to disalienate our way of seeing, and that was why painting needed to turn away from everyday appearances and obey an 'inner model'.

In November 1925, the first painters to make this shift contributed to an exhibition entitled 'La peinture surréaliste' at the Galerie Pierre. The list included Picasso (with two Cubist canvases), Klee (an irregular participant) and De Chirico, who had nevertheless betrayed the hopes raised by his 'metaphysical period' in seeking to return to the 'grand' style of painting, so forfeiting that 'fatalistic' quality which was part of the very illogicality of his art. The other artists involved were Man Ray, Max Ernst (with *Two Children Are Threatened by a Nightingale*), Jean Arp

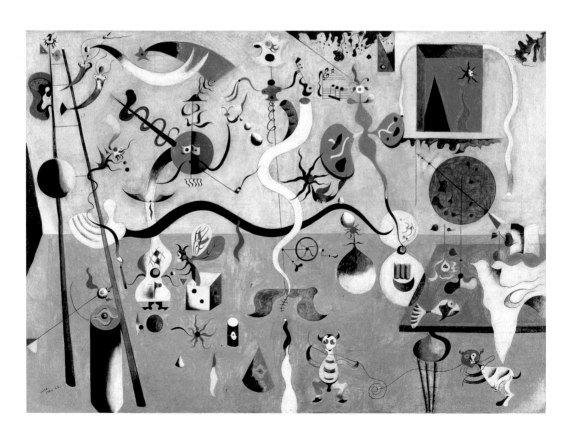

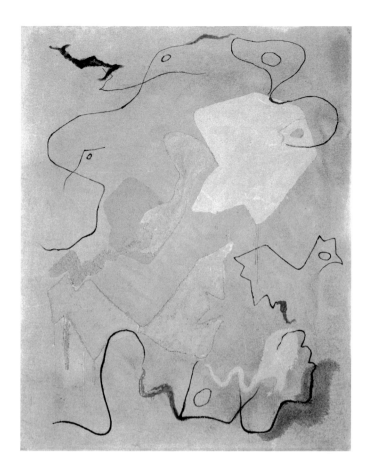

(*Birds in an Aquarium*), Joan Miró (*Carnival of the Harlequin*), Pierre Roy and André Masson. Miró and Masson, who had neighbouring studios in the rue Blomet, and Pierre Roy were thus joining forces with artists who shared a Dada background.

Miró had already shown work at the Galerie Pierre in June, and Benjamin Péret had written the preface for his exhibition catalogue. Miró's painting gradually cast off its scrupulous faithfulness to the real world, dismantling outward appearances and eventually resulting in a world teeming with signs, shapes and creatures that were witty and sometimes aggressive. *Carnival of the Harlequin* was not the product of automatic painting: it was assembled from a number of separate drawings prompted by hallucinatory episodes that resulted from periods of extreme hunger. As such, the painting originated from what Breton termed an 'inner model' and was characterized by a new-found freedom, in both psychological and pictorial terms.

André Masson was a master of automatic drawings and soon discovered a means to create paintings in the same way, avoiding what he deplored as the 'inevitable act of reflection': he did this by spreading layers of sand and glue onto a canvas until an image was suggested by

Below right:
The Galerie Surréaliste on the rue Jacques-
Callot (6th arr.), opened in March 1926.

Opposite:
Yves Tanguy, *Untitled*, 1927.
Oil on canvas, 61×50 cm (24×19 ⅝ in.).
Private collection.

the material itself, at which point he simply highlighted this image with
a few brushstrokes of paint. The resulting picture had nothing premed-
itated about it: what it revealed depended on motions of the hand that
could be responses to a sort of willed hallucination.

The works of Pierre Roy, on the other hand, had no connection
whatsoever with automatism or hallucinatory states. What was surpris-
ing in these works was the nature of the assembled objects or the
placing of a figure in an incongruous setting. Roy's detailed elaboration
of improbable worlds, invested with an implicit symbolism and located
midway between everyday life and dreams, attracted attention in the
early days of Surrealism, but interest in his work soon waned.

For a painter, being a Surrealist had nothing to do with technical
skill, however dazzling, or the ability to surprise. Instead, it presupposed
a belief in the collective values of the group – the defence of poetry, love
and freedom – and participation in its activities – meeting and dis-
cussing various issues in cafés, taking a political stand, signing tracts and
statements that made these political viewpoints public. A painter's style
mattered very little, and nor did the development of new techniques,
however relevant or effective these might be, and in the Surrealist publi-
cations painters also contributed texts and responses to surveys. Some of
the artists associated with the movement found it difficult to participate
in what tended to operate as a 'common way of thinking': Miró very
rarely spoke at meetings and never signed any of the tracts, and Magritte
disliked the atmosphere of the discussions, which he judged to be unnec-
essarily verbose. Without such constraints, there would not have been a
coherent group at all, but they distanced other artists who might, in one
way or another, have seemed to share some common ground with Surre-
alism, but always for formal rather than intellectual reasons. These
included Balthus – whose 1934 exhibition at Pierre Loeb's gallery created

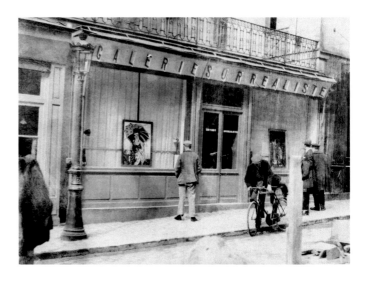

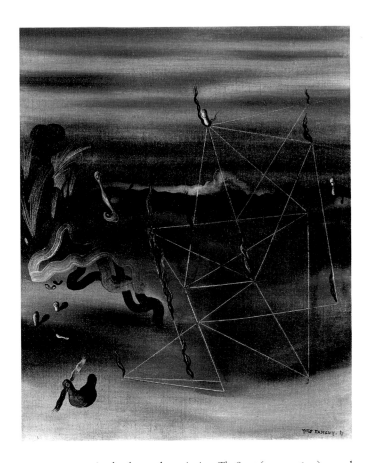

a momentary stir, thanks to the painting *The Street* (see pp. 6–7) – and Papazoff and Chagall – both of whom thought that the Surrealists over-intellectualized painting. In his review of the Galerie Pierre exhibition, Maurice Raynal considered that 'Surrealist painting cannot go very far because it is conceived without reference to any concern for style, com-position, architecture or form.' He was unable to acknowledge (and he was not alone in this) that, from the Surrealist point of view, painting was not an autonomous pursuit, that its traditional 'preoccupations' were of no interest, and that it was only practised as a way of exercising the capacity for thought, and encouraging others to think differently through recourse to an unbridled imagination.

In March 1926, with the opening of the Galerie Surréaliste (16 rue Jacques-Callot), the group's intentions and choices became clearer. The gallery's first exhibition was devoted to 'Pictures by Man Ray and Objects from the Islands', a rather unorthodox title that deliberately accorded equal value to the pictures and the 'primitive' objects. The same formula was used in 'Yves Tanguy and Objects from America' (May 1927). Surrealism was preoccupied with primitive art, which it saw as imbued with a magic that had for the most part deserted Western art, and believed its task was to restore it. In Tanguy's work, the paintings –

over and above any pleasure they might evoke in the viewer – opened on to a world haunted by unnameable forms, a silent place that might be the promise of either sanctuary or exile, and of which it was difficult to say whether it revealed strictly personal obsessions or revived some ancient universal memory. Nothing was premeditated, despite the precision of the forms and the care with which they were added to the composition: the painter himself 'discovered' them by coating his canvas with random colours and looking at the irregular shapes they made: the painted areas and the areas of shadow resemble germs waiting to grow and multiply.

Alongside its permanent collections – including paintings, 'primitive' and surrealist objects, snowballs, gramophone records and more – the Galerie Surréaliste also held solo exhibitions for Max Ernst and Jean Arp and for early work by De Chirico. Jean Arp's work, between 1926 and 1933, was based on a small number of shapes cut out of wood (moustache, table, eyebrow, fork, navel, breasts) and assembled in witty arrangements. Each 'shape-cum-word' was taken out of its usual context and placed in a new situation. A 'still life' would list its constituent parts – *Table, Mountain, Anchors and Navel* – as if their interrelatedness (underlined by the cut-out shapes) were self-evident: independently of what we think we see and know, Arp is saying, everything in this world is united by secret relationships and the universe is a web of connections that go largely unnoticed.

In 1925, Max Ernst began producing drawings using frottage – placing a sheet of paper on an irregular surface and rubbing it with a soft pencil to produce unexpected shapes, with which he could then alter. This technique, later adapted for paint on canvas, was based on a kind of 'clairvoyance' (like the work of Masson and Tanguy), the outcome of

GRAMME

CENTIGRAMME

MILLIGRAMME

Salvador Dalí 1929

which would always be different, since in each case it was the individual unconscious that suggested the subject.

The hostility of Surrealism to prevailing tastes encouraged it to form a sort of alternative society, within which poets wrote prefaces for the exhibitions, painters produced illustrations for poets, and works of art circulated among a handful of people without reaching a wider audience. At the end of the 1920s, Ernst, Miró, Tanguy and even Picabia were selling very few paintings; these ended up mainly in the collections of their friends and a few close acquaintances. They were regularly exhibited, but the break with conventional notions of painting affirmed by these canvases, and the fact that the artists were members of a group whose reputation was dubious, made it hard for them to be accepted. Instead of participating in the widespread debate about the lessons that could be learnt from Cézanne, they referred to the Symbolists, if they referred to any artistic movement at all, and suggested that the works they felt the greatest affinity for were those of primitives and of the mentally ill. The intransigence of the Surrealists in political terms, their

temporary alliance with the Communist Party, and their eagerness to conceive of a revolution in absolute terms, as transforming both the social order and the way people think, all of which alienated the public, also led to defections among the group's longest-standing members and the exclusions announced in the *Second Manifesto of Surrealism*, published by Breton in 1929. By this time, the group was more interested in politics than in the careers of its artists – but the arrival of Salvador Dalí would change this situation.

Dalí's exuberance, the free reign he gave to his 'madness', the development of his 'paranoiac-critical' method, which enabled him to transform his obsessions into tools of revelation and to utterly discredit reality all gave a new impetus to the artist's pictorial role from 1929 on, and justified the welcome extended to him by Breton and his friends. The public too were fascinated by Dalí, due to his impeccable technique and the hallucinatory quality of his subject matter: he could take any object and pass it through a filter of metamorphoses and curious dream states to produce the most extraordinary images. Dalí's pictures highlighted one of the characteristics of Surrealist painting: figurative painting of an apparently academic kind – the sort of thing that might be associated with a 'return to order' – was placed in the service of aims and subjects (explicit or otherwise) that were revolutionary in intent. Indifference to stylistic modernity – Dalí used the curves and spirals of fin-de-siècle architecture as his most modern reference point and later claimed to draw his inspiration from Meissonier – was, paradoxically, a mark of his intense desire to bring about change. It was the reality of this desire and the potentially shocking nature of Dalí's images that led to the incident at Studio 28, in December 1930, when members of a fascist league destroyed a number of his canvases during the premiere of *L'Âge d'or*, the film that he had produced with Buñuel (see p. 306).

Dalí was not the only artist who combined a detailed figurative style with disturbing subject matter. René Magritte had been living in Perreux-sur-Marne since August 1927 and was producing paintings that highlighted the pitfalls of the 'perfect' image – juxtaposing fragments of 'reality' that had no immediate relationship with one another, linking everyday objects with names that did not correspond to them (*The Key of Dreams*), placing different names on undifferentiated surfaces (*The Empty Mask*) and using figurative art to denounce the illusion of realism (*The Treachery of Images* of 1929, with its famous caption 'This is not a pipe'). Magritte never managed to show his work in Paris, however, and when he returned to Brussels in 1930, the only thing that he had published was his illustrated text 'Les mots et les images', which appeared in the final issue of *La Révolution surréaliste*.

Le Révolution surréaliste was followed by *Le Surréalisme au service de la révolution*, whose title alone advertised the revolutionary nature of the group's aims, but this did not mean that Surrealist art had to subscribe to any

particular political aim. The group's painters and sculptors remained entirely free to explore their chosen field in whatever manner they wished. Valentine Hugo, for example, could deploy her graceful angles and arabesques in portraits of poets and illustrations for their work (see p. 251). Clovis Trouille, meanwhile, could vent those anti-religious and anti-militarist feelings that so delighted his friends, alongside the 'popularist' aspects of his eroticism and the anarchic spirit that imbued compositions that were utterly classical in appearance. Jacques Hérold, whom Tanguy introduced to the group in 1933, remained somewhat on the periphery, perfecting a style of painting that looked for the hidden structure concealed within things and its potential for magical transformation. Hérold's fellow Romanian Victor Brauner drew the admiration of Breton when he showed *The Strange Case of Mr K* at Pierre Loeb's gallery in 1934: lined up in rows, the many figures of 'Mr K' appeared to embody all the social ills of the time, and when the painting was exhibited at the Galerie Henriette in 1939, it had to be taken down following a complaint. Moving away from abstraction after 1933, Kurt Seligmann began turning his interest in science into composite figures formed from a mixture of

Opposite:
Jacques Hérold,
The Seed of the Night, 1937.
Oil on canvas, 81×65 cm
(31 ⅞ × 25 ⅝ in.).
Private collection.

Right:
Kurt Seligmann,
The Great Swindler, 1933.
Bibliothèque Nationale de
France, Paris.

Below:
Hans Bellmer,
photograph of *The Doll*, 1935.

heterogeneous objects and geometric shapes. Hans Bellmer's photographic series *The Doll* was sent over from Germany and immediately published in the journal *Minotaure*: the postures and torments that Bellmer inflicted on his 'creature' reflected an eroticism based on the darkest side of desire, in the tradition of de Sade, whom the Surrealists greatly admired.

Alongside more familiar categories of art, the Surrealists were greatly interested in objects: these could be manipulated at will and permitted an objective view of a subject, so putting an end to the old opposition between the exterior and interior worlds. In 1930, Alberto Giacometti exhibited his *Suspended Ball* at the Galerie Pierre. It was not exactly a sculpture. Breton described it as follows: 'A ball of wood marked with a feminine indentation is suspended, by a thin violin string, above a crescent, one edge of which just brushes the hollow.' Anyone seeing this sculpture would instinctively be tempted to slide the ball up and down the ridge, but the angle of the crescent makes this only partially possible – evoking the concept of frustrated eroticism. Up until 1934, Giacometti continued to assemble objects and geometric shapes in such a way as to leave room for chance occurrences: *Invisible Object*, for example, was adorned with a mask found in a fleamarket.

In 1936, the Galerie Charles Ratton held an 'Exhibition of Surrealist Objects'. There were two hundred exhibits ranging from works by Picasso to 'primitive' objects and including Duchamp's *The Brawl at Austerlitz* (1921), a mobile by Alexander Calder, 'found' and 'interpreted' objects, mathematical objects and objects made by members of the group, including, among others, Dalí (*Aphrodisiac Jacket*), Ernst, Man Ray, Arp, Tanguy, Óscar Domínguez, Marcel Jean (*Spectre of the Gardenia*), Meret Oppenheim (*Breakfast in Fur*) and Maurice Henry (*Homage to Paganini*). This transformation of ordinary objects was a confirmation of the distance that the Surrealists maintained from any notion of 'progress', particularly of a technical or functional kind: they were not

Opposite:
Alberto Giacometti,
Suspended Ball, 1930–31.
Wood, metal and wire,
60.5 × 36.5 × 34 cm (23 ¾ × 14 ⅜ × 13 ⅜ in.).
Musée National d'Art Moderne,
Centre Georges Pompidou, Paris.

Below left:
The 'Exhibition of Surrealist Objects',
Galerie Charles Ratton, 14 rue de
Marignan (8th arr.), 22–31 May 1936.

Above:
The Gradiva gallery, 31 rue de Seine, 1937; door designed by Marcel Duchamp.

Opposite:
The International Surrealist Exhibition, Galerie des Beaux-Arts, January–February 1938. Above: Salvador Dalí with a mannequin. Below: the main room designed by Marcel Duchamp. Photographs by Denise Bellon.

interested in rational improvements, but in the way in which an object, no matter how old or worn or broken or outdated it might be, could become the vehicle for meanings that were never conceived of when it was first made. A year before the scientific and technical advances of the age were flaunted at the 1937 Exposition Internationale, the Galerie Ratton was repudiating the very idea of progress.

Assembling a Surrealist object did not require particular technical skills: it was an activity that anyone could engage in. Another such technique was decalcomania, which Óscar Domínguez began to use in 1935. This involved coating a sheet of paper with thick paint, placing it face down on another sheet, then pulling the two apart, leaving behind a haphazard arrangement of shapes. Its success was due in part to its automatic nature – the end product could not be predetermined – and in part to the fact, once again, that anyone could try it: examples printed in *Minotaure* were produced by Breton and his wife Jacqueline, Georges Hugnet and Marcel Jean, as well as by Tanguy and Domínguez himself.

In February 1937, André Breton opened the Galerie Gradiva, at 31 rue de Seine, but the gallery's rapid demise confirmed the difficulty of promoting Surrealist works. It was due to the Galerie Gradiva, however, that Roberto Matta came to the attention of the Surrealists and was immediately invited to contribute to the group exhibition that was then being planned. The International Exhibition of Surrealism opened on 17 January 1938 at the Galerie des Beaux-Arts, and was organized by Breton and Duchamp, with the help of Man Ray, Ernst and Dalí. It was much more than a simple juxtaposition of works of art. The exhibition was 'staged' in such a way as to forge relationships between the works themselves, and between the art and the spectators, thereby creating added levels of meaning. By the entrance, water rained down on the heads of Dalí's strange passengers in the leafy, snail-ridden environment of his *Rainy Taxi*. A 'Surrealist Street', peopled by mannequins in fancy dress, led into the central gallery, whose atmosphere combined comfortable relaxation – the ground was carpeted in moss and dead leaves, and in the corners of the room four beds stood invitingly – with a hint of menace: 1,200 hundred sacks of coal were suspended from the vaulted ceiling over a central brazier, creating the risk of fire started by falling dust. The walls were hung with paintings by both old and new members of the group, some of the latter having never before shown their work in a solo exhibition – and objects were scattered about, while works on paper were arranged by Duchamp on the panels of two revolving doors. When the exhibition first opened, visitors viewed the works by torchlight, but the torches soon ran out and the organizers were obliged to resort to more conventional lighting.

The exhibition was a relative success with the public, continuing to attract visitors for some time after the opening night, which was attended by everyone who was anyone in Paris. But as a demonstration

of the inadequacies of intellectualism as compared with imaginative flights of fancy and the fragmented imagery of dreams, it was met with stubborn incomprehension on all sides. Drieu La Rochelle wrote in *Je suis partout*: 'As I wandered around that wretched Surrealist Exhibition, full of what you might describe as the obstinacy of a sick child who's gone insane and prefers to commit suicide rather than grow up, my

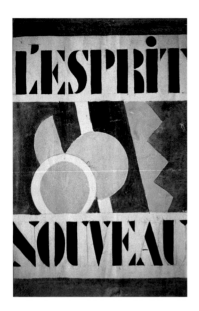

heart sank. What a lot of wasted time and misspent days, what frightful melancholy.' And Francis Gruber, who admired Max Ernst's work and Dalí's *Rainy Taxi*, nevertheless announced in *Peintres et sculpteurs de la Maison de la culture* that the rest was nothing but 'a village fête for the impotent … pornography worthy of the Bal des Quat'z-arts'. Critics deplored what they saw as the negation of the French spirit – there were, after all, a great many foreigners among the Surrealists! – in what amounted to no more than a jumble of odds and ends, fit only to amuse the snobs. Surrealism was an outdated phenomenon, anyway, they argued: it had had its day and everyone knew that it had little to offer in pictorial terms. Writing in *XXe siècle*, the new journal edited by Gualtieri di San Lazarro, Raymond Cogniat noted – rather more perceptively – that 'each visitor is forced to accept the unacceptable and can only escape his discomfort through laughter or anger'.

Among the things that Breton brought back from his last trip to Mexico was a text he co-wrote with Trotsky, *Towards a Free Revolutionary Art*, which denounced Nazism and Stalinism, and defended creative freedom against totalitarianism of any kind. It was time, it seemed, to unite those who were determined to 'serve the revolution via the methods of art and defend the freedom of art against the usurpers of the revolution' – aims that were espoused by FIARI (the Fédération Internationale de l'Art Révolutionnaire Indépendant) and expressed in its journal, *Clé*, which only ran to two issues, the second being published in February 1939. What had seemed incomprehensibly sombre and depressing during the 1937 Exposition Internationale was soon to appear prescient.

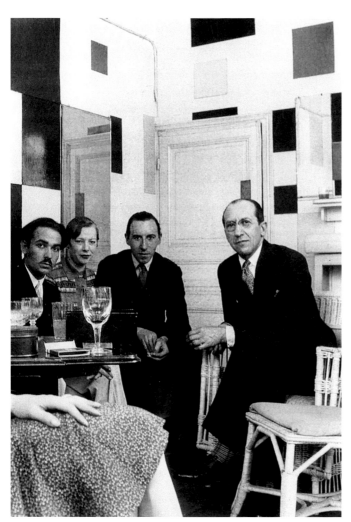

ABSTRACTION

Paris may have seemed ideally suited to accommodating every artistic tendency, but in fact abstraction had great difficulty in making any impact there. It had begun outside France, in Germany, Russia and the Netherlands, and the total lack of interest shown by public institutions, the choices made by the School of Paris and, during the 1930s, the debates surrounding the socio-political implications of certain versions of realism, all played a large part in its poor reception.

In Paris, very little was known of Suprematism and Constructivism, or about the conflicts occurring within the De Stijl movement or its influence on architecture. El Lissitzky settled in Berlin in 1922 and it was there that he published, with Arp, a mini-encyclopaedia of modern art entitled *The Isms of Art* (1925); and it was also in Berlin that Kazimir Malevich exhibited in 1920 and 1927, and where his works remained following the second exhibition.

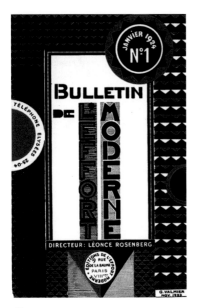

Above:
Cover of *Bulletin de l'Effort Moderne*,
no. 1, January 1924.

Below right:
Exhibition by the Cercle et Carré group
at Galerie 23, on the rue La Boétie, 1930.
From left to right: Franciska Clausen,
Florence Henri, Manolita Torres García,
Joaquín Torres García, Piet Mondrian,
Jean Arp, Pierre Daura, Marcelle Cahn,
Sophie Taeuber-Arp, Friedrich
Vordemberge-Gildewart, Vera Idelson,
Luigi Russolo, Nina Kandinsky, Georges
Vantongerloo, Vasily Kandinsky
and Jean Gorin.

Opposite:
Jean Hélion, *Constructivist Composition*,
1930–31. Oil on canvas, 110 × 110 cm
(43 ¼ × 43 ¼ in.). Private collection.

Abstraction was not totally absent from the Salons (appearing first at the Surindépendants, then from 1931 at the Salon '1940') and galleries, and Paris's Polish contingent was particularly active in this area: in December 1925, Victor Poznanski organized 'L'art d'aujourd'hui', the first exhibition of the international avant-garde; and the bookseller Jacques Povolozky exhibited non-objective artists at La Cible, including Kupka, Gleizes, Gallien, Vordemberge-Gildewart and Flouquet. In 1928, the Salon d'Automne reserved a room for Polish artists, showing works by Stazewski and Strzeminski, reproductions of which appeared, along with a painting by Malevich, in *Kilométrage de la peinture contemporaine*, written by Jan Brzekowski, who also edited three issues of the bilingual journal *L'Art contemporain* with Nadia Grabowska (later Nadia Léger).

Foreign journals devoted to non-figurative tendencies were not widely available in Paris, and in French publications it was rare to find well-researched articles, like those by Carl Einstein (*Documents*, November 1929) and Will Grohmann (*L'Amour de l'art*, April 1934). This absence of serious information relating to the theoretical foundations of abstraction and the diversity of abstract works was a major handicap that was only partially offset by the time that artists began to regroup in the 1930s.

Mondrian returned to Paris in 1919 and continued to live there, in the rue du Départ, until 1938. He contributed the essay 'Natural Reality and Abstract Reality' to *De Stijl*, and in 1920 his booklet *Neoplasticism* was published by Léonce Rosenberg. While announcing that 'Neoplasticism is an art for adults', whereas 'the old art was a children's art', he nevertheless continued to earn a living by producing flower paintings which he sold to buyers in the Netherlands. In 1923, an exhibition devoted to De Stijl at Rosenberg's gallery was a flop; the following year, Mondrian broke off relations with Van Doesburg, whom he criticized in particular for pub-

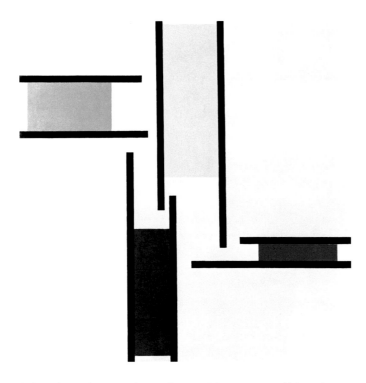

lishing the Dada-inspired journal *Mecano*. His presence and his work were regarded as exemplary by those who came to visit him – the prolific Michel Seuphor, Vantongerloo, Arp, Max Bill, Moholy-Nagy, Gabo, Ben Nicholson and Calder, among them – but during all his years in Paris he only had one solo exhibition, in 1928, at the Galerie Jeanne Bucher. In *Cahiers d'art*, he was accorded an 'esteem that cannot go as far as admiration' because he seemed to reduce painting to a 'means of emphasizing architectural volumes'. Mondrian's influence began to be felt, nevertheless, in the work of artists like Jean Gorin.

In 1928, five painters whose work was rejected by the Salon d'Automne exhibited at the Galerie Marck, in the rue Bonaparte. They included Jean Hélion and Joaquín Torres García, who were sharing a studio at the time. Torres García later met Van Doesburg, Mondrian and Seuphor and together they founded the group Cercle et Carré, which organized a major exhibition in the rue La Boétie. Neoplasticism was strongly represented (with works by Mondrian, Huszár, Vantongerloo, Gorin and Vordemberge-Gildewart), but was by no means alone: there were also works by Kandinsky, Schwitters, Buchheister, Pevsner and Stazewski, as well as figurative paintings influenced by Cubism, Futurism and Purism. This show, which was covered in the three issues of the association's journal, was violently criticized in *Art concret*, in which Hélion, who had been heavily influenced by Mondrian since 1928, declared himself in favour of works which were founded on mathematical relationships and calculations, and conceived in their

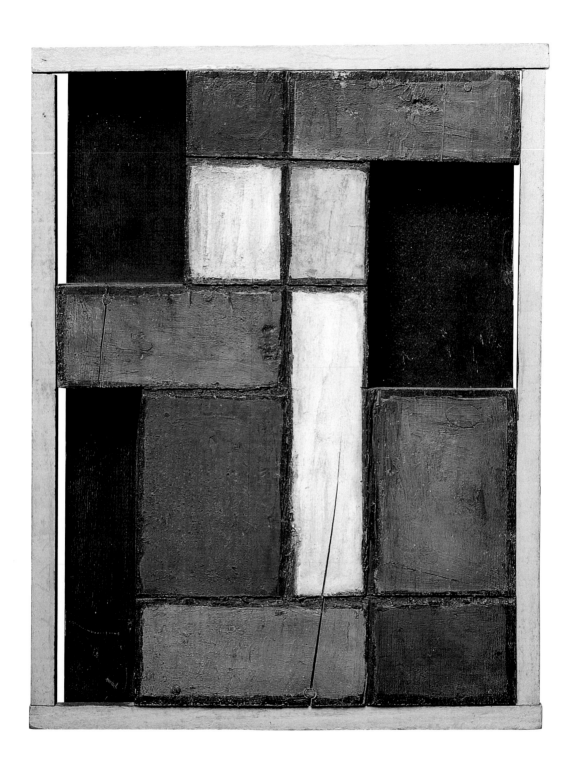

entirety before being painted. Van Doesburg, Carlsund and Tutundjian shared these demands, but 'Concrete Art' as a movement was short-lived and only a few dozen copies of its journal were ever printed.

Cercle et Carré was not financially viable and occasional solo exhibitions such as Joaquín Torres García's shows at the Galerie Jeanne Bucher and the Galerie Percier, and Hélion's at the Galerie Pierre, excited little real interest. It was therefore important to find another way of bringing non-figurative artists together. The Abstraction-Création group was founded in February 1931 along relatively eclectic lines: 'The best artists in Paris and abroad ought to join, even if their tendencies are different from ours.' With a committee that included Arp, Gleizes, Hélion, Kupka, Valmier, Herbin, Vantongerloo and Van Doesburg (who died a month later), disagreements were quick to follow, given the diversity of their various theoretical approaches.

Abstraction-Création hoped to print eight issues of its journal a year, in addition to a number of monographs, but rapidly came up against a shortage of funds: from 1932 to 1936, only five issues of the journal were published, along with two monographs. While it accepted artists with a range of ideological and political viewpoints, the basic requirement was that the pictures exhibited (at 44 avenue de Wagram, where meetings were also held) should be resolutely non-figurative.

Opposite:
Joaquín Torres García,
Construction No. 1, 1930.
Painted wood, 42.2 × 32.1 × 6 cm
(16 ⅝ × 12 ⅝ × 2⅜ in.).
Private collection.

Below:
Alexander Calder in his studio at
14 rue de la Colonie (13th arr.), 1931.
Photograph by Marc Vaux.

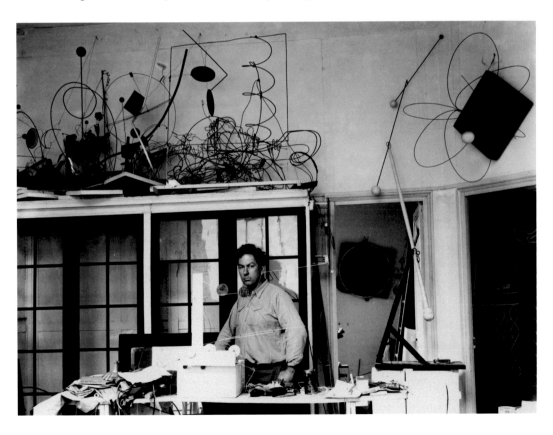

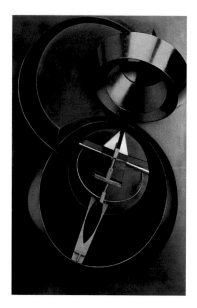

Above:
Antoine Pevsner, *Construction*, 1935.
Metal, 60×40×17 cm (23 ⅝×15 ¾×6 ¾ in.).
Instituto Valenciano de Arte Moderno,
Valencia.

Opposite:
Sophie Taeuber-Arp, *Gradation*, 1934.
Oil on canvas, 65×51 cm (25 ⅝×20 ⅛ in.).
Stiftung Hans Arp und Sophie
Taeuber-Arp, Rolandseck.

Below:
Auguste Herbin, *Spiral*, 1933.
Oil on canvas, 95×72 cm (37 ⅜×28 ⅜ in.).
Private collection.

However, it became necessary to make some compromises, in order to
attract the public – for example, by inviting 'big names' like Picasso and
Brancusi, to the fury of Robert Delaunay. Abstraction-Création
encompassed a lyrical and biomorphic approach that contradicted the
more rigorously Constructivist tendencies and came close to certain
aspects of Surrealism (to which Concrete Art and Seuphor were
hostile). This other current was due both to the influence of Jean Arp,
whose works drew their strength from such ambivalence, and to the
presence of Seligmann, Paalen, Vulliamy and Calder – inventor of the
'mobile' (named by Marcel Duchamp in 1932) and the 'stabile' (coined
by Jean Arp), who came to abstraction in 1930, after creating his *Circus*
and his wire sculptures – and of Tutundjian and Okamoto – some of
whom were to end up in the Surrealist camp.

 Abstraction-Création was riven with tensions and disagreements. In
December 1934, a number of artists – including Pevsner, Gabo, Fre-
undlich, Delaunay, Valmier, Arp, Sophie Taeuber-Arp and Hélion –
withdrew from the group, objecting to Auguste Herbin's management
and the 'line' that he favoured. Nevertheless, the group had some
hundred or so members and showed work – often for the first time in
Paris – by artists as varied as Barbara Hepworth, Fritz Glarner, Ben
Nicholson and Lajos Tihanyi. In contrast with the School of Paris,
which was centred on the capital, Abstraction-Création had a strongly
international focus, with Paris just one focal point among many.
Abstraction-Création aimed to make it part of a network, along with
Berlin, Moscow, The Hague, Lodz, London and Switzerland, but the
moment was clearly not right: abstraction began to seem increasingly
remote from the social reality that was becoming the focus of other
artistic trends. In the first issue of the journal, an article by Paul Vienney,
a close friend of Herbin's and, like him, a Communist, pointed out that
abstract art, cut off from the people, had nothing to do with the creation
of a socialist society. Non-figurative painters were thus warned of their
lack of social relevance in the short term, but even those who affirmed an
allegiance to the left did not let this affect them: they accepted, implic-
itly, that the links between art and politics were so complex that the
freedom to experiment and invent could not be limited for reasons of
social necessity, and that any public that had been introduced to abstract
art was at least being obliged to shake off its old expectations.

 But the principles of abstraction, when rigorously followed, called
for a capacity for analysis and reason whose power was being constantly
challenged by current events. The potential for a future that was better
than the present was suggested by both Neoplasticism and Concrete Art,
in the works of Arp and those of Calder, but for the moment, such a
future already seemed to be very much in doubt, and perhaps this was the
reason why the shows organized by Abstraction-Création – like those of
Cercle et Carré previously – were only really of interest to those taking

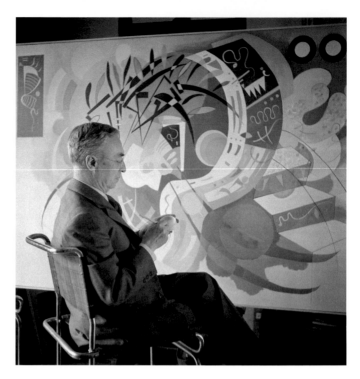

part themselves. Hélion himself noted this fact and later criticized the followers of abstraction for the narrowness of their ideas and for ignoring anything that fell outside the scope of their immediate concerns. He admired the fact that in Surrealism, by contrast, almost nothing was taboo, and he began introducing figurative allusions (which he had strongly rejected a few years earlier) into his own compositions.

Vasily Kandinsky settled in Boulogne in January 1934, and remained somewhat removed from the artistic scene, though he did contribute to a few group exhibitions. When he left Germany after the closure of the Bauhaus by the Nazis, the Surrealists – whose paintings he did not much like – invited him to show his work at the Salon des Surindépendants. Kandinsky's two solo exhibitions in Paris (at the Galerie Zak in 1929 and Galerie de France in 1930) were well received, and Waldemar George praised what he described as 'an optical music, a quality of magic, an art of harmonious relationships'. But Kandinsky himself felt that people did not really understand his work or know how to place him in historical terms. Kandinsky's later exhibitions – at the Cahiers d'Art (1934 and 1935) and the Galerie Jeanne Bucher (1936 and 1939) – came at a time when the art market was particularly flat and they were not very successful. The artist saw this as the consequence of a 'great battle between abstract art and Surrealism', but also as confirmation of French lack of interest in abstraction, and an indication of the confusion 'of abstract art in general with Constructivism alone and its mechanical approach'.

Although he dreamed of becoming part of the Paris scene, Kandinsky actually felt increasingly marginalized. In the monthly *L'Histoire de l'art contemporain*, edited by René Huyghe (and published as a book in 1935), his work was analysed by Will Grohmann, but when Christian Zervos published his *Histoire de l'art contemporain*, in 1938, Kandinsky complained that he was under-represented (there were 11 reproductions of his work, as opposed to 55 for Picasso, 34 for Braque and 37 for Matisse), and he was not mentioned at all in Huyghe's *Les Contemporains* (1939), although neither were Torres García, Vantongerloo, Van Doesburg or Hélion.

In 1937, however, Kandinsky became involved with the plans for a major exhibition entitled 'Origines et développements de l'art international indépendant', which brought 5,000 visitors through the doors of the Jeu de Paume between 30 July and 31 October. It was the complement to the 'Maîtres de l'art indépendant', to which Raymond Escholier invited foreign artists resident in Paris before 1925. Having met André Dezarrois, Kandinsky persuaded him that Paris ought to follow the example of the exhibitions in Lucerne in 1935 ('Thèse antithèse synthèse') and New York in 1936 ('Cubism and Abstract Art' at MoMA). Yvonne and Christian Zervos led the organizers, Breton

Opposite:
Vasily Kandinsky in his studio
in Neuilly, December 1936.

Below:
Vasily Kandinsky, *Orange Violet*, 1935.
Oil on canvas, 89 × 116 cm (35 × 45 ⅝ in.).
The Solomon R. Guggenheim Museum,
New York.

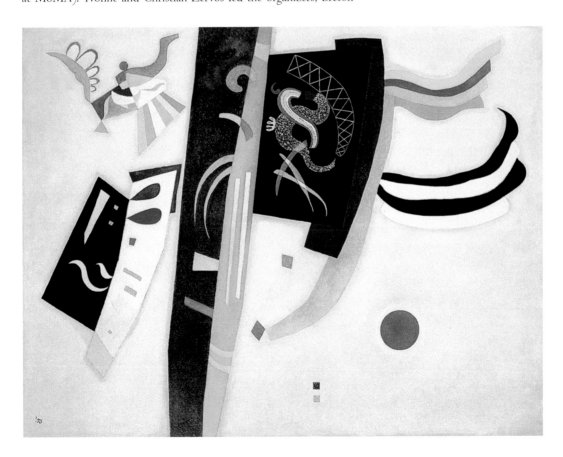

Right:
Christian Bérard, *René Crevel*, 1925.
Oil on canvas, 73×60 cm (28 ¾ × 23 ⅝ in.).
Musée National d'Art Moderne,
Centre Georges Pompidou, Paris.

Opposite:
Marcel Gromaire, *Seated Nude*, 1929.
Oil on canvas, 81×65 cm (31 ⅞ × 25 ⅝ in.).
Musée d'Art Moderne de la Ville de Paris.

supplied a list of Surrealists, and Kandinsky was represented by Marcoussis (since he did not yet have French citizenship and so could not sit on the committee). There were several omissions (including Duchamp, Vieira da Silva, Malevich and the Futurists), the catalogue was just a list of works, without dates, and in August an open letter appeared (signed by Breton, Brancusi, Tzara, Kupka, Arp and others) denouncing the excessive role played by certain dealers in the selection process. However, Kandinsky was satisfied, overall, with the results: the exhibition marked abstraction's first showing at an official Paris institution, and it had attracted more visitors than any previous exhibition of abstract art; and in addition it seemed that his own importance as an artist was at last being recognized. His five canvases were even hung in the place of honour, although not in the order that he had requested.

REALISM AND THE TEMPTATIONS OF POLITICS
The multiple meanings of the term 'realism' meant that any painting which was neither obviously 'Surrealist' or 'abstract' could lay claim to it: as long as the subject was easily recognizable, it could be applied to any style or approach.

The painters exhibited by Waldemar George in 1926 (Galerie Druet) and whom he termed 'neo-humanists' were certainly figurative artists, but in the case of Christian Bérard, the brothers Eugène and Leonid Berman, Pavel Tchelitchew and Kristian Tonny, their realism was also imbued with a sort of dreamy nostalgia, a diffuse melancholy, in keeping with the sense of transience implied by their portraits and landscapes, which was linked with the artificial nature of painting itself. Of this group, it was the paintings by Bérard that were probably the most thought-provoking, although his body of work remained small as he soon moved on to the theatrical set and costume designs that made his name. Bérard's self-portraits and images of his family and friends (see p. 268) favoured apparently simple poses and were scrupulously respectful of the sitter's features, while giving the viewer a sense of intimacy, of something neither revealed nor withheld. Realism here signified the absence of anecdote, the purging of everyday details and the rejection of straightforward naturalism of the kind that was found each year among the realists at the Salon des Artistes Français.

This accessible brand of realism gave way, during the 1930s, to interpretations that were more strongly influenced by the political situation. Increasing numbers of immigrants were fleeing the Nazis and bringing news of the new regime's cultural policies. In the hands of photomontage specialists such as Erwin Blumenfeld, César Domela and John Heartfield, images became weapons in the struggle against political repression. The artists who were linked with the Maison de la Culture deemed it necessary to form a sort of anti-fascist front, in which 'abstract artists' and 'realists' could both take part: since the immediate need was to fight against the 'primary danger', aesthetic differences were temporarily set aside. A major anti-fascist exhibition, involving some two hundred painters and sculptors from various movements, reunited under the term 'Revolutionary Artists', was held at the Porte de Versailles in 1934, and an Exposition Internationale sur le Fascisme – whose purpose was both informative and denunciatory – was held at the Galerie la Boétie the following year. John Heartfield also exhibited at the Maison de la Culture in 1935, with his work bring praised by Aragon for its 'revolutionary beauty' in his catalogue preface, and Franz Masereel organized a 'workers' drawing and painting circle' for the unions of the Paris region. Masereel appears to have been fully aware of the Soviet situation at the time, but nonetheless believed that 'the cause is just' and in any case preferred workers to intellectuals, who 'bored [him] stiff'.

The Galerie Billiet-Worms was one of the galleries that supported the realist movement or – as some people preferred to call it, the 'neo-realist' movement, in order to indicate that a work of art should be as powerful as it was well executed, if not more so. Between 1934 and 1936, the gallery showed works by Grosz and Masereel, and also hosted the

Above:
John Heartfield, *The Spirit of Geneva*, 1932.
Original of a photomontage published in the journal *AIZ* in November 1932.
49×35.6 cm (19 ¼×14 in.).
Nationalgalerie, Berlin.

Opposite:
Francis Gruber, *Self-Portrait*, 1935.
Oil on canvas, 182×147 cm (71 ⅝×57 ⅞ in.).
Private collection.

Right:
Boris Taslitzky, *The Strikes of June 1936*, 1936.
Oil on card, 40×60 cm (15 ¾ × 23 ⅝ in.).
Private collection.

Below:
Édouard Pignon, *The Dead Worker*, 1936.
Oil on canvas, 134×180 cm (52 ¾ × 70 ⅞ in.).
Musée National d'Art Moderne,
Centre Georges Pompidou, Paris.

Opposite:
André Fougeron, *Martyred Spain*, 1937.
Oil on canvas, 98×154 cm (38 ⅝ × 60 ⅝ in.).
Private collection.

exhibitions 'Le retour du sujet', 'Forces Nouvelles', 'Le réalisme et la
peinture' (with works by Gromaire, Lhote and Gruber) and 'Les indéli-
cats' (linocuts, including work by Pignon and Fougeron).

The Forces Nouvelles painters (Humblot, Jannot, Lasne, Pellan,
Rohner, Tal Coat and Henri Hérault) sought to achieve an exact repre-
sentation of nature and rejected distortion as a method – their respect
for the subject made them the representatives of a form of realism made

more interesting by the fact that their paintings also used somewhat artificial light effects and geometric organization. They were said to be concerned with the political aspects of realism, though this was not necessarily so, but the critics in any case acclaimed them as being among the best painters of their generation.

When the strikes began in 1936, artists took on a reporting role, turning up in the factories to sketch incidents as they unfolded. They were encouraged to abandon the traditional canvas for new types of interactive art: banners and posters, placards and works for display in public places. For the 14 July processions, joined by a million people, the place de la Bastille was decorated with gigantic portraits of Robespierre, Marat, Saint-Just and Mirabeau, framed by decorative motifs (designed by Jean Lurçat), and a number of artists demonstrated with placards bearing portraits of Daumier (by Boris Taslitzky) and Callot (by Gruber). Le Nain and Georges de la Tour – whose works were rediscovered at the 1934 exhibition entitled 'Peintres de la Réalité en France au XVIIe Siècle' – had supplanted Poussin and Ingres as old masters, and the young realists dreamed of art that was free of theorizing and accessible to all. When Romain Rolland's play *14 July* was performed at the Théâtre de l'Alhambra (with a set by Picasso), it was accompanied by an exhibition of works by, among others, Matisse, Léger, Lurçat, Lipchitz, Gromaire and Lhote. This was enthusiastically received by Pignon, Amblard and Taslitzky, who were eager to familiarize 'the people' with the art of earlier generations as well as that of up-and-coming artists.

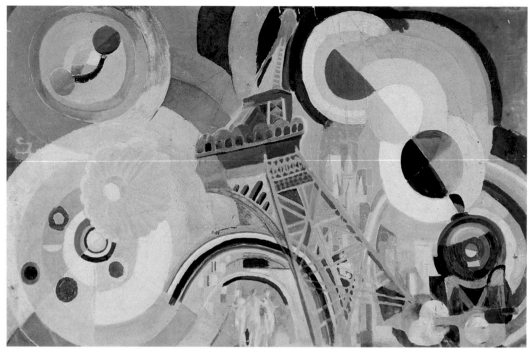

Above:
Robert Delaunay,
Air, Iron and Water: Study, 1936–37
Gouache on paper, mounted on
plywood, 47 × 74.5 cm (18 ½ × 29 ¼ in.).
Private collection.

Below:
The 1937 Exposition Internationale:
sculptures mounted on top of the
Italian (left), Russian (centre) and
German pavilion (right).

Opposite:
The Air Pavilion at the 1937
Exposition Internationale,
interior designed by Robert
and Sonia Delaunay.

When Louis Aragon and Léon Moussinac organized the debates that underpinned the 'realism quarrel', their aims were actually more modest, and it was abstraction, implicitly, which was being placed in the dock. Each participant was invited to defend his own concept of realism. Gromaire's ideas had little in common with those of Lhote or Le Corbusier (for whom the only future for painting was to be amalgamated with architecture), while Léger (back from the United States) advocated a collective mural art affirming a 'new realism' that would suit the tastes of the working classes without compromising its own identity. Aragon's demands were more stringent: the realism of the Front Populaire would have to be 'a socialist realism, or painting of any dignity would cease to exist'. But there was greater reticence in the attitude of André Lhote and

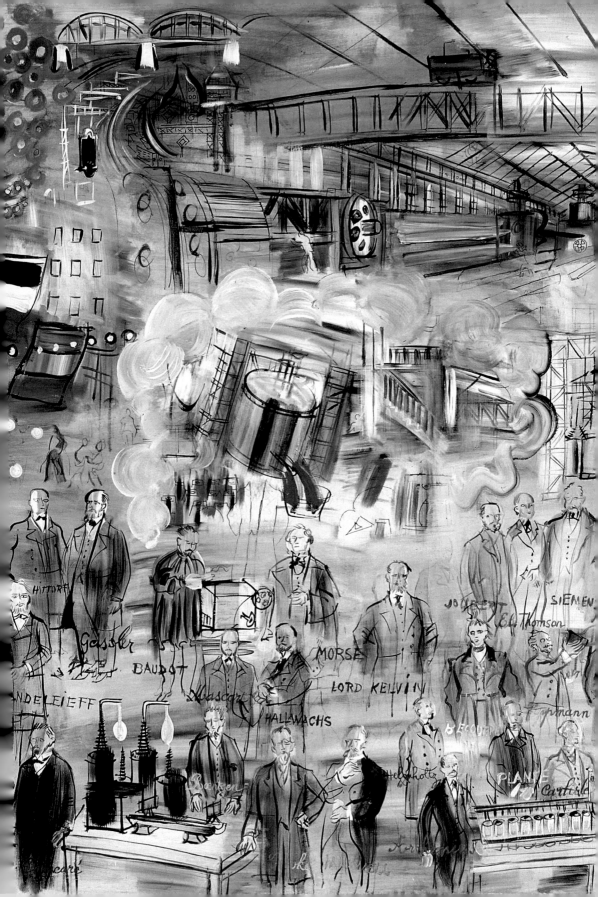

Right:
Fernand Léger, *Power Transmission*, c. 1937.
Gouache, 50.5 × 105 cm (19⅞ × 41⅜ in.).
Musée National Fernand Léger, Biot.
For the opening of the Palais de la
Découverte at the Grand Palais,
Fernand Léger was commissioned to
design a large-scale canvas, made by his
pupils and based on this gouache.

Below right:
Panel (centre) by Fernand Léger for
the CGT trade union, in the Pavillon
de la Solidarité at the 1937 Exposition
Internationale.

Jean Cassou – neither of them great supporters of 'socialist realism' as it was practised in the USSR, which had been poorly received in Paris three years earlier, at the exhibition entitled 'Soviet Paintings Relating to the Execution of the Five-Year Plan'. And Moussinac – who had little time for the 'revolutionaries of pure abstraction' – was unimpressed by simple political imagery, even if it had left-wing credentials. As for far-right tendencies, *l'Art dans le IIIe Reich. Une tentative d'esthétique dirigée*, by Emil Wernert, informed its readers that the Reich had already eliminated 'any elements that claimed affiliation with Expressionism, Cubism and other artistic *Experimenten*'. It emphasized a rise in fresco painting and noted the sculpture of Arno Breker, before concluding that art in Germany had become 'a form of political propaganda', and that it had been 'mobilized in the same way as most national activities'.

While the 'realism quarrel' remained unresolved, the exhibition 'Maîtres Populaires de la Réalité', organized by the Musée de Grenoble,

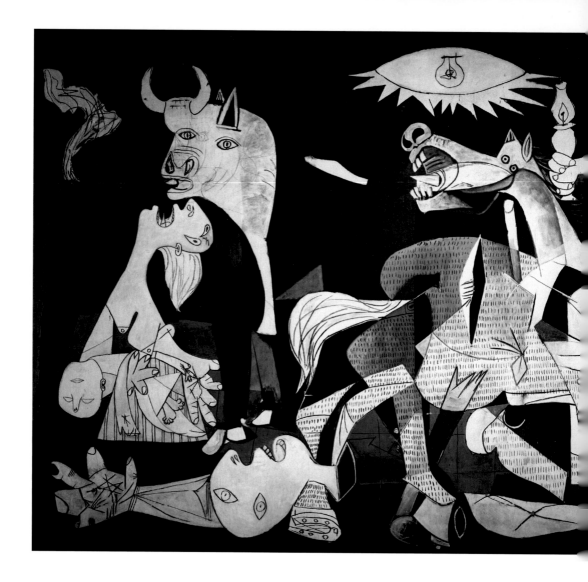

confirmed the commitment of the 'Naive' school of art – with whom, on this occasion, Maurice Utrillo had thrown in his lot – to the representation of reality. The reputation of Henri Rousseau – whose *Snake Charmer* was presented to the Louvre – was well established: Picasso, Breton and Delaunay were no longer the only ones to take his paintings seriously and six books on his work (by Roch Grey, Philippe Soupault, Christian Zervos, Adolphe Basler, André Salmon, and Jérôme and Jean Tharaud) were published in the 1920s. Rousseau's successors had also made a name for themselves through group exhibitions ('Peintres du Coeur Sacré', 1928; 'Peintres Populaires d'Hier et d'Aujourd'hui', 1929; 'Primitifs d'Aujourd'hui', 1932) and solo shows: André Bauchant, elected a member of the Salon d'Automne in 1921, periodically showed his work at the Galerie Jeanne Bucher, and Camille Bombois exhibited

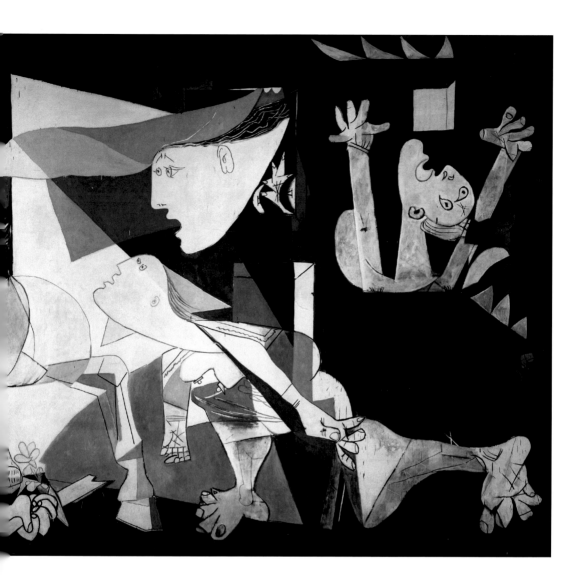

Pablo Picasso, *Guernica*, 1937.
Oil on canvas, 349.3 × 776.6 cm
(137 ½ × 305 ½ in.).
Museo Nacional Centro de
Arte Reina Sofía, Madrid.

at the Galerie Bernheim-Jeune in 1929. The quiet charm of their works
was valued by both critics – including Wilhelm Uhde, Florent Fels and
Maximilien Gauthier – and collectors. Writing about his great-grand-
mother Reine Mary-Bisiaux, in 1931, Marcel Gromaire praised the
'primitives' for having avoided both the 'sheep-like stupidity' of the aca-
demic painters and the 'painful egotism' of the avant-garde who wished
to 'burn every bridge': between those two extremes, the appeal of these
artists lay in their craftsmanship and modesty, and also in their ability
to introduce an element of reverie or 'poetry' into a reality that is never
lost to sight – although the journal *Documents* suggested that its 'conven-
tional innocence' could be that of a 'self-righteous moralist'.

While the Naive artists were busy lavishing attention on their can-
vases, many other contemporary artists saw mural art as an opportunity

Above:
Alexander Calder and his *Mercury Fountain* in the Spanish Pavilion at the 1937 Exposition Internationale. Photograph by Hugo P. Herdeg.

Opposite, above right:
Joan Miró, *Help Spain*, 1937
Stencil design, gouache on paper, 57 × 43.2 cm (22 ½ × 17 in.).
Musée Zervos, Vézelay.

Opposite, below:
The Musée d'Art Moderne, sculptures by Léon Drivier and Auguste Guénot, bas-reliefs by Alfred Janniot, 1937.

to move beyond a bourgeois clientele. The Salon de l'Art Mural was held in 1935 and Vantongerloo declared that the traditional canvas 'is simply a degenerate form of art which society, with its bourgeois social system, has monopolized for its own purposes'. As on previous occasions, official commissions for murals for the 1937 exhibition went to academic artists and remained largely faithful to the spirit of Art Deco. Matisse, Delaunay, Léger and Laurens, for example, were sidelined from the projects relating to the Palais de Chaillot and the new museums, while Odette Pauvert decorated the Jewelry Pavilion and painted six banners for the Pavillon Pontifical and Pierre Dionisi was responsible for the ranks of symbolic figures at the exhibition entrance on the avenue Delessert, and the façades of the Tourism, Spa Therapy and Yachting Pavilions were the work, respectively, of Pierre Gandon, Yves Brayer and Jean de Botton. In terms of sculpture, there was the usual array of bas-reliefs, nudes and nymphs in languid poses, which were the work of Charles Malfray, Alfred Janniot, Marcel Gaumont, Georges Saupique, Paul Landowski, Marcel Gimond and Gilbert Privat.

The most striking decorative works – Dufy's *La Fée Électricité* (see p. 277) and the Delaunays' efforts for the Railway Pavilion and Air Pavilion – were the result of private commissions, with financing as delicate as any airborne manoeuvre. Charles Dominique Fouqueray, an Academy member and official painter to the French air force, was the official mural painter for the Air Pavilion, but visitors to the exhibition tended to ignore his work in favour of the planes and huge hoops rigged up by Delaunay and Aublet (see p. 275). Fernand Léger collaborated with Charlotte Perriand on a fresco for the Agriculture Pavilion and also painted a mural for the Palace of Discovery, in front of which stood Jacques Lipchitz's statue *Prometheus Strangling the Vulture*, with its hero wearing a Phrygian cap and the vulture symbolizing Nazism. When the sculpture was withdrawn following political pressure, more than a thousand artists of all political persuasions protested.

The Palais de Tokyo and its two museums were among the exhibition's longer-lasting contributions to Parisian art. The architecture competition, launched in 1934, attracted 128 entries – including projects by Tony Garnier, Le Corbusier and Mallet-Stevens, which the selection committee rejected in favour of Jean-Claude Dondel and André Aubert, whose work was less 'modernist' (see p. 84). Similarly, for the Palais de Chaillot, Jacques Carlu was chosen in preference to Auguste Perret, a decision that was greeted with a stream of protests from artists and writers. For many years, artistic circles had deplored the academic taste that reigned at the Palais du Luxembourg, which had been the supposedly 'temporary' home of 'modern' painting. Visitors to the exhibition 'Masterpieces from the Musée de Grenoble' at the Petit Palais in 1935 were met with a very different approach: in Grenoble, Andry Farcy had succeeded in purchasing a number of contemporary

works by Bonnard, Modigliani, Grosz and even Fautrier (who gave up painting in 1934 to become a ski instructor), and also attracted major donations from artists (Matisse), writers and dealers (Paul Guillaume and Pierre Loeb) and collectors (Georgette Agutte-Sembat): the result was that modern art represented almost half of the exhibited 'master-pieces'. It was clearly the moment for Paris to make up for lost time and back the new policies of Jean Cassou (appointed visual arts adviser by the minister Jean Zay), through whose efforts the French state had acquired a painting by Dalí. Under Cassou's aegis, there was no longer any confusion between Henri Matisse and the naval painter Albert Matisse, as had been the case in 1925.

Léon Blum organized a retrospective of 'Masterpieces of French Art' for the opening of the Musée National d'Art Moderne, and the curators of the Musée d'Art Moderne de la Ville de Paris organized a parallel exhibition of contemporary works, called 'Les Maîtres de l'Art Indépendant', at the Petit Palais – despite rumbling protests at the city council, where some claimed that these so-called 'masters' (Bonnard, Matisse, Dufy, Picasso, Braque, Delaunay, Léger, Derain, Despiau, Maillol and the entire School of Paris) were all foreigners, of the kind regarded in Germany as 'degenerate' and also rejected by Italy and the

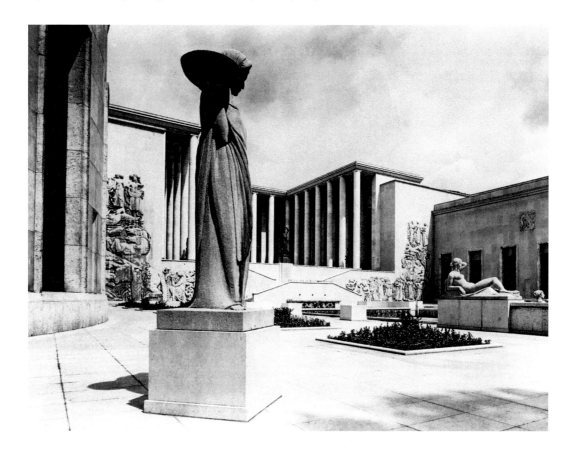

USSR, and who 'by virtue of the trinity of publicity, trickery and money, have managed to win themselves a reputation, the Legion of Honour and the official commissions'. Despite this, there was a decent showing of 'independent' art and it was greeted fairly positively by the press. In Kandinsky's judgment, the event 'absolutely followed the trend of the Paris market, which does all it can to systematically leave in the shade anything and everything new' – hence his interest in the complementary exhibition at the Jeu de Paume, which (unlike the Petit Palais exhibition) included abstract and Surrealist works.

The wings of the Palais de Tokyo were inaugurated on 24 May 1937, a few days before the Exposition Internationale opened, and were decorated with, among other things, allegorical bas-reliefs celebrating the 'glory of the arts' that were the work once again of Alfred Janniot. In the square in front of the building, a large gilded bronze sculpture representing the *Spirit of France* was erected. This was by Antoine Bourdelle, one of whose pupils before the First World War, Vera Mukhina, was responsible for sculpting the gigantic pair of workers that were placed on the roof of the Soviet Pavilion. Close by, the large ornamental lake was ringed with female figures of a symbolic or semi-symbolic nature (Paul Simon's *Ceres* and a row of *Nymphs* by Drivier, Guénot and Dejean). The Spanish Pavilion had more to offer young artists in terms of interest: Miró's *The Reaper*, Julio González's *Montserrat*, *Mercury Fountain* by Alexander Calder (see p. 282), and of course Picasso's *Guernica* (see pp. 280–81), which was not popular with either Spanish Republicans or the majority of the French left wing, but whose presence may well have persuaded a number of painters that it was possible to be politically committed without enrolling in the International Brigades and that art too could be a weapon. This was certainly the lesson learned by André Fougeron, who showed his *Martyred Spain* (see p. 273) at the Salon des Surindépendants that year and who, along with a handful of other artists, turned figurative art into an increasingly political arena.

Confirming that fascism was definitely attacking on all fronts, *Cahiers d'art* published an article by Zervos entitled 'Reflections on the Aesthetic Policy of the Third Reich' in 1937, followed by Grohmann's 'Contemporary Art in Germany' in early 1938. At the end of the same year, an exhibition at the Maison de la Culture entitled 'Free German Art' – a response to Germany's denunciation of all forms of modernism as 'degenerate art' – brought together works by Max Ernst, Paul Klee, Max Beckmann, Ernst Barlach and Ernst Ludwig Kirchner (who had just committed suicide).

On 17 November 1938, Robert Delaunay held the first of his 'Thursday' sessions (the last was on 27 July 1939). They were attended by between twelve and twenty-five people, who came to hear him talk about his work and his theories on colour and 'simultaneous contrasts'. These included friends (among them, the Gleizes, Mme Van Doesburg,

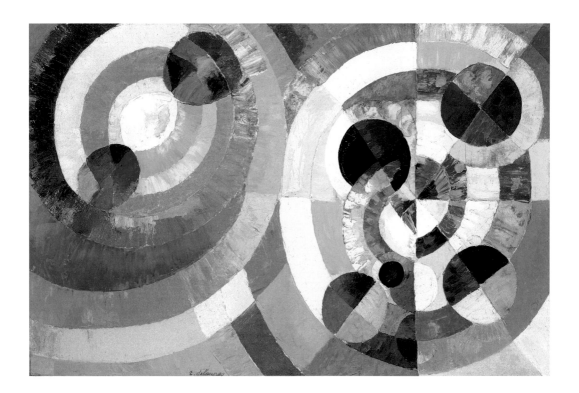

Gabrielle Picabia, Otto Freundlich and his wife Jeanne Kosnick Kloss and Henri Valensi) and young artists (Fredo Sidès and Serge Poliakoff, who showed his first abstract painting in late 1938) who were keen to be initiated into the world of abstraction that Delaunay had been exploring since 1930 and which had been validated by his decorative work for the 1937 exhibition.

Kandinsky wrote to Josef Albers, in March 1939, saying that even if few people believed there would be a war, 'the situation is monopolizing our attention to such a degree that there is not the tiniest little space left for art'. A 'little space' was nevertheless still found for abstraction in June–July 1939, when the show 'Réalités Nouvelles, Renaissance Plastique' (Galerie Charpentier) brought together sixty-four artists, in three groups. They included Arp, the Delaunays, Duchamp, Herbin, Van Doesburg, Freundlich, Gabo, Kandinsky, Kupka, Lissitzky, Malevich, Magnelli, Mondrian, Pevsner, Schwitters and Vantongerloo, as well as Picabia, Léger, Survage, Kassák, Baumeister, Gorin, Hélion, Nicholson and Le Corbusier. Not all the works could be strictly described as abstract, but the many variations on abstraction demonstrated both the richness of the trend in historical terms and the potential that it offered for experimentation.

In August 1939, the museums of Paris shut their doors, and evacuation plans that had been in preparation for three years were put into effect. The next Salon des Réalités Nouvelles waas not held until 1946.

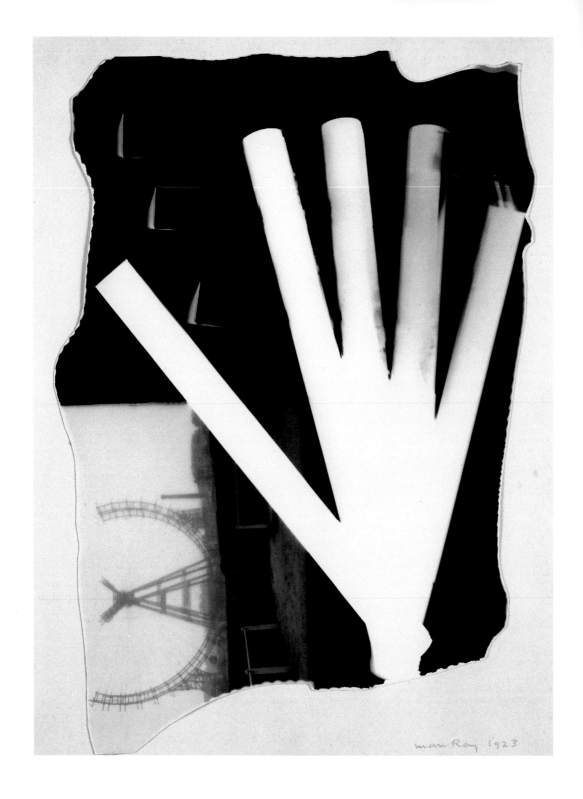

A NEW WORLD OF IMAGES
Vincent Bouvet

The Changing Faces of Photography

After the Great War, photography in France renewed its ties with pictorialism, which had earned its place as an official art form; but a new form of photography, reflecting the realities of urban life and industrialization, was also beginning to emerge. These modern photographers aspired to an objective vision of reality that was on a par with artistic creation and surpassed mere documentary work. Eugène Atget was – despite himself – the precursor of this 'new vision', and his photographic series on Paris and its environs, originally intended as modest 'documents for artists', revealed the beauty inherent in ordinary everyday scenes. Photography was no longer just for professionals either, since technical advances were making cameras accessible to a much wider public.

Many foreign photographers settled in Paris around this time, some of them deliberately choosing to break away from tradition, others compelled by the political situation, and some simply attracted by the city itself, which offered access to a whole network of art galleries, picture agencies and publications. The American artist and photographer Man Ray, an immigrant from New York, was the central figure in this community, which also included the Germans Erwin Blumenfeld, Hans Namuth, Harry Meerson and Willy Maywald, as well as many artists from central and eastern Europe, such as the Hungarians André Kertész, Brassaï and Robert Capa, the Romanian Eli Lotar, the Pole Chim and the Lithuanians Moï Ver and Izis. Together with French photographers like Jacques André Boiffard, Maurice Tabard, Roger Schall, Pierre Boucher and René Zuber, between 1919 and 1939 they formed a loose association known as the 'Photography School of Paris'. Significantly, the circle included a number of women photographers. Ilse Bing moved to Paris in 1930, after discovering the work of Florence Henri, whose mirror compositions and distorted perspectives also fascinated another female contemporary, Gisele Freund. Freund came to Paris from Berlin in 1929 and created a remarkable series of portraits of writer friends linked with the Librairie de l'Odéon circle. Germaine Krull, also originally from Germany, published a dozen or so commissioned images as well as taking newspaper and advertising photographs. The American Lee Miller, Man Ray's model and later muse, assistant and life partner, became a major photographer in her own right, taking some particularly memorable war images after 1939. Laure Albin-Guillot, an inspired portrait photographer, experimented with special filters to achieve soft-focus effects and her work was used in advertising and to illustrate luxury magazines. Yvonne Chevalier specialized in

Above:
Jacques André Boiffard,
*Illuminated poster for Mazda
on the Grand Boulevards.*
Illustration for *Nadja* by
André Breton, 1928.
Private collection.

Opposite:
Man Ray, *Untitled*, 1923.
Rayogram.
The Art Institute of Chicago.

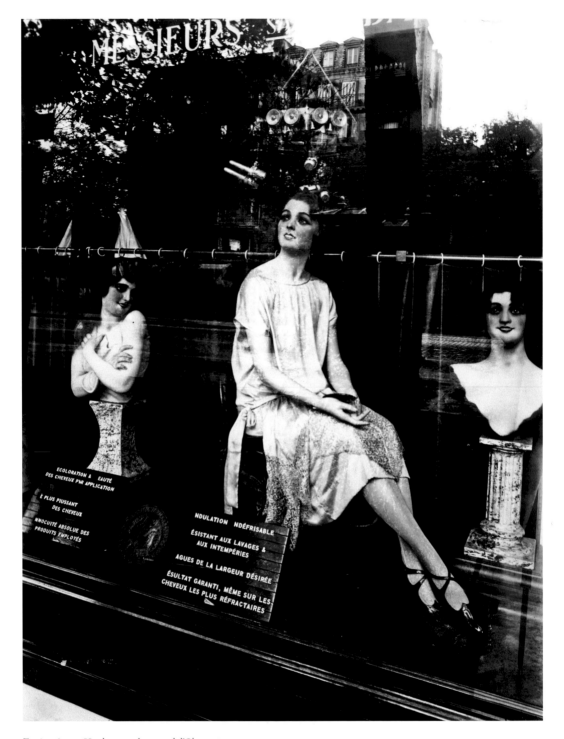

Eugène Atget, *Hairdresser on the avenue de l'Observatoire*,
1926. From *Picturesque Paris*, 3rd series.
The Museum of Modern Art, New York.

André Kertész, *Latin Quarter*, 1926.
Médiathèque de l'Architecture
et du Patrimoine, Paris.

Above:
Moï Ver, *Untitled.*
Taken from the book
Paris, 80 photomontages, 1931.

Opposite:
Eli Lotar, *At the Abattoirs of La Villette*, 1929.
Musée National d'Art Moderne,
Centre Georges Pompidou, Paris.
Photograph published in *Documents*, no. 6,
November 1929, to illustrate the article
'Abattoir' by Georges Bataille.

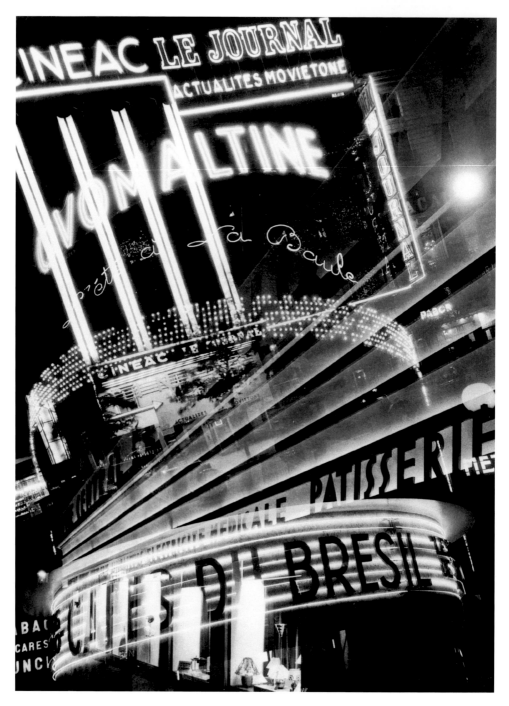

François Kollar, *The Lights of the City,*
advertisement for Ovomaltine, 1932.
Private collection.

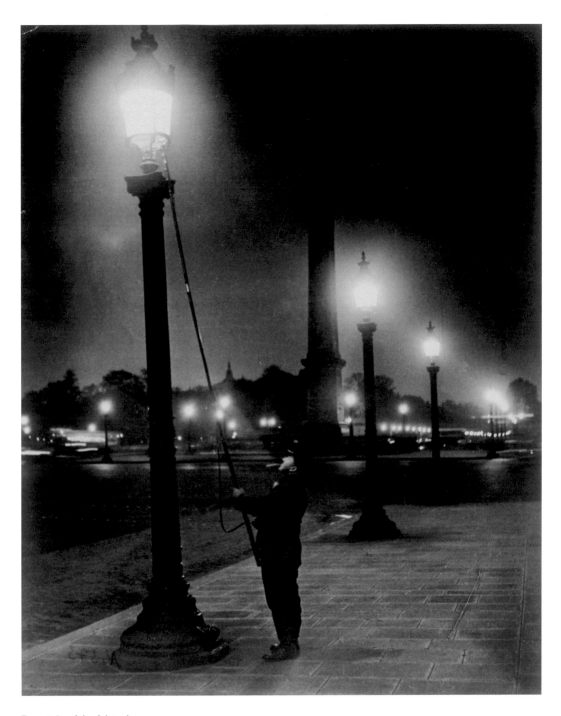

Brassaï, *Lamplighter lighting the gas
lamps on the place de la Concorde*, 1933.
Private collection.

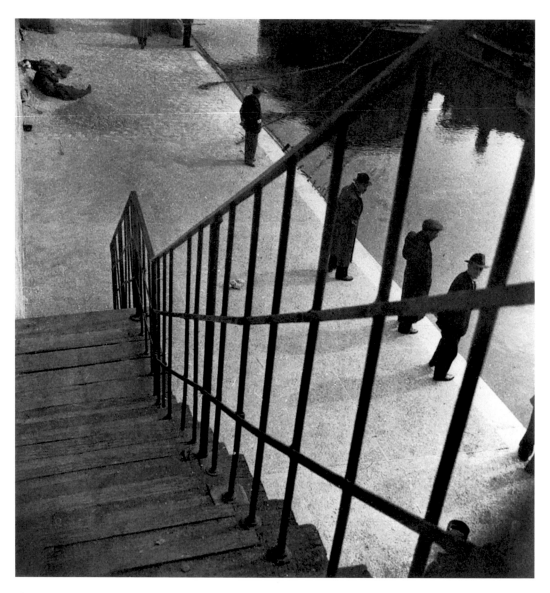

Florence Henri, *Untitled (By the Quayside)*, c. 1930.
Private collection.

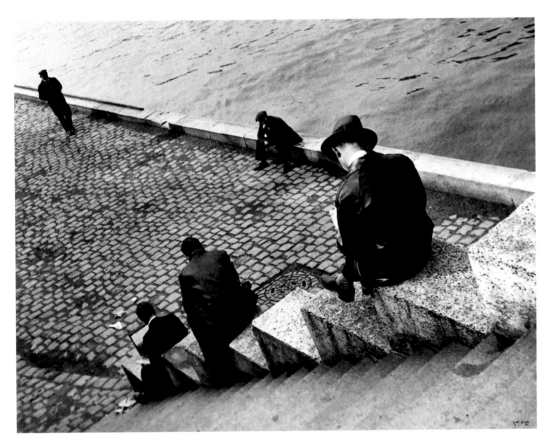

Ilse Bing, *Three Men on the Steps by the Seine*, 1931.
Private collection.

Germaine Krull, *The Eiffel Tower*, c. 1928.
Private collection.

Lee Miller, *Untitled*, c. 1931.
Museum of Modern Art, San Francisco,
Prentice and Paul Sack Photographic Trust Collection.

subtly photographed nudes. Rogi-André, wife of André Kertész, took many portraits of artists and writers, and Dora Maar was particularly interested in creating Surrealist collages. She became Picasso's mistress and was the only person who was allowed to photograph him while he was working on his monumental painting *Guernica*. It was the cosmopolitan nature of the School that was the source of its richness, but with the 'return to order' of the 1930s, the same cosmopolitanism was denounced by Le Rectangle, a group founded in 1936 by Emmanuel Sougez, Pierre Jahan and René Jacques. Le Rectangle championed a 'pure photography', while other more virulent opponents of the School were blatantly anti-Semitic. The international exhibition held by MoMA in New York in 1937, however, confirmed that Paris played a leading role in the field of contemporary photography.

Paris galleries now began showing photographs as well as other works of art. Le Sacre du Printemps held a Kertész exhibition in 1927, and in 1934 the Studio Saint-Jacques organized an exhibition devoted to advertising, with photographs by Laure Albin-Guillot, Pierre Boucher, François Kollar and Emmanuel Sougez – a theme that was repeated the following year by the Galerie de la Pléiade. In 1937, François Tuefferd opened Au Chasseur d'Images, the first gallery dedicated exclusively to

photography. In 1928, the Salon des Indépendants de la Photographie, known as the 'Salon de l'Escalier', organized a major exhibition of modern photography at the Théâtre des Champs-Élysées, and the following year the Film und Foto (FiFo) exhibition in Stuttgart became a showcase for the avant-garde. In 1926, Daniel Masclet organized the First International Salon of the Photographic Nude, and in 1936 the Exposition Internationale de la Photographie Contemporaine at the Musée des Arts Décoratifs showed a total of 1,692 photographs, while at the 1937 Exposition Internationale, photography was finally given a section of its own.

Paris inspired photographers eager to track down not just scenes from daily life but modernity in all its forms. In her album *Metal* (1927), Germaine Krull singled out industrial structures like the Eiffel Tower and transformed them into abstract landscapes (see p. 296). *Metal* was followed by *100 x Paris* (1929), with its bird's-eye views of moving streams of traffic, and *Visages de Paris*, produced in collaboration with André Warnod in 1930. The same year saw the publication of Roger Parry's *Banalité*, with a preface by Léon-Paul Fargue (published by Gallimard, with a print run of only 332, this was the first book of photography aimed at collectors), as well as *Atget, photographe de Paris*, Moï Ver's *Paris* and *Paris ville d'art* by Emmanuel Sougez. Also worthy of mention are *Paris vu par André Kertész*, with a text by Pierre Mac Orlan (1934), *Le Louvre la nuit* by Laure Albin-Guillot (1937), *Paris méconnu* by Émeric Feher (1937) and *Envoûtement de Paris* by René Jacques (1938). Brassaï published *Paris by Night* (1933), with an introduction by Paul Morand, and Roger Schall produced *Paris by Day* (1937), with a preface by Jean Cocteau. These two works were commissioned by Charles Peignot, who was the director of the type foundry Deberny et Peignot, the founder of the journal *Arts et métiers graphiques* – which devoted two special issues a year to international photography – and an enthusiastic promoter of the photographic image. The advent of the Leica camera and small-format film made it much easier to capture the 'decisive moment'. 'Humanist' photography began to develop, with Marcel Bovis, Robert Doisneau and Willy Ronis recording the daily life of working-class Parisians: this movement reached its peak in the years that followed the Second World War.

Newspapers, fashion and publicity all offered new opportunities for photographers, and during the 1930s photography took over from illustration as the mainstay of advertisements and fashion magazines, particularly those at the more luxurious end of the market. Florence Henri opened her own picture agency in Montmartre, and under the direction of Maurice Tabard, the Deberny et Peignot studio attracted the services of young photographers such as Émeric Feher and Pierre Boucher; the Studio Draeger worked with François Kollar; André Vigneau ran the studio of Lecram Press; Jean Moral worked for the

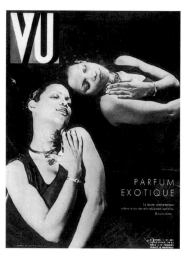

Above:
Portrait of Phily Lokay.
Photograph by Gaston for the cover
of the magazine *VU*, 13 February 1935.

Opposite:
Thérèse Bonney, *Spiral staircase in the home of*
Jan and Joël Martel, 10 rue Mallet-Stevens, 1927.
Médiathèque de l'Architecture
et du Patrimoine, Paris.

publisher Claude Tolmer, and Paul Outerbridge Jr opened his own studio – to mention just a few examples. Techniques used to enhance the products included close-ups, cut-outs and photomontages.

Paris's many fashion magazines included an increasing number of photographs, including the work of Horst P. Horst, Egidio Scaioni and Roger Schall, among others. George Hoyningen-Huene, the head of photography at French *Vogue*, developed a sophisticated style that combined classical references with avant-garde practices, while rival magazine *Harper's Bazaar* also commissioned many images from Paris photographers. The Studio Reutlinger (1850–1937) was famous for its portraits of fashionable ladies, actresses and models employed by the top couture houses like Doucet and Lanvin. Austrian photographer Dora Kallmus, known as 'Madame D'Ora' and celebrated for her soft-focus fashion shots and society portraits, opened a studio in Paris at the invitation of *Vogue*. Harry Meerson launched his career in 1931, taking portraits against a plain white ground; Brassaï and Dora Maar both used his studio to print their photographs. In the same year Roger Schall opened a studio in Montmartre that gained a reputation for its exacting standards and employed up to fourteen photographers. The Studio Harcourt was founded in 1934 by the Lacroix brothers, who were magazine publishers, Robert Ricci, son of the fashion designer Nina Ricci, and Cosette Harcourt. In 1938, the studio moved to the former home of the collector Maurice Kahn, on the avenue Iéna, providing a luxurious environment ideally suited to its well-heeled clientele.

L'Art vivant, a bi-monthly journal with a fairly modernist bias, embraced photography in 1928 by printing a review of the Salon de l'Escalier by Florent Fels. The American photographer Thérèse Bonney contributed to both American and French magazines, covering the Salon d'Automne and the Salon des Artistes Décorateurs; she founded the first American picture agency in Europe and became an ambassador for French architecture and the Art Deco style in the United States, helping to organize exhibitions of French art in New York and American art in France. Her many photographs of apartment blocks, shop fronts and luxury boutiques reflected the creativity of 1920s and 1930s Paris. Founded in 1861, the Studio Chevojon produced scientifically precise photographs of Paris's major building projects and detailed coverage of work by leading architectural firms; these were published in upmarket magazines or the architectural press.

Published between 1928 and 1940, the weekly magazine *VU*, founded by Lucien Vogel, was the first publication of its kind to devote a substantial amount of space to photojournalism. The *VU* photographers – including André Kertész, Brassaï, Germaine Krull and Robert Capa – were commissioned to cover a whole range of political and cultural events in France and abroad. This kind of photographic reporting influenced the illustrated press all over the world and served as a model

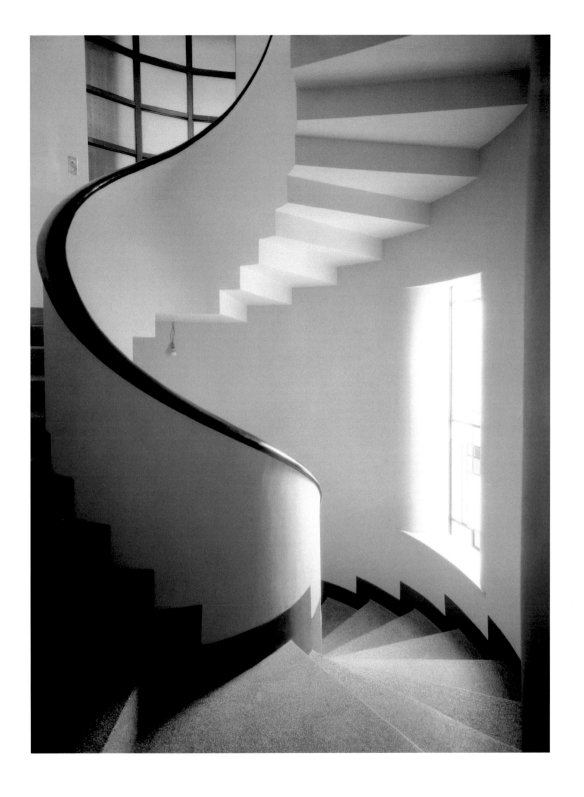

Below:
The Photography Pavilion at the 1937
Exposition Internationale.

Opposite, above:
Studio Harcourt, *Marlène Dietrich*, 1938.
Médiathèque de l'Architecture
et du Patrimoine, Paris.

Opposite, below:
Still from *L'Âge d'or* by Luis
Buñuel and Salvador Dalí, 1930.

for the US magazine *Life*. *Le Figaro illustré* was a monthly publication, and in 1933 the Communist Party launched its weekly journal *Regards*, with photographs by Pierre Jamet and André Papillon, while Romain Rolland, Maxim Gorky, André Gide, Henri Barbusse and André Malraux were all on the editorial board. In 1938 Jean Prouvost bought the weekly sports magazine *Paris-Match*, and turned it into an international current affairs magazine along the lines of *VU* and *Life*.

Prior to the 1920s, illustrated papers and magazines did not employ full-time photographers, but bought in photographs as and when they were needed. With the huge increase in demand from newspapers and periodicals following the war, the number of picture agencies began to multiply, contracting professional photographers to supply them with new images. The first European press agency, Delphot, opened in Berlin in 1928, but photojournalism was in fact very much centred on Paris. Founded in 1933 by Charles Rado, a Jewish Hungarian immigrant, in collaboration with Émile Savitry, Ergy Landau and Brassaï, the Agence Rapho was the pioneer among French picture agencies, while the American-based Keystone View Company opened a Paris branch in 1927. A number of photojournalists – Boiffard, Boucher, Cartier-Bresson, for example – were sympathizers of the AEAR (Association des Écrivains et Artistes Révolutionnaires), while Robert Capa became the quintessential war correspondent. Established agencies such as Trampus, Meurisse, Rol and Lapi faced stiff competition from newcomers such as Branger, France Press and Fulgur, agencies well placed to cover the momentous events that occurred during the 1930s. In 1927, Emmanuel Sougez founded the photography department of the biggest-selling weekly, *L'Illustration*.

In 1934, René Zuber and Pierre Boucher were founders of the specialist agency Alliance-Photo, which brought together a number of

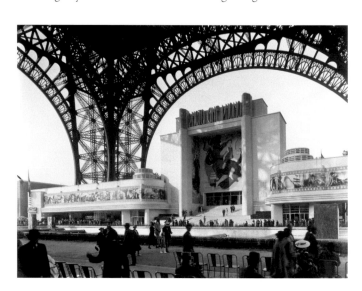

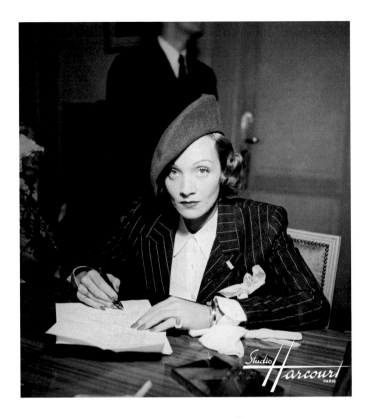

freelance photographers such as Pierre Verger, Émeric Feher and Denise Bellon. Alliance-Photo was one of the first agencies to establish a code of practice by insisting that the photographer's name should appear alongside any published image. The Agence Roger-Viollet was founded in 1938 by Hélène Roger-Viollet, a staunch campaigner for women's voting rights and the first journalist to cover the Spanish Civil War. The agency's initial archive of images – predominantly showing Paris life since 1880 – was gradually expanded to include work by Albert Harlingue, Laure Albin-Guillot and the Studio Lipnitzki.

From Silent Movies to Talking Pictures

The Great War put a sharp check on the expansion of the French film industry – already threatened by the Italian film studios and by Hollywood particularly. Young French filmmakers like Jacques Feyder, Raymond Bernard and Julien Duvivier nevertheless had opportunities to prove themselves during the 1920s. Early avant-garde filmmakers championed the primacy of atmosphere over plot. Louis Delluc was a frontrunner in this 'impressionist' movement, as well as being a pioneer of film criticism. He directed a number of films, including *Fièvre* (1921) in which he skilfully manipulated the depth of field and introduced flashbacks. In 1924, Marcel L'Herbier made *L'Inhumaine*, which was the product of an extraordinary artistic collaboration, with a screenplay by

Below:
Fernand Léger on the set of *L'Inhumaine*
by Marcel L'Herbier, 1924.

Opposite:
L'Inhumaine by Marcel L'Herbier, 1924.
Entrance of the 'Engineer's House', set
design by Robert Mallet-Stevens.

Pierre Mac Orlan, sets by Robert Mallet-Stevens and Fernand Léger,
costumes by Paul Poiret and music by Darius Milhaud, but the results
were indifferently received. In April 1927, at the Opéra de Paris, Abel
Gance showed a shortened version of his monumental *Napoléon*, filmed
using a number of innovative techniques (handheld cameras, a triple-
screen effect called Polyvision), and in February of the following year,
for the opening of Studio 28, he showed *Autour de Napoléon*, a documen-
tary about the making of his Napoleonic epic. Jean Epstein
experimented with dreamlike slow-motion shots in *The Fall of the House of
Usher* (1928), while Germaine Dulac created works that ignored the con-
ventions of narrative cinema: *The Seashell and the Clergyman*, shown at the
Studio des Ursulines in 1928, provoked a huge rumpus because Antonin
Artaud was so unhappy with her treatment of his screenplay.

A second wave of young avant-garde directors followed the banner
of Surrealism. Man Ray filmed his *Retour à la raison* (1923) – at the
request of Tristan Tzara – by adapting his 'Rayograph' technique to the
moving image, and in *Entr'acte*, a cinematic interlude commissioned by
Picabia for his ballet *Relâche* in 1924, the young René Clair strung
together a number of sequences that had no logical connection: Man
Ray and Marcel Duchamp play chess on the roof of the Théâtre des
Champs-Élysées, a dancing ballerina turns into a bearded man, a hearse

Above:
The lobby of Studio 28, ransacked after a screening of *L'Âge d'or*, 3 December 1930.

is pulled by a camel. In 1928, Luis Buñuel and Salvador Dalí filmed *Un chien andalou* (1928), a kind of 'manifesto of the absurd', which they followed in 1930 with the provocative *L'Âge d'or*. When the latter was screened at Studio 28, members of a fascist league protested by wrecking the auditorium and destroying the paintings by Miró, Ernst and Dalí displayed in the lobby.

Although Paris had been abundantly photographed, it had made few appearances on film, mainly for technical reasons. The characters in René Clair's *Paris qui dort* (1923) climb to the top of the Eiffel Tower in an attempt to escape the diabolical rays of a mad scientist, then make their way across the sleeping city. And a few short documentary films focused on Paris and its outlying districts: George Lacombe, for example, filmed the desolate area around the old city walls (*La Zone*, 1928); Pierre Chenal and Jean Mitry made *Paris-Cinéma* (1927), and *Nogent, eldorado du dimanche* (1929) was the young Marcel Carné's impressionistic debut film, recording a Sunday on the banks of the Marne.

The year 1930 saw the arrival of the first French-made talking pictures. The earliest of these were filmed in studios and recreated the streets of Paris using cardboard sets. René Clair's *Sous les toits de Paris* — with its shop girls and street singers, their caps set at a jaunty angle —

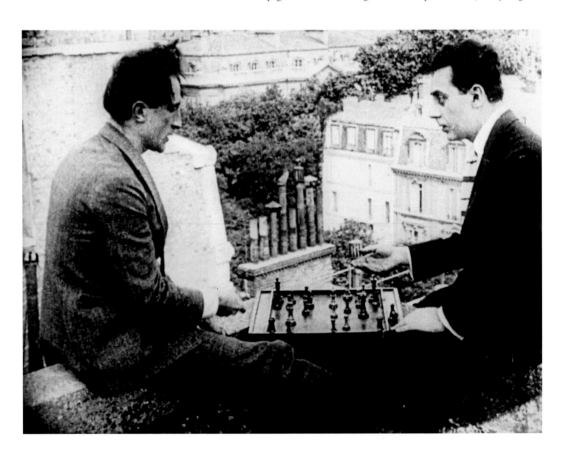

Opposite:
Marcel Duchamp and Man Ray playing chess.
Still from *Entr'acte* by René Clair and Francis
Picabia, 1924.

Above:
Still from Man Ray's film *Retour à la raison*, 1923.
The Art Institute of Chicago, Julien Lévy Collection.

Below:
Sous les toits de Paris by René Clair, 1930.
Film made at the Épinay studios.

Opposite:
Annabella and Louis Jouvet in *Hôtel du Nord* by Marcel Carné, 1938.

was made at the Épinay studios and was one of the first great talkies (and musicals) made in France and an international box-office success. The sets for Marcel Carné's *Hôtel du Nord* (1938) – the Hôtel itself and the Canal Saint-Martin bridge – were entirely reconstructed in an area close to the Billancourt studios, while for *Quai des brumes* (also 1938), Carné gave up the idea of trying to recreate the old quarter of Montmartre (the setting for Mac Orlan's novel) and filmed his exteriors in the town of Le Havre instead.

The popularity of the left-wing Front Populaire was an unprecedented phenomenon in France and Jean Renoir made several films demonstrating his sympathy for the Front and its supporters. *The Crime of Monsieur Lange* (1935) told the story of a group of workers who formed a cooperative to save their company from bankruptcy. *La Vie est à nous* (1936) and *La Marseillaise* (1938), a homage to the French Revolution, were partly financed by the Communist Party and the trade union block, the Confédération Générale du Travail. It was also during this period between the wars that Renoir directed a whole string of films that have become French cinema classics: *La Chienne* (1931), *Boudu Saved From Drowning* (1932), *Partie de campagne* and *Les Bas-Fonds* (1936), *La Grande Illusion* (1937), *La Bête humaine* (1938) and *The Rules of the Game* (1939).

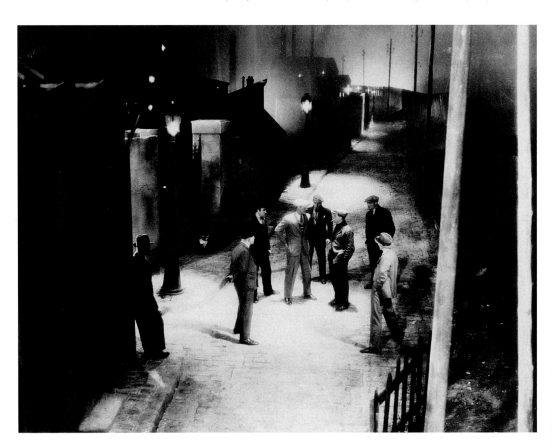

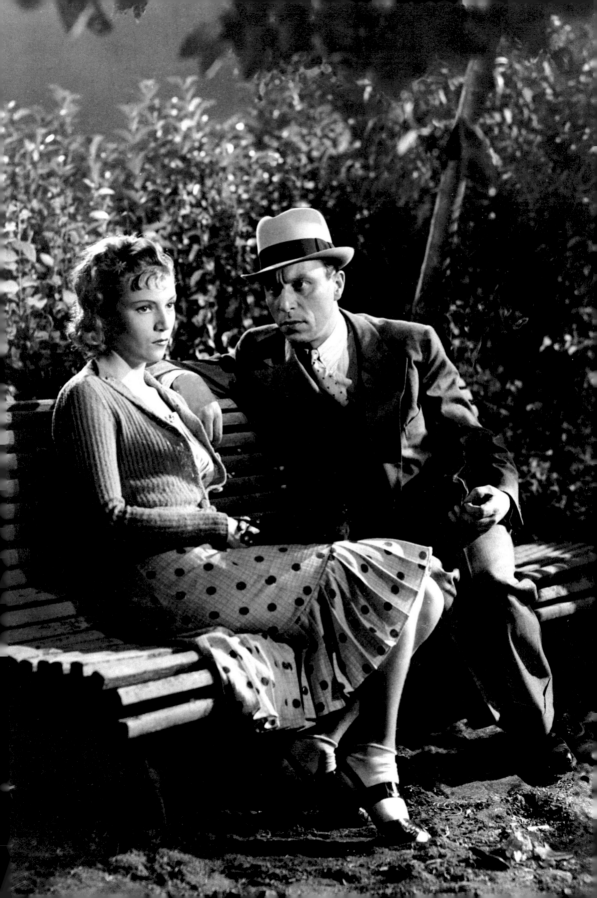

A number of playwrights were also attracted by the film industry. Marcel Pagnol, for example, adapted the first two plays of his Marseille trilogy – *Marius* was filmed by Alexander Korda in 1931, and *Fanny* by Marc Allégret in 1932 – before taking over as director himself for *César*. In contrast with the Parisian style of stars like Gabin or Arletty, Pagnol's favourite actors – Raimu, Fernandel, Fernand Charpin – spoke in southern French accents and went on to become established figures of French popular film. Sacha Guitry also adapted several of his own successful plays (*Faisons un rêve, Mon père avait raison, Désiré*) and one of his novels (*The Story of a Cheat*, 1936), before making historical dramas such as *The Pearls of the Crown* (1937) and *Remontons les Champs-Élysées* (1938). Guitry continued to use the same set of actresses for all these films – Marguerite Moreno, Pauline Carton and Jacqueline Delubac – in which he also starred himself.

Whether a film was successful or not depended a great deal on the actors, many of whom had a background in classical theatre, including Louis Jouvet and Jules Berry. The public felt a deep affection for these stars and would flock to see them on screen, almost regardless of the quality of the films in which they appeared. Typecasting was commonplace: Mireille Balin (who partnered Jean Gabin in Duvivier's *Pépé le Moko* and Grémillon's *Gueule d'amour*) and Viviane Romance (Gina in *La Belle Équipe*) played femme fatales; Simone Simon (*La Bête humaine*) and Ginette Leclerc (*La Femme du boulanger*) were bitchy; Annabella and Danielle Darrieux were seductive, and Françoise Rosay and Gaby Morlay were women of character. Jean Gabin played the big-hearted rogue, Albert Préjean was usually the working-class boy made good, and Charles Boyer, Pierre Richard-Willm and Pierre Fresnay were all leading men. Some actors transcended these categories: Harry Baur, Charles Vanel, Jules Berry and Michel Simon, for example. The many supporting roles gave French cinema greater breadth of human interest

Above:
The Belleville-Pathé cinema (19th arr.),
1931–32.

Below:
The Rex cinema on the boulevard
Poissonnière (2nd arr.), 1931.
Photograph by Samand.
Musée Carnavalet, Paris.

Opposite:
A couple looking at the poster for
the film *The White Black Sheep*, directed
by Sidney Olcott, 1926.

and gave the public a chance to identify with the likes of Noël Roquevert, Robert Le Vigan, Marcel Dalio, Jean Tissier, Julien Carette and Pierre Larquey.

Genre films also flourished – detective stories, colonial films and comedies, featuring stereotypes like the femme fatale and the handsome hero. Pathé and Gaumont preferred to show moneyspinners like *Les deux orphelines*, a costume drama by Maurice Tourneur, or *Les Croix de bois* by Raymond Bernard, from the novel by Roland Dorgelès, which recreated the horrors of the 1914–18 war. For reasons of cost or laziness, many producers were content at best to adapt literary classics (as long as the rights were free), and at worst to produce comedies of manners or risqué mediocrities.

Going to the cinema was the nation's favourite pastime after the war. It was cheap, offered a wide choice of films that changed regularly, and the many cinemas provided places for young people to meet on a Saturday night and for family outings on a Sunday afternoon. In 1934, Paris had a total of 22,000 cinema seats, as against 13,000 in the provinces. The number of cinema tickets sold in 1939 in Paris alone – including to visitors from the suburbs, the provinces and abroad – was in the region of 200 million. A handful of music halls and theatres and similar venues were converted into cinemas, and a number of specially designed complexes also appeared. The Gaumont Palace was modernized by Henri Belloc in 1930 (with 6,000 seats on two floors); the Sèvres Pathé was designed by Henri Sauvage; the Marignan was built in 1933 on the Champs-Élysées; the Louxor Pathé had its façade and interior decorated in the style of an ancient Egyptian temple; and the Rex opened in 1932. The feature presentation itself was not the only attraction, and

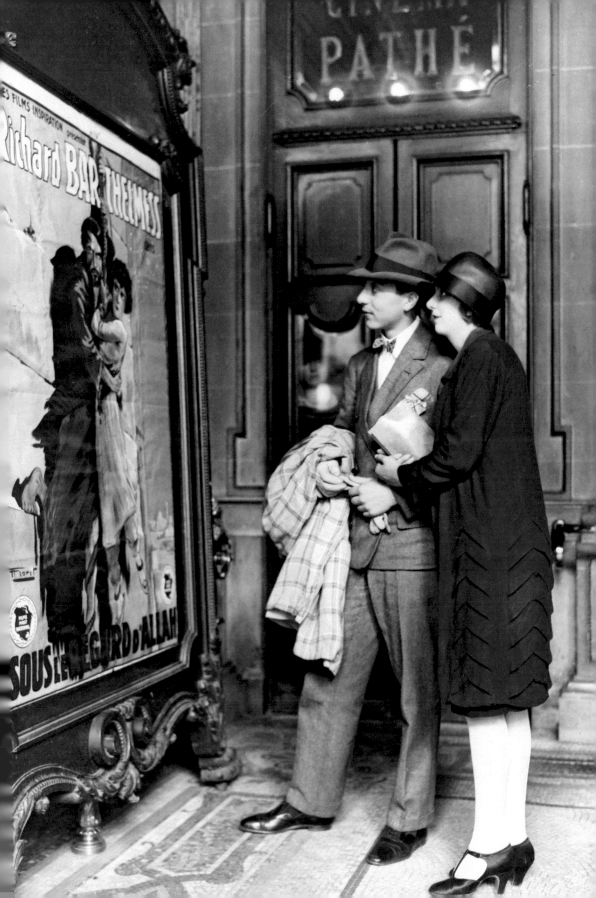

there would often be some form of entertainment during the interval. The first Gaumont newsreel was screened in 1932, and cinema advertising – which had previously been limited to fixed advertisements on the safety curtain – took off when Jean Mineur founded the first agency that specialized in publicity films.

In addition to the big picture houses that showed mainstream films, a number of art cinemas – such as L'Oeil de Paris, the Vieux-Colombier, the Panthéon and the Studio des Agriculteurs – began screening more experimental and innovative works. At the Studio des Ursulines, the public could see Pabst's *Joyless Street* (in which Greta Garbo made her international screen debut), Fritz Lang's *M*, and the world premiere of Sternberg's *The Blue Angel*, the film that shot Marlene Dietrich to fame, which ran for fourteen months. The Cinéma Balzac opened in 1935, close to the Champs-Élysées, and screened Hollywood movies in their original version, establishing itself as one of the main Paris cinemas showing exclusive films. The Cinéma Mac-Mahon opened in 1938 and became a favourite haunt for film lovers. Henri Langlois and Georges Franju started a film club known as the Cercle du Cinéma, where they showed old films which they had succeeded in unearthing, and in 1936 the Cinémathèque Française was created out of this as an archive for films and other historical material from the film industry.

The Graphic Design Revolution

Belle Époque Paris had seen the birth of poster art with the work of Toulouse-Lautrec, and Leonetto Cappiello seemed to be his natural successor. Cappiello's advertisements made an immediate impact through their sheer simplicity – brightly coloured people or animals set against a single-colour background, with lettering integrated into the composition. Lithographed posters, temporarily fixed to an available surface, and permanent advertisements painted on the sides of buildings now became a regular feature of the Paris cityscape, making every street an ever-changing show.

A new generation of graphic artists emerged in Paris during the 1920s. The most famous of them were members of the UAM, the Union des Artistes Modernes (whose cruciform logo was designed by Pierre Legrain), and included Adolphe Mouron, better known as Cassandre, Charles Loupot, Jean Carlu and Paul Colin. These four artists were responsible for inventing a modernist style of advertising, employing strong colours and hand-drawn lettering, favouring geometric shapes and celebrating the glory of machines and the industrial age.

Cassandre's early career was influenced by the collective of painters and critics known as the Section d'Or, which included Fernand Léger and Amédée Ozenfant. Cassandre followed the tenets of the Bauhaus, seeing it as the role of the poster artist to 'establish a clear, powerful and precise means of communication'. His reputation was secured by his

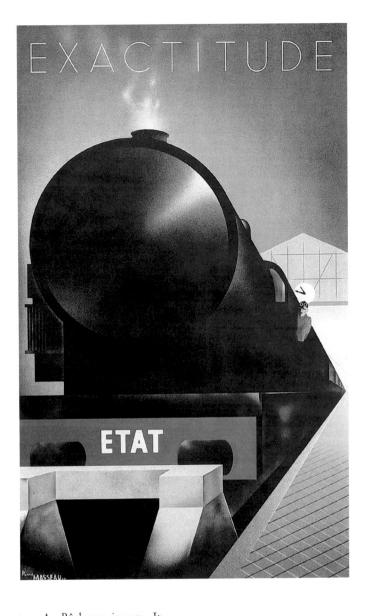

large-format poster for the furniture store Au Bûcheron in 1923. It showed a woodcutter chopping down a tree, with the figure and the tree trunk forming a V-shape between what looks like folds of fabric, fanning out in graduated shades from orange to white. This was followed, in 1927, by posters for the *Nord Express* and the *Étoile du Nord* – where the rails converging at a vanishing point on the horizon create an impression of speed – and, in 1935, by his monumental and lyrical image of the ocean liner *Normandie*. Cassandre believed that a poster's impact could be maximized through the use of 'poetic language', and to achieve this he relied on the technique of airbrushing, which created soft shading and graduated tones that accentuated the sense of perspective.

He also created popular characters like the little man who advertised Dubonnet (1932; see p. 23): the famous triptych of images showed the blank figure slowly filling up with colour as he drinks the aperitif. This fragmented image could easily be recognized by Metro passengers as they hurtled along the track. Cassandre was a revolutionary artist who worked on the principle that the image depended on the text and not the other way round. He designed three fonts for the Deberny et Peignot type foundry: Bifur (1927), which shocked his contemporaries because of its geometric simplicity and omission of parts of the letters, the black and grey Acier (1930) and Peignot (1937), both of which were more warmly received.

Cassandre was profoundly influential in his field and taught a course on commercial graphics at the École Nationale Supérieure des Arts Décoratifs. One of those to pass through the École Nationale training, with its emphasis on 'rigour' and 'graphic precision', was Pierre Fix-Masseau, who designed the streamlined locomotive of *Exactitude* (1932; p. 217) for the Réseau de l'État railway company. France's private rail companies were nationalized in 1937 to create the SNCF, whose famous logo was designed by Maximilien Vox. Vox also designed a set of alphabetical frontispieces for the *Larousse du XXe siècle* encyclopedia.

Charles Loupot, who worked with Cassandre for a time, used warmer tones and made letters an integral part of his compositions (such as the T of Twining's tea). Like Cassandre, he used simplified figures, such as the geometrically drawn man advertising Valentine paint (1928) or the silhouettes of his two Saint-Raphaël waiters (1937), pared down almost to the point of abstraction in a restricted colour palette of black, white and red. The popularity of the Saint-Raphaël waiters was immense and they appeared on promotional objects that ranged from carafes to ashtrays. Loupot also worked for Bugatti, designing posters celebrating the world of speed.

Jean Carlu worked in a Cubist style reminiscent of Juan Gris, creating layered designed with simplified shapes and a brilliant colour palette (*Monsavon*; see p. 188). He used photography and photomontage in posters for the Office de Propagande Graphique pour la Paix (*Pour le désarmement des nations* and *Votez SDN*), which he founded in 1932, as well as to tackle current events, as on his hardhitting cover design for the bestselling *La Dette*. Always progressive in his approach, Carlu came up with the idea of the neon poster (*Cuisine électrique*, 1935) and produced three-dimensional signs for the Odéon record company using sheets of enamelled metal, working in collaboration with the sculptors Jan and Joël Martel.

Paul Colin was the poster designer with the most painterly approach. He worked mainly for theatres and music halls, designing not only publicity material but also sets and costumes. His career really took off in 1925 thanks to his supremely stylized poster for the *Revue*

Above:
Charles Loupot, *Le Café Martin*, 1929.
Private collection.

Opposite:
Paul Colin, *The Night of Fur: Grand Ball at Le Claridge*, 1928.
Musée de la Publicité, Paris.

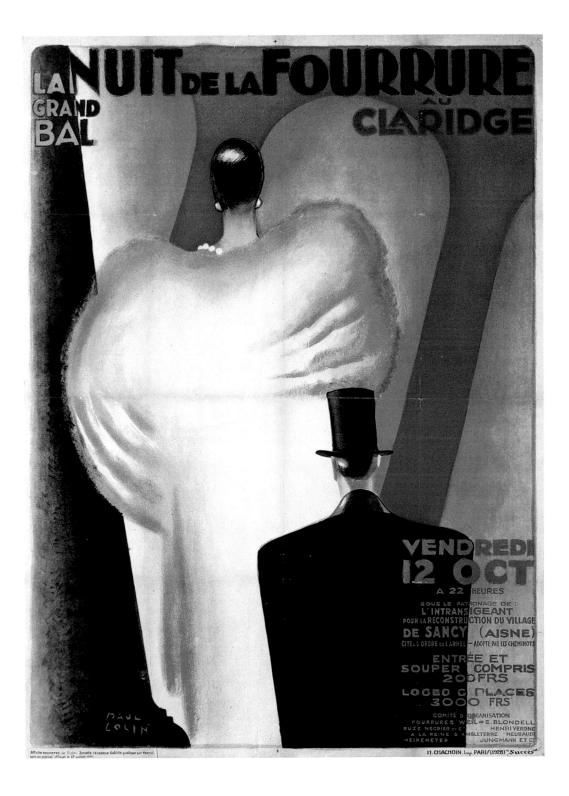

Cover of a special issue of the magazine
VU on colonization, with a photomontage
by Alexander Liberman, 3 March 1934.

Nègre (see p. 372). Designers Charles Gesmar and Zig (Louis Gaudin) also produced successful posters and concert programmes for performers including Mistinguett, Maurice Chevalier and Édith Piaf.

Cappiello was still creating imaginative designs around this time, promoting consumer products such as Kub stock cubes (1931) with his persuasive yet simple graphics. And there were a great many other graphic artists making a career for themselves: Roger Broders, Pierre Commarmond, Éric de Coulon and Léon Cauvy produced posters for the tourist industry; Jean Adrien Mercier and Jean Dubout designed cinema posters, and Paul Mohr and Francis Bernard (see p. 166) specialized in advertising for household products. The artists had contractual links with different printing firms – Cappiello worked, successively, for Vercasson, Imprimeries Réunies and Devambez, and Cassandre for Hachard & Cie – and began to work increasingly closely with advertising agencies, which boomed in this period of economic growth. One of the most enterprising of these agencies was Publicis, founded by Marcel Bleustein-Blanchet in 1927.

In addition to his catalogue of more than a thousand different fonts, Charles Peignot founded the magazine *Arts et métiers graphiques*, which ran until 1939 and whose sixty-eight issues covered the history of book publishing, illustration, the latest printing techniques and contemporary graphics, both in France and abroad. It was a state-of-the-art journal both in terms of its innovative page design and the quality of its typography. Graphic designers became the art directors for new publications: Jacques Nathan at *L'Architecture d'aujourd'hui* and Alexander Liberman at *VU*, whose slogan 'the text explains, the photo proves' heralded a revolution in magazine publishing in the 1930s.

As early as 1932, the UAM exhibition included a room devoted to advertising and the graphic arts, but true recognition came with the first Advertising Pavilion at the 1937 Exposition Internationale. This new phenomenon confirmed the definitive shift from old-style advertising to full-blown publicity campaigns that involved three different professions – advertising, marketing and design. The front of the pavilion was adorned with gigantic neon signs by Cassandre, Maximilien Vox and Lajos Martin, Roger Pérot and Francis Bernard, and the 'luminograph' over the entrance displayed a moving stream of neon slogans and pictograms. Inside, the main hall brought together a selection of the best posters from recent years reproduced in large format, together with designs from abroad, while Jean Carlu's 'cavalograph' displayed two rows of posters, old and new, that moved at different speeds, enabling viewers to compare their relative impact.

VU

NUMÉRO SPÉCIAL
HORS SÉRIE
3 MARS 1934

PRIX : 6 FRANCS
DIRECTEUR : LUCIEN VOGEL
PHOTO VU - MONTAGE D'ALEXANDRE

COLONISATION

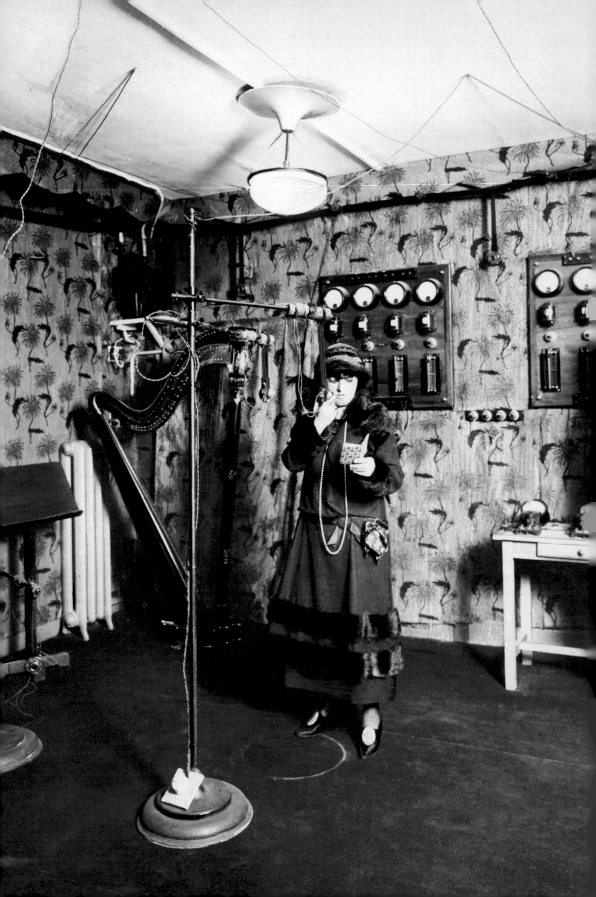

INTELLECTUAL LIFE

Gérard Durozoi

Life After Wartime

In 1919, Marcel Proust was awarded the Prix Goncourt for *À l'ombre des jeunes filles en fleurs*, the second volume of *À la recherche du temps perdu*, the first book having met with little success in 1913. From this point on, Proust was published by Gallimard, who had previously turned him down but were now anxious to affirm their position as the major publishing house of the day – an aspiration they fulfilled, since soon every writer would dream of being printed between those famous white covers. After some years of isolation, Proust resumed society life to an extent, but died in 1922 before his novel cycle could be published in its entirety. His name became famous, but few readers of the day were able to see beyond the anecdotal and autobiographical elements of the work and truly understand Proust's ambitions or his concept of an art that could 'convert pain into beauty'. The novelty of Proust's work escaped the great majority of the public, whose concern, now that the war was over, was to pick up where they had left off – with old familiar habits and established authors. To ladies of fashion, even going to the Collège de France to attend lectures by Henri Bergson – whose reputation as the greatest French philosopher was confirmed when he won the Nobel Prize in 1928 – even without reading his latest works (*Duration and Simultaneity*, 1922 and *The Two Sources of Morality and Religion*, 1932), seemed a great deal easier than floundering in Proust's linguistic labyrinths. Meanwhile, the rationalists and advocates of 'common sense' that could overcome strong emotions drew sustenance from the writings of Émile-Auguste Chartier, better known as Alain, delving into the multiple volumes of his *Propos*, as well as *Système des beaux-arts* (1920), *Les Idées et les âges* (1927) and *Les Dieux* (1934).

André Gide was already well established and made it his unmistakable mission to search out the truth, in all its multiple forms – even if this truth seemed barely acceptable to some. His defence of homosexuality, *Corydon* (1924), earned him a good deal of animosity. The autobiographical *If It Die*, which appeared two years later, was less contentious, but it was with *The Counterfeiters*, a novel-within-a-novel which incorporated a criticism of itself, that in 1925 Gide once more joined the literary forefront, as he had in 1914 with *The Vatican Cellars*.

The only writer to rival him at the time – though writing in a different register – was Paul Valéry. His essay 'La crise de l'esprit' ('We civilizations know now that we are mortal…') was published in 1919 in the first issue of the relaunched *Nouvelle Revue Française* (*NRF*) and his reflections on culture, politics and civilization provided the subject matter for *Regards sur le monde actuel* (1931) and exercised his mind until his death in 1945. As a poet, Valéry reworked his Symbolist poems for his

Above:
Georges Cretté, book binding for
Les Climats by Anna de Noailles, 1924.
28 × 23 cm (11 × 4⅜ in.).
Private collection.

Opposite:
Comtesse Anna de Noailles reading
some of her poems for a Radiola radio
broadcast, 22 November 1922.

1924

P. Albert Laurens

Left:
Paul Albert Laurens,
André Gide, 1924.
Oil on canvas, 61 × 50 cm
(24 × 19 ⅝ in.).
Musée d'Orsay, Paris.

Opposite:
Caricature of Paul
Claudel by Adrien
Barrère, published in
Fantasio, 1 January 1927.

Album de vers anciens (1920) and published *Charmes* (1922); he became the inaugural holder of the Chair of Poetics at the Collège de France in 1937. As an analyst of the mind, Valéry continued his *Monsieur Teste* cycle (1926) and compiled his extensive *Cahiers*. Appointed a member of the Académie Française in 1925 and invited to give many lectures and write countless prefaces, Valéry was garlanded with honours and – in contrast to Gide's uncompromising individualism – adopted the slightly haughty attitude of a thinker capable of tackling any and every subject and singling out the essential ideas from the circumstantial trivia.

Although his diplomatic role took him away from Paris until 1935, Paul Claudel published many works, including plays (*Le Père humilié*, 1920, and *Le Soulier de satin*, 1929), poems (*Feuilles de saints*, 1925) and essays (*L'Oiseau noir dans le soleil levant*, 1927, and *Positions et propositions*, 1928). Since

COLETTE
LA MAISON DE CLAUDINE

LE LIVRE MODERNE ILLUSTRÉ
J. FERENCZI ET FILS
EDITEURS. PARIS

PRIX : DEUX FRANCS CINQUANTE

converting to Catholicism in 1890, he had attracted a faithful following in Catholic circles that shared his hostility to intellectuals and parliamentarianism. His 'universal' spirit feared neither the excesses of theatrical references nor the potentially twee tone of a return-to-the-soil philosophy: what mattered to Claudel was that order – if possible a transcendent order – should be imposed on the anarchic nature of existence.

Colette – one of the very few women writers of the period – was more modest in her aspirations, which involved detailed explorations of the struggle between the sexes. The *Claudine* books, which appeared at the beginning of the century, highlighted women's aspirations to greater freedom; the war years had proved that relative independence was beneficial to women, and Colette described sexual and emotional situations that seemed groundbreaking at the time – the relationship, for example, between a 'mature' woman and her younger lover in *Chéri* (1920) and an adolescent love affair in *Le Blé en herbe* (1923).

Leaving the Past Behind

'Monsieur Alain continues to babble. He may yet go on for some time.' This assessment came from Philippe Soupault, writing in *Littérature* in 1920. It was with the aim of putting an end to such ramblings that Dada ranted and raved, making everything (poetry, prose, theatre, painting) seem laughable or grotesque, and developing the habit of insulting members of the public who rushed to attend its performances as they would rush to honour an invitation from one of those 'salons' where literary reputations were still built up and broken down (although less eagerly than prior to 1914). Due partly to snobbery, and despite the fury that André Breton, Louis Aragon, Philippe Soupault and their circle displayed in their attacks on good sense and the established order, the public saw little difference between a Dadaist soirée and a tea party with the Duchesse de La Rochefoucauld – except for the fact that the former was more entertaining than the latter. And yet it was in all seriousness that the Paris Dadaists asked writers the question 'Why do you write?' and gleefully published their pitiful answers. But Breton and his friends decided that it was time to leave aside the shock tactics that were now growing stale from repetition, and to embrace experiments that overturned convention and everyday routine in quite a different way: automatic writing, hypnotic trances and the insights into the 'true workings of the mind' apparently offered by psychoanalysis – which the Surrealists were virtually alone in taking seriously at the time. It was this kind of exploration that became the main focus of Surrealism after 1924, signalling that the movement was *not* a literary school but a 'revolution of the mind', which refused to yield any longer to social imperatives.

The *Manifesto of Surrealism* was as critical of the strictures of rationalism as it was of realism and the novel. It extolled the powers of the imagination and called for an exploration of thought in its widest sense, extending far beyond the conscious. The journal published by André Breton's group, *Le Révolution surréaliste*, contained a fairly indiscriminate

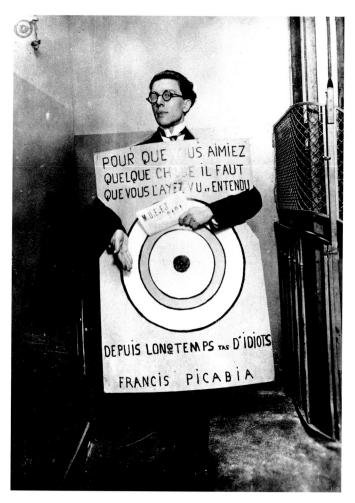

mixture of dream stories, poems and accounts of the many manifesta-
tions of the 'fantastic' in everyday life, and hoped to displace thought
from its well-trodden paths by revealing new perspectives on reality and
the way it is perceived. Being a member of the Surrealist group meant
having little truck with journalism (although some members earned
their living from it); it meant signing tracts and collective declarations
that had little to do with literature, and staunchly upholding values such
as poetry, love and freedom.

The Surrealists were involved in many scandalous events. The
greeted the death of Anatole France, a man of letters regarded as one of
France's national treasures, by publishing a collective tract of a particu-
larly incendiary nature. At a banquet held in honour of the Symbolist
poet Saint-Pol-Roux they insulted Paul Claudel ('one cannot simultane-
ously be a French ambassador and a poet') and displayed shockingly
pro-German sentiments. They wrecked a bar in Montmartre that had
dared to call itself Maldoror. They applauded heartily at performances
of Raymond Roussel's plays, and even fought with other members of the

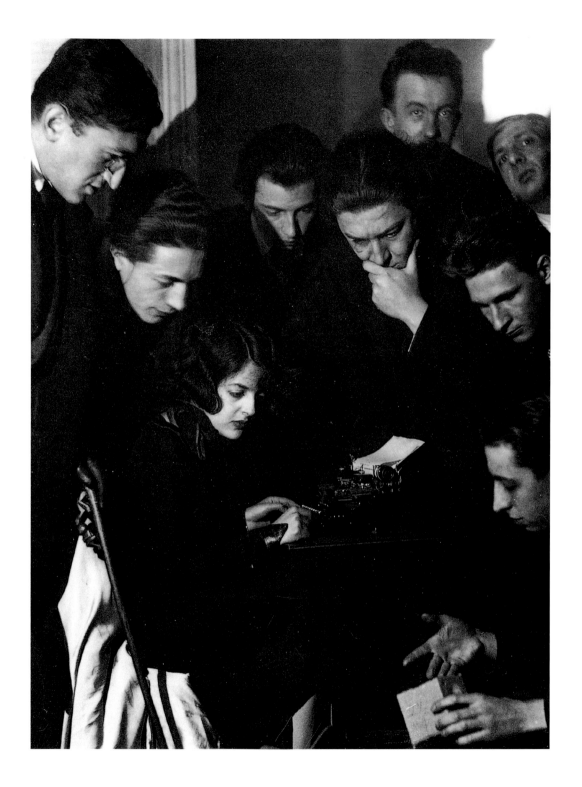

audience who mocked and ridiculed the works. They also published a series of open letters in *La Révolution surréaliste* affirming the wish to overthrow public institutions and calling for a total shake-up of the social order. The Surrealists also got mixed up in politics, taking a stand against the Second Moroccan War, trying to apply the Hegelian dialectic to events of all kinds, and seeking to establish links with the Communist Party while at the same time deploring the conformism of Communist cultural ideas. In short, they were quite impossible to deal with. Gallimard published works by Aragon (*Le Mouvement perpétuel*, 1925; *Le Paysan de Paris*, 1926) and Breton (*Les Pas perdus*, 1924; *Nadja*, 1928), but Éluard, Crevel, Desnos, Péret and Char had to make do with less prestigious publishers, and the Éditions Surréalistes were virtually a vanity press and only survived due to the sale of 'luxury' editions to a handful of book collectors. Its notable publications included works based on shared poetic sensibilities, such as *Ralentir travaux* (Breton, Éluard and Char) and *L'Immaculée Conception* (Breton and Éluard).

The life of the Surrealist group was a breeding ground for argument and dissent. Soupault, one of the group's founders, distanced himself from it in 1926: he was criticized by the others for publishing

too many novels, and Soupault in turn disapproved of the rest of the group's obsession with politics. By the time the *Second Manifesto* was published in 1929, there had been several defections (Artaud, Limbour, Vitrac). Breton was not one for humouring former friends, and Desnos, Bataille, Limbour, Leiris and a handful of others criticized him in a tract entitled 'Un cadavre' (A Corpse'). But such ripples only reached the very small audience that was customary for any work by the Surrealists as well as for their various competing publications, including *Bifur* (Ribemont-Dessaignes) and *Documents* (Bataille).

NEW WORKS, NEW AUDIENCES

The Surrealists distanced themselves from the contemporary literary scene, which was favourable to the discovery of new authors as long as their concept of literature was not too revolutionary. Literary awards were gaining in influence and publishing houses were expanding, even though book distribution was not yet the major industry it was to become. The highly conservative *Revue des deux mondes* (which deliberately refused to mention Proust or Gide) celebrated its centenary in 1929; but the *Mercure de France* was losing ground in favour of the *Nouvelle Revue française*, whose editor Jacques Rivière declared his support for the 'demobilization of literature'. Jean Paulhan took over from Rivière in 1925 and succeeded in attracting a mixture of contributors – some illustrious names (Valéry, Proust) and some comfortably familiar ones (Alain and the critics Albert Thibaudet and Ramon Fernandez), along with a few newcomers: Dada, for example, was 'recognized' by Gide in the pages of the *Nouvelle Revue*. The journal founded by Maurice Martin du Gard in 1922, *Les Nouvelles littéraires*, appealed to a wide readership with its combination of reportage, debate and reviews. Readers soon grew tired of memoirs of life on the Front (Dorgelès's *Les Croix de bois* and Kessel's *L'Équipage*) and preferred the escapist novels of Pierre Benoit (*L'Atlantide*, *Le Sac salé*), Victor Margueritte's *La Garçonne* (a 'scandalous' novel of manners which sold 600,000 copies) and *La Madone des sleepings* by Maurice Dekobra. Those with a taste for adventure and mystery embraced detective novels, which took over from serialized stories: 1927 saw the creation of the series 'Le Masque', followed shortly by 'L'Empreinte' in 1929, and several series published by Gallimard ('Détective', 'Scarabée d'or', 'Chefs-d'oeuvre du roman d'aventures'). These included titles by British and American writers (Dashiell Hammett, for example, was much admired by Gide) as well as original works in French by authors such as Noël Vindry or Georges Simenon, creator of Maigret.

A similar desire to be entertained was apparent at the theatre too: Sacha Guitry, Édouard Bourdet, Marcel Pagnol (*Topaze*, 1928) and Marcel Achard attracted full houses with light comedies in the style of the boulevard theatres, updated with modern humour. The successful playwrights of the 1920s explored endless variations on married life and its

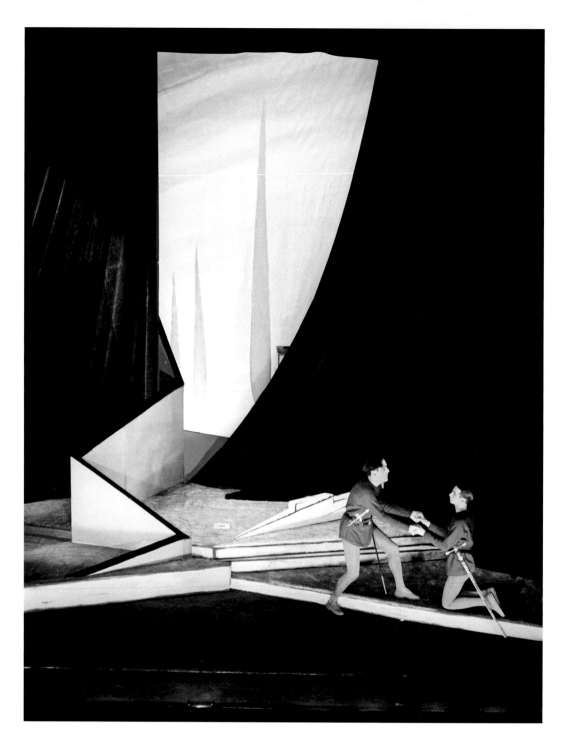

Above:
Georges Pitoëff in his production
of Shakespeare's *Romeo and Juliet*,
Théâtre des Mathurins, June 1937.

Opposite:
Poster for the play *Topaze* by Marcel
Pagnol, *c.* 1928.

Jacqueline Delubac and Sacha
Guitry in *Les Châteaux en Espagne*,
Théâtre des Variétés, 1933.

Charles Dullin (centre front) and the cast
of Jules Romains's adaptation of Ben
Jonson's *Volpone*, Théâtre de l'Atelier,
September 1937.

trials and tribulations. The members of the 'Cartel des Quatre' were
more demanding, seeing the theatre as an opportunity for innovation, in
terms of both choice of material and direction. George Pitoëff staged
works by foreign authors – Shakespeare, Strindberg and Chekhov – and
discovered Pirandello in 1924 (*Six Characters in Search of an Author*) and later
Jean Anouilh (*Le Voyageur sans bagage*, 1937; *La Sauvage*, 1938). Charles Dullin
formed a regular company which performed an eclectic repertoire at the
Théâtre de l'Atelier. Gaston Baty primarily staged adaptations of
famous novels, but Louis Jouvet attracted large crowds to the Théâtre des
Champs-Élysées with *Knock* by Jules Romains (1923), and plays by Jean
Giraudoux (*Siegfried*, *Amphitryon 38*, *Intermezzo*), in a style that captivated
audiences more than Giraudoux's novels had formerly done.

Antonin Artaud and Roger Vitrac founded the short-lived Théâtre
Alfred-Jarry, but remained on the fringes of mainstream theatre. Artaud
viewed the stage as a metaphysical space in which the meaning of exis-
tence could be explored, while in *Victor, or The Children Take Over* (1928),
Vitrac sought to show that bourgeois values were an obstacle to living.

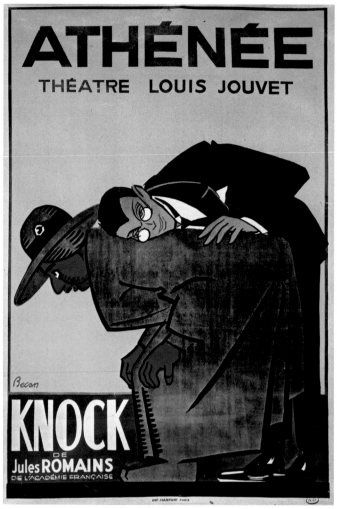

Above:
Louis Jouvet and Alfred Adam
in *Knock* by Jules Romains,
Théâtre de l'Athénée, 1937.

Right:
Poster by Becan (Bernhard Kahn)
for the play of *Knock* by Jules Romains
at the Théâtre de l'Athénée, 1937.

Opposite, above:
Robert Le Vigan and Jean-Pierre Aumont
(centre) in *La Machine Infernale* by Jean
Cocteau, Comédie des Champs-Élysées,
April 1934.

Opposite, below:
Antonin Artaud in *Les Cenci*,
Théâtre des Folies-Wagram, May 1935.
Sets and costumes by Balthus.

Artaud, whose production of *Les Cenci* was a flop in 1935, later elaborated
his theories in *Le Théâtre et son double* (1938): 'A true theatre play wakes the
senses from their sleep, frees the repressed unconscious, incites a kind of
virtual revolt.' But these notions were far removed from the plays of the
period, whether they were the fantasies (*Les Mariés de la tour Eiffel*, 1924) or
'serious' plays (*La Machine infernale*, 1934) of Jean Cocteau – 'grand impre-
sario of the age' and 'popularizer of all that is new' (Maurice Sachs), who
was also keen to make his mark on the theatre – or the lyrical flights of
Fernand Crommelynck (*Tripes d'or*, 1925) or the love affairs cynically dis-
sected by Steve Passeur (*Pas encore*, 1927).

Above all, the period between the wars was the golden age of the
novel, in both qualitative and quantitative terms. These years saw the
publication of vast family and social sagas, in the manner of Balzac and
Zola, in some cases spanning decades. In *Les Thibault* (1922–40), Roger
Martin du Gard suggested to the bourgeoisie that the future depended

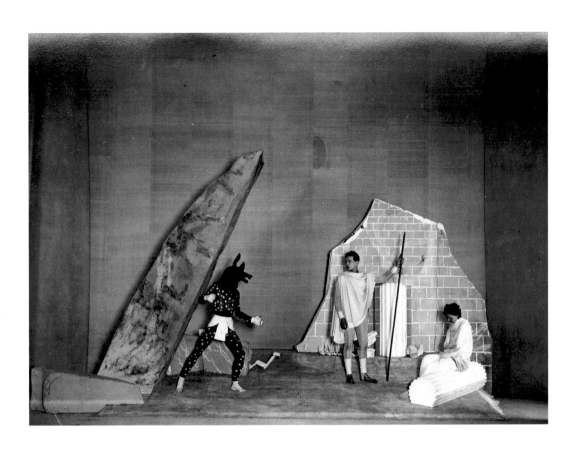

on its capacity for change. In *Les Hommes de bonne volonté*, a cycle of twenty-seven novels published between 1932 and 1947, Jules Romains retraced twenty-five years of world history in an attempt to demonstrate the capacity of the human spirit to overcome all obstacles. In his *Chronique des Pasquier*, Georges Duhamel championed the values of humanism and common sense, while Louis Aragon's work was based on an entirely different dynamic: following his break with Surrealism and the ties he forged with the Communist Party, *Les Cloches de Bâle* (1934) and *Les Beaux Quartiers* (1936) not only seek to explore the 'real world' but are predominantly a meditation on love, and on the possibility of happiness founded on collective harmony, and are not too weighed down by the demands of Aragon's socialist realism.

There were other novelists whose aims were less ambitious but whose works nevertheless had a certain appeal, even though those who prided themselves on psychological analysis (André Maurois and Jacques Chardonne, for example) basically continued to plough the same

Above:
Jean Cocteau, *Portrait of Raymond Radiguet*, 1924. Private collection.

Right:
Advertisement for the book *Magie Noire* by Paul Morand, published in *Charivari*, 21 July 1928. Private collection.

Opposite, above:
Saint-John Perse, *c.* 1930.

Opposite, below:
François-Louis Schmied, binding for the book *Les Ballades Françaises, Montagne. Forêt. Plaine. Mer* by Paul Fort, 1927. 22 × 27 cm (8 ⅝ × 10 ⅝ in.). Bibliothèque Municipale, Reims.

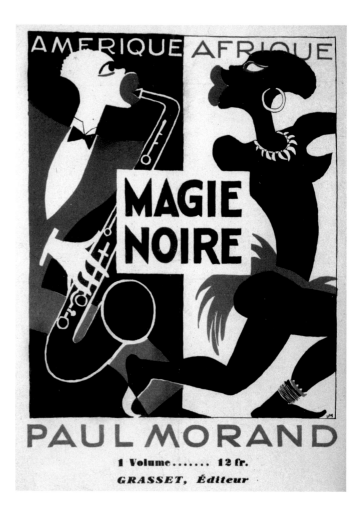

AMÉRIQUE AFRIQUE

MAGIE NOIRE

PAUL MORAND

1 Volume....... 12 fr.

GRASSET, *Éditeur*

old furrows. The French novel saw itself as qualified to tackle any area of human experience, at the very time when advances in science were providing it with serious competition. Psychoanalysis – albeit in a rather distorted form – was becoming more widespread, with Princess Marie Bonaparte founding the Société Française de Psychanalyse in 1926. The *Annales d'histoire économique et sociale*, a journal launched by Marc Bloch and Lucien Febvre in 1929, heralded a new approach to the study of history. There were also developments in the fields of sociology (based on the work of Durkheim) and ethnography and anthropology, as taught by Marcel Mauss. *L'Afrique fantôme* – published by Michel Leiris, somewhat unsuccessfully, after he took part in the Dakar–Djibouti ethnographical mission (1931–33) – was more like a novel than much fiction of the day.

Novels could be 'populist' in approach and focus on the life of the common people, as Francis Carco did with his prostitutes and rag-pickers, Eugène Dabit with the micro-society of his *Hôtel du Nord*, or Louis Guilloux in *La Maison du peuple* and *Le Sang noir*. It could combine

technical virtuosity with polite disdain for convention, as in the works of
Cocteau (*Thomas l'imposteur*, 1923; *Les Enfants terribles*, 1929) or Raymond
Radiguet, whose *The Devil in the Flesh* (1923) was published by Bernard
Grasset and was the focus of a major advertising campaign. Novels could
also celebrate the cosmopolitan nature of the modern age (Paul
Morand, *Ouvert la nuit*, 1922) or, conversely, the delights of the country, in
contrast to the decadence of city life, as in the case of Maurice Genevoix
(*Raboliot*, winner of the Prix Goncourt in 1925) and Jean Giono, whose
works elevated his native region of Haute Provence to the status of myth
(*Colline*, 1928; *Regain*, 1930; *Que ma joie demeure*, 1935) – but these evocations
of rural France were already heavily imbued with nostalgia. Such diverse
tendencies were not really in competition with one another, but designed
to please a varied readership, and each literary season brought a selection
of new titles, whose 'newness' was always relative.

 Unlike the novel, poetry had a fairly restricted readership. Saint-John
Perse's solemn prose poem *Anabase* (1924) captured the richness of a
distant realm in language that was both unusual and formally precise, but
the poet was appointed to the French foreign ministry in 1929 and
refused to publish anything else while in office. After the publication of
Douze petits écrits (1926), the work of Francis Ponge only appeared in a few
literary journals. In *Gravitations* (1925) and *La Fable du monde* (1938), Jules
Supervielle hovered between the physical and imaginative worlds, just as
he hovered between France and his native Montevideo. Henri Michaux's
prolific work charted the unsettling territory of his inner world (*Qui je
fus*, 1928; *Un certain Plume*, 1930; *La Nuit remue*, 1935) and of physical spaces
both real and imaginary (*Ecuador*, 1929; *Voyage en Grande Garabagne*, 1936),
but Michaux was well aware that he was writing for a limited audience.

CHRISTIAN VALUES AND THE QUEST FOR HEROISM

Real innovation in the field of the novel was only to be found when
authors were able to expand an individual situation in order to touch the
collective consciousness, or – more rarely – to shift the boundaries of
'literature' and its language.

 In the early 1920s, the historian of philosophy Étienne Gilson sought
to revive the philosophy of St Thomas Aquinas as a global system of
thought that went beyond the bounds of theology. Embracing a Chris-
tian humanism inspired by Aristotle and Aquinas, Jacques Maritain
affirmed the primacy of the spirit, even when it impinged on political
democracy, and set out to encourage a great many intellectuals to adopt a
religious perspective, while Abbé Henri Bremond, theoretician of 'pure
poetry', was busy preaching the 'good word' in literary circles. Freed of
the anti-Republican nationalism that characterized Maurras's *L'Action
française* (condemned by the Pope in 1926), Catholicism was seeking to
establish a new social identity, and in 1932 Emmanuel Mounier founded
the journal *Esprit* as a forum for progressive left-wing Catholic thinking.

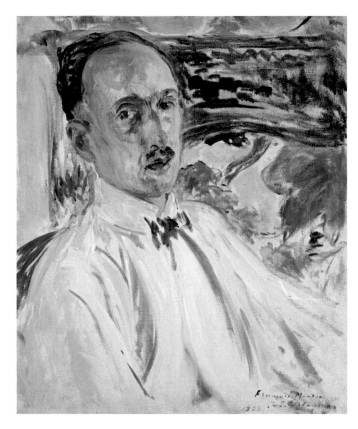

This was the context within which François Mauriac was writing. His novels (*Thérèse Desqueyroux*, 1927; *The Knot of Vipers*, 1932) described the bitter conflict between the flesh and the spirit and showed that the victory of the latter over the former is never certain; the underlying concern of these novels, with their sombre settings and bleak plots, was unquestionably with metaphysics rather than technique. Initially a right-wing nationalist, Georges Bernanos was also interested in the struggle between good and evil, which he embodied in characters who were either admirable (*Sous le soleil de Satan*, 1926; *La Joie*, awarded the Prix Femina in 1929) or loathsome (the renegade priest in *L'Imposture*, 1927). Breaking with traditional Catholicism in 1930, Bernanos depicted a radical opposition between true faith and religious complacency in *Le Journal d'un curé de campagne* (1936). Marcel Jouhandeau, a writer who was torn between his homosexuality and his Christian faith, produced an honest self-portrait in *Monsieur Godeau intime* (1923) before going on to portray the mediocrity of his peers whom he deemed to be beyond the reach of salvation in *Chaminadour* (1934). Written after his own wedding, Jouhandeau's *Chroniques maritales*, begun in 1938, described the living hell of a marriage in which the hope of redemption somehow survives.

Even before his conversion in 1940, the characters in Julien Green's novels (*Adrienne Mesurat*, 1927; *Léviathan*, 1928) were caught up in dark and

Right:
Antoine de Saint-Exupéry
and his navigator André Prévot,
in front of their Caudron-Renault
before leaving for Sudan,
Le Bourget airport, *c.* 1937.

Opposite:
André Malraux in front of the plane
before his air trip to Yemen with
Édouard Corniglion-Molinier, 1934.
Florence Resnais Collection.

seemingly inescapable destinies, although some hope of a transcendent order still glimmered through the chaos. Pierre Jean Jouve's poems (*Le Paradis perdu*, 1929; *Noces*, 1931) and novels (*Paulina*, 1880; *Hécate*, 1928) showed that although he was interested in Freudian theories, Christian concepts also played a part in his meditations on love, sin and death, which sought to eradicate the 'nothingness of time'.

Christian values were not, of course, the only values extolled in novels. In *Le Songe* (1922), Henry de Montherlant depicted war as the prelude to a rebirth of the individual. Sport (*Les Olympiques*, 1924) and the confrontation with death (*Les Bestiaires*, 1926) could also affirm the most noble part of the self, freed from trivial circumstance and acquiring a 'passion for indifference'. *Service inutile* (1935) set forth this 'aristocratic' morality, a throwback to a Catholic concept of heroism, while the four novels of *Les Jeunes Filles* (1936–39) focused on the haughty cynicism of a famous writer and the foolishness of the women he seduces. This series was Montherlant's biggest commercial success, but Paul Léautaud concluded that the author had no real knowledge of women and had written a great deal of nonsense about them.

In the case of Antoine de Saint-Exupéry, the heroism was of a strictly modern kind. Aside from their historical interest as accounts of the early days of civil aviation, *Southern Mail* (1928), *Night Flight* (1931, awarded the Prix Femina) and *Wind, Sand and Stars* (1939) embodied a clear invitation to push beyond the limits of the individual, and so overcome all obstacles – both geographical and mechanical – and promote a solidarity with the rest of the human race. André Malraux skilfully transposed his own experiences into his novels, including his involvement in the Spanish Civil War. His passion for art led him to organize an archaeological expedition to Cambodia, after which he was accused by the French colonial authorities of removing fragments of temple bas-reliefs, but this journey also encouraged an interest in political events in

China, including the Canton uprising of 1925. His experiences gave rise to the three novels *The Conquerors* (1928), *The Royal Way* (1930), and *Man's Fate* (1933, awarded the Prix Goncourt), which combine history and fiction as they recount the adventures of numerous characters, and their struggles, both political and metaphysical. Malraux's energetic style of writing and his transformation of events into parables resonated with a public who began to believe that Malraux himself was not merely a novelist but a major player on the world stage, one of History's heroes.

It was through his anti-hero Bardamu that Céline turned so-called 'literary' language on its head in *Journey to the End of the Night*, published by Denoël in 1932 and winner of the Prix Renaudot. The novel seemed to turn its back on all the conventional rules of literature and used unusual language to convey a dark vision of humanity grappling with the absurdities of existence. By overturning conventional syntax and vocabulary – in an attempt to recreate individual emotions and collective preoccupations – and by mixing up registers and alternating rhythms, he created a kind of oral quality which was to impress Sartre. The text conjured up visions that were alternately tragic and grotesque, comic and moving, and thus demonstrated the capacity of a literature freed from its former constraints to convey the many-faceted nature of reality itself. Published in 1936, Céline's second novel, *Death on Credit*, confirmed his reputation.

FOREIGN VOICES

In *La Fin d'une parade philosophique: le bergsonisme* (1929), Georges Politzer denounced the concept of idealism being used to serve the bourgeois opposition to change. Three years later, in *Les Chiens de garde*, it was Paul Nizan who, from the same Marxist standpoint, accused bourgeois philosophy and literature of serving reactionary politics through their idealism: the universities, divided between Bergsonism, neo-Thomism and neo-Kantism, were hardly at the forefront of philosophical thinking.

Most seriously of all, developments outside the borders of France were being greatly underestimated: Hegel, Marx and Nietzsche all had the misfortune to be German and only the Surrealists were sufficiently unpatriotic to pay any attention to the contributions of the two former.

In 1929, however, the Société Française de Philosophie invited Edmund Husserl to give a series of lectures at the Sorbonne (*Cartesian Meditations*): phenomenology was gradually extending its reach and exerting an influence on some young philosophers, including Jean-Paul Sartre and Maurice Merleau-Ponty, and was supplemented in some cases with a partial reading of Heidegger. Kierkegaard was also arousing interest through the efforts of Jean Wahl. But it was Hegel whose ideas made the biggest impact in intellectual circles from 1933 onwards: Alexandre Kojève gave lectures on Hegel's *The Phenomenology of Spirit* at the École Pratique des Hautes Études, attracting the likes of Raymond Aron, Bataille, Lacan, Queneau, Breton and Merleau-Ponty. But when Walter Benjamin came to Paris in 1934 to escape the Nazis, he encountered the usual mistrust of German intellectuals – even from Gide, although the two had already met in Germany – and found himself unable to contribute to a single journal.

From the early 1920s onwards, publishers were nevertheless opening their doors to works of foreign literature. At Sagittaire, the 'Collection

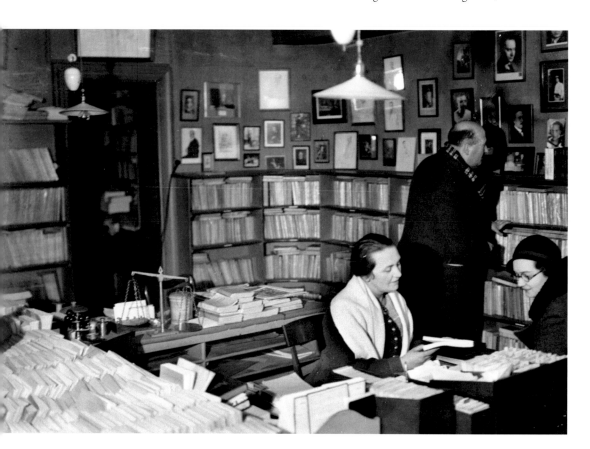

de la Revue Européenne', edited by Léon Pierre Quint and Philippe Soupault, published Gorky, Unamuno, Gómez de la Serna and Carl Sternheim, while Strindberg, Tagore, Schnitzler, Stefan Zweig, Katherine Mansfield, D. H. Lawrence and Virginia Woolf appeared in Stock's 'Cabinet Cosmopolite' series. Gallimard introduced John Dos Passos, William Faulkner, Kafka and Erskine Caldwell to a French readership, while Charles Du Bos at Plon published works in translation including novels by E. M. Forster and Virginia Woolf and, in 1926, a translation of Joyce's *Dubliners*, with a preface by Valery Larbaud. Larbaud believed in fostering a European spirit and advised booksellers – most notably, Adrienne Monnier – on their choice of foreign authors. Monnier's Maison des Amis des Livres (7 rue de l'Odéon) was much more than a lending library: it was also a meeting place for authors and readers, Breton called it 'the most appealing place of its time for the exchange of ideas'. Opposite, at no. 12, Sylvia Beach opened her English-language bookshop Shakespeare and Company, in 1921: Beach published Joyce's *Ulysses* in 1922, while a French translation of the novel (under Larbaud's supervision) was published in 1929 by the Maison des Amis des Livres.

Joyce spent long periods in Paris between 1920 and 1939. He mainly spent time with people who were enthusiastic about his work, mixing

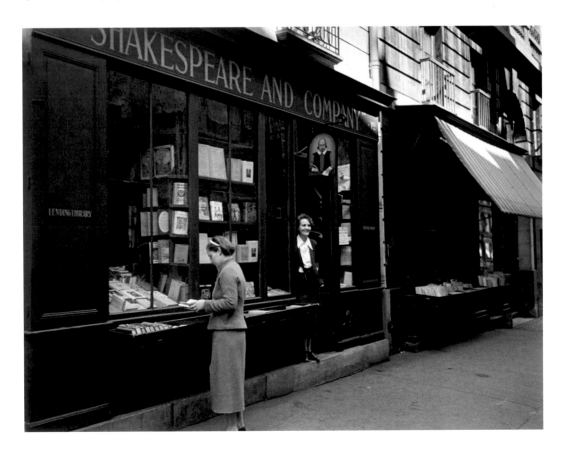

little with French literary circles and even avoiding his fellow country-men. His *Work in Progress* (as it was then known) engrossed him entirely and excerpts were published in Eugene Jolas's English-language journal *Transition*. Jolas – editor of an *Anthologie de la nouvelle poésie américaine* (1925) and translator of African-American songs (*Le Nègre qui chante*, 1928) and poems (*Mots-déluges*, 1933) – published writers of all nationalities, pro-vided that they were 'potent forces of the arts'. Another American to appear in *Transition* was Gertrude Stein, whose home in the rue Madame served as a magnet for Americans in Paris – Hemingway, F. Scott Fitzger-ald, William Carlos Williams, Ezra Pound and Sherwood Anderson – as well as Valery Larbaud and Tristan Tzara. In February 1935, after the pub-lication of the *Autobiography of Alice B. Toklas*, *Transition* printed a pamphlet entitled 'Testimony against Gertrude Stein', in which Jolas maintained that 'she had no understanding of what really was happening around her'. He and a few other friends of Joyce (including the young Samuel Beckett) produced a homage to the writer entitled *Our Exagmination round his Factification for Incamination of Work in Progress*, published by Sylvia Beach in May 1929. Two years later, in the *NRF,* Philippe Soupault – the only link between Joyce and Surrealism – published 'Anna Livia Plurabelle', a trans-lated excerpt of *Work in Progress*, which was finally published in 1939, in New York and London, under its definitive title *Finnegans Wake*.

Despite being much admired, Joyce exercised a less immediate influ-ence on French literature than Faulkner, Dos Passos and some British novelists. In his articles for the *NRF*, Maurice Blanchot defined his concept of the novel as the creation of forms and figures through a sin-

gular style of writing. Formal concerns were what exercised the mind of Raymond Queneau, who transposed Descartes's *Discourse on the Method* into 'spoken' language in *Le Chiendent* (1933), used a mixture of material from Hegel, Freud and the study of ethnology in *Gueule de pierre* (1934), and produced an autobiography in verse form, *Chien et chêne* (1937). Like Julien Gracq's *Au château d'Argol* (1938) – admired by Breton – and the early works of Nathalie Sarraute (*Tropismes*, 1939), Queneau's efforts went largely unheralded. Jean-Paul Sartre's *Nausea* (1938), on the other hand, was a successful attempt at popularizing philosophical ideas: many readers were able to identify with Roquentin's sense of the absurdity of existence and the angst he feels at the self-contained nature of things.

A Time of Choices

The publication of *The Treason of the Intellectuals* by Julien Benda, in 1927, provoked a great deal of debate. The author saw intellectuals as witnesses to the human spirit, and so believed that they ought to be indifferent to practical outcomes. If they made political choices, it could only be in the name of 'abstract justice' and of reason, which was more important than emotional – and particularly nationalistic – fervour. And yet the 1930s were to force writers to focus on certain courses of action and to adopt clear ideological choices.

Politics was nothing new for the Surrealists, whose new journal was unambiguously titled *Le Surréalisme au service de la révolution* – but this 'revolution' was very much on their own terms: having been among the first to question Stalinism, they moved towards a position of left-wing opposition to the Communist Party, which was disseminating its theories and cultural policies in the journals *Europe* and *Commune*. In *The Communicating Vessels* (1932), Breton attempted, in vain, to convince the Communists of

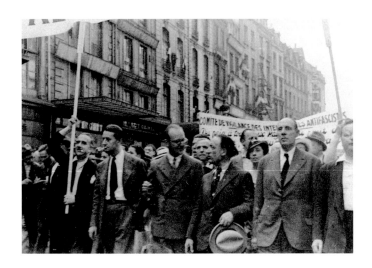

the need to bring Freud and Marx together in order to instigate a revolution that encompassed every aspect of existence. At the time of the attempted fascist coup, in February 1934, the Surrealists published a 'Call to Arms', signed by ninety people of all political hues (from Alain to Malraux). The Comité de Vigilance des Intellectuels Fascistes was created in the wake of these events and placed itself in the service of the workers' and trade union organizations. In 1935, the Association des Écrivains et Artistes Révolutionnaires organized an 'International Congress for the Defence of Culture', which was attended by Gide, Barbusse, Malraux, Heinrich Mann, Aragon and Ilya Ehrenburg – but not Breton, who had slapped Ehrenburg in the face the previous day.

In October 1935, Georges Bataille founded 'Contre-Attaque', whose aim was to turn the very weapons that fascism had used to gain power against it. Many Surrealists joined the group, but the movement was more concerned with a possible fascist takeover in France than with the reality of Nazism in Germany (only Soupault, who had seen it in action, tried very early on to sound the warning) and it only lasted six months.

The emergence of the Soviet Union fascinated a number of writers, although the workers returning from there were often fairly disillusioned. Gide hoped to 'live long enough to witness the success of this enormous endeavour', but in his *Return from the USSR*, published in 1936 after a trip there with Dabit and Guilloux, he expressed his disappointment at what he saw as the total suppression of the individual. He was accused of being a traitor by the left, and of being very slow to wake up by the right.

The Spanish Civil War led to a hardening of attitudes. Benjamin Péret joined the Republicans and Malraux helped to organize their air force, publishing on his return a reportage-style novel entitled *Hope* (1937), which persuasively showed that literature and action were powerful tools in combination. Breton, for his part, was exasperated by the Front Populaire's failure to act; but the far right were also making themselves heard:

Drieu La Rochelle (who argued the need for a 'fascist socialism') and the anti-Semitic Lucien Rebatet and Robert Brasillach, writing for *Je suis partout*, saw Franco and Hitler as Europe's only hope. Catholic circles were divided due to the Spanish Republic's hostile position on religion, and when Maritain asked Claudel to sign a petition condemning the bombing of Guernica, Claudel refused. He was disgusted by Hitler, but even more so by anti-Catholicism. Shaken by the bloody events in Spain, Georges Bernanos published *Les Grands Cimetières sous la lune* (1938), in which he sided with the Spanish Republic and denounced self-righteous conformism. After the signing of the Munich Agreement, he left for Brazil.

Like Gide and a great many others, Céline visited the USSR, and his admirers – who had no idea where his profoundly anarchic tendencies would eventually lead him – were disappointed when, on his return, he published a short anti-Communist pamphlet entitled *Mea Culpa*. This was followed by *Bagatelles pour un massacre* (1937) and *L'École des cadavres* (1938), in which the author's obsessive concern with hygiene spilled over into a ranting racial hatred that was met with delight in certain quarters. Marcel Jouhandeau (who called Benda a 'little Semite clown') gave full vent to his anti-Semitism in *Le Péril juif* (1938), saying 'the Jews are oppressing us' and 'I vow here to expose them to the condemnation of my people, as long as a single one remains in France who is not bound by special rules'. And in *Pleins pouvoirs* (published in September 1939) even the mild-mannered Giraudoux declared 'We are in full agreement with Hitler on this point – that a policy only attains its highest form when it is racial' – expressing sentiments that were not to be found in his popular works for the stage. It was apparent that, when intellectuals 'betray' their vocation, they can sink into complete ignominy just as easily in Paris as anywhere else.

Opposite:
Demonstration by the Comité de Vigilance des Intellectuels Antifascistes, February 1934. André Malraux is at the front; in the background, André Breton and Paul Éluard can be seen.

Below:
The Congrès International des Écrivains pour la Défense de la Culture, Palais de la Mutualité (5th arr.), June 1935. At the table, from left to right: Henri Barbusse, Madeleine Paz, Paul Nizan, André Malraux and André Gide; at the back, Paul Vaillant-Couturier in a white shirt; on the left of the stage, sitting with legs crossed, Tristan Tzara.

24-5-20-

A MUSICAL CROSSROADS

Vincent Bouvet

IMPRESSIONISM AND NEOCLASSICISM

Between the late 19th century and the end of the Great War, major musical developments occurred which were not always fêted but nonetheless ushered in an era of radical innovation, marked by the breaking down of tonality, the rejection of harmony for its own sake, audacious modulations and a freer approach to rhythm. Claude Debussy, who died in 1918, was to exercise a powerful influence on the musicians of the inter-war years.

Maurice Ravel, in particular, recaptured the 'impressionist' shading of his predecessor while developing a pure, fluid sound that was very much his own. Ravel was forty-three at the end of the war and had already composed some of his most beautiful instrumental and dramatic works, including *Jeux d'eau* (1901) and *Daphnis et Chloé* (1912). *La Valse*, composed in 1920, was conceived as both a ballet and a symphonic poem, while *L'Enfant et les sortilèges* (1925), with a libretto by Colette, evokes the fairytale world of childhood: a small boy is scolded for his rudeness and has a tantrum, which brings the toys and objects around him to life; eventually he is reconciled with his mother. The famous *Bolero* (1928) was an exercise in technical virtuosity, with its variations of timbre on a single theme. Another innovative piece was Ravel's *Piano Concerto in D for the Left Hand* (1929–30), written at the request of the pianist Paul Wittgenstein, who lost his right arm in the war. The work contained jazz influences, as did the *Piano Concerto in G*, composed during the same period.

Albert Roussel was also influenced by Debussy, an influence he was only to shake off in his maturity as his own stylistic language evolved from raw rhythmicality into the richness of neoclassicism, as expressed in ballet (*Bacchus and Ariadne*, 1930), symphonic music (*Symphony No. 4 in A Major*, 1934) and chamber music (*String Trio*, 1937). In the latter works, he provided a link between post-impressionism and the polyphonic school of the 1930s.

After *The Firebird* (1910), *Petrushka* (1911) and *The Rite of Spring* (1913), Igor Stravinsky returned to Western classicism with the ballet *Pulcinella* (1919), which was inspired by *commedia dell'arte*, with 'Ingresque' sets by Picasso. Although his *Symphonies of Wind Instruments* (1920) contained echoes of *The Rite of Spring*, the following year Stravinsky began composing works that can be viewed as 'reactions' to earlier musical styles. In order to escape Bach's regularity of rhythm, he introduced elements of dissonance and awkwardness into the score for *Octet for Wind Instruments* (1923); likewise in his *Concerto for Piano and Wind Instruments* (1924), with its linear approach to the string section and a piano sound that recalls a

Above:
Paul Colin, costume for the character of the dragonfly in *L'Enfant et les sortilèges* by Maurice Ravel, 1919–25.
Bibliothèque de l'Opéra, Paris.

Opposite:
Pablo Picasso, *Portrait of Igor Stravinsky*, 24 May 1920.
Graphite and charcoal on paper, 61.5×48.2 cm (24 ¼×19 in.).
Musée Picasso, Paris.

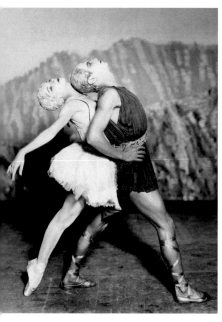

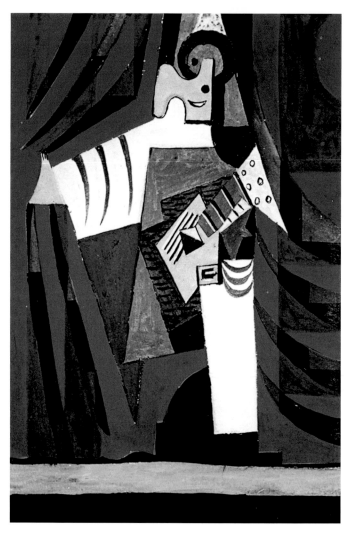

Above:
Alice Nikitina and Serge Lifar
in the ballet *Apollo* with music by Igor
Stravinsky, Théâtre Sarah-Bernhardt, 1928.

Right:
Pablo Picasso, *Pulcinella Taking a Bow*, 1920.
Gouache on paper, 15 × 10 cm
(5 ⅞ × 3 ⅞ in.). Private collection.

harpsichord. It was in Paris, where he settled in 1922, that Stravinsky composed the two great emblematic works of modern neoclassicism. In *Oedipus Rex* (1927), an opera-oratorio (whose text, based on Sophocles's tragedy, was written by Cocteau and translated into Latin), the music was deliberately simple, even 'inexpressive', while the *Symphony of Psalms* (1930), an essentially 'archaic' choral work, deliberately omitted some instruments from the orchestra in order to create less resonance. Meanwhile, Stravinsky was working on his last two European ballets for Diaghilev and Ida Rubinstein: *Apollo*, written for strings alone and choreographed by George Balanchine, and *Le Baiser de la fée*, which paid homage to Tchaikovsky's exuberant romanticism. Stravinsky dedicated his *Violin Concerto in D* (1931) to the Polish-born virtuoso Samuel Dushkin, through whom he expanded his understanding of the violin and its technical potential, building this knowledge into his *Duo Concertant for*

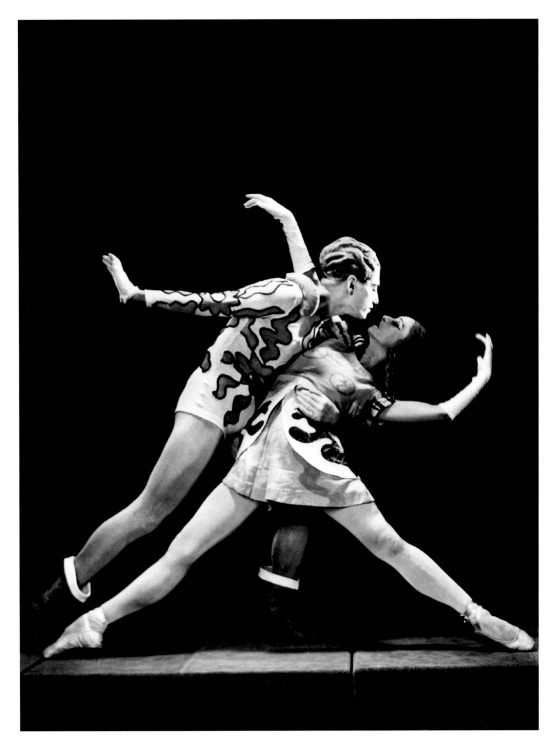

Serge Lifar and Olga Spessivtseva in the ballet
Bacchus and Ariadne, with music by Albert Roussel,
Opéra de Paris, 1931.

Right:
Les Fâcheux, score by Georges Auric with a
costume design by Georges Braque, 1924.

Opposite:
The group of composers known as
Les Six and Jean Cocteau, seated in the
foreground. From left to right: Francis
Poulenc, Germaine Tailleferre, Georges
Auric (not present, but his face appears in
Cocteau's drawing), Louis Durey, Darius
Milhaud and Arthur Honegger, 1922.

Violin and Piano, an extraordinary coming together of Bach and jazz.
There are other echoes too in his work — of Beethoven in the *Concerto for
Two Pianos* (1935) and Rossini in the ballet *Jeu de Cartes* (1936).

Following the scandal provoked by the ballet *Parade*, written by
Cocteau and first performed in Paris by the Ballets Russes, Erik Satie
came to be seen as a key avant-garde figure. He had never wanted to
attract a following, but in 1923 four composers whom Satie had met
through Darius Milhaud formed a group around him, calling them-
selves the 'School of Arcueil'. The group — Henri Cliquet-Pleyel, Roger
Désormière, Henri Sauguet and Maxime Jacob — aimed to rehabilitate
melody and reconcile the rigour of Bach with the frenetic rhythms of
jazz, but it disbanded soon after Satie's death in 1925.

The beginnings of French neoclassicism coincided with the publi-
cation, in 1918, of *Le Coq et l'Arlequin* by the ubiquitous Jean Cocteau, a
familiar figure in literary and artistic circles. *Le Coq* was a collection of
non-conformist opinions championing a new style of music — the
music of contemporary composers whom Cocteau had met in 1917 at a
concert given in honour of Erik Satie, and later at the 'Nouveaux

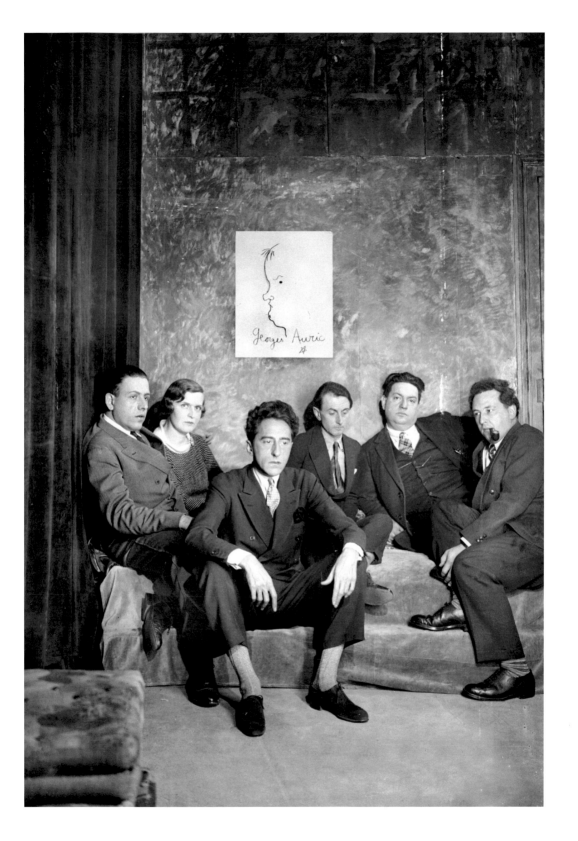

Jeunes' concerts held by the opera singer Jane Bathori at the Théâtre du Vieux-Colombier. Simultaneously denouncing Wagner's romanticism, Debussy's impressionism, Rimsky-Korsakov's Slav influences and Stravinsky's primitivism, Cocteau argued the need for a return to a simpler, more economical style of composition which he described as 'French clarity'.

Georges Auric, Arthur Honegger, Darius Milhaud, Francis Poulenc, Louis Durey and Germaine Tailleferre were all regular guests at Jean Cocteau's 'Saturday soirées', and formed a group known as Les Six. This was, according to Cocteau, 'not in any sense an aesthetic alliance, but a union based on friendship'. Lacking a musical manifesto, the members of Les Six followed their own individual paths while adopting the joint aim of reinstating melody and focusing on the classical forms of the suite, sonata, quartet, concerto and symphony, into which they introduced new sounds. Their only collective works were *L'Album des Six*, a collection of piano pieces, and the music for Cocteau's ballet *Les Mariés de la tour Eiffel* (1921). The group soon disbanded.

The most active member of the Six, Georges Auric, had his first successes with music for ballets and stage productions, then in 1930 wrote his first film score, for Cocteau's *The Blood of a Poet*, going on to collaborate with directors René Clair (*À nous la liberté*, 1932) and Marc Allégret (*Lac aux dames*, 1934; *Entrée des artistes*, 1938). Arthur Honegger's orchestral work *Pacific 231*, written in 1923, was an ode to the beauty of the machine and hugely successful, while his rigorous approach to composition found an ideal collaborator in Paul Claudel in the 1930s. Darius Milhaud composed a whole range of serious and comic operas, ballets, incidental music, choral works (both sacred and secular), melodies, symphonic suites and chamber music. In the 1920s particularly, his compositions were characterized by a *joie de vivre* that recalled Brazilian rhythms and jazz (the ballets *Le Boeuf sur le Toit*, 1920, and *The Creation of the World*, 1923) as well as the bright sunshine of Provence (*Le Carnaval d'Aix*, 1926). Francis Poulenc was a classical composer open to every sort of innovation. He wrote a variety of pieces, including *Les Mouvements perpétuels* for piano (1919), the ballet *Les Biches* (1924) and *Le Concert champêtre* for harpsichord and orchestra, first performed in 1919 by Wanda Landowska. Poulenc's name was associated with all the big musical events occurring in Paris. He set poetry to music, including both works from an earlier age and those of his contemporaries like Apollinaire, Max Jacob, Louis Aragon, Colette, Louise de Vilmorin and Paul Éluard.

The well-known musicians of the time – Jacques Ibert, Jean Rivier, Georges Migot, Marcel Delannoy, Igor Markevitch and Jean Françaix – tended to regard avant-garde techniques as a waste of time, preferring the neoclassical aesthetic based on the renewal of traditional forms, involving the rehabilitation of a broader tonal system, counterpoint

Above:
Poster for the film *À nous la liberté* by René Clair. Illustration by Roger Cartier.

Opposite:
The Jeune France group, with Daniel-Lesur at the piano, Olivier Messiaen, André Jolivet and Yves Baudrier, May 1937.

and melody. But in 1936 four young composers, Yves Baudrier, André Jolivet, Olivier Messiaen and Daniel-Lesur, founded the group known as 'Jeune France', as a homage to Berlioz and a way of safeguarding French orchestral music. Their aim, as declared in their manifesto *Pour un nouvel humanisme musical*, was to compose new works free of the conventionality of abstract and neoclassical composition and removed from the pressures exerted by the majority of listeners, elitists and concert organizers. Their first concert, conducted by Roger Désormière at the Salle Gaveau, was given a genuinely warm reception, but the group's disparity meant that it was short-lived. André Jolivet's *Mana* (1935), written for piano, marked the beginning of his interest in atonality and Yves Baudrier also rejected a traditional style of writing in favour of 'sound representations of the mind', while Daniel-Lesur demonstrated his debt to musical tradition with his *Suite française* in 1934 and the deeply mystical Olivier Messiaen followed his own unique path.

Edgard Varèse completed his orchestral sequence *Amériques* in 1921, but remained on the fringes, celebrated only by a very small circle as one of the most progressive representatives of new music. Varèse had taken refuge in the US during the Great War but returned to France in 1928, remaining there until 1933 and exerting a profound influence on André Jolivet in particular.

Private Salons and Concert Halls

The artistic policies of the Third Republic were the sorry inheritance of the French monarchy's patronage. The Ministry of Public Instruction and the Fine Arts devoted a very small portion of the national budget to music, most of this being spent in Paris on the Opéra

Garnier, the Opéra-Comique and the concert halls. The result was that individual music lovers were essentially obliged to take the initiative. Some ten times a year, the Princesse de Polignac invited artists and music lovers to première performances of works that she had commissioned. Stravinsky's *Les Noces* was performed at the Polignac salon in June 1923, with Francis Poulenc, Georges Auric, Vittorio Rieti and Marcelle Meyer playing the four piano parts, and the princess also commissioned Jean Wiéner's *Concerto Franco-Américain* for piano. Cele-

Above:
Double bass cases belonging to the Concerts Lamoureux orchestra, Salle Pleyel.

Right:
Front row, left to right: Vittorio Rieti, Darius Milhaud, the Marquise de Casa Fuerte, Roger Désormière and Igor Markevitch; back row: the Marquis de Casa Fuerte, Prince Massimo and Henri Sauguet, 1931.

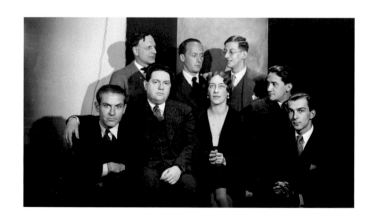

brated musicians gave recitals at her salon, including the pianists Arthur Rubinstein, Vladimir Horowitz, Clara Haskil, Dinu Lipatti, Alfred Cortot and Jacques Février, the harpsichordist Wanda Landowska and the organists Maurice Duruflé and Marcel Dupré. Singers who performed there included the tenor Hugues Cuenod and bass Doda Conrad, the soprano Jane Bathori and the alto Irène Kedroff.

Between the wars, the big symphony orchestras founded during the 19th century continued to flourish. These included the Société des Concerts du Conservatoire, the Concerts Pasdeloup (one of whose regular conductors was Désiré-Émile Inghelbrecht), the Association Artistique des Concerts Colonne and the Concerts Lamoureux. New ones were also created: the Société Philharmonique de Paris, founded in 1929 by Alfred Cortot and Pierre Monteux (who would conduct the orchestra up until 1938), and the Orchestre Symphonique de Paris, conducted by Charles Munch from 1935 to 1938. The French state also financed the founding of two new orchestras, the Orchestre National de France (1934) and the Orchestre Radio Symphonique avec Choeurs (1937), both run by Radio France.

Marguerite Long, 1920s.

The 1930s also saw the emergence of a number of contemporary music societies, whose existence was possible thanks to financial backing by wealthy music lovers. In 1931, Yvonne Guiraud, Marquise de Casa Fuerte, winner of the top violin prize at the Conservatoire National, formed La Sérénade, based on the idea of renewing the elitist tradition of the 'salon' for the benefit of concert-goers. Darius Milhaud, Georges Auric, Igor Markevitch, Roger Désormière, Francis Poulenc and Henri Sauguet were joint artistic directors and debuted some of their works for the group. La Sérénade also organized the French premieres of works by Alban Berg and Kurt Weill, whose music came as something of a shock to French ears. The young composer and music correspondent for *Paris-Soir* Pierre Octave Ferroud founded Le Triton in 1932 with the intention of introducing new French music to a wider audience and of giving listeners a taste of what was happening abroad musically. In 1935, La Spirale was founded in 1935 and held concerts of works by both French and foreign composers; Olivier Messiaen, André Jolivet and Daniel-Lesur were all on the group's committee.

Wanda Landowska, 1933.

Concert bills featured famous names like the trio of Alfred Cortot, Jacques Thibaud and Pablo Casals, and soloists such as the pianists Marguerite Long and Robert Casadesus, and the harpsichordist Wanda Landowska, who was responsible for both reviving early harpsichord music and adapting the instrument to contemporary styles. The Concerts Touche, Poulet, Siohan and Straram promoted modern music and young performers, and from 1922 to 1925 Jean Wiéner organized 'salad concerts' in which classical pieces were interspersed with jazz.

Large auditoriums dedicated exclusively to music were a rarity in Paris. Orchestras often had to share venues with opera companies, and

Right:
Daniel Vásquez Díaz,
Manuel de Falla at the Piano
Oil on canvas.
Real Conservatorio, Madrid.

Opposite, above:
Caricature of Pablo Casals
by Andreu Dameson, 1937.
Biblioteca de Catalunya, Barcelona.

Opposite, below:
Alfred Cortot with students from the
École Normale de Musique, Paris.

sometimes even circuses. The Théâtre du Châtelet was the nerve centre of contemporary music in the early years of the 20th century, associated most notably with the Ballets Russes. Between the wars, the theatre experienced a creative dip but continued to stage visually spectacular operettas that were a great success with less elitist audiences. The Théâtre des Champs-Élysées lived up to its ultra-modern architecture by continuing to play a pioneering role, following its 1913 *succès de scandale* with *The Rite of Spring*, with performances from the Ballets Suédois and Josephine Baker's sensational debut in the *Revue Nègre*.

The Salle Pleyel was commissioned in 1927 by the piano manufacturers Pleyel et Cie for the purpose of bringing music to much larger audiences. It was designed by the architects Jean-Marcel Auburtin and later André Granet and Jean-Baptiste Mathon, who created a vast concrete structure faced with stone. The complex was officially opened on 18 October 1927 in the presence of leading statesmen and representatives of the music world such as the composers Paul Dukas, Manuel de Falla, André Messager and Reynaldo Hahn. The Salle Pleyel had particularly good acoustics and opened its doors to the most famous musical groups, soloists and conductors. It was here that the Orchestre Sym-

phonique de Paris, conducted by Pierre Monteux, gave the first performance of Poulenc's *Concert Champêtre*, Stravinsky's *Symphonies of Wind Instruments*, dedicated to the memory of Claude Debussy and Milhaud's *The Creation of the World*. The hall's seventy-four-stop organ was commissioned from the famous firm of Cavaillé-Col, and played for the first time by Marcel Dupré in 1930.

The concert hall of the École Normale de Musique, known as the Salle Cortot, was built between 1928 and 1929 by Auguste and Gustave Perret. Both the space and the funds available for the project were limited. The result was a huge resonance chamber built entirely of concrete and incorporating an innovative acoustic system that used thin vibrating panels attached to the internal walls. The hall had a seating capacity of four hundred and was adorned with simple bronze-painted surfaces, with the only decoration on the façade consisting of a frieze formed by the air vents.

TEACHING THE WORLD

Just as it provided academies for painters, Paris also offered future musicians the opportunity to develop their skills in an environment that was educationally demanding and created a climate favourable to the promotion of the arts. Founded in 1919 by the pianist Alfred Cortot and Auguste Mangeot, editor of *Le Monde musical*, the École Normale de Musique de Paris was closely involved in the musical life of the capital between the wars. Its courses were open to anyone and the school's policies respected individual development, in contrast with the somewhat autocratic approach characteristic of the Conservatoire National Supérieur de Musique. The École was internationally renowned for the modernity of its curriculum – involving instruction in every aspect of music and courses specifically linked to artistic expression – and the

high calibre of its teaching staff, who included the cellist Pablo Casals, the violinist Jacques Thibaud and the harpsichord player Wanda Landowska. The pianists Samson François and Dinu Lipatti were just two of the well-known musicians who graduated from the École. From the mid-1930s, jazz concerts were held there regularly.

The American Conservatoire in Fontainebleau was another influential establishment. Founded in 1921, it provided courses over the three summer months for more than fifty students, the majority from the US. Many composers, including Stravinsky, Ravel, Françaix and Georges Enesco, and performers like Robert Casadesus, taught or played there, encouraging collaboration from students. The composer, organist and conductor Nadia Boulanger was the Conservatoire's guiding light: she taught composition for more than seventy years and exerted a profound influence on several generations of American composers, the best known being Aaron Copland.

As was the case prior to 1914, many foreign musicians came to try their luck or further their musical growth in Paris, in some cases settling there permanently. The modal music revived by Debussy inspired the Spaniard Manuel de Falla, the Hungarians Béla Bartók and Zoltan Kodály, and the Romanian Georges Enesco, who were all eager to revive the popular music of their respective countries. And it was of course in Paris that George Gershwin composed *An American in Paris*, the Spaniard Joaquín Rodrigo his *Concerto d'Aranjuez* and the Brazilian Heitor Villa-Lobos his *Chôros*. But the capital did not always manage to coax the best out of its resident artists: Sergei Prokofiev vegetated there for ten years before finally returning to the Soviet Union. A number of composers from Eastern Europe who were united in their enthusiasm for French culture, but each attached to the music of their birthplace, formed a

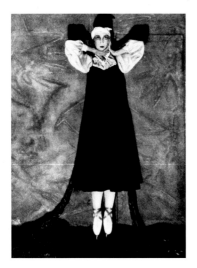

group that has been wrongly termed the 'School of Paris'. They included the Pole Alexandre Tansman, the Hungarian Tibor Harsanyi, the Czech Bohuslav Martinu, the Romanian Marcel Mihalovici and the Russian Alexander Tcherepnin. In 1933, Paris began to see an influx of musicians denounced by the Nazis as propagators of 'degenerate art' and persecuted for their Jewishness – among them, Kurt Weill, Hanns Eisler and his pupil Joseph Kosma, Arnold Schoenberg, the conductor Bruno Walter, and the singer Lotte Lenya. With the exception of a few shows of support, these artists met for the most part with either indifference or outright hostility, and the majority ended up emigrating to the United States.

The Ballets Russes

Sergei Diaghilev succeeded in keeping the pre-war magic of the Ballets Russes alive while introducing a greater diversity of themes that were reflected in choreography and set design. He was aided in this by the endlessly inventive choreographers Michel Fokine, Léonide Massine, and later George Balanchine – who choreographed ten ballets between 1925 and 1929, including Stravinsky's *Apollo* – and Bronislava Nijinska, all of them fellow Russians). Natalia Goncharova designed sets and costumes for the company, but Parisian artists and set designers gradually eclipsed the Russian designers of the pre-war period such as Léon

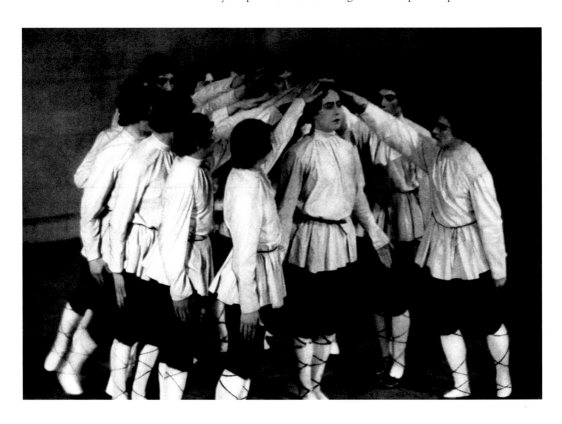

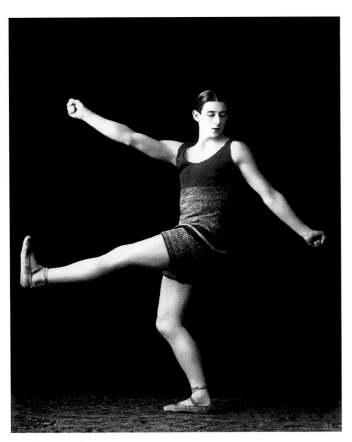

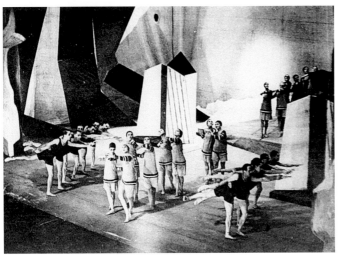

Opposite, above and below:
Noces, Théâtre de la Gaîté-Lyrique,
June 1923. Music by Igor Stravinsky,
choreography by Bronislava Nijinska,
sets and costumes by Natalia Goncharova.

Below:
La Chatte, Théâtre Sarah-Bernhardt,
May 1927. Music by Henri Sauguet, story
by Sobeka (Boris Kochno), choreography
by George Balanchine, sets and costumes
by Naum Gabo and Antoine Pevsner.

Top and above:
Le Train Bleu, Théâtre des Champs-Élysées, June 1924.
Music by Darius Milhaud, scenario by Jean Cocteau, choreography
by Bronislava Nijinska, sets by Henri Laurens and costumes by Coco Chanel
With Anton Dolin (the Handsome Youth), Lydia Sokolova (Perlouse) and
Léon Woizikowsky (the Golfer).

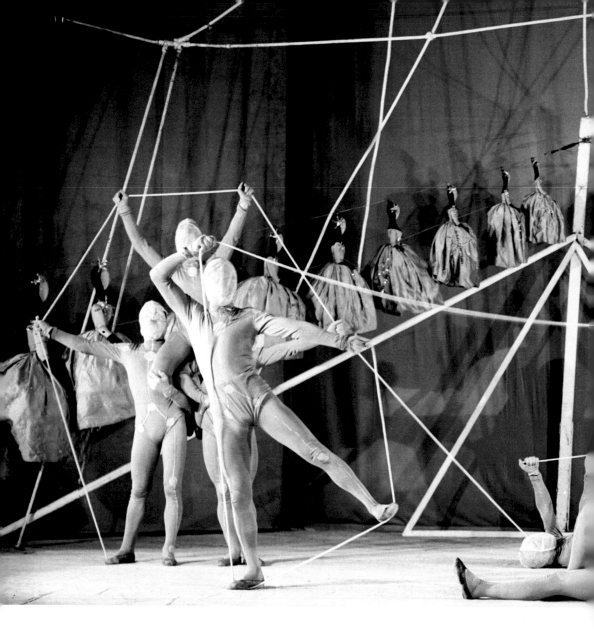

Ode, Théâtre Sarah-Bernhardt, June 1928. Music by Nicolas Nabokov, based on a text by Mikhail Lomonosov, libretto by Boris Kochno, choreography by Léonide Massine, sets by Pavel Tchelitchew.

Bakst and Alexandre Benois. Diaghilev also worked with André Derain and commissioned designs from more controversial figures like Max Ernst and Joan Miró. For the sets for Stravinsky's *Les Noces*, performed at the Théâtre de la Gaîté-Lyrique in 1923, Goncharova used a pale palette including white as a counter to the striking colours of Russian folk art. For the 'great French season' of 1924, the Ballets Russes revived *Parade* and *Les Biches* with pastel-coloured sets designed by Marie Laurencin, while Georges Braque used a range of browns and greens in his designs for *Les Fâcheux*, based on a comic ballet by Molière with a score by Georges Auric: the dancers wore double-sided costumes and when

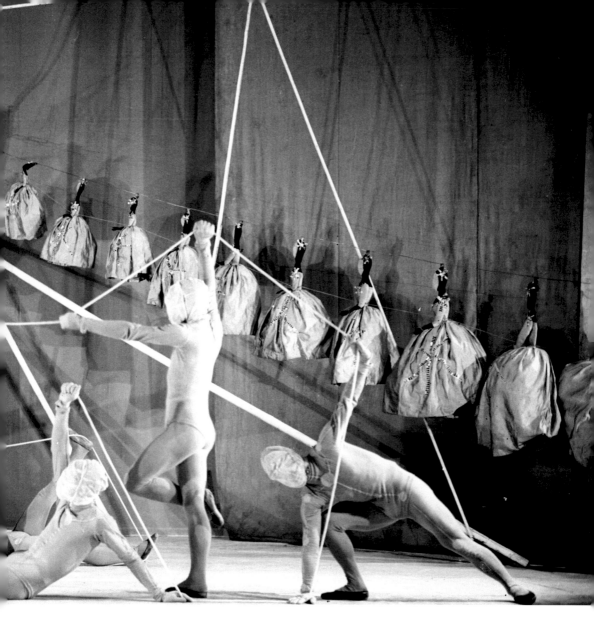

they turned their backs on the audience, they seemed to melt into the
background, like insects camouflaged against leaves. But the season's
major work was *Le Train Bleu*, a 'danced operetta', named after the luxury
express train that linked Paris with the Côte d'Azur. It premiered at the
Théâtre des Champs-Élysées and featured a motley cast of handsome
gigolos, flappers and fashionable holidaymakers. The list of collabora-
tors makes impressive reading: the libretto was by Jean Cocteau and the
music composed in twenty days by Darius Milhaud; Anton Dolin was
the male lead, accompanied by Lydia Sokolova and Léon Woizikowsky.
The boldly striped jersey costumes were by Coco Chanel and the sets by

Above:
Fernand Léger, costume designs
for *The Creation of the World*, 1923.
Watercolour on paper,
34 × 22.7 cm (13 ⅜ × 8 ⅞ in.).
Dance Museum, Stockholm.

Opposite:
Fernand Léger, curtain design
for the ballet *Skating Rink*, 1922.
Watercolour on paper,
40.5 × 48 cm (16 × 18 ⅞ in.).
Dance Museum, Stockholm.

Henri Laurens. The front curtain was a large-scale reproduction of
Picasso's *Two Women Running on the Beach* and it was dropped to the sound
of a fanfare composed by Georges Auric.

Diaghilev had moved a long way from the 'folkloric' approach asso-
ciated with the early days of the Ballets Russes and was now taking an
ultra-modernist approach. The sets and costumes for *La Chatte*, per-
formed to a score by Henri Sauguet, were designed by the two brothers
Naum Gabo and Antoine Pevsner, signatories of the *Realistic Manifesto*
who had left Russia in 1923 and mounted a major exhibition in Paris in
1924. They used materials that were completely new to ballet, such as
glass, steel and celluloid, with an emphasis on transparency and geomet-
ric shapes. The shiny black oilcloth covering the floor and ceiling of the
stage reflected the light and the colourless costumes of the dancers, and
the overall impression was of sculpture in motion. Another innovation,
due this time to Pavel Tchelitchew, was the use of neon lights (generally
not allowed for safety reasons) in the final tableau of the ballet *Ode*
(pp. 364–65), which premiered at the Théâtre Sarah-Bernhardt in 1928.

The Ballets Suédois

In 1920, Rolf de Maré, a Swedish patron of the arts, acquired a seven-
year lease on the Théâtre des Champs-Élysées, with the aim of hosting a
whole range of events at a single venue. He enlisted the help of Louis
Jouvet to run the Comédie des Champs-Élysées and put Gaston Baty in
charge of the Studio des Champs-Élysées. The programme for the main
auditorium included both orchestral works and ballets.

The same year, de Maré founded the Ballets Suédois for the dancer
and choreographer Jean Börlin. This avant-garde company sought to

adapt ballet to contemporary themes and work from an academic basis to revitalize dance technique. De Maré collaborated with some of the most modern artists of the time – Cole Porter, for example, whose *Within the Quota*, the first ever 'jazz ballet', was orchestrated by Charles Koechlin. *L'Homme et son désir*, based on a poem by Paul Claudel and set to music by Darius Milhaud, was first performed by the Ballets Suédois in 1921, and the same year the public were treated to a work of complete fantasy, *Les Mariés de la tour Eiffel*, written by Jean Cocteau and set to music by Les Six. *Skating Rink*, with a jazz score by Arthur Honegger and the inclusion of some film footage, created a sensation in 1922, and was followed in 1923 by Blaise Cendrars's ballet *The Creation of the World*, which was inspired by the rhythms of Africa, and used costume and set designs by Fernand Léger and a score by Darius Milhaud. The company's last great creation was the ironic and absurdist ballet *Relâche*, written in two acts by Francis Picabia, set to music by Erik Satie and including a filmed interlude (*Entr'acte*; see p. 306) directed by René Clair.

Above:
Francis Picabia, design for *Relâche*, 1924.
Watercolour and Indian ink, 32.5×25 cm
(12 ¾×9 ⅞ in.). Private collection.

Below:
Francis Picabia, curtain design for *Relâche*,
1924. Ink and watercolour on paper,
32×50 cm (12 ⅝×19 ⅝ in.). Dance
Museum, Stockholm

The Opéra de Paris

Following his appointment as director of the Opéra de Paris in 1913,
Jacques Rouché's artistic initiatives – in the realms of theatre, music and
choreography – brought the Palais Garnier an unrivalled international
reputation, especially for its touring ballet company. A combination of
private income, liberally spent, and acute artistic sensibilities allowed
Rouché to transform the Opéra from top to bottom. He staged twenty-
six world premieres and thirty-eight French or Paris premieres of works
including Albert Roussel's *Padmâvatî*, Henri Rabaud's *Mârouf*, Georges
Enesco's *Oedipe*, Maurice Ravel's *L'Enfant et les sortilèges* and Darius
Milhaud's *Médée*, as well as Richard Strauss's *Der Rosenkavalier* and *Elektra*
and Puccini's *Turandot*. He also incorporated older works – by Lully,
Rameau (*Castor and Pollux*), Mozart (*The Magic Flute*, *Don Giovanni*) and
Gluck – using new stage designs, and extended the Opéra's repertoire to
include major works from the previous century. Initially, these were all
French (Massenet's *Thaïs*, *Samson et Dalila* by Saint-Saëns, *Faust* and *Roméo
et Juliette* by Gounod, and Berlioz's *La Damnation de Faust*), but later the
Opéra went on to perform works by composers that included Verdi
(*Aida*, *Rigoletto*) and Wagner (*Die Walküre*, *Lohengrin*). Rouché offered
artists like Maurice Denis, Raoul Dufy and André Masson the oppor-
tunity to design sets for the first time and was enthusiastic about
embracing the latest technical innovations in staging, such as light pro-

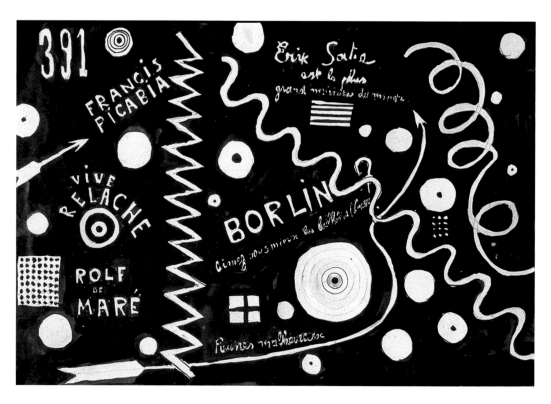

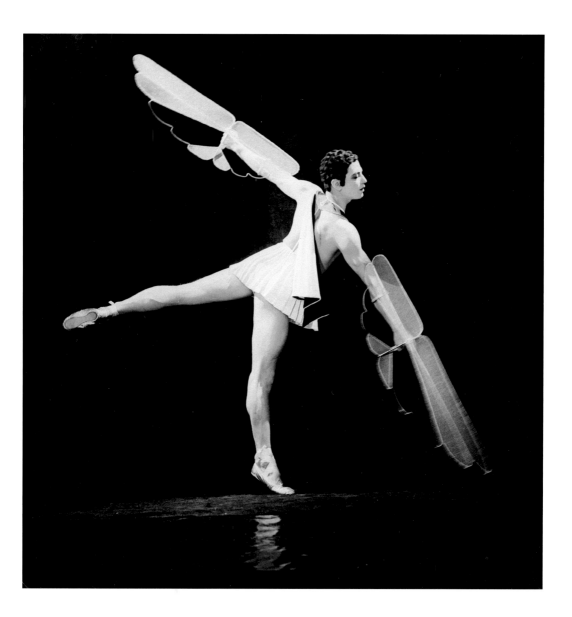

jections, revolving floors and three-dimensional sets that filled the entire depth of the stage.

Following the dissolution of the Ballets Russes in 1929 and his success with Beethoven's *The Creatures of Prometheus*, Serge Lifar joined the Opéra's ballet company as lead dancer and ballet master. Lifar developed a more rigorous technique and recruited a new generation of dancers, including Yvette Chauviré. He instituted weekly ballet performances, modernized the company's repertoire and created his own ballets in a neoclassical style, such as *Icarus* (1935), in which the choreography governed the music (by Arthur Honegger), rather than the other way round.

Above:
Serge Lifar in the ballet *Icarus*,
Opéra de Paris, May 1936.
Music by Arthur Honegger,
choreography by Serge Lifar,
sets and costumes by Paul Larthe.

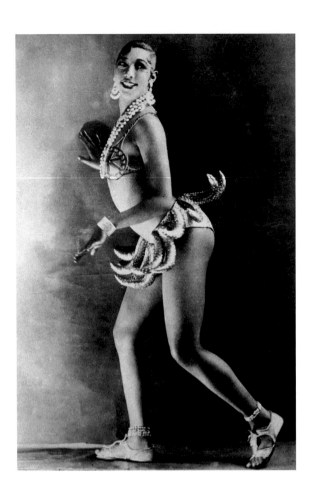

Left:
Josephine Baker at the Folies-Bergère,
La Folie du jour, April 1926.

Opposite, above left:
Paul Colin, *Josephine Baker*.
Illustration plate from *Le Tumulte noir*, 1927.
Private collection.

Opposite, below left:
Robert Portefin, poster for the
modern opera *Jonny Mène la Danse*, 1928.
Private collection.

Opposite, right:
Michel Gyarmathy,
Josephine Baker at the Folies-Bergère, 1927.
Lithograph, 116×314 cm (45 ⅝×123 ⅝ in.).
Private collection.

THE JAZZ CRAZE

It was at the beginning of the 20th century that the cakewalk, a direct influence on the evolution of jazz, first crossed the Atlantic. Among the American Expeditionary Forces that joined the war in 1917 were a great many musicians, and the big Paris venues very quickly embraced American music for their shows. Following demobilization, a lot of African-American musicians chose to remain in Paris, where they did not have to endure racial segregation. They formed small bands that played in cabarets and music halls where the clientele could drink, dine to music and dance at any hour of the day or night. Soon Paris found itself in the grip of a jazz fever that included dances like the shimmy, the foxtrot, the One-Step, the Black Bottom and the Charleston. Jean Cocteau described the shock experienced by Parisians when they first heard black musicians, 'throwing out trumpet calls the way one throws raw meat or fish to seals'. During the 1920s, many jazz clubs sprang up in Montmartre, between the place Clichy, the place Blanche and the place Pigalle, one of the most famous being the Abbaye de Thélème, a

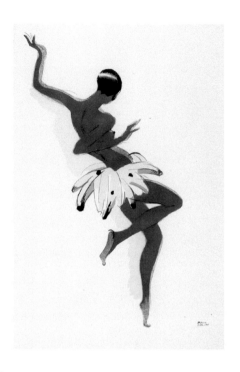

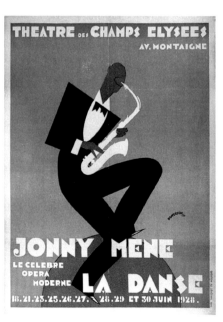

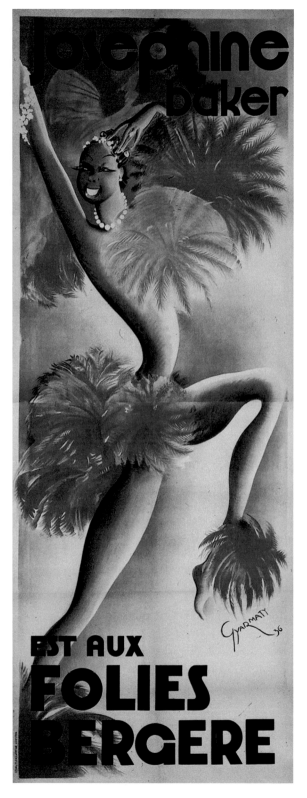

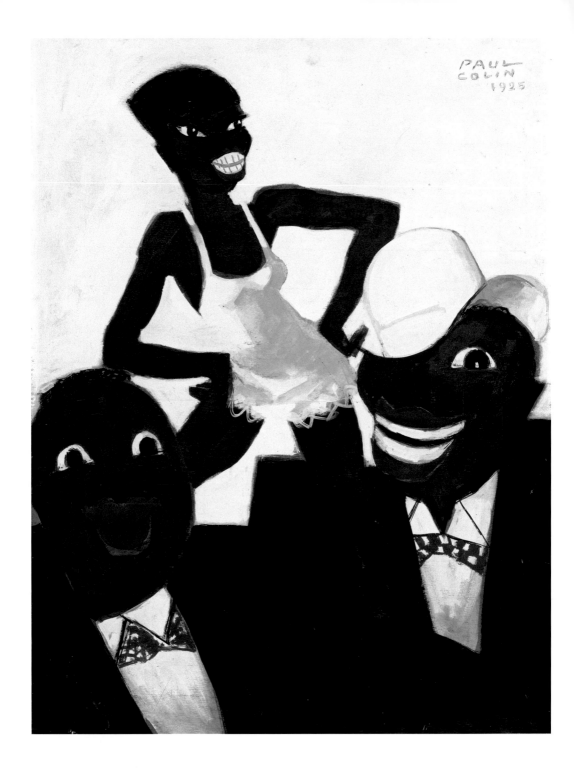

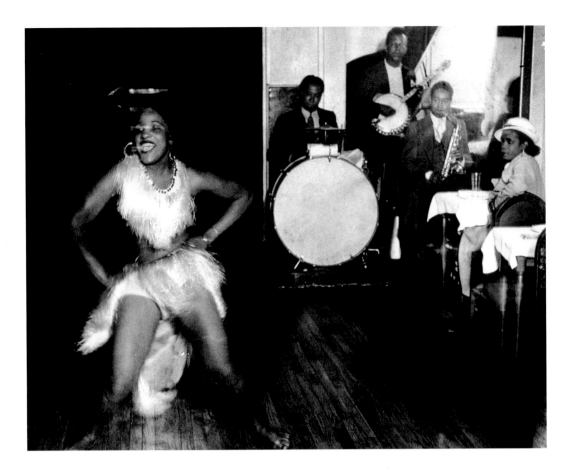

favourite haunt of Paris jazz musicians and one of the city's biggest cabarets, complete with a resident female band.

After disbanding the Ballets Suédois in 1925, Rolf de Maré launched a new type of show at the Théâtre des Champs-Élysées – 'music-hall opera'. Fernand Léger suggested to de Maré that he should capitalize on the success of the 'Art nègre' exhibition at the Musée des Arts Décoratifs by staging an 'exotic' show that would appeal to a wide audience. The cast for this new show was recruited from among New York's black musicians and performers and included Josephine Baker as lead chorus girl and star dancer, and the pianist Claude Hopkins and his orchestra, with Sidney Bechet on saxophone. The troupe arrived in Paris in September 1925 and was immediately taken in hand by Jacques Charles, director of productions at the Moulin Rouge, who persuaded Josephine Baker to dance topless. A massive publicity campaign was launched, with Paul Colin's highly effective poster as its centrepiece. The energetic music and sensual dancing combined to create a sensation when the *Revue Nègre* premiered on 2 October 1925, and it was sold out for ten weeks. The fashion for primitive and tribal art, which had

Above:
Brassaï, *Gisèle at La Boule Blanche, Montparnasse, c.* 1932. Private collection.

Opposite:
Paul Colin, *La Revue Nègre*, 1925.
Oil on wood, 100 × 80 cm (39 ⅜ × 31 ½ in.).
Musée National de la Coopération
Franco-Américaine, Blérancourt.

Above:
Jazz band in the garden of the magazine *Jazz Hot*, 14 rue Chaptal (9th arr.).

Below:
Rico's Cuban band at La Coupole, *c.* 1936.

Opposite:
Paul Colin, *The Black Birds at the Moulin-Rouge*, 1929. Private collection.

been slowly building in avant-garde circles for the previous twenty years, now became a mainstream phenomenon.

The first French performances of works by Gershwin – *Rhapsody in Blue* in 1926 and the *Concerto In F* in 1928 – marked the recognition of symphonic jazz by Paris audiences. Now that jazz was respectable, even the 'Bal des petits lits blancs', the ultra-chic society ball held at the Opéra de Paris, hosted a jazz band in 1926, and theatres like the Gaîté-Lyrique, concert halls (Salle Gaveau and Salle Pleyel) and cinemas (Gaumont Palace) regularly employed jazz musicians. The area around the Champs-Élysées became *the* place for jazz fans, while musicians of all nationalities got together for jamming sessions in the new clubs. The spread of jazz accelerated with an increased number of recordings: the Columbia label enjoyed a quasi-monopoly at the start but faced competition from firms like Gramophone, Decca and Polydor, whose extensive catalogue covered a range of jazz styles. In 1937, Charles Delaunay (son of Sonia and Robert Delaunay) founded the Swing record label, the first of its kind to be dedicated exclusively to American and French jazz. The general public tended to use the term 'jazz' for any kind of syncopated music from the USA, so in 1932, a group of connoisseurs founded the Hot Club de France with the aim of introducing the public to genuine improvised jazz. In 1935, the club's president, Hughes Panassié launched *Jazz Hot*, the first bilingual jazz magazine.

The presence of so many American jazz musicians in Paris during the 1920s gave young French musicians – including pianist Ray Ventura, violinist Stéphane Grappelli and guitarist Django Reinhardt – opportunities to learn from them and develop their own career paths. In 1934, the Quintette du Hot Club de France included Roger Chaput and Django and Joseph Reinhardt on guitar, Stéphane Grappelli on violin and Louis Vola on double bass; a great many other musical groupings were to follow.

The influence of jazz also extended to classical music. Maurice Ravel regularly visited jazz clubs, and the trombonist Léo Vauchant, one of the best-known jazz musicians of the time, assisted him with the incorporation of jazz into his works – ragtime in *L'Enfant et les sortilèges* and swing in the *Piano Concerto in G* and the *Sonata for Violin and Piano*. Stravinsky also wrote *Ragtime for Eleven Instruments*, Georges Auric wrote a foxtrot, and Darius Milhaud incorporated jazz rhythms into his ballet *The Creation of the World*.

SUNSHINE RHYTHMS

Following the vogue for gypsy music and the Argentine tango, it was the turn of Cuba and the Caribbean to fill the Paris night with their rhythms. In 1928, the rumba singer Rita Montaner was a sensation at the Cabaret Le Palace, and in 1930 she gave the first Paris performance of *El Manisero*, a song composed by Moisés Simons (Cuban-born but

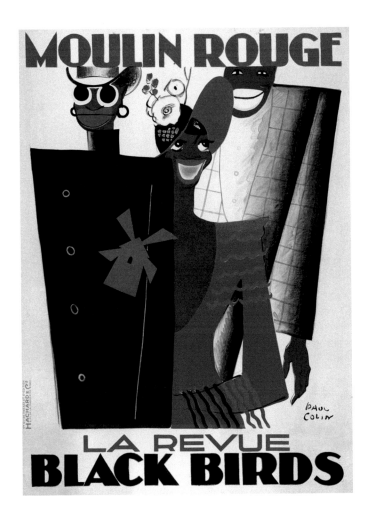

living in Paris) that was to become a big international hit. A number of dance halls with resident Cuban bands sprang up: in Montmartre, the best known was Le Palerme, on the rue Fontaine, nicknamed 'Calle Cubana'. Bands also performed at La Coupole, Le Dôme, La Rotonde and other Montparnasse clubs, and Le Bateau Ivre, in the Quartier Latin, was a venue for Cuban jazz. The Cuban guitarist Don Barreto was a great success at Melody's Bar. He had trained in jazz and *biguine*, a type of dance music that had originated in the French West Indies, and Paris fell in love with it. The clarinettist Alexandre Stellio and his band were particularly popular *biguine* musicians, while new Creole groups and Caribbean night clubs sprang up in the early 1930s, mainly around the Montparnasse and Pigalle districts. Despite the quota system imposed by the musicians' union to limit the working hours of foreigners in Paris, the vogue for Caribbean music extended to mixed bands that brought together musicians from Haiti, Guadeloupe, Martinique, Cuba and Barbados.

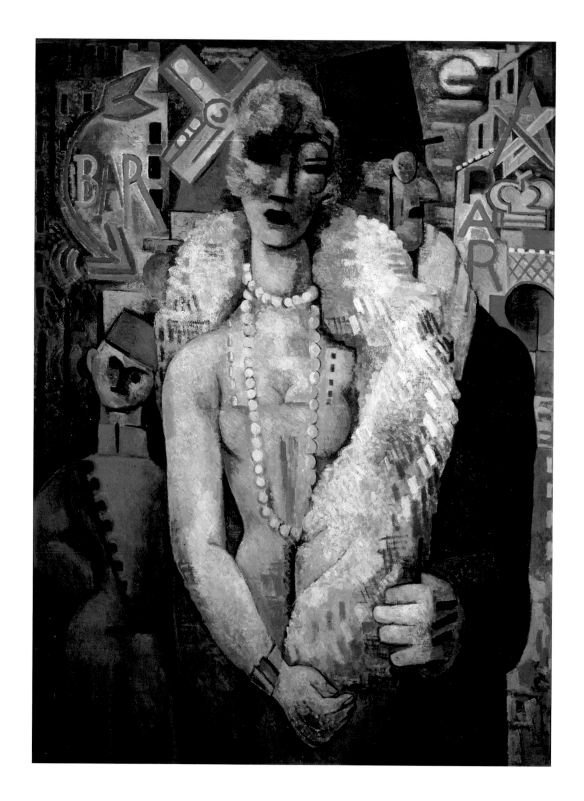

DAYS OF PLEASURE

Vincent Bouvet

A CAFÉ SOCIETY

A genuine crossroads of modernity, the Carrefour Vavin, at the intersection of the boulevard du Montparnasse and the boulevard Raspail, was a focal point of Paris life from the 1920s onwards; it attracted trend-setting artists, writers and intellectuals and a great many unknowns looking to become famous, as well as a clientele titillated by the reputed promiscuity of the painters and their models.

Situated at the corner of the boulevard du Montparnasse and the rue Delambre, Le Dôme first opened its doors in 1897 as a *bar-tabac*. After 1905, as it began attracting immigrant artists and exiles, its reputation grew. Between the wars, it was frequented by wealthy Germans and Americans, and on 19 September 1921 it hosted a reception to promote the film distribution company United Artists, with Charlie Chaplin, Douglas Fairbanks and Mary Pickford in attendance. In 1924, the owner Paul Chambon entrusted the management of Le Dôme to Ernest Fraux and René Lafon, who had previously worked in Montmartre. They tripled the café's takings in the space of two years, and in 1928 a luxury bar, known as the Bar Américain, was opened as an annexe to the main café.

Opposite:
Marcel Gromaire, *Place Blanche*, 1928.
Oil on canvas, 130×96 cm (51 ⅛ × 37 ¾ in.).
Musée Carnavalet, Paris.

Below:
Le Dôme café, *c.* 1925.

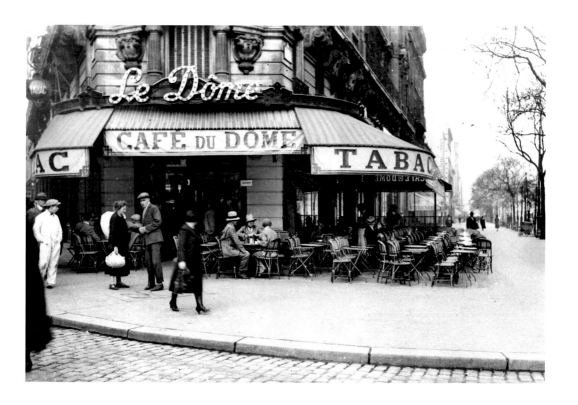

Above:
A group of Polish artists outside
La Rotonde, c. 1925.

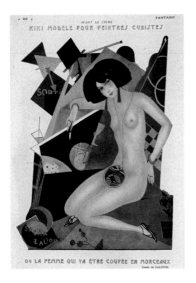

Situated at 105 boulevard du Montparnasse was Victor Libion's café La Rotonde, which provided its cosmopolitan clientele with a selection of foreign newspapers, while at number 99, on the corner of the rue Vavin, Le Sélect was open twenty-four hours a day. It opened its doors in 1928 and attracted many Americans, becoming a regular meeting place for the likes of Hemingway, Fitzgerald, Pound, Henry Miller, Faulkner, Dos Passos, Gershwin and Calder (who exhibited his wire *Circus* there). In 1928, it was the scene of a famous brawl, following the premiere of Roger Vitrac's play *Victor, or The Children Take Over*. Vitrac had broken away from the Surrealist group, along with Artaud, Soupault, Leiris, Prévert and Ribemont-Dessaignes, and in a collective pamphlet, Vitrac had described André Breton as a 'cop' and a 'cleric'; he was now being called to account. After the crash of 24 October 1929, the bar's American clientele vanished almost overnight.

At 102 boulevard du Montparnasse, on the site of an old charcoal warehouse occupying an area of 800 m² (8,600 ft²), the managers of Le Dôme oversaw the construction of a new two-storey complex that was bigger than anything of its kind in Paris. The plans by architects Barillet and Le Bouc included a restaurant, a bar, a dance hall and a huge terrace that spilled out on to the pavement. In keeping with neighbouring establishments, Fraux and Lafon called their new venue La Coupole. Building

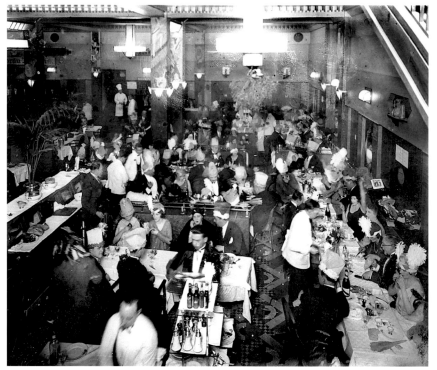

Above:
The bar of La
Coupole, c. 1930.

Left:
The ground-floor
brasserie at La
Coupole, c. 1930.
Some thirty artists
from Montparnasse
decorated the
pillars.

Opposite, below:
*Kiki, a Model for
Cubist Painters.*
Drawing by Sacha
Zaliouk, published
in *Fantasio*,
15 May 1925.

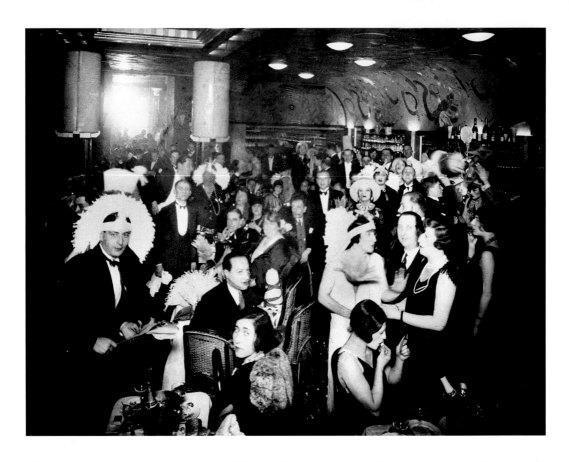

Above:
Dancing in the basement of La Coupole.

Opposite:
Sem, *Les Montparnos*, 1928.
Watercolour. Private collection.

work began in January 1927 and La Coupole opened on 20 December the same year. The celebrations were memorable: before midnight struck, the 2,500 guests had already downed the 1,200 bottles of champagne that had been laid on and had raided the wine cellar with equal gusto. The high ceiling of the restaurant was supported by pillars, the upper sections of which were decorated with works by thirty-two artists – most of them students of Fernand Léger from central Europe – commissioned by the Solvet brothers, who designed the interiors.

Le Dôme and La Coupole were the two favourite haunts of many artists and writers of the day. Hemingway, Man Ray, Henry Miller, Blaise Cendrars, Paul Claudel, Francis Jammes and André Breton were some of the names who favoured Le Dôme, while Cocteau, Radiguet, Picasso, Foujita, Zadkine and Kisling gravitated towards La Coupole. Their visits were immortalized in photographs and the works of caricaturist Georges Goursat, commonly known as 'Sem'. The dance hall at La Coupole was an unmissable part of any night out in Paris, en route between The Jockey, a little further up the boulevard du Montparnasse, and Le Bal Nègre on the rue Blomet. The bar at La Coupole was religiously frequented by Joseph Kessel and Ernest Hemingway, and it was there that Louis Aragon first met Elsa Triolet on 6 November 1928.

Les "Montparnos"

Montmartre had its cafés too. The Surrealists' favourite haunts were at the lower end of the rue Lepic – the Cyrano and the Café de la Place Blanche, not far from the rue Fontaine where Breton lived. Café Wepler, on the place Clichy, was another legendary spot, discovered by the exiled Henry Miller in 1928, who described it as a 'sex market'. During the 1930s, the focus of intellectual life shifted towards Saint-Germain-des-Prés, in the golden triangle formed by the Brasserie Lipp, the Café de Flore and the Deux Magots.

The period between the wars saw the growth of a new type of establishment where the emphasis was on spectacular décor: at the Café du Colisée (1932), La Maison du Café (1933), the Café du Triomphe (1934) and the Dupont-Barbès and Dupont-Latin (1935), all decorated by Charles Siclis, the focus was on generous sweeping curves incorporating paintings or pieces of sculpture, brilliant colours, gleaming copper and silvery zinc, glinting mirrors and atmospheric lighting. A number of architectural firms specialized in cafés: Auguste Prunier, for example, worked on the Grand Vatel, between the place Concorde and the place de la Madeleine, a complex that was unusually large for Paris, comprising three floors accessed from a large entrance hall, with two restaurants, a brasserie, an American bar and a tearoom.

For a restaurant to be thoroughly 'modern', Robert Mallet-Stevens specified that it ought to be light and airy, with clean lines and plenty of space between the tables, allowing the waiters easy access; in addition, the room needed to show off its guests to advantage, since one of the primary pleasures of eating out was observing fellow diners. Of the many restaurants that opened in Paris around that time, Le Chiquito, near the Champs-Élysées, was a perfect illustration of the discreetly sophisticated approach that Mallet-Stevens was advocating. Designed by Charles Siclis in 1927 and named after the Basque pelota world champion, this beautiful place was described as a 'sumptuous and witty evocation of the noble Basque land and its people'. The 19th-century Gare Saint-Lazare was modernized at the end of the 1930s, under the supervision of architect Henri Pacon, and attracted a great deal of attention for its subtle use of materials and elegant colour schemes. Its restaurant was softly lit and had pale pink walls and curtains in a deeper shade that set off its polished sycamore furniture and red and beige upholstery; its café had gilded bronze columns teamed with black Bakelite tables on gilded bronze feet and lacquered seats covered in chestnut-coloured leather, and its bar had walls entirely encrusted with

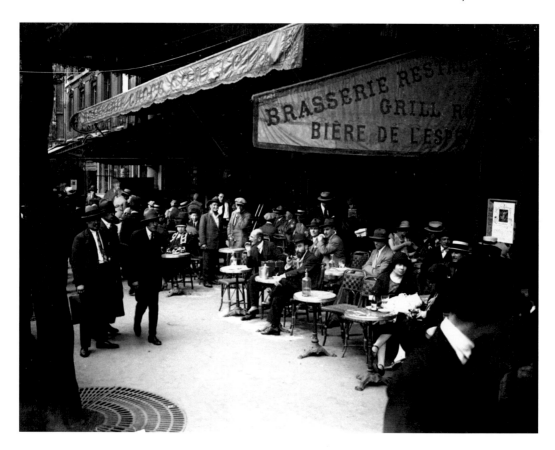

shells set in cement, along with a floor tiled with large squares of black slate, and furniture in lacquered wood and leather.

One of the consequences of the Alsace-Lorraine region reverting to French rule after the Great War was the huge popularity enjoyed by brasseries, the typical restaurants of the region. Like the Normandy-style rotisseries, which were also very fashionable, brasseries gave Parisians a sense of stepping back in time. The first Paris establishment to serve draught beer, the Brasserie Boffinger in the Bastille district, was opulently decorated with stained-glass windows, padded black leather seats, copperware, ceramics and mirrors, and in 1931 it acquired an additional room, decorated with landscapes of Alsace painted by Hansi (Jean-Jacques Waltz). Another brasserie, Chez Jenny, which opened near the place de la République in 1932, was decorated with folk-art scenes in marquetry work by the Maison Spindler, recreating the atmosphere of an Alsace *Weinstube*.

Not all brasseries adopted a regional style: some embraced the starkness of modernist architecture or favoured a more decorative approach. Le Vaudeville, opposite the Bourse, was decorated in 1926 by the Solvet brothers, who also worked on La Coupole and La Closerie des Lilas during the same period: their designs included dark wood panels and veined marble, etched glass and wrought-iron light fittings. The Cazes family, who already owned the Brasserie Lipp in Saint-Germain-des-Prés, acquired the Brasserie Balzar, near the Sorbonne, in 1931, and the architect Louis Madeline designed the interior in a very restrained style using dark woodwork, white walls, imitation leather seats, bar stools, black and white floor tiles and a metal wall clock. The word 'brasserie' conjures up the image of oyster bars and seafood platters, for which the Parisians have always had a particular weakness. Not far from the place de l'Étoile, the restaurant Prunier served only seafood, in an opulent setting designed in 1925 by the architect Louis-Hippolyte Boileau: its façade was decorated with green and blue fish mosaics, and its interior with etched glass, gilded metal panels and a tiled glass floor.

Daytime options for fashionable ladies included the tearooms in the big hotels and other select establishments; alternatively, they could eat alone or with friends in the restaurants and salons provided for their customers by all the big department stores such as Printemps and Au Bon Marché.

One completely new phenomenon was the appearance of cheap fast-food catering: the two milk bars on the boulevard de Clichy and the boulevard du Montparnasse offered 'American-style' milkshakes and sandwiches, while the Pam Pam chain of cafés set out to attract a younger crowd with a simple décor based on natural materials and light colours, prefiguring the fashion of the 1950s.

Above:
Advertisement for the brasserie Caboche-Laversin, 1929.

Opposite:
Outside the Brasserie de Strasbourg, near the Gare de l'Est, 1926.

Overleaf:
A waiter and an oyster seller outside the Le Havre restaurant, near the Gare Saint-Lazare, 1926.

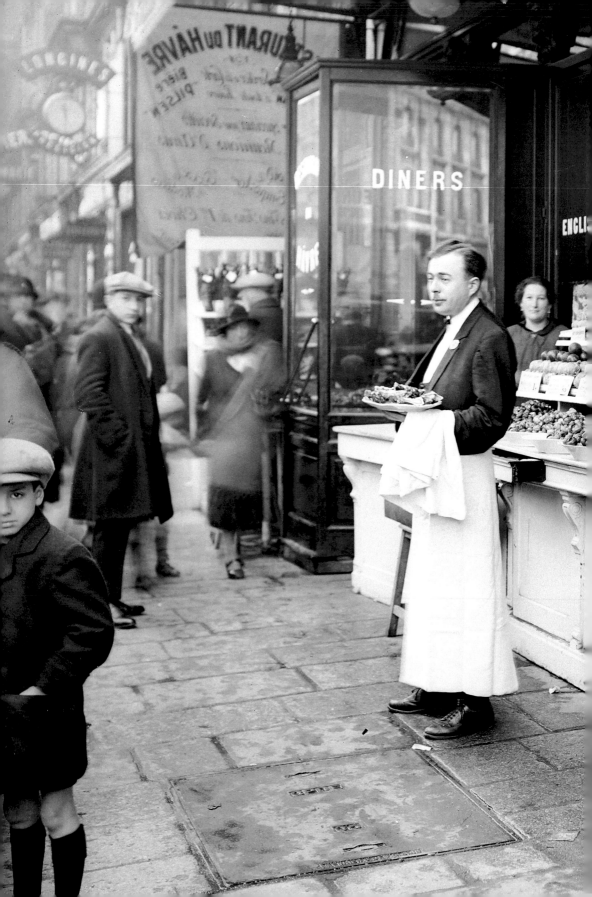

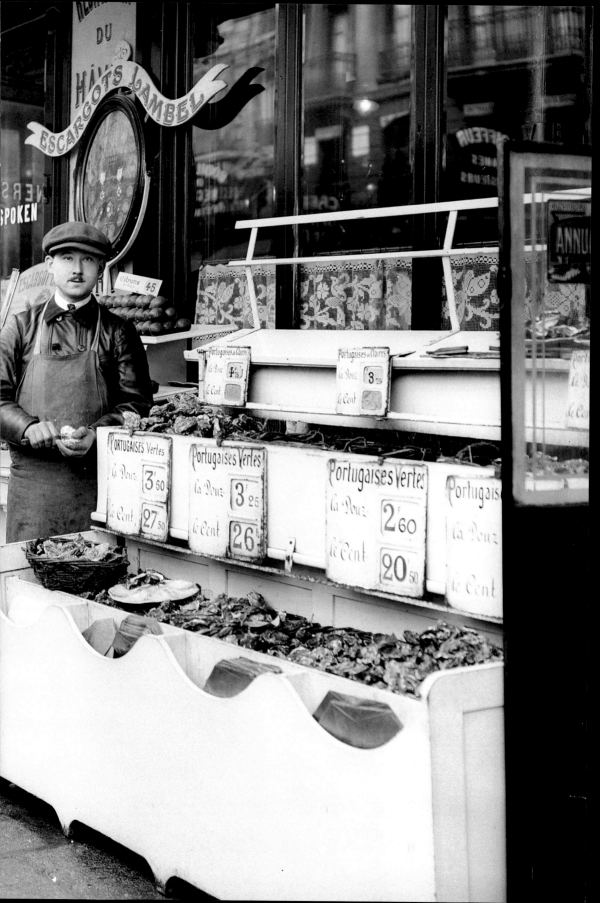

Hotels

The beginnings of the modern hotel business can be dated back to the opening of the Hôtel Ritz in the place Vendôme in 1898: the hotel's standards of hygiene and comfort, the quality of its food and the range of facilities it offered set a benchmark for luxury across Europe until the outbreak of the Second World War. Luxury hotels congregated in the same area: the Hôtel de Crillon, on the place de la Concorde, and Le Meurice, on the rue de Rivoli, were celebrations of the great French decorative styles of the past. By 1914, several high-class establishments had also opened on the Champs-Élysées (the Astoria, Le Claridge), and between the wars this cosmopolitan transformation continued with the construction of two more luxury hotels. The Hôtel George-V, which opened in 1928, was designed by the architects Lefranc and Wybo at the request of André Terrail, owner of the Tour d'Argent restaurant, and built as a classical-style complex with three sides opening on to a courtyard. The neighbouring Hôtel Prince-de-Galles dates from 1929, and its modern take on classical architecture was the work of André Arfvidson. The Hôtel de Paris on the boulevard de la Madeleine offered opulence combined with restrained modernism; it was designed by Émile Molinié and Charles Nicod, who specialized in luxury buildings, and decorated with glass by René Lalique and wrought ironwork by Edgar Brandt.

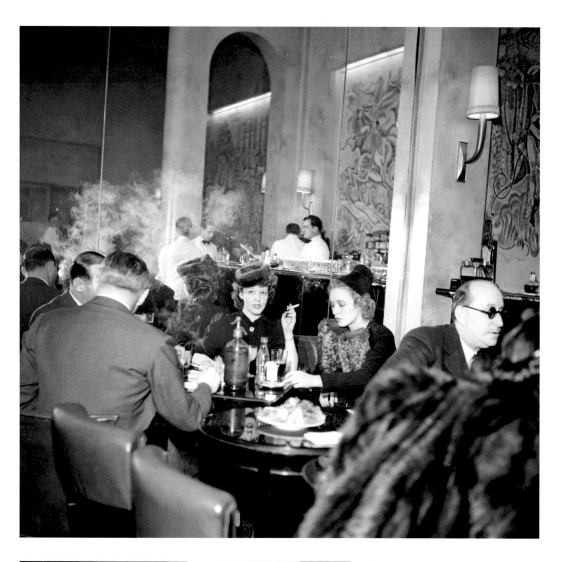

Above:
The bar at the Hôtel Ritz,
place Vendôme, 1939.

Right:
Salon of the Hôtel George-V.

Opposite:
Ladies taking tea in the garden
of the Hôtel Ritz, c. 1930.

Above:
Chas Laborde, *In Montparnasse*, c. 1925.
Engraving. Musée Carnavalet, Paris.

Below:
The Dingo American Bar and Restaurant,
rue Delambre (14th arr.), 1925,

All Paris's luxury hotels had smoking rooms where it was possible to buy spirits, but it was not until 1921 that the Paris Ritz opened a bar worthy of the name. The Bar Cambon was an immediate success, particularly with American tourists enjoying a reprieve from the revival of prohibition back home. In 1936 the Hôtel Plaza Athénée, on the avenue Montaigne, opened Le Relais Plaza, an American bar designed by Jacques Dupuis and decorated with murals by Francine Sarqui.

The fashion for bars, a natural spin-off from the jazz craze, was boosted by Paris's many North American visitors. More than a hundred smart establishments cropped up around the Champs-Élysées and the boulevards de la Madeleine and de l'Opéra, in the district of Les Ternes, and in Montmartre and Montparnasse. American bars offered a whiff of exoticism but at affordable prices. Harry's Bar (the oldest cocktail bar in Europe) was opened in 1911 on the rue Daunou, not far from the Opéra, by a former American jockey. Harry McElhone acquired the bar in 1923 and transformed it into a Paris landmark, an essential stopover for any expatriate, and it was on the piano there that Gershwin composed part of *An American in Paris*. Also in 1923, the Dingo American Bar opened on the rue Delambre. The Dingo was mainly frequented by the Anglo-American community and was a very lively venue thanks to its colourful barman, James 'Jimmie' Charters, a former lightweight boxing champion. In *Paris is a Party*, Hemingway refers to the bar, where he met F. Scott Fitzgerald in April 1925, two weeks after the publication of *The Great Gatsby*.

Cocteau and his gang — Raymond Radiguet, Jean and Valentine Hugo, Georges Auric — were regulars at Louis Moysès's little bar, Le

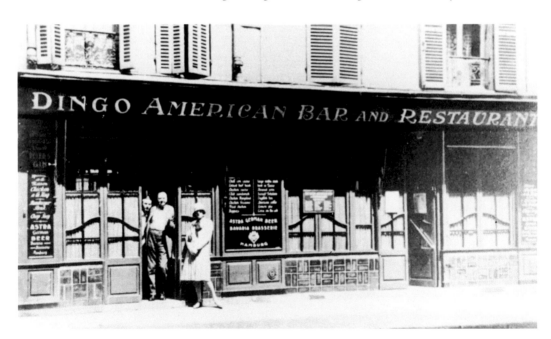

Left:
Outside the Dingo American Bar in 1925:
Lou Wilson stands second from the left,
next to Jimmie Charters; seated on the left
is Duff Twysden, who was Hemingway's
model for Lady Brett Ashley in the novel
The Sun Also Rises; sitting on the right,
Kiki de Montparnasse.

Below:
Le Boeuf sur le Toit on the rue Boissy-
d'Anglas (8th arr.), bar side.

Gaya, just behind the place de la Madeleine, and in 1921 they persuaded
him to turn the place into a fashionable piano-bar. Cocteau drummed
up support among all his friends and the opening in February 1921 was
attended by a big crowd of artists, writers and society people, including,
among others, André Gide, Picabia, Tzara, Misia Sert, Diaghilev and his
Ballets Russes, and Paul Poiret. Moysès had recruited Jean Wiéner, a clas-
sical pianist who was passionate about jazz, and Vance Lowry, who
played saxophone and banjo, and Cocteau accompanied them on the
drums. In 1922, Moysès moved Le Gaya to the rue Boissy-d'Anglas, near
the place de la Concorde, where the new bar occupied two storefronts on
either side of a *porte cochère*. He named it Le Boeuf sur le Toit after the Sur-
realist ballet by Milhaud, Cocteau and Massine, first performed at the

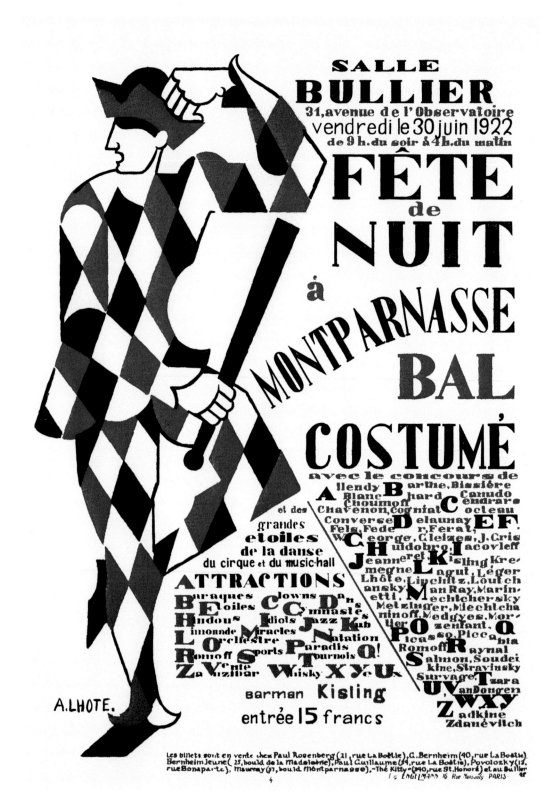

Opposite:
Fête de Nuit in Montparnasse, Costume Ball,
1922. Advertisement for an event held at
the Salle Bullier, on 30 June 1922.
Illustration by André Lhote.

Left:
The Jockey, a nightclub on the corner of
the boulevard du Montparnasse and the
rue Campagne-Première (14th arr.),
November 1923.

Below:
Costume ball at the Maison Watteau,
6 rue Jules-Chaplain (6th arr.), 23 March
1924. Lena Börjeson held an annual ball at
the Maison Watteau, the headquarters of
the Académie Scandinave, with interiors
by Pascin, Dardel, Krohg and Grünewald.

Théâtre des Champs-Élysées in 1920. Mirrors increased the feeling of
space and reflected Francis Picabia's painting *The Cacodylic Eye* (p. 237).

In November 1923, a former American jockey named Miller and the
American painter Hilaire Hiler took over Caméléon, a café on the
boulevard du Montparnasse, and renamed it The Jockey. For four years,
The Jockey was hugely successful, opening its doors to revellers from all
over the world. Hiler decorated the walls with murals and played jazz
piano with a monkey on his shoulder, and Alice Prin, more famously
known as Kiki de Montparnasse, sang a couple of songs there every
night, electrifying her audience with her sensual performances and
eccentric outfits. It was at The Jockey in 1933 that Anaïs Nin introduced
Henry Miller to Hiler, who later taught Miller watercolour painting.

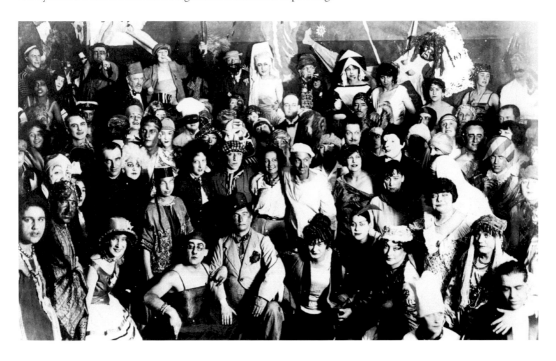

Above:
The couturier Paul Poiret at the
Bal Nègre, March 1927.

Below:
Sem, *Le Bal de la rue Blomet*, 1928.
Watercolour. Private collection.

Opposite:
Paul Colin, *Bal Nègre*, poster for
the Théâtre des Champs-Élysées,
11 February 1927.

In 1924, Jean Rézard des Wouves, a Martiniquan who was standing for Parliament, set up his campaign headquarters in the back room of a *café-tabac* in the 15th arrondissement. The political meetings soon spilled over into dance sessions which, once the elections were over, became a permanent fixture – and so Le Bal Nègre was born. Initially a meeting place for the Caribbean community, and then for all the black communities in Paris, who came to dance the *biguine*, the Bal subsequently became a magnet for the artists of Montparnasse and intellectuals looking for a touch of the exotic: Desnos took his Surrealists friends there, and Foujita was a regular, along with Van Dongen, Picasso, Kisling, Pascin, André Gide, Paul Morand, Jean Cocteau and his cronies, Josephine Baker, Maurice Chevalier, and many others.

Cabarets and dance halls were also loved by Paris's night owls. Particularly popular venues were La Cigogne, on the rue Bréa, where the walls were decorated with murals of storks playing jazz; Le Rody Bar, on the rue Lafayette, designed in 1928 by Jan and Joël Martel, with a red and black logo inspired by De Stijl, and La Perruche, on the boulevard de Clichy, with its unmistakable sign. Not all dance halls were noisy, smoke-filled dens. In the 1930s, a more elegant style of venue appeared, where patrons could spend the evening dancing before dinner, returning after the theatre for a drink and a few spins around the dance floor to the sounds of a jazz band. Two such dance halls were especially interesting because of their fantastical interiors, designed by the architectural duo Blech and Bertrand. Le Grand Jeu had a band on a moving stage; gigantic chess pawns held up the brightly lit ceiling of the bar, while an

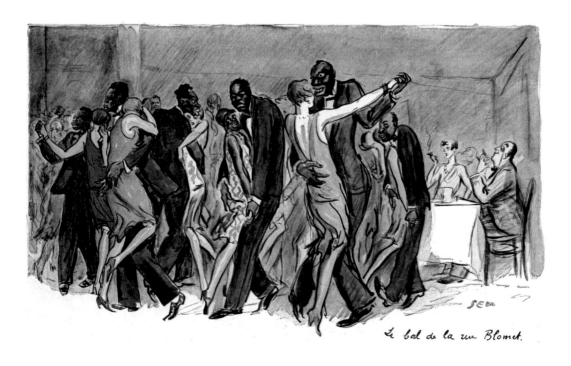

Le bal de la rue Blomet.

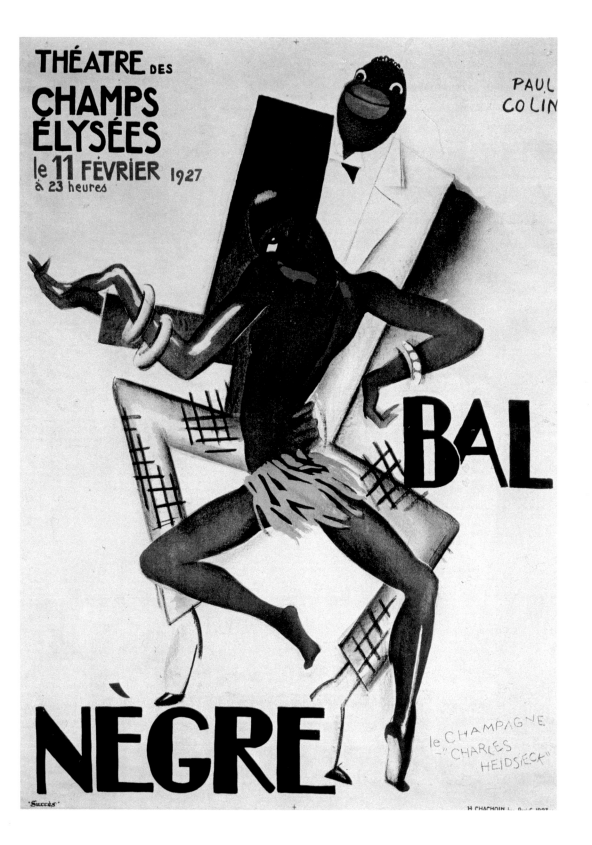

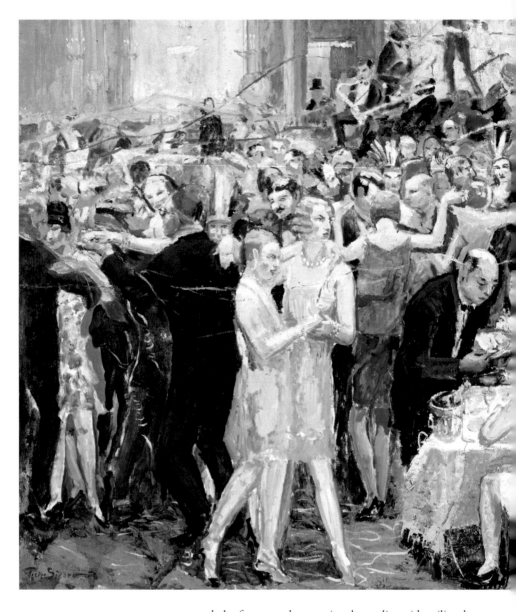

enormous deck of tarot cards was painted on calico with aniline dye to create a stained-glass window effect. La Villa d'Este, meanwhile, was reminiscent of an Italian garden, with porticoes and alcoves, vases and balusters. The dance hall was on three levels, and the white and gold walls, dark purple ceiling, white vellum, and versatile lighting effects all merged to create an atmosphere of aristocratic pleasure.

Cabarets served as showcases for young talent. Chez Fyscher, on the rue d'Antin, run by a Turk with British nationality (who gave the club its name) was the first nightclub to open in Paris. The premises were small, and only open from October to March, but very popular in the mid-1920s with a wealthy international set who came to hear established

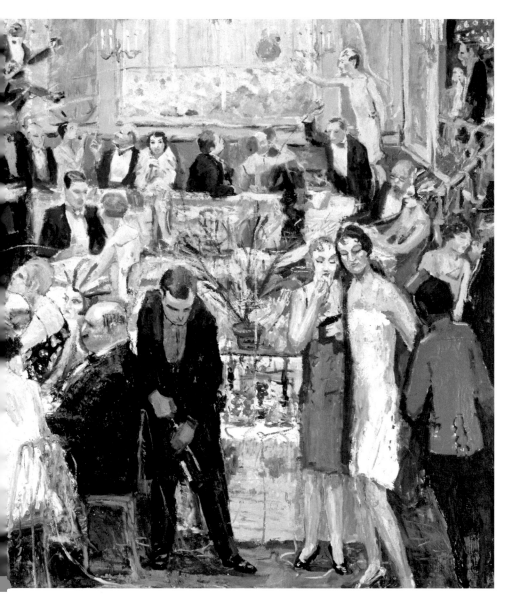

singers like Damia, Fréhel and Yvonne George, and up-and-coming names like Lucienne Boyer and Lys Gauty. In 1938, Sophie-Rose Friedmann, known professionally as Agnès Capri, opened a cabaret on the rue Molière that bore her stage name. This slender woman with her high voice debuted in 1935 at the Bœuf sur le Toit, and interpreted Jacques Prévert's work, causing a scandal by performing a Prévert piece with the lyric 'Our Father who art in heaven, stay there!' on Easter Day. The duo of Charles Trenet and Johnny Hess made their debut at O'Dett's, Piaf at Louis Leplée's nightclub Guerny's, and Rina Ketty, recently arrived from Italy, at the Lapin Agile, where the accordionist Jean Vaissade wrote her most famous songs for her, including *Sombreros et mantilles*.

Pierre Sicard, *Le Pigall's*, 1925.
Oil on canvas, 126 × 229 cm
(49 ⅝ × 90 ⅛ in.).
Musée Carnavalet, Paris.

PROSTITUTION

Over the centuries, Paris acquired such a reputation for debauchery –
from medieval bawds and Enlightenment brothels to licentious novels
and Toulouse-Lautrec's *petites femmes de Paris* – that in some quarters (par-
ticularly the US) it came to be regarded as the 'new Babylon'.

Before the Marthe Richard Law was passed in 1946, making broth-
els illegal, prostitution in Paris was regulated by the French police and
compulsory health inspections were carried out. The theme of 'love for
sale' inspired the writers Pierre Mac Orlan, Francis Carco, Blaise Cen-
drars, Joseph Kessel and Henry Miller; it was also a central subject for
painters such as Jules Pascin, and it haunted the repertoire of the *chanson
réaliste*. While men might sing of going out on the town with a 'tart with
a heart of gold', women tended to recall the harsher realities of the Paris
underworld, and the fact that prostitutes were rarely 'good-time girls'.
Theirs was a sordid day-to-day existence of pavements and pimps (*macs*
or *julots*), and brothels (variously known as *claques*, *lupanars*, *boxons* or
bouges) where the women plied their trade. The main red-light district
was at the foot of Montmartre, between Barbès, Pigalle, Blanche and
Clichy, where all manner of brothels sprung up and were controlled by
criminal gangs.

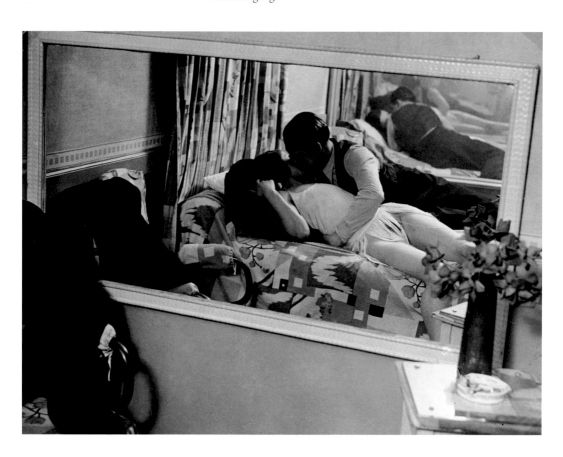

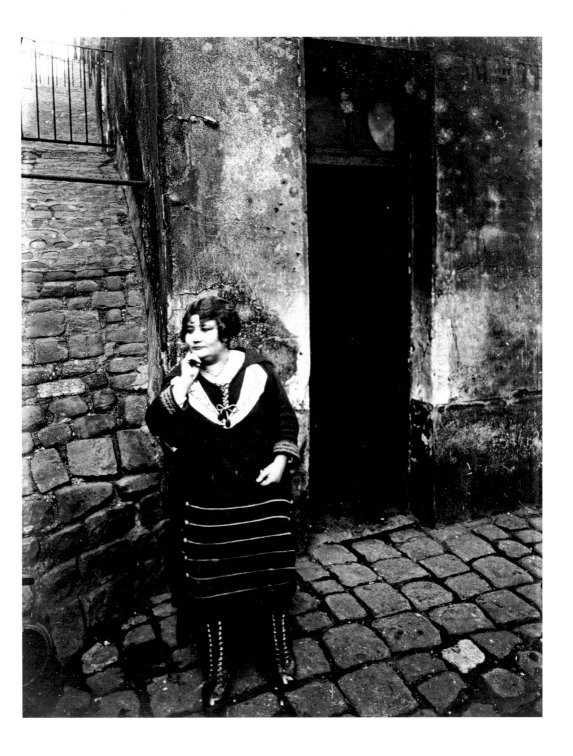

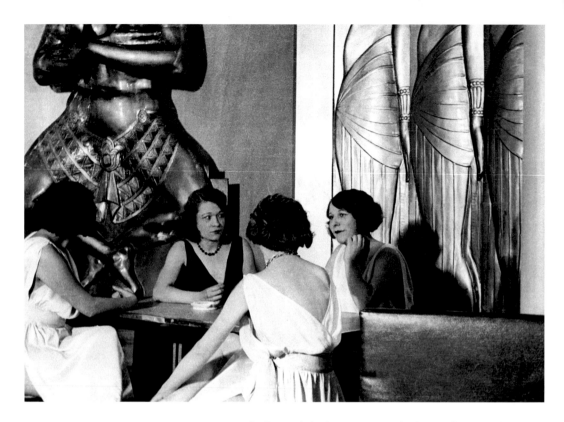

In the 'hierarchy' of prostitution, the lowest form was known as *abattage* and denoted casual streetwalking. This went on around the stations and in the area near the old city walls. The next level up was the *maison d'abattage*, where services were provided, for a modest fee, by professional prostitutes who were somewhat past their prime. These places were to be found in the Saint-Paul and La Chapelle districts. At the *maison ouverte*, or 'open house', the girls were only in residence when they were working and they paid the owner rent and a fee for the right to work. The *maison de rendez-vous* was a private apartment where women worked secretly, at fixed hours, handing over half their earnings to the madam in charge. And, finally, there were the high-class establishments, the *maisons closes* or *maisons de tolérance*, the most famous of which were Le Chabanais, which enjoyed its heyday prior to 1914, the One-Two-Two and Le Sphinx. All of them provided a choice of rooms decorated in different styles – railway carriage, medieval hall, ship's cabin, African hut – in an attempt to satisfy a range of male fantasies.

'Inverts' and 'Amazons'

Because of the lack of open repression in Paris (unlike the rest of Europe), the city became a focal point for gay men and lesbians and saw the emergence of a varied social scene catering for unconventional sexual orientations. Homosexuality and bisexuality were treated with relative

tolerance in moneyed, cultural and artistic circles, and almost came to be regarded as a badge of modernity during the 1920s. Jean Cocteau and his young admirers were regulars at the Boeuf sur le Toit, the meeting place of the avant-garde, where openly lesbian singers like Dora Stroeva, Yvonne George and Jane Stick performed. Brassaï captured this world in *Paris by Night*, photographing places where men or women from across the social spectrum could come together. Marcel Proust dealt with the theme of gay love in *Sodome et Gomorrhe* in 1922, but it was André Gide who truly confronted the taboo surrounding homosexuality when he published *Corydon* in 1924 under his real name (the novel having first been published anonymously in 1911). André Breton was known to be fiercely hostile towards homosexuality, but Salvador Dalí and Robert Desnos were more open to it. The book *My Body and I* (1925) reflected René Crevel's personal experiences, while in *Le Monde désert* (1927), Pierre Jean Jouve told the story of a triangular relationship between two men, a painter and a writer, and a young Russian woman. Books like these continued, however, to be printed only for a private readership. Jean Cocteau, who made no secret of his orientation, clandestinely published an erotic story entitled *Le Livre blanc* in 1928, and the second edition (450 copies of which were printed) was supplemented with eighteen explicit drawings.

Opposite:
Women from Le Sphinx brothel,
boulevard Edgar-Quinet (14th arr.), *c.* 1930.

Below:
Brassaï, *Gay Ball at Magic City*, 1931.
Private collection.

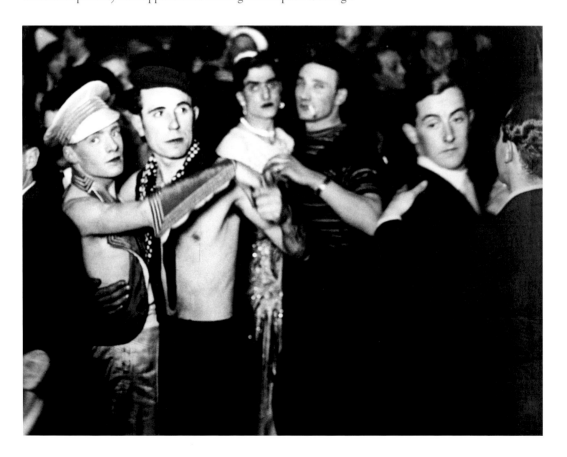

During the 1930s, the attitude of tolerance and even permissiveness was gradually eroded, however, and records identifying 'deviants' were established – giving rise to repressive laws under the Vichy regime.

One of the consequences of the Great War was a greater level of emancipation in the lives of women, and the publication of the controversial novel *La Garçonne* in 1922 highlighted modern women's rights to financial independence and physical pleasure – with their own sex if they chose. The reality of everyday life in Paris – though clouded by a constant atmosphere of suspicion – still seemed less oppressive than their Puritan homeland to all those American women, mainly artists, painters and writers, who came to the city in search of freedom. At the beginning of the 20th century, Natalie Clifford Barney held a salon at her rue Jacob home which welcomed lesbians and where a great many women, both French and expatriate, gathered over the course of fifty years, including the poets Renée Vivien and Lucie Delarue-Mardrus, the writers Colette, Radclyffe Hall, Djuna Barnes and Élisabeth de Gramont, the painters Romaine Brooks and Marie Laurencin, the photographer Berenice Abbott, the publishers Jane Heap and Margaret

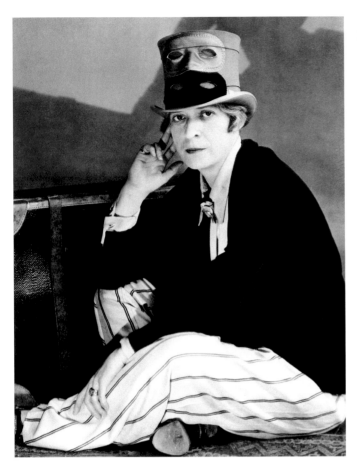

Anderson (founder of *The Little Review*), the journalist Janet Flanner and
the courtesan Liane de Pougy. Gertrude Stein and Alice B. Toklas were
an established partnership, whose apartment in the rue de Fleurus acted
as a magnet for the avant-garde, as did the bookshops run by Adrienne
Monnier and Sylvia Beach. All these women were among the first
'modern', independent, and in many cases wealthy, lesbians who openly
acknowledged their sexual orientation. They participated in the avant-
garde because this allowed them to express their own way of looking at
the world, free of the social and moral constraints that existed before
the war. Many adopted a multidisciplinary approach in their work,
which – in the case of Chana Orloff, Marie Laurencin and the photog-
rapher Claude Cahun (Lucy Schwob) and her partner, the painter and
graphic designer Marcel Moore (Suzanne Malherbe) – extended to the
representation of lesbian sexuality. Women painters portrayed two dif-
ferent facets of lesbian life: on the one hand, there were the sensual
nudes and portraits of proud 'Amazons', as painted by Tamara de Lem-
picka, and on the other, in complete contrast, the portraits by the
American Romaine Brooks, in which the subject's severe expression and

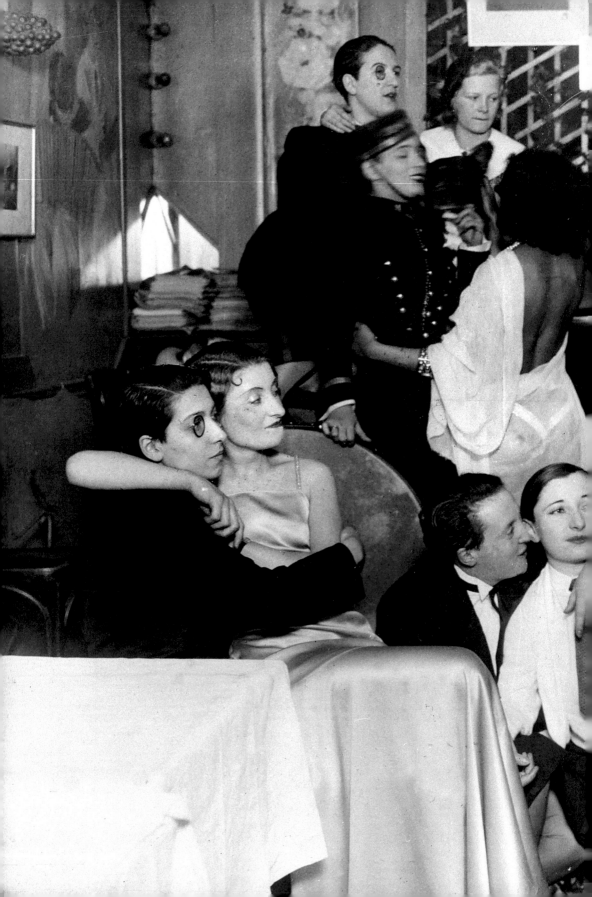

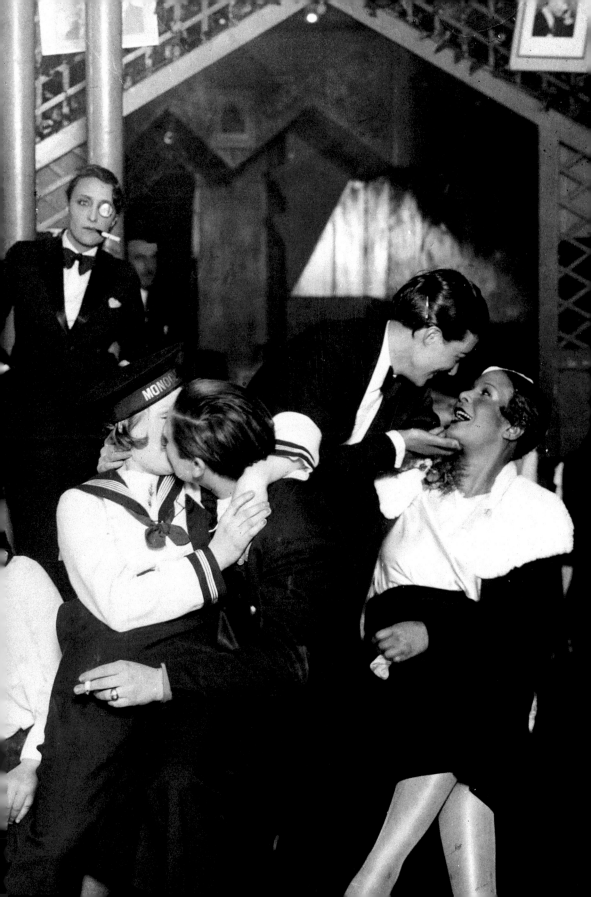

the dominance of dark colours create a sense of tragedy, as seen in her portraits of Nathalie Barney and Élisabeth de Gramont.

Following the androgyny of the *années folles*, the 1930s saw a return to greater femininity, but also witnessed the appearance of trousers for women – regarded by many as responsible for the shift towards a 'dangerous' equality of the sexes. The combination of culottes, tailored jacket and a trilby hat quickly came to be viewed as a distinctively lesbian look. A favourite haunt for gay women was the nightclub Le Monocle in Montparnasse; no stars performed there but there was a resident female band. The idol of all bachelor girls was the deep-voiced singer Suzy Solidor, whose straight hair and stunning figure inspired a great many artists, making her the subject of more than two hundred portraits. Jeanne Loviton (pen name Jean Voilier) was the muse of writers including Paul Valéry, who dedicated erotic poems to her, and Jean Giraudoux, while continuing to have numerous relationships with other women. The few works of literature of the time that featured lesbian themes tended to take a dark and tragic tone. Édouard Bourdet's play *La Prisonnière* (1926) was the story of a young woman struggling to free herself from the hold of her female lover, and in her *Journals*, Mireille Havet, who enjoyed brief recognition as a writer during the 1920s, described her troubled life, marked by extremes of decadence and loneliness, passionate affairs and tragic break-ups, and dependency on drugs.

Transvestites and Drag Artists

By adopting the pseudonym Rrose Sélavy — the name that also appeared on his ready-made *Belle Haleine, eau de voilette* — and dressing up in women's clothes, Marcel Duchamp was already subverting gender roles as early as 1920. The 'third sex' became an acknowledged orientation and transvestites became the queens of Paris nightlife. La Petite Chaumière, in Montmartre, was the leading transvestite cabaret and was followed by Chez Bob et Jean, run by dancer Bob Giguet and female impersonator Jean d'Albret, also in Montmartre. At Chez Charpini, the duo of Jean Émile Charpine (alias Charpini), also known as the 'male soprano', and the pianist and tenor Antoine Brancato parodied famous songs, interspersing them with skilfully aimed jokes. O'dett, alias René Goupil, made a name for himself in 1934 at Le Fiacre, singing risqué numbers dressed as an aging chatelaine and intermittently hurling insults at his audience; he remained equally popular when he opened his own club Chez O'dett over towards Pigalle. Barbette, the stage name of Vander Clyde, was an American dancer and trapeze artist who performed in drag and was immortalized in the photographs of Man Ray, which capture the various stages of his act up until the revelation of his true identity at the final bow. Barbette's ambiguous physicality and technical brilliance fascinated audiences at the Alhambra, the Empire and the Moulin Rouge, and Jean Cocteau cast him in his 1930 film *The Blood of a Poet*.

Opposite:
Charpini and Brancato,
music-hall performers, 1939.

Below:
The transvestite performer Barbette
at the Théâtre de l'Empire, 1937.
Photograph by Gaston Paris.

Overleaf:
Setting up a show at the Folies-Bergère,
as seen from the wings, 1937–39.

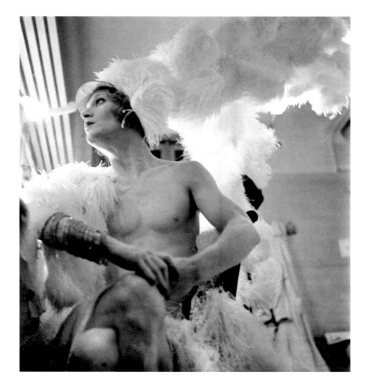

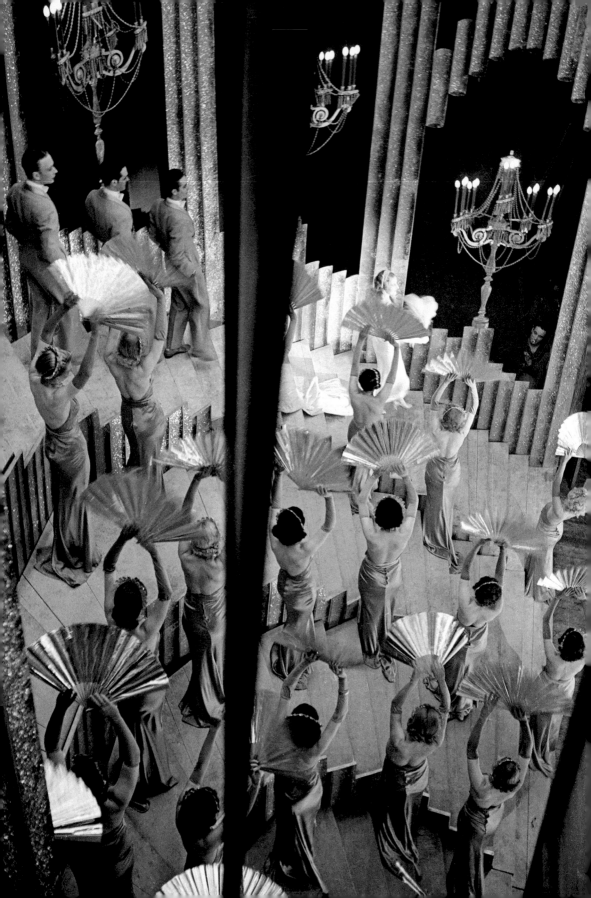

BIBLIOGRAPHY

GENERAL

Philippe Bernard and Henri Dubief, *The Decline of the Third Republic, 1914–1938*, Cambridge: Cambridge University Press, 1986

Michel Collomb, *Les Années folles*, Paris: Belfond/Paris-Audiovisuel, 1986

Suzanne Page and Aline Vidal, *Années 1930 en Europe. Le temps menaçant, 1929–1939*, Paris: Paris-Musées/Flammarion, 1997

Théodore Zeldin, *A History of French Passions 1848–1945*, Oxford: Clarendon, 1983

EVERYDAY LIFE

Jean Bastié and René Pillorget, *Paris de 1914 à 1940*, Paris: Association pour la Publication d'une Histoire de Paris, 1997

Jacques Lanzmann, *Paris des années 1930*, Paris: La Martinière, 1992

Pierre Saka and Yann Plougastel (eds.), *La Chanson française et francophone*, Paris: Larousse, 1999

Julien Stallabras, *Paris photographie, 1900-1968*, Paris: Hazan, 2002

THE CITY OF LIGHT

Yvonne Brunhammer, *Cinquantenaire de l'exposition de 1925*, Paris: Musée des Arts Décoratifs, 1977

Yvonne Brunhammer and Amélie Granet, *Salons de l'automobile et de l'aviation. Décors éphémères d'André Granet*, Paris: Norma/IFA, 1993

Jean-Louis Cohen, Joseph Abram and Guy Lambert (eds.), *Encyclopédie Perret*, Paris: Monum/Éditions du Patrimoine/IFA/Le Moniteur, 2002

Jean-Claude Delorme and Philippe Chair, *L'École de Paris. Dix architectes et leurs immeubles*, Paris: Éditions du Moniteur, 1981

Kenneth rampton, *Le Corbusier*, London: Thames & Hudson, 2001

Catherine Hodeir and Michel Pierre, *L'Exposition coloniale internationale de Paris*, Paris: Complexe, 1991

Dorothée Imbert, *The Modernist Garden in France*, New Haven, NJ and London: Yale University Press, 1993

René Jullian, *Histoire de l'architecture en France de 1889 à nos jours. Un siècle de modernité*, Paris: Philippe Sers, 1984

Anne Lambrichs and Maurice Culot, *Albert Laprade*, Paris: Norma, 2007

Antoine Le Bas, *Des sanctuaires hors les murs. Églises de la proche banlieue parisienne (1801–1965)*, Paris: Monum/Éditions du Patrimoine, 2002

Bertrand Lemoine (ed.), *Cinquantenaire de l'Exposition internationale des arts et techniques dans la vie moderne*, Paris: IFA/Paris-Musées, 1987

Bertrand Lemoine and Philippe Rivoirard, *L'Architecture des années 1930*, Paris: Délégation à l'Action Artistique de la Ville de Paris; Lyon: La Manufacture, 1987

François Loyer, *Histoire de l'architecture française de la Révolution à nos jours*, Paris: Mengès/Éditions du Patrimoine, 1999

Jacques Lucan (ed.), *Le Corbusier, une encyclopédie*, Paris: Centre Georges Pompidou, 1987

Bernard Marrey and Jacques Verroust, *Matériaux de Paris, l'étoffe de la ville de l'Antiquité à nos jours*, Paris: Parigramme, 2002

Jean-Christophe Molinier, *Jardins de ville privés, 1890–1930*, Paris: Ramsay, 1991

Gérard Monnier (ed.), Claude Loupiac and Christine Mengin, *L'Architecture moderne en France*, vol. I, *1889–1940*, Paris: Picard, 1997

Pierre Pinon (ed.), *Les Traversées de Paris. Deux siècles de révolutions dans la ville*, Paris: Éditions du Moniteur, 1989

Gilles Plum, *Paris Art déco*, Paris: Parigramme, 2008

Simon Texier, *Paris contemporain*, Paris: Parigramme, 2005

Bernard Toulier (ed.), *Mille monuments du XXe siècle en France*, Paris, Éditions du Patrimoine, 1991

Élisabeth Vitou, *Gabriel Guévrékian, 1900–1970. Une autre architecture moderne*, Paris: Connivences, 1987

THE DECORATIVE ARTS

Yves Badetz, *Maxime Old: architecte-décorateur*, Paris: Norma, 2000

Arlette Barré-Despond, *UAM*, 'Arts décoratifs et designers' series, Paris: Éditions du Regard, 1991

Patricia Bayer, *Art Deco Interiors*, London: Thames & Hudson, 1998

Françoise de Bonneville, *Puiforcat*, 'Arts décoratifs et designers' series, Paris: Éditions du Regard, 1986

Emmanuel Bréon, *Ruhlmann: Genius of Art Deco*, Paris: Somogy; Montreal: Musée des Beaux-Arts de Montréal, 2001

Yvonne Brunhammer, *Mobilier français, 1930–1960*, 'Le mobilier français d'époque' series, Paris: Massin, 2000

Yvonne Brunhammer and Suzanne Tisé, *The Decorative Arts in France 1900–1942: la Société des Artistes Décorateurs*, New York: Rizzoli, 1990

Guy Bujon and Jean-Jacques Dutko, *Eugène Printz*, 'Arts décoratifs et designers' series, Paris: Éditions du Regard, 1991

Florence Camard, *Ruhlmann: Master of Art Deco*, London: Thames & Hudson, 1984

Florence Camard, *Michel Dufet, architecte décorateur*, Paris: Éditions de l'Amateur, 1988

Florence Camard, *Süe et Mare et la Compagnie des arts français*, Paris: Éditions de l'Amateur, 1996

Thierry Couvrat Desvergnes, *Dupré-Lafon, décorateur des millionnaires*, Paris: Éditions de l'Amateur, 1986

Susan Day, *Art Deco and Modernist Carpets*, London: Thames & Hudson, 2002

Alastair Duncan, *Art Deco Complete*, London: Thames & Hudson, 2009

Alain Gruber (ed.), *L'Art décoratif en Europe. Du néoclassicisme à l'art déco*, Paris: Citadelle et Mazenot, 1994

Alain-René Hardy, *Art Deco Textiles: The French Designers*, London: Thames & Hudson, 2003

Pierre Kjellberg, *Arts déco, les maîtres du mobilier, le décor des paquebots*, Paris: Éditions de l'Amateur, 1998

Annelies Krekel-Aalberse, *Art Nouveau and Art Deco Silver*, London: Thames & Hudson, 1989

Félix Marcilhac, *Dominique, décorateur-ensemblier du XXe siècle*, Paris: Éditions de l'Amateur, 2008

Pierre-Emmanuel Martin-Vivier, *Jean-Michel Frank: The Strange and Subtle Luxury of the Parisian Haute-Monde in the Art Deco Period*, New York: Rizzoli, 2008

Laurence Mouillefarine and Évelyne Possémé (eds.), *Art Deco Jewelry: Modernist Masterworks and their Makers*, London: Thames & Hudson, 2009

Hans Nadelhoffer, *Cartier*, London: Thames & Hudson, 2007

Évelyne Possémé, *Mobilier 1910–1930*, 'Le mobilier français d'époque' series, Paris: Massin, 1999

Lisa Schlansker Kolosek, *The Invention of Chic: Thérèse Bonney and Paris Moderne*, London: Thames & Hudson, 2002

Jacqueline Siriex, *Leleu, décorateurs ensembliers*, Paris: Monelle Hayot, 2007

Marc Vellay and Kenneth Frampton, *Pierre Chareau: Architect and Craftsman 1883–1950*, London: Thames & Hudson, 1985

THE WORLD OF FASHION

Sylvie Aubenas and Xavier Demange, *Les Seeberger, photographes de l'élégance, 1909–1939*, Paris: BNF/Seuil, 2006

Dilys E. Blum, *Shocking! The Art and Fashion of Elsa Schiaparelli*, New Haven, NJ: Yale University Press, 2003

Edmonde Charles-Roux, *The World of Coco Chanel: Friends, Fashion, Fame*, London: Thames & Hudson, 2005

Jacqueline Demornex, *Madeleine Vionnet*, London: Thames & Hudson, 1991

Yvonne Deslandres, *Poiret: Paul Poiret 1879–1944*, London: Thames & Hudson, 1987

Yvonne Deslandres and Florence Müller, *Histoire de la mode au XXe siècle*, Paris: Somogy, 1986

Meredith Etherington-Smith, *Patou*, London: Hutchinson, 1983

Catherine Join-Dieterle, *Les Années folles, 1919–1929*, Paris: Paris-Musées, 2007

Dean L. Merceron, *Lanvin*, New York: Rizzoli, 2007

Gérard-Julien Salvy, *La Mode des années 1930*, Paris: Éditions du Regard, 1991

PAINTING AND SCULPTURE

Des années 1930, groupes et ruptures, Paris: CNRS, 1985

Louis Aragon, *Pour un réalisme socialiste*, Paris, Denoël et Steele, 1935.

Anne Bony, *Les Années 1920*, Paris, Éditions du Regard, 1989

Anne Bony, *Les Années 1930*, Paris, Éditions du Regard, 1987

André Breton, *Surrealism and Painting* (1928), London: Macdonald, 1972

Jan Brzekowski, *Kilométrage de la peinture contemporaine, 1908–1930*, Paris: Fischbacher, 1931

Yves Chevrefils Desbiolles, *Les Revues d'art à Paris, 1905–1940*, Paris: Ent'revues, 1993

Jean-Paul Crespelle, *La Vie quotidienne à Montparnasse à la grande époque, 1905–1930*, Paris: Hachette, 1976

La Critique hostile à Picasso, Paris: Jannink, 2000

Christian Derouet (ed.), *Cahiers d'art. Musée Zervos à Vézelay*, Paris: Hazan, 2006

Waldemar George, *La Grande Peinture contemporaine à la collection Paul Guillaume*, Paris: Arts à Paris, 1929

Catherine Gonnard and Élisabeth, Lebovici *Femmes artistes, artistes femmes, Paris, de 1880 à nos jours*, Paris: Hazan, 2007

René Huyghe (ed.), *Histoire de l'art contemporain*, Paris: Félix Alcan, 1935; *Les Contemporains*, Paris: Pierre Tisné, 1939

Édouard Joseph, *Dictionnaire des artistes contemporains, 1910–1930*, Paris: Art et Édition, 1930

Daniel-Henry Kahnweiler, *My Galleries and Painters*, London: Thames & Hudson, 1971

Kandinsky-Albers, Une correspondance des années 1930, Paris: Cahiers du Musée National d'Art Moderne/Archives, 1998

Jeanne Laurent, *Arts et pouvoirs en France de 1793 à 1981. Histoire d'une démission artistique*, Université de Saint-Étienne, Centre Interdisciplinaire d'Études et de Recherche sur l'Expression Contemporaine, 1982

Edward Lucie-Smith, *Art Deco Painting*, Oxford: Phaidon, 1990

Camille Mauclair, *La Farce de l'Art vivant*, Paris: La Nouvelle Revue Critique, 1929; *Les Métèques contre l'art français*, Paris: La Nouvelle Revue Critique, 1930

George Melly, *Paris and the Surrealists*, London: Thames & Hudson, 1991

Nadine Nieszawer, Marie Boyé and Paul Fogel, *Peintres juifs de Paris, 1905–1939. L'École de Paris*, Paris: Denoël, 2000

Marie-Aline Prat, *Cercle et Carré, peinture et avant-garde au seuil des années 1930*, Lausanne: L'Âge d'Homme, 1984

Emil Wernert, *L'Art dans le IIIe Reich. Une tentative d'esthétique dirigée*, Paris: Paul Hartmann, 1936

Christian Zervos, *Histoire de l'art contemporain*, Paris: Cahiers d'Art, 1938

A NEW WORLD OF IMAGES

Olivier Barrot and Raymond Chirat, *Gueule d'atmosphère. Les acteurs du cinéma français, 1929–1959*, Paris: Gallimard, 1994

N. T. Binh and Franck Garbaz, *Paris au cinéma*, Paris: Parigramme, 2003

Christian Bouqueret, *Des Années folles aux années noires. La nouvelle vision photographique en France, 1920–1940*, Paris: Marval, 1997

Renée Davray-Piekolek, *Paris grand écran. Splendeurs des salles obscures, 1895–1945*, Paris: Paris-Musées, 1995

Jean-Pierre Jeancolas, *Histoire du cinéma français*, Paris: Nathan, 1999

Jean-Pierre Jeancolas, *Le Cinéma des Français. Quinze ans d'années 1930 (1929–1944)*, Paris: Nouveau Monde, 2005

Roxane Jubert, *Typography and Graphic Design: From Antiquity to the Present*, Paris: Flammarion, 2006

Francis Lacloche, *Architectures de cinémas*, Paris: Éditions du Moniteur, 1981

Emmanuelle Toulet, *Le Cinéma au rendez-vous des arts, France, années 1920 et 1930*, Paris: BNF, 1995

Alain Weill, *Graphics: A Century of Poster and Advertising Design*, London: Thames & Hudson, 2004

Michel Wlassikoff, *Histoire du graphisme en France*, Paris: Les Arts décoratifs/Carré, 2005

INTELLECTUAL LIFE

Pierre Assouline, *Gaston Gallimard: A Half-Century of French Publishing*, San Diego: Harcourt, Brace, Jovanovich, 1988

Fernand Baldensberger, *La Littérature française entre les deux guerres*, Paris: Éditions du Sagittaire, 1943

Sylvia Beach, *Shakespeare and Company*, New York: Harcourt, Brace, 1959

Gisèle Freund, *Three Days with Joyce*, New York: Persea Books, 1985

Bernard Grasset, *La Chose littéraire*, Paris: Gallimard, 1929

Pierre Hebey, *L'Esprit NRF, 1908–1940*, Paris: Gallimard, 1990

Georges Hugnet, *Petite anthologie poétique du surréalisme*, Paris: Jeanne Bucher, 1934

Joyce & Paris, 1902, 1920–1940, 1975: Papers from the Fifth International James Joyce Symposium, Paris: CNRS, 1979

Fred Kupferman, *Au pays des Soviets. Le voyage français en Union soviétique, 1917–1939*, Paris: Gallimard et Julliard, 1979

Paul Loffler, *Chronique de l'association des écrivains et des artistes révolutionnaires (Le mouvement littéraire progressiste en France), 1930–1939*, Rodez: Subervie, 1971

Claude-Edmonde Magny, *Histoire du roman français depuis 1918*, Paris: Seuil, 1950; new ed. 1971

Adrienne Monnier, *The Very Rich Hours of Adrienne Monnier*, London: Millington, 1976

Olivier Rony, *Les Années roman, 1919–1939*, Paris: Flammarion, 1997

Maurice Sachs, *Au temps du Boeuf sur le toit*, Paris: La Nouvelle Revue Critique, 1939, new ed. 2005

Jean-François Sirinelli, *Intellectuels et passions françaises. Manifestes et pétitions au XXe siècle*, Paris: Fayard, 1990; new ed. Gallimard, 1996

William Wiser, *The Crazy Years: Paris in the Twenties*, London: Thames & Hudson, 1983

William Wiser, *The Twilight Years: Paris in the Thirties*, New York: Carroll & Graf, 2000

A MUSICAL CROSSROADS

1909–1929, les ballets russes de Diaghilev, exhibition catalogue, Paris: Centre Culturel du Marais, 1977

Petrine Archer-Straw, *Negrophilia: Avant-Garde Paris and Black Culture in the 1920s*, London: Thames & Hudson, 2000

Roland de Candé, *Histoire universelle de la musique*, Paris: Seuil, 1978

Marie-Françoise Christout, 'Peinture et scénographie du XXe siècle. Évolution du décor de ballet (1909–1939)', in Jérôme de La Gorce (ed.), *Iconographie et arts du spectacle*, Paris: Klincksieck, 1996

Dominique Garban, *Jacques Rouché, l'homme qui sauva l'Opéra de Paris*, Paris: Somogy, 2007

Antoine Goléa, *La Musique de la nuit des temps aux aurores nouvelles*, vol. II Paris: Alphonse Leduc, 1975

Roger Nichols, *The Harlequin Years: Music in Paris 1917–1929*, London: Thames & Hudson, 2002

Lucien Rebatet, *Une histoire de la musique, des origines à nos jours*, Paris: Robert Laffont, 1991

Marie-Christine Vila, *Paris musique. De l'école de Notre-Dame à la Cité de la musique. Huit siècles d'histoire*, Paris: Parigramme, 2007

DAYS OF PLEASURE

Gilles Barbedette and Michel Carassou, *Paris gay, 1925*, Paris: Non-Lieu, 2008

Gérard-Georges Lemaire, *Cafés d'autrefois*, Paris: Plume, 2000

PICTURE CREDITS

AMSTERDAM, Stedelijk Museum 225
BERLIN, Nationalgalerie 270
BOULOGNE-BILLANCOURT, Musée Départemental Albert-Kahn 106, 107; Musée des Années 1930 123a, 123b
BUFFALO, Albright-Knox Art Gallery 244
CHICAGO, The Art Institute 286, 307
FLORENCE, Photo Scala/© 2009 Digital Image, The Museum of Modern Art, New York 6–7, 34b, 190, 197, 211, 288, 330a
JERUSALEM, Anna Ticho Houe Museum 206b
LE HAVRE, Association French Lines 132
LONDON, Tate 192
LYON, Musée des Beaux-Arts 315; Musée des Tissus et des Arts Décoratifs/ P. Verrier 160
MADRID, Museo Nacional Centro de Arte Reina Sofia 280–281
MONACO, Nouveau Musée National de Monaco/Marcel Loli 10
NEW YORK, The Solomon R. Guggenheim Museum 267, 285
PARIS, Archives Hazan 70b, 74a, 78, 80b, 81, 84b, 86, 89, 90, 95, 96b, 103, 104, 105a, 109, 110, 111, 112, 113, 114, 115, 118, 119, 126, 127, 140b, 141/ Chevojon 66, 73a, 76, 77, 84a, 85, 96a, 97, 302; Bibliothèque Nationale de France 27a, 133, 253a; Centre Georges Pompidou, Bibliothèque Kandinsky 228 /Fonds Marc Vaux 263; CNAC/MNAM / Dist. RMN / All rights reserved 14, 137, 204, 205, 213, 268 /Adam Rzepka 20, 343, 396 /Georges Meguerditchian 23, 206a, 237, 254, 298 / Philippe Migeat 36, 226, 272b / Jacques Faujour 139r, 194, 245, 290 / Jacqueline Hyde 163r, 220 / Christian Bahier and Philippe Migeat 202 / Bertrand Prévost 235; Médiathèque de l'Architecture et du Patrimoine / Dist. RMN / François Kollar 12, 174 / André Kertész 23, 289 / Thérèse Bonney 301 / Studio Harcourt 303a / Raymond Voinquel 310; Musée de l'Armée / Dist. RMN / Pascal Segrette 230; RMN / All rights reserved 198, 232–233b / Hervé Lewandowski 18–19, 201 / Jean-Gilles Berizzi 37, 130–131, 229, 399 / Michèle Bellot 39, 373 / Gérard Blot 145, 278–279a, 293, 372, 397 / A. Morin-Gallimard 203 / Béatrice Hatala 348; Institut Français

d'Architecture 67, 87; Fondation Le Corbusier 68, 210; Fonds Photographique Denise Bellon 278; Leemage / Selva 11, 171, 325, 326a, 333al, 336b, 341, 378b, 383a, 393 / Heritage Images 15 / Josse 324, 334ar, 339a, 354 / Costa 349 / Aisa 358, 359a / Fototeca 390; Mobilier National/I. Bideau 124, 128, 129, 136 / Fr. Baussan 125a; Musée des Arts Décoratifs 69, 319; Musée d'Art Moderne de la Ville de Paris 221, 223, 269; Palais Galliera, Musée de la Mode de la Ville de Paris 148; Photothèque Hachette 48, 51a, 61, 63b, 64–65, 70a, 71, 79, 91, 99a, 101, 108, 146, 166b, 172, 184, 217, 222, 230b, 231, 274, 313, 322, 336a, 388a / Walery 49, 333ar / Archives Citroën 73b / Emmanuel Sougez 189 / Gaston and Lucien Manuel 333b / Kritosser 338 / Edmond Joaillier 359b; Roger-Viollet 9, 21, 22, 26, 28, 29a, 29b, 30, 31, 32–33, 34a, 35, 38, 40–41, 42a, 42b, 43, 44, 45bl, 45br, 46, 47a, 47b, 50, 51b, 52–53, 55, 56, 57, 58a, 58b, 60, 63a, 74b, 80a, 88, 92–93, 94, 98, 102b, 105b, 142b, 143, 144, 147, 149a, 150, 151, 152a, 152br, 153, 154al, 156a, 156br, 157, 158a, 158b, 159, 164, 167b, 173, 176, 178, 179, 180, 181, 182, 186a, 216, 218, 219, 266, 308, 309, 311, 312a, 339b, 340, 342, 374b, 377, 378a, 379b, 380, 381, 387a, 387b, 391a, 392b, 398, 405 / Musée Carnavalet 2, 24–25, 59, 62, 82-83, 175, 183, 186b, 312b, 376, 394–395, 400 /Pierre Jahan 8 / Albert Harlingue 27b, 337a, 347, 379a, 382, 402–403 / Ullstein Bild 155 / Jacques Boyer 187 / Pierre Barbier 277 / André Buffard 326b / Studio Lipnitzki 332, 334al, 335a, 335b, 344, 351, 353, 355, 356b, 357a, 357b, 364–365, 369, 386, 392a / Lapi 356a, 374a, 404 / Gaston Paris 360, 406 / TopFoto 361 / Maurice Branger endpapers, 384–385
PHILADELPHIA, The Philadelphia Museum of Art 248
REIMS, Bibliothèque Municipale 337b; Musée des Beaux-Arts / C. Devleeschauwer 122b, 125b, 138
ROLANDSECK, Stiftung Hans Arp und Sophie Taeuber-Arp 265
ROUBAIX, La Piscine, Musée d'Art et d'Industrie André Diligent / Arnaud Loubry 212a, 214
SAN FRANCISCO, Museum of Modern Art 297
STOCKHOLM, Dance Museum 366, 367, 368b
TORONTO, The Royal Ontario Museum 135
VALENCIA, IVAM 264a
VÉZELAY, Musée Zervos / Jacques Faujour 195, 207, 283, 284
WASHINGTON, National Gallery of Art 200

IMAGE COPYRIGHTS

INDEX